PREPARING DINOSAURS

PREPARING DINOSAURS

The Work behind the Scenes

CAITLIN DONAHUE WYLIE

The MIT Press
Cambridge, Massachusetts
London, England

© 2021 Massachusetts Institute of Technology

This work is subject to a Creative Commons CC-BY-NC-ND license.

Subject to such license, all rights are reserved.

The open access edition of this book was made possible by generous funding from Arcadia—a charitable fund of Lisbet Rausing and Peter Baldwin.

The MIT Press would like to thank the anonymous peer reviewers who provided comments on drafts of this book. The generous work of academic experts is essential for establishing the authority and quality of our publications. We acknowledge with gratitude the contributions of these otherwise uncredited readers.

This book was set in Adobe Garamond Pro by New Best-set Typesetters Ltd. Printed and bound in the United States of America.

Library of Congress Cataloging-in-Publication Data

Names: Wylie, Caitlin Donahue, author.
Title: Preparing dinosaurs : the work behind the scenes / Caitlin Donahue Wylie.
Description: Cambridge, Massachusetts : The MIT Press, [2021] | Includes
 bibliographical references and index.
Identifiers: LCCN 2020041106 | ISBN 9780262542678 (paperback)
Subjects: LCSH: Science—Social aspects. | Research—Social aspects. |
 Laboratory technicians. | Museums—Social aspects. | Paleontology—Research.
Classification: LCC QE718 .W95 2021 | DDC 560—dc23
LC record available at https://lccn.loc.gov/2020041106

10 9 8 7 6 5 4 3 2 1

For Eleanor Joan Bollinger Donahue

Contents

Acknowledgments *ix*

INTRODUCTION *1*
1 **PREPARING EVIDENCE** *25*
2 **PREPARING COMMUNITIES** *61*
3 **PREPARING TECHNOLOGIES** *101*
4 **PREPARING SCIENCE** *135*
5 **PREPARING PUBLIC SCIENCE** *171*
CONCLUSION *203*

Notes *223*
References *227*
Index *245*

Acknowledgments

This book is a study of how people and nature come together to create knowledge. The people who welcomed me into their labs and their lives made this book and my career possible, and also made learning from them a pleasure. This journey began with the wise professionals at the University of Chicago and London's Natural History Museum, who patiently taught me how to scrape away matrix and glue breaks, and to unglue my fingers: Sara Burch, Tyler Keillor, Bob Masek, and Scott Moore-Fay. Paul Sereno and Chris Carter let me prepare fascinating fossils and meet fascinating preparators in their labs. Later, the expert preparators named here as "Jay," "Kevin," "Amanda," and "Carla" hosted me as an ethnographer at their museums for several weeks. They embraced my presence and my questions with patience, kindness, and open-mindedness. Countless other research workers talked with me, showed me around their labs, and filled out my survey. Their names are absent in this book, but their ideas and experiences are the heart of it.

This book is also a tool to prepare a scholar (me). The community that has trained me in its mysterious rituals of making knowledge is generous, brilliant, and kind. Its members are too many to name here, but they know who they are, and I hope that they know how grateful I am. My PhD supervisor, Jim Secord, still grins while pointing out when my work "isn't quite prepared out of the rock yet" and where to "dig" to make it better. Fortunately for me, he continues to provide wise and enthusiastic advice, even though I am no longer his responsibility. He and many other

professors and students at the Department of History and Philosophy of Science at the University of Cambridge showed me how to be a scholar, such as how to integrate multiple disciplines, how to ask questions in seminars, how to write publishable papers, and how to teach. I strive to follow their admirable examples. Likewise, the enthusiastic and optimistic scholars I met during my formative four months at Berlin's Max Planck Institute for the History of Science inspired me to write a book. David Sepkoski invited me there as a postdoc and has been a tireless mentor ever since.

Many listeners and readers have improved the ideas in this book. I received particularly astute knowledge from audiences at talks I gave at the Max Planck Institute, the Committee on Conceptual and Historical Studies of Science at the University of Chicago, the Egenis Centre at the University of Exeter, the Field Methods workshop at the University of Virginia, and many meetings of the Society for the Social Studies of Science. Among many generous readers, the following experts provided invaluable insights on chapters at key moments and sometimes across several drafts: Michael Barany, Katy Barrett, Ira Bashkow, Bernie Carlson, Adrian Currie, Fiona Greenland, Sabina Leonelli, Lisa Messeri, Josh Nall, Nicole Nelson, Gwen Ottinger, Allison Pugh, Beth Reddy, Robin Scheffler, Kelley Swain, and the many anonymous reviewers who have commented on this manuscript and my other publications. Katie Helke and her team at the MIT Press believed in this book and its author, as they demonstrated through their excellent advice and hard work. This book would never have been written and my life would be much diminished without the friendship, empathy, and powerful presence of my writing buddies, especially Alison Lefkovitz, Emily McTernan, and the UVA Faculty Writing Group.

The New Jersey Institute of Technology took a chance by hiring me as a not-quite-official PhD, giving me the honor of learning how to teach by working with their wonderful students. The University of Virginia invested in me as a researcher as well as an educator. What a privilege it is to work alongside inspiring colleagues and students. In particular, the wise mentorship of Ira Bashkow, Bernie Carlson, Mike Gorman, Kay Neeley, and Nancy Steffen-Fluhr has made all the difference.

My parents, Ken Wylie and Dr. Mavis Donahue, have provided unquestioning support, crucial vacations, careful citation-checking, and enthusiastic childcare. They never thought it was weird that I wanted to study science and history and culture and technology and everything else. What a gift. Breanne, Brendan, Brian, Deena, Laura, Matilda, and Sean don't really understand what I do because it's irrelevant to their affection and goofiness, which is also a gift. Tobias and Jonas make life joyful and deliver necessary hugs, laughter, and love. I dedicate this book to Eleanor Donahue, storyteller and grandma extraordinaire, for teaching me the power, value, and incredible fun of listening to people's stories.

INTRODUCTION

Mounted dinosaur skeletons tower over museum visitors, broadcasting a sense of solidity and grace. They gaze eyeless into the distance, bathed in the dim light that protects the photosensitive glue supporting their bones. They seem to have stomped out of the distant past and paused on the exhibit's reinforced floor. Humans stream around them, incongruously active compared to the stiff dinosaurs. Children flit from specimen to specimen, crying out their excitement and (mostly) pretend fear. Adults look upward, pointing out teeth and claws and text panels to each other.

Fossils inspire curiosity and awe in part because they are natural. Visitors flock to see these skeletons not because they are science fiction but instead because they represent real (and bizarre) animals. Museums emphasize specimens' naturalness, such as in exhibit text panels that list facts about dinosaurs as once-living animals but not as fossilized bones that people have painstakingly collected, prepared, studied, and mounted. Paleontologists too focus on the animals by publishing proposed facts without describing how the specimens that inspired those facts were processed into scientific evidence. This book asks how these bones become specimens and, crucially, who does this expert work.

If visitors think about it, they would acknowledge that these magnificent skeletons did not stroll in from the Mesozoic era and stand obligingly in place in the museum. But they might not know that these skeletons were once fragmentary, distorted chunks of rock, embedded in the geologic strata formed from their prehistoric habitats and virtually unrecognizable

to the untrained eye. After all, now those fossilized bones are clean and uncrushed. They have been assembled into skeletons with no missing parts, ringed by panels spelling out confident-sounding facts about the animals' lifestyles and environments. How does this transformation happen? Naive visitors might think that scientists pick up fossils from the ground, blow the dust off them, and declare them a new species. More savvy visitors might know that vertebrate fossils are usually rare, fragile, and encased in rock, but they might assume that removing that rock and keeping the fossils from disintegrating is relatively routine, easy work that doesn't affect the fossils' appearance or value as evidence. The people who do this work have a different view: the seemingly mundane processes of preparing specimens are skillful, creative, and a fundamental part of learning about past life. This book investigates the people who prepare fossil specimens for research and display, and, accordingly, how their work defines prehistoric animals, museum displays, and science itself.

Some exhibits hint at the people and work behind the specimens. Among the extinct animals standing upright (thanks to vertebra-cradling steel) or lying half buried in slabs of rock (perhaps still curled in their death pose), there might be information about how scientists, technicians, students, volunteers, and amateurs find fossils in the field, along with a shovel or geologic map.[1] Often this is the only public mention of the many kinds of work that make possible the intricate structures of petrified bone that we call dinosaurs, mammoths, and saber-toothed cats.

As a wonderful exception, a few exhibits house a small, brightly lit room enclosed by windows, in sharp contrast to the large twilight exhibit hall. This room looks like a display case—a giant version of the specimen-containing vitrines placed throughout the museum. But behind this glass are people (figure 0.1). Clad in dusty T-shirts, they bend over fossils, peering closely to look for the subtle interface between fossil bone and its surrounding rock, which they call matrix. Then they scratch away matrix—and not fossil, they fervently hope—with tools that resemble a dentist's. These workers are surrounded by tubs of plaster, bottles of glue, buckets of discarded matrix, microscopes, noisy fans sucking rock dust out of the air, and tables laden with specimens as well as coffee cups,

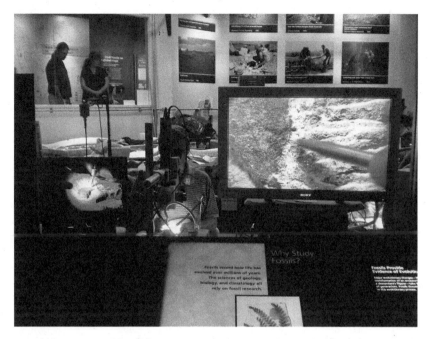

Figure 0.1
Photographed from museum visitors' perspective outside a glass-walled laboratory, a volunteer preparator works on a fossil with video cameras capturing his hand (left screen) and his view down the microscope (right screen) for visitors to watch.

houseplants, and toy dinosaurs. Visitors typically assume that the people on display are scientists—a misconception that some museums' text panels perpetuate. These workers, however, claim a different identity from "scientist"; they are fossil preparators. Fossil preparators describe their work of removing matrix and gluing fragmented bones as preparing fossils. Another logical though incorrect interpretation of watching them work would be, as I heard one impressed visitor exclaim to a child, "Look! People making fossils!"

Preparators do not "make" fossils from scratch; rather, they make fossils into specimens. Selecting natural objects to study and then turning them into specimens that can be studied is one of the central tasks of science. After all, specimens are the foundation of knowledge about life and environments, and how they change. Some specimens are alive, such as the

creatures nurtured by workers in zoos, aquariums, and botanical gardens. Others are preserved in forms such as pickled or dried animals, pressed plants, sliced rocks, polished minerals, insects pinned in boxes, and pollen grains captured on glass microscope slides. As objects carefully labeled and stored in perpetuity in museum and university collections, specimens offer trustworthy physical evidence for scientists' knowledge claims.

We might assume, as museums and scientists imply, that these objects move directly from their habitats into scientific papers and exhibits. Along the way, though, people process them physically and epistemically, so that they become researchable and displayable. For vertebrate fossils as well as other objects, this work involves separating useless background (such as matrix) from informative specimen (such as fossilized bone), often based only on subtle differences in appearance and material composition. Preparing nature for study and display requires decisions about what an object should look like, and what it should be capable of. For example, should a preparator remove all the matrix around a fossil or leave it partly embedded? Should a preparator make a fossil solid enough to be handled by applying glue that degrades over time, or omit the unstable chemical additives and allow the fossil to remain physically fragile? Should a preparator fill in the inevitable missing bones by imagining and sculpting replacement parts? Many questions like these shape how research workers, including scientists, preparators, conservators, collection managers, and volunteers, decide how to convert nature into specimens and knowledge. This book complements previous rich analyses of scientists' interpretations of specimens by investigating the people and practices involved in making these long-lasting, trusted, yet changeable objects.[2]

How workers prepare fossils illustrates how research communities produce the evidence, experts, methods, and perceptions of science that constitute our beliefs about nature. To understand this important work, we must understand the workers. First, I discuss how fossil preparation inspires a new model for understanding science. This model highlights the crucial roles of work, objects, and craft in research. Next, I explain how I studied technicians who leave few written traces. Because scientists rarely describe fossil preparation or include preparators as authors in scientific

papers, thereby making them "invisible" in print (Shapin 1989, 1994), I used ethnographic methods of interviews and observation. Finally, I outline how this book's chapters analyze how people prepare dinosaurs and other fascinating creatures, and what their work can teach us about scientific evidence, practice, and knowledge.

PREPARING KNOWLEDGE

Doing research comprises four component processes that work together. Specifically, evidence must be prepared into forms that can be studied. Workers must be prepared with skills and values to do good work in a research community. Tools and techniques must be prepared to help practitioners do that work. Research workers and their audiences must be prepared to engage with scientific knowledge based on a shared sense of what science is. These ongoing, interlinked processes simultaneously rely on and produce scientific knowledge. I follow the skillful, hands-on work of preparing fossils to investigate this system. To encompass the wide range of iterative interactions between research workers, nature, and society that makes science possible and meaningful, I conceptualize *preparation* as a fundamental feature of scientific work and knowledge.

This form of preparation expands on the theory of social construction, which similarly highlights the foundational roles of things, communities, practices, and social values in research. Philosopher Sergio Sismondo (1996, 66) explains, "Scientists inhabit a world in which both the social and many of the material realities that they encounter are constructed. Many of the social realities are supposed to take account of or mimic the material ones, and some material realities are constructed with help from the social ones." This cycle of constructing both the material and social worlds is crucial for making nature comprehensible. For example, some research communities conduct carefully controlled experiments on constructed materials (e.g., industrially purified chemicals or specially bred organisms) to investigate natural processes. How they define their questions and practices influences how they prepare their materials, and what they learn from those materials influences the questions they ask and how they work with the materials.

This cycle allows scientific ideas, work, and objects to adapt to each other, and thereby align with and be useful in their social context.

The concept of preparation focuses on the adaptation and iteration inherent in this cycle. In comparison, "construction" implies an end point, an eventual finished product. Anthropologist Bruno Latour (1999, 115) worried that the metaphor of constructing scientific facts sounds too flimsy and therefore insulting to scientists by implying that "if it is constructed it must also be deconstructible." Preparation thus highlights the process more than the product, the journey more than the destination. Facts are constructed, and then some are deconstructed or renovated over time; preparation emphasizes how those changes happen from a longer-term perspective. Of course, one always prepares *for* something, which also implies an end point. But that end point is arguably more flexible and open, and less preplanned, than a construction project. Because research work is embedded in its time, place, and culture, the end points for which workers prepare their evidence, communities, technologies, conceptions of science, and knowledge change in response to their context. These moving goalposts may seem counterproductive, but actually this adaptability is crucial because knowledge can only make sense within its social world. When that world changes, as it is always doing, then knowledge—and the work of producing it—must change too. And after all, knowledge is rarely, if ever, truly finished. Rather, it is reexamined and reconfigured across time and cultures. Research workers will never reach their intended end point; it is a target to aim for instead of a permanent achievement. Crucially, that dynamic end point informs *how* workers do their work, which in turn alters the outcomes. The concept of preparing knowledge, then, captures the endless and critical interactions between research work, knowledge, and society.

Specimens are part of this cycle too, although some scholars of science and technology studies (STS) disagree. For example, Sismondo (1996, 67) names natural history specimens as an unusual exception to the social construction of material reality: "The material objects that scientists study are different from social ones in *some* interesting ways. They are made from other material objects, rather than just actions. Sometimes, if rarely, they are

not even constructed or manipulated by people, as in the case of the objects that some naturalists, geologists, and early astronomers have studied." It is indeed hard to argue that stars and planets themselves are influenced by social factors (although how they are observed, documented, and interpreted certainly is). And of course, taxidermied animals, trimmed rocks, and prepared fossils contain plenty of material that exists due to factors beyond "just actions" of humans (unlike the socially constructed categories of race, gender, beauty, justice, and so on, that exist—and are powerful—because humans have decided that they exist).

Pieces of nature, however, are made into specimens by humans. Their naturalness becomes combined with social values as soon as humans deem them specimens. People develop scientific objects and interpretations in a social and material context that philosopher Ian Hacking (1999, 10) calls, in a wonderful double entendre, a "matrix." For example, a fossil forms in its geologic matrix, and later, when collected by a human, enters a social matrix of institutions, people, and beliefs. While Hacking (1999, 32) contends that nature does not "interact" with the categories that we assign to it, clearly this situation shows otherwise. If research workers decide that a natural object is a specimen, then they handle, process, and interpret that specimen differently from just any object. Classifying an object as a specimen therefore results in changes to its physical form, not just to how humans understand it. Hacking (1999, chap. 8) even chooses a case study about geologic knowledge to argue for the broad reach of the social construction of theories about nature. If social construction is more obvious in natural phenomena that are visible only indirectly or via technology (e.g., quarks, electrons, or microbes), then demonstrating that social values also shape scientists' interpretations of visible, tangible rock specimens is a powerful point. For the same reason, Latour uses paleontology to satirize an extreme view of the social construction of reality. In Latour's (1980) "fable," the actual past appearance and lifestyle of a dinosaur changes as scientists' beliefs about that dinosaur change; thus the scientists create reality in the process of trying to understand it. But nature is not created by people; specimens—as pieces of nature modified by humans for epistemic uses—are.

Thinking about specimens as cultural objects with embedded social values (e.g., Haraway 1984; Alberti 2008), much like technologies (e.g., Mackenzie 1990; Bijker, Hughes, and Pinch 2012), reveals how they reflect issues of power between social groups. How preparators prepare fossils thus exemplifies the "entanglement of nature and culture in the specimen" (Alberti 2008, 85), such as how preparing specimens also defines the various groups of workers within a research community (chapter 4). Anthropologist Brian Noble (2016, 358–359) portrays this entanglement in the form of the many influences on the design of a dinosaur exhibit with a glass-walled preparation laboratory at the Royal Ontario Museum:

> The scientist's wish for conveying the dynamic process of palaeontological reconstruction, . . . the marketer's competitive goals to succeed in museums in the slipstream of *Jurassic Park*'s successes at the movies; the hopes invested in the meticulous action of a laboratory; the diplomatic efforts of the interpretive planner to translate across many knowledge experiences with special attention to those aligned with middling Canadian family living; the participation of audiences in constituting a fuller, if also more personal, vision of the living creature and its relations; the tensions of media and curatorial producers and their complex of tools and procedures. . . . This is the work of articulating dinosaurs.

The network of interactions between various groups, values, constraints, evidence, and kinds of knowledge defines—or in Noble's term, "articulates"—dinosaurs' appearance, behavior, and environment for the museum's visitors. Noble's analysis of the politics of display helps inform this book's analysis of the politics of research. The recursive craft of altering and interpreting pieces of nature, then, can be understood as a series of decisions and actions that "transform" natural objects into specimens to serve as what sociologist Chandra Mukerji (1989, chap. 8) calls "ostensive models" that combine description and theorizing. Preparing evidence and facts is not a singular transformation but rather an ongoing series of physical and epistemic changes through which research workers try to balance the priorities and influences of their various colleagues.

Preparing evidence involves "transform[ing]" materials to achieve physical and epistemic goals (e.g., a stable fossil with maximum completeness,

a safe machine that produces reliable results, or a data set that has been cleaned and formatted for a particular study). This situated craftwork—and the technicians, students, and volunteers who do it alongside scientists—provides evidence about nature and thereby influences how scientists—and the rest of us—understand the world. Yet these tasks and workers receive little recognition in print, such as through authorship or methodological descriptions. Portraying research work as knowledge preparation recognizes all the "preparers" involved in this multifaceted process.

LABOR IN THE LABORATORY

Beyond Scientists

So who does the work of preparing knowledge by preparing evidence, communities, technologies, and conceptions of science? This question avoids the more exclusive job-based designations of "science" as done by scientists, "research" by researchers, "technical work" by technicians, or "support work" by support staff. In practice, all research workers—that is, anyone who contributes to research, including scientists, technicians, volunteers, and students—do various overlapping, recursive combinations of preparing evidence and interpreting it, making it difficult to extract which tasks count as "science" and therefore which workers deserve scientific recognition. By making most research labor "invisible" in print (Shapin 1989, 1994) and low status in institutional hierarchies, scientists effectively reify the more visible products and people of science: facts and scientists. Most ethnographies of laboratory life focus on *scientists'* labor. Sidelining the rest of the research workers, such as those who primarily do the skillful, creative, tailored work of preparing evidence, can portray scientists as lone geniuses, and scientific work as highly controlled, standardized, and predictable. This inaccurate view marginalizes all the other workers as well as overlooks the evidence crafting that scientists do themselves. Consistently including all research workers in STS analyses would enrich insights into scientific practice and knowledge. For example, an appreciation for nonhuman actors has broadened and enriched our understanding of participation in research (e.g., Latour 1987; Haraway 2000, 2016); all categories of

human actors deserve analytic attention too. This book shows how the model of preparing knowledge guides us to follow the behind-the-scenes, between-the-lines activities of science in order to reveal the various kinds of people who do them.

Scientists in many contexts and time periods have endeavored to obscure the people and practices of research in order to promote the credibility of the resulting data and knowledge claims. This goal inspires efforts to make technicians "equivalent" (Yarrow 2003, 67), "interchangeable" (Lucas 2001, 9), or even "part of the 'instrument' to be calibrated" (Schaffer 1988, 118). Scientists in some fields closely supervise less skilled technicians, who "are required to act with machine-like regularity, keeping thought and creative variation to a minimum" (Lynch et al. 2008, 89–90). Scientists thus try to dismiss the relevance of low-status, nonscientist research workers to the output of their work (Shapin 1989, 1994). Nonetheless, even supposedly unskilled workers have unnamed, uncredentialed abilities that researchers rely on, such as technicians' expertise at building, operating, and repairing machines (Kusterer 1978; Mukerji 1989; Law 1994; Orr 1996; Sims 1999; Doing 2009).

This "machine-like" portrayal does not apply to all research workers. Scientists differentiate "support staff" who follow routine protocols from higher-skilled technicians, whose expertise some fields even acknowledge with authorship (Charlesworth et al. 1989, 82–89). The crucial indicator of technicians' skill, according to scientists, is "their reliability in producing certain types of data" (Latour and Woolgar 1986, 223)—that is, how well they achieve scientists' desired results. Technicians who produce desirable data then receive little supervision or instructions from scientists, thereby allowing them to carry out methods as they see fit (Latour and Woolgar 1986, 223; Mukerji 1989, 137; Lynch et al. 2008, 89–90). For example, skilled technicians and scientists work as de facto equals to ensure the safe operation of high-voltage electrical equipment for plasma physics research (Sims 2005). These workers believe that achieving safety relies on their own careful attention, experience, and "instinct" more than on academic credentials such as a PhD. Because of the indefinable nature of embodied know-how as well as many laboratories' reliance on

diverse skills, scientists sometimes grant trusted technicians control over their techniques. This autonomy empowers research workers by implicitly asking them to apply their expert judgment to decide how they prepare evidence.

Furthermore, assigning research workers different levels of power enables some workers to do tasks that others cannot. For example, for one technician, "his low status and affable personality enabled him to move from lab to lab with materials, (often) inconclusive results, and ideas without provoking any controversy" (Rabinow 1996, 114). The technician's low institutional rank and categorization as a nonscientist made him nonthreatening, thereby achieving valuable information sharing for scientists. But how does this invisible role and work affect the technician? STS scholars tend to view laboratory laborers from scientists' perspectives. As a result, these studies don't tell us what the technicians think about scientists' expectations or how they experience their roles in research.

Fossil preparators offer important insights into laboratory labor because they don't fit the common views of technicians as standardized and "interchangeable" or as quasi-scientists. Preparators don't have PhDs or authorship on publications. They receive no formal training or methodological protocols. To distinguish themselves from low-skill, instruction-following technicians, preparators portray their practices as creative and artistic (chapter 1). Moreover, the majority of people who prepare fossils are volunteers, not staff. One might think that these skillful volunteers would threaten preparators' employment, yet the presence of volunteers actually empowers staff preparators by granting them control over selecting, training, and supervising a workforce. Thus preparators control their methods and communities, unlike most technicians, and lack the typical indicators of professional fields that most technicians have, such as official training and credentials (Abbott 1988; Barley, Bechky, and Nelson 2016). This combination of shared and divergent traits makes preparators and fossil labs valuable sites for studying how nonscientists shape science.

The fluidity of research tasks in practice complicates many distinctions we make about science. To shed light on the craft knowledge and "moral economy" of research work in the early twentieth century, historian Robert

Kohler (1994) studied how scientists developed the *Drosophila* fruit fly as a "standard" organism for genetics experiments. The work of creating stocks of standardized flies might seem merely technical or perhaps even routine. Instead, it was deeply embedded in these scientists' group identity and knowledge about biology, such as generously sharing individuals' painstakingly bred fly collections to legitimize the emerging field's research and produce higher-quality knowledge for everyone (Kohler 1994). Similarly, sociologists Kathleen Jordan and Michael Lynch (1998, 776) argue that we can capture a more complete view of scientific practice and practitioners by "following the technique around," as exemplified by their work documenting how scientists, technicians, and students use polymerase chain reaction in various biological and forensics laboratories. I extend their analysis beyond one technique to follow the skillful practices of preparing evidence, communities, technologies, and conceptions of science, whose deep interconnection is a defining feature of research work and unifying force in research communities. So instead of worrying about the oversimplified and overstudied question of which processes and people are science and not science, here I study scientific work and workers in situ and inclusively.

Most scientific fields preserve at least some variability in who does which tasks. For example, paleoanthropologists and invertebrate paleontologists typically prepare fossils as well as study them. But workers in vertebrate paleontology enact a strict division of labor. They consider the work of processing data to be separate from the work of interpreting data—to the extreme that different people do those tasks. Few vertebrate paleontologists prepare fossils, and most don't even know how. This is not a case of routine work that scientists *could* do themselves but instead choose to outsource to lower-status workers. Rather, research workers consider fossil preparation to be a separate field from that of scientists, involving its own training, practices, and culture. Similarly, conserving, organizing, and displaying fossils are the primary responsibilities of other groups that consider themselves separate from fossil research, namely conservators, collection managers, and exhibit designers. This highly stratified social structure is reflected in how practitioners defend their domains from others' encroachment, such as cases of paleontologists forbidding preparators from doing research, and

preparators hiding specimens to prevent paleontologists from preparing them (chapters 2 and 4). This crucial separateness enables each group's distinct contexts of (in)visibility and (dis)empowerment.

Most fields assign scientific recognition based on the perceived status of tasks, such that only people doing work deemed "research" (e.g., theory building) receive credit in the form of authorship and higher institutional rank. When scientists prepare samples or run experiments, their work often goes as unrecognized as when nonscientists do it. Likewise, if nonscientists such as technicians, students, or citizen scientists propose a theory that scientists deem credible, then they will typically receive recognition for it. Thus the *task* is deemed nonscientific, not necessarily the worker. In comparison, fossil research communities assign scientific recognition based on workers' job, such that anyone without a "scientist" job title does not receive recognition in print or power in institutional hierarchies, even if they propose theories or have a PhD. These stark divisions do not match workers' everyday responsibilities, which are interdependent to the point that everyone who works with fossils contributes to scientific knowledge by influencing evidence, communities, technologies, and/or conceptions of what science is.

A research community that defines its workers as separate and its categories of work as inviolable is somewhat unusual, and hence offers a clear demonstration of social processes that are usually more subtle and difficult to study. As such, vertebrate paleontology serves as a model in the sense that it amplifies specific attributes of a system; it is not a model *of* science but rather a model *for* understanding how research workers structure their social order (Creager, Lunbeck, and Wise 2007, 2). Its social structure highlights how communities define and practice power, such as by recognizing or sidelining certain kinds of work or people. As in the study of nature, exceptional cases in the study of society can help illuminate typical features. Like paleontologists examine the remains of a few individual animals in great detail as a way of learning about large-scale questions of adaptation and morphology, this study explores the social world of vertebrate paleontology to investigate aspects of scientific work, knowledge, and community.

Cleaning or Sculpting Fossils?

So what do fossil preparators do, and what can their work teach us about science? When I talk with scientists and preparators, they describe fossil preparation with both realist and constructivist metaphors. For example, scientists say that preparators "clean" fossils—a realist and somewhat dismissive portrayal of the work, and one that preparators themselves rarely invoke. Cleaning implies preexisting evidence waiting to be revealed. The work therefore sounds clean in the sense of free from values, theories, and individuals' biases as well as simple, straightforward, and quotidian. In this view, practitioners' actions respond to reality alone. That reality, though, is not unyielding. Preparators subtly embrace constructivism more often than scientists do, such as by talking about their work as "creative" and, occasionally, "sculpting." This kind of language emphasizes the complexity of their work as well as their own power in defining fossils. Of course, supposed cleaners also make decisions that influence evidence (e.g., fossils' appearance, completeness, and stability; taxidermied animal skins' shapes and type of preservation; and data sets' selected information and organization). They thus constitute what that evidence is by altering its form. The cleaning and sculpting (and hence the realist and constructivist claims) are inseparable and simultaneous.

It may seem obvious how potential evidence should be cleaned, especially to nonexperts; however, distinguishing fossil from matrix, good data from bad, and signal from noise relies on skillful, experienced judgment, and nonetheless often provokes debate among experts. Historian Samuel Alberti (2008, 81) describes the processes of preparing specimens as that natural objects "are subject to physical processes to make them stable (such as conservation); a series of textual practices to order them (such as cataloguing); a range of spatial techniques to store them; and a variety of exhibitionary techniques to render them intelligible." By preparing a fossil, a preparator gives it a "social life" and a new meaning as a representation of an organism (Appadurai 1986; Alberti 2008; Rheinberger 2010; Daston 2004). Preparation, as arguably the most nature-altering process for specimens, is a crucial and little-understood component of how people make nature researchable. This book investigates the moments of recursive

practice in which, to combine practitioners' words, people sculpt evidence by cleaning it.

The sturdy, complete fossils that we see assembled as beautiful, frozen-in-time animals in museum exhibits are an admirable product of human work and judgment. So too are the fossils that wait on museum shelves for scientists' eyes only. Fossils of vertebrate animals are usually rare and sometimes one of a kind, and every fossil bears the physical and chemical marks of its unique journey from a living bone to a fossilized one. Thus fossil animals are not Lego sets; they lack most of the pieces, the remaining ones are broken and deformed by geologic processes, there are no instructions, and even the finished-product image on the Lego box does not exist when research workers have no idea which animal a bone belonged to. Fossils are not replicable, unlike a chemical reaction or a synchrotron run. As a result, fossils are carefully stored for future reference. A preserved data source—unlike a written "inscription" of ephemeral experimental results (Latour and Woolgar 1986)—allows for the repreparation of evidence and renegotiation of knowledge (e.g., Cruickshank 1994; Wylie 2009), and as such, a long and dynamic life span of research usefulness for preparators' products.

Furthermore, vertebrate fossils vary significantly in fragility as well as size, anatomy, and scientific value. This diversity, which is shared by specimens of extant organisms, requires adaptable techniques to produce specimens with certain characteristics such that scientists can interpret and compare them. Fossils are visible and tangible without instruments, unlike many research objects (e.g., gravity waves, cells, and subatomic particles). This makes them more accessible to nonexperts like museum visitors, and means that research workers retain the embodied skills of directly handling and observing their objects of study (chapter 3). This interaction with material variations is the essence of craft (Paxson 2012, chap. 5; Ocejo 2017, chap. 6). Thanks to a craft worker's interventions, "rather than liabilities, irregularities become positive factors in the creative process" (Risatti 2007, 195, quoted in Paxson 2012, chap. 5). Working with the irregularities of once-living things is likewise a defining aspect of the craft of preparing evidence. After all, those irregularities may be why

an object is scientifically important, such as to represent an unrecorded species, behavior, or environmental trend.

Scholars use the concept of craft to refer to the iterative exchange between materials and human action as well as the embodied skill of doing that action (e.g., O'Connor 2006; Paxson 2012). This feedback loop between action and assessment is common to a variety of craft workers, from potters to programmers (Sennett 2008). Craft relies on knowing an object well. This kind of knowing requires collecting data in the form of sensory inputs, such as the object's texture, colors, and weight. Anthropologist Heather Paxson (2012, chap. 5) calls this judgment "synesthetic reason," in that multiple sensory assessments merge to shape each other and inform the craft worker's decisions and actions. How research workers rely on embodied knowledge to assess how to work with a specimen exemplifies synesthetic reason.

Like craft, the cleaning/sculpting of fossils relies on embodied expertise about materials and epistemic expertise about the intended purposes for those materials. Like a carpenter shapes trees into tables in ways that celebrate the wood's grain while achieving a functional surface, research workers alter natural objects to serve as evidence. Craft, though, does not seek out an existing object as science does. The sculptor Michelangelo complicated this distinction when he apocryphally explained that to carve the *David* statue, he only had to remove all the marble that was not David. Two fossil preparators independently told me about Michelangelo's words (Wylie 2015), and historian Peter Galison (1987, 256) also used them to explain evidence selection. Fossil preparators appreciate this metaphor because they indeed remove the rock to reveal their desired product. In similar ways, Galison (1987, 256) argues, scientists remove "the background," such as "noise" or other irrelevant information, in order to define "the foreground" as the object or results they seek. This work entails careful, conservative actions followed by skillful assessment of the results to inform the next action. *David* did not emerge from Michelangelo's marble block all at once but rather via one precisely judged chisel stroke after another. The metaphor of the statue waiting hidden in the rock also captures a practitioner's expert sense of what is desirable about the material (e.g., a

marble block's potential to evocatively represent a man with a slingshot, the traces of subatomic particles on a bubble chamber readout full of misleading "noise," a plant specimen covered in its accompanying but unwanted dirt and insects, or a fossil's edge peeking out from a heavy block of matrix) and how to achieve that potential. Craft and research workers have this skillful sense in common.

Craft workers, however, strive for somewhat standardized or at least similar products made from somewhat predictable materials, while research workers strive for products that are roughly similar enough to be compared despite a wide range of variation within and across materials. Research workers therefore conduct the ongoing, iterative design of objects and techniques to produce evidence that might undergo further future constitutive cleaning (e.g., repreparing fossils, sampling DNA from taxidermied animal skins, or reorganizing data sets for different analyses).

Research workers and STS scholars are well aware of the inseparability of investigating nature from constructing evidence. Yet they (and we) struggle to explain it, in part because the interconnection of these processes is deeply context dependent and can challenge the assumption that research is objective. Fossil labs, then, offer rich evidence about how craft can supersede the divisions of labor and power between scientists and nonscientists, and, perhaps, between research workers and the public.

OBSERVING "INVISIBLE" TECHNICIANS

To learn about research workers, I needed to go beyond exhibits and publications. So I followed the workers on the job by joining several vertebrate paleontology labs as a participant observer. I wanted to learn how different kinds of workers in these communities communicate, collaborate, make decisions, acquire and share skills and knowledge, and interact with these amazing ancient objects. Luckily I had a head start. As a high school student, I attended a summer program at the University of Chicago that included a week collecting fossils in the field with Professor Paul Sereno. The course didn't mention fossil preparation, but it was an eye-opening investigation of anatomy, evolution, geology, and the art of digging. After

the course, I volunteered in Paul's Dinosaur Lab every Sunday of my senior year, learning to prepare fossils under an undergraduate student's tutelage. When I joined the University of Chicago as an undergraduate myself, I worked as a student preparator, pestering staff preparators for help and scraping rock—and sometimes, mistakenly, fossil—for about eight hours per week. I earned the admiration of other students, who begged for lab tours after spotting my dusty clothes and glue-stained fingers.

In my third year, I spent a term in London as a volunteer at the Natural History Museum's Palaeontological Conservation Unit. It was there that I witnessed the diversity of scientific practice. At the Dino Lab, I had learned to remove all the matrix from a fossil and then add cyanoacrylate (a kind of glue that bonds permanently through a chemical reaction) and epoxy (permanent self-hardening clay) to strengthen and reconstruct bones. The Palaeontological Conservation Unit preparators told me only to clear matrix from small specific areas of fossils and handed me a bottle of reversible (i.e., dissolvable and arguably removable) adhesive. When I asked for cyanoacrylate, they were surprised and a little offended. I didn't understand why until they kindly explained that British institutions value the approach of fossil conservation that includes doing only minimal preparation and reconstruction, and using only reversible materials.

This culture shock led to my revelation that fossils are not prepared in the same ways. Doesn't it matter to scientists' studies, I wondered, whether fossils are fully revealed and permanently strengthened with cyanoacrylate, or are still partly embedded in matrix and reinforced with reversible adhesives? Variations are not merely technical; US and British research workers also differ in behavior, hierarchy, and priorities. I returned to the Dino Lab and my major in the history and philosophy of science with a shaken view of scientific universality. Later, I wrote the first paper for a master's degree at the University of Cambridge about how my mentor at the Palaeontological Conservation Unit, preparator Scott Moore-Fay, reprepared an enormous fossil pliosaur skull that was first prepared in the nineteenth century (Wylie 2009). My experience in these two labs—at a US private university and British public museum—inspired this study by revealing that techniques, philosophies of fossil care, and technicians' roles can vary

enormously without inspiring complaints from scientists or skepticism of fossil-based knowledge.

I am therefore somewhat of an insider to the fossil research community. I am familiar with preparators' lingo and practices. I can distinguish between fossil and matrix. I can discuss Monty Python and science fiction alongside tales of fieldwork adventures and disastrously broken fossils, as common topics of lab chats. This background informed my choices of research sites and facilitated conversations with research workers. My former bosses and coworkers were a crucial source of willing interviewees and generous invitations to visit institutions. I also met preparators and scientists at the conferences of the Society of Vertebrate Paleontology and the Association for Materials and Methods in Paleontology, where I wrote field notes and sometimes gave talks about my research. I designed a survey about preparators' demographics, training, work experiences, and opinions about methods that captured an informative snapshot of their community. Because of the relatively small number yet wide variety of fossil-preparing institutions, I conducted a multisited brief ethnography instead of the more traditional single-sited, long-term one (e.g., Falzon 2009). This approach brought me to six labs in universities (five of which are associated with university museums) and eight labs in natural history museums. Nine of the labs are in the United States, four are in the United Kingdom, and one is in Canada.

My goal was to investigate local cultures and work practices as well as identify concerns that span institutions. At each site, I interviewed and observed people who work with fossils, including preparators, scientists, conservators, collection managers, exhibit designers, and volunteers.[3] I spent one to three days at twelve of the labs and five weeks each at two labs. My goals for the short visits were to see what the labs look like and to learn workers' opinions on key issues about practices and social order. Typically, a staff member—almost always a preparator—would give me a tour, and then I would interview staff members and volunteers.[4] On the longer visits to two US natural history museums, I was in the lab full time to witness work practices and social interactions in addition to conducting interviews. These two museums, which I call the Northern Museum and

the Southern Museum, are valuable for their significant vertebrate fossil collections, respected preparators and scientists, wonderful fossil exhibits, and glass-walled labs where visitors can watch preparators at work. I participated in the lab communities by attending social occasions (e.g., lunch breaks and bar trips) and institutional events (e.g., meetings), and doing some preparation work.[5] Ethnography proved a powerful methodology for revealing subtle mechanisms of social organization and everyday practice in these scientific workplaces.

I chose to assign pseudonyms to all the people and institutions in this study. All my interviewees except one agreed to be identified by name. However, I decided that the ethical necessity of protecting the participants from embarrassment or damage to their professional reputations far outweighs the benefits to my research of full disclosure. Being unnamed in publications thus can serve another purpose beyond scientists' pursuit of objectivity: protection from public attention. Even without tying quotations and actions to individuals, these interviews and observations speak volumes about the social and epistemic roles of research workers.

Based on these data, I suggest that we think about knowledge as the intersection of many interlocking and iterative processes of preparation, namely preparing evidence, communities of workers, technologies, and private and public conceptions of science. Thinking about science as all these kinds of work, done by scientists and nonscientists alike, offers a more comprehensive model of how we learn about the world.

PREPARING KNOWLEDGE ABOUT SCIENTIFIC LABOR

This book examines the everyday work of science. Each chapter asks how research workers prepare a component of knowledge: evidence, communities, technologies, and conceptions of science. What emerges shows that these kinds of work are inseparable from and more accurately understood to *constitute* epistemic work. The book concludes with a reflection on how acknowledging all these processes as parts of knowledge would usefully broaden the boundaries of scientific work and workers, thereby

welcoming contributors with a wider variety of backgrounds, experiences, and identities.

Chapter 1 follows the unpublished work of making nature researchable by preparing evidence. Preparators practice constitutive cleaning by preparing rock-encased fossils according to their own and scientists' priorities. These aims include stability, completeness, and visibility as well as aesthetics and efficiency. Methods to achieve these goals are not standardized; instead, preparators tailor them to each fossil in a process that they call "creative problem solving." Preparing evidence, then, involves making decisions in ways that are situated, individualized, and expert.

Chapter 2 asks how technicians define and unite themselves, and thereby how they prepare their community. Preparators lack shared credentials, methods, and publications, and are dispersed in small groups across institutions. How, then, do they create a group identity and assimilate new members? One mechanism is mutual teaching and learning, as preparators supervise novices' hands-on learning as well as exchange advice and ideas on email list hosts and at conferences. Rather than imparting specific protocols, preparators help new staff members and volunteers develop an experiential sense of good work. Yet the craft of choosing and designing techniques is a privilege reserved for the staff. Volunteers prepare fossil evidence under employees' supervision and direction. How staff preparators define this social order despite their shared training and work with volunteers offers rich insights into how technicians conceptualize their skill and identity.

Chapter 3 studies how research communities prepare technologies—that is, techniques and tools. Specifically, preparators privilege their own skills over new technologies, and scientists prefer to rely on trusted technicians over new technologies. Thus preparators' tools have a strikingly long life; today's most common tools were invented over a century ago. A more recent technique, analyzing fossils with CT scanners, offers the appeal of high-tech machinery and digital specimens that can be manipulated on-screen. However, scientists are skeptical of it. They prefer physical fossils shaped by expert preparators to on-screen images produced by black-boxed

machinery operated by unfamiliar people. This trust suggests that craft skill drawn from experience and relationships plays such an integral role in science that it has been—and is likely to continue to be—preserved.

Chapters 4 and 5 examine how research workers perceive science and their role in it. I investigate how research workers define their identities and work privately in the lab (chapter 4), and how they portray themselves for the public in museum exhibits (chapter 5). These chapters analyze situations in which preparators are empowered (i.e., as de facto leaders and decision makers in the lab as well as on display in glass-walled labs in museums) and disempowered (i.e., in publications and institutional hierarchies). These contexts suggest the important social functions of selective recognition, such as preserving both objectivity and craftwork by obscuring preparation in print, presenting paleontology as a transparent and accessible field through glass-walled labs, and dividing power between practitioners such that scientists control publications while nonscientists control the lab's work, workers, and public portrayal. Thus preparing knowledge about nature involves preparing knowledge about science.

To conclude, I consider how adopting the view of preparing knowledge enriches how we understand science and its place in our society. Preparing knowledge relies on methodological adaptation, skillful creativity, and ongoing feedback between nature and people, all of which are conducted by a variety of research workers. This work shapes scientific evidence, in the sense that how we learn about nature depends on who prepares it into evidence, the technologies they select and design, and their judgment of what counts as data. The paleontology community's social structure demonstrates how other sciences might incorporate nonscientists into research work, such as technicians and volunteers without typical scientific credentials. Highlighting the contributions of nonscientists to research can serve as a welcoming invitation to people who feel excluded from science due to discrimination based on race, gender, class, or ability. Calling attention to the wide variety of research work may also make science a more appealing educational choice or career for more kinds of people by disproving stereotypes about research work, such as that it is boring, difficult, lonely, or dependent on math. Crucially, creating a community of scientists and

nonscientists can empower and educate both groups. Nonscientists can learn how science is done and apply their diverse skills, experiences, and values to propose socially relevant research topics and ways to investigate them, while scientists can learn what the public wants to know and cultivate fellow research workers as powerful supporters of scientific institutions and knowledge. As a form of improved transparency and inclusiveness, thinking about science as the process of preparing knowledge can help encourage broader participation and trust in science.

1 PREPARING EVIDENCE

Early in my visit to the Northern Museum, near the end of a workday, Carla invited me to watch as she removed matrix from a flattened, fossilized fish skeleton. As I leaned over her shoulder, she precisely pressed the slim vibrating tip of the smallest-available air scribe (a pen-size pneumatic jackhammer, also called a micro jack) against the thin layer of rock covering the delicate bones. The slightly jumbled skeleton bulged beneath the matrix like that of a freshly dead fish lying just below wave-lapped sand (figure 1.1). Carla read my mind about the fish's lifelike appearance, saying loudly over the air scribe's buzz, "What I like about this fish aesthetically is you can see the bones under the scales. So I'm trying to keep as much [of the scales] on as possible, because to me it's artistic." She admired the fish's morphology and preservation, which shaped her vision of how the prepared fossil should look. Achieving this "artistic" vision would do justice to the fish's beautiful natural shape. She was worried, however, that the scales were only loosely attached to the bones, and thus "it takes time to keep them on." She planned to be extra careful while removing matrix, and she considered gluing the scales in place if necessary: "You can always prep the glue off, but I want to make sure that the scales stay on." Glue-coated scales are better than no scales for Carla since "if they come off, it'd be hard to re-create them because of that texture." A sculpted scale can't capture a real scale's subtle parallel ridges. She pointed her air scribe tip at a round, grooved scale: "They're like little records. . . . If you paint them on, it wouldn't look really convincing" without the three-dimensional surface.

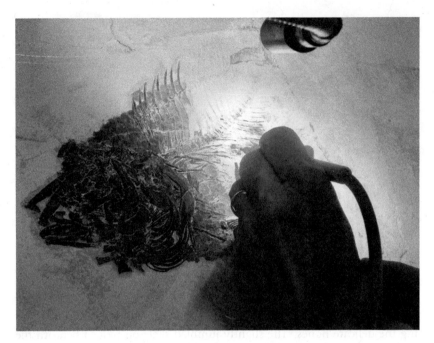

Figure 1.1
A preparator removes matrix from a "beautiful" fish skeleton covered in tiny fossilized scales.

So Carla strove to laboriously preserve the scales in place rather than drill through them and replace them later with painted reconstructions. Carla was not just cleaning this fish; she was deciding what it should look like.

Carla watched the pulverized rock fly off the end of her air scribe for only a few seconds before she stopped, narrating her thoughts for my sake: "I don't want to get too cocky with my micro jack here, so I'm going to switch tools." She delicately slid the plate-size rock slab containing the fish into a clear plastic box with tubes and armholes cut through the sides. She adjusted the air abrader, a modified sandblaster, to blow fine abrasive powder through a handheld nozzle at low air pressure and low flow rate, a gentle setting to protect the fossil's fragile scales. Carla sat beside the box, put her hands through the holes, and turned on the nozzle's flow to hit an area of matrix away from the fish, testing the potency of the pressurized particles. She was unsatisfied with the test and adjusted the machine to further weaken the flow, then aimed the nozzle at the ranks of scales on the

fish's flank. Despite swapping an air scribe for the gentler air abrader and her careful calibration of the machine, the particles immediately pulverized a hole through the matrix and loosened one of the underlying scales. Carla stopped the flow, swore calmly, and reached for the little bottle of glue she'd already set inside the glass box in expectation of such unfortunate outcomes. She balanced a single drop of cyanoacrylate (also called by the brand names Super Glue or Krazy Glue) on the tip of a metal dental scraper and touched it to the edge of the loose scale, where it was absorbed into the bone through capillary action and instantly bonded the scale in place. With a deep breath, Carla shook off the stress of the repair and aimed the nozzle at the next scale, moving it around the fossil a little faster than before to prevent boring another hole. She explained that air abrasion can blow matrix off gently, "but if you're not really diligent, you can do a lot of damage in a short amount of time." She meant that you have to watch carefully to see what effect the abrader is having on the fossil, and adjust the machine and your technique accordingly. The other option is "you can have [the air abrader] on such low pressure that you never get anything done. You gotta find a balance" between damage and progress. Carla considers finding and maintaining this balance an art that requires careful attention and experimentation.

With its precisely adjusted pressure and flow rate along with Carla's skillful way of moving it quickly and smoothly around the specimen, the nozzle looked like a magic wand that turned rock into fish. As the skeleton emerged under Carla's hands, she described preparation as individualized work: "Everybody's different; they all have their own style. Me, I like a crisp, clean line" of fossil, such as by exposing each individual fish tooth in their tight rows. "I look at other people's and they just do the outline, just half prepared. But it's somebody else's standard." She didn't sound critical of people who only outline teeth; rather, she presented this diversity of expectations of a prepared fossil as normal and unproblematic. Carla sighed happily: "I love these guys." When I asked her why she loves fish, she said as if it were obvious, "What's not to love? They're beautiful."

One of the key processes of preparing knowledge is preparing evidence. We know from studies of scientific practice that the work of distinguishing

evidence from not evidence, such as "noise" or "background," is complex, situated, and not obvious (e.g., Latour and Woolgar 1986; Galison 1987, 1997; Latour 1999; Collins 2004; Kohler 2006; Leonelli 2009; Chapman and Wylie 2016). Preparing evidence, then, involves deciding what materials and/or observations are relevant, what form they should take (e.g., physical appearance and organization), and how to achieve that form. These decisions often fall to individual practitioners, who make in-the-moment judgments based on their expert observations and then apply skillful actions to pursue their expectations of the evidence. Diversity in individuals' preferences, skills, and priorities, including judgments of what is beautiful, results in a variety of possible forms that a single piece of evidence can take (Wylie 2019a). It is therefore crucial to study the factors that influence how those possible forms take shape.

Evidence comes from physical objects that require preservation and/or ephemeral observations that require documentation. All forms of evidence must be organized and stored. For example, philosopher Sabina Leonelli (2008, 2016) argues that biological data sets are "packaged" (i.e., categorized, formatted, and labeled) for inclusion in an online, open-access database in ways that obscure how they were made. Omitting data sets' origins allows them to seem more universal and thus useful for a wider variety of research questions. Yet "the reliability of facts cannot be assessed except by reference to the way in which facts are produced" (Leonelli 2008, 12). Given this, the database also includes information about how each data set was made, which is stored at a separate link from the data set itself. The conflicting need to both obscure and access data preparation is evident in most scientific publications, which either omit preparation work altogether or offer a simplified description without mentioning the embodied knowledge and tacit rules of thumb involved (e.g., Collins 1975; Latour and Woolgar 1986; Latour 1987; Cambrosio and Keating 1988; Jordan and Lynch 1992, 1998; Barley and Bechky 1994; Lynch 2002). Ethnography, then, is the most informative—and perhaps sole—way to study how practitioners define, preserve, and categorize evidence.

This chapter explores specimens as one of the many possible kinds of evidence. Fossil preparation is a powerful example of the epistemic

significance of how people prepare specimens because prepared fossils are more visible and tangible than many scientific objects, such as cells, stars, or readouts from laboratory instruments. Also, unlike technicians who follow published, widely used protocols (even with their own tacit, skillful strategies), fossil preparators choose and design methods to prepare a fossil that matches scientists' priorities as well as their own. The expectation, freedom, and perhaps necessity to tinker, adapt, and invent techniques characterize the iterative craftwork of preparing fossils. This chapter asks how preparators and scientists define good fossils physically and epistemically as an example of how research workers define good specimens more generally.

As we'll see, good specimens are the product of good preparation, not purely of lucky preservation. Because all specimens are different and these variations often require flexible, tailored methods, preparing specimens involves skillful craft and expert judgment. For instance, a "good" vertebrate fossil in the field is scientifically interesting, such as a representative of a new or rare species, or an unusual animal for that locality. Once it's collected, preparators are responsible for making that fossil researchable, with arguably any method they deem appropriate. To identify the characteristics of good evidence and preparation, first I follow preparator Jay through a typical set of tasks. Like Carla's detailed work with the fish, Jay's experiences preparing, repairing, and replicating fossils offer insights into preparators' usually tacit priorities for specimens as well as their methodological flexibility. Next, a fierce controversy about a crucial element of preparation work—glue—sheds light on preparators' beliefs about good fossils, good practices, and whether their decision-making power should belong to individuals or the collective community of preparators. Finally, preparators claim autonomy over their techniques and tools by likening preparing fossils to making art, based on a shared reliance on creative problem solving. Methodological flexibility, I argue, empowers practitioners of constitutive cleaning. How preparators prepare fossils, then, reveals the unwritten epistemic and social foundations of paleontological practice and knowledge, and raises questions about why this work is largely undocumented and nonstandard.

THE EVERYDAY WORK OF PREPARING SPECIMENS

Defining Fossils

On a Thursday at 9:30 a.m., Jay, a longtime staff preparator at the Southern Museum, had a list of things to do. He wanted to search a bag of matrix for microscopic fossil mammal teeth and start gluing them in place on their tiny jaw, deliver light bulbs to the museum's glass-walled preparation lab, replace a microscope light bulb in the specimen research space, check the lab's air filtration system, buy a more powerful microscope lens (to facilitate his work on the mammal jaw), make a storage jacket for a fossil horse skull, mold a fossil squirrel skull to produce a replica, "and I have to finish my coffee." This diversity of tasks, workplaces, and even ranges of vision—from searching for teeth under a microscope to inspecting the lab's huge air filtration apparatus—indicate the many kinds of knowledge, skills, and priorities involved in producing and maintaining specimens. This section follows Jay through the three fossil-focused tasks on his to-do list. I analyze these particular tasks because they represent commonplace activities and because Jay worked on them all on the same day (and then finished them over several days); thus they portray the everyday realities of preparing fossils to serve as scientific evidence.

In each of these tasks, Jay invented or tinkered with techniques. Critics could label this work a "kludge," a colloquial term that distinguishes "rational" and "elegant" techniques from lucky, sometimes mysterious actions that simply "work" (O'Malley 2011, 409). Kludging and preparing specimens both rely on methodological adaptation and the ongoing assessment of techniques' results. Also, both approaches value the finished product and its effectiveness for its purpose more than the process of achieving that product. But that process is also a critical component of scientific work, even if seemingly irrational or inelegant. It reveals the tacit values that inform practitioners' judgments of whether a technique "works" and thereby how they conceptualize good evidence. Furthermore, adaptable techniques, including kludges, crucially enable the study of diverse and unpredictable pieces of evidence.

Reconstructing fragmented fossils, like Jay's mammal jaw, is technically difficult, epistemically loaded, and strikingly quotidian. Fossils almost

always arrive in the lab in pieces, but without all their pieces. So which fragments preparators reattach—and where they reattach them—is rarely obvious and requires judgment calls. Even defining what is a fragment relies on expertise. Jay began work on the mammal jaw by searching a small box of sand-grain-size matrix under a microscope, hoping to find more slivers of teeth to match the jaw that he and colleagues had discovered during a collection trip a few months earlier. As I watched, Jay triumphantly lifted a barely visible "frag" (fragment) of fossilized tooth enamel out of the matrix with tweezers. He inspected it and guessed that the frag might "bridge the gap" between two other pieces he'd found, thereby making it possible to assemble all three pieces into one reconstructed tooth. Removing matrix from fossils is a process of defining them in their current state, while repairing and reconstructing fossils involves, as the prefix "re-" implies, returning a specimen to its appearance in life. That achievement is, of course, impossible, but making a tooth look complete instead of shattered is considered a step closer to seeing that tooth as it looked when it was part of an animal. Soon after finding the frag, Jay decided to stop searching because the loose matrix contained only "tooth dust"—pieces of enamel that he judged too small to reconstruct or be scientifically useful.

Jay planned ahead, thinking through his decisions about how to best reunite the two pieces of the jawbone and, later, the teeth. First, he purposefully left finger-size hunks of matrix attached to the half-centimeter-long jaw pieces, as "handholds" to help him manipulate the tiny fossils while gluing them together. He would prepare away the handholds after he finished the repair. Next, he evaluated the options for adhesives. He decided on cyanoacrylate for its faster and stronger bond than other glues, which are important benefits when working with microfossils. The downside is that "you only get one shot," he said, because cyanoacrylate bonds instantly and it would be nearly impossible to undo the join on such small bones. Positioning the pieces by their handholds and holding his breath, Jay delicately placed cyanoacrylate on the nearly invisible gap between them, adhering the two pieces. This task required steady hands, knowledge of adhesives' properties, and judgment of which pieces had once formed the same bone and how they fit together.

With the jaw pieces reunited, next Jay "built" each microscopic tooth, placing its frags in a base of soft clay to hold them while he aligned their broken edges. He put a drop of cyanoacrylate on a single paintbrush hair and allowed capillary action to suck the glue into the crack between two frags, where it bonded them together. He repeated these actions for each frag in each tooth. Finally, based on his knowledge of anatomy and assessment of which broken edges corresponded, Jay lined up the rebuilt teeth in a small box in the order he thought they belonged on the jaw. He spent a long time getting ready to glue the teeth to the jaw, even though—or perhaps because—the task would only take an instant. But then he paused, and decided that he needed a few quiet days to best set up this final, stressful, "one-shot" reconstruction. He put the task "on standby" and eventually completed it a few weeks later.

Jay's decisions about the mammal jaw aimed at enabling research by making the specimen as complete as possible. By reconstructing the jaw, Jay also protected its fragments from becoming separated or lost. He chose his methods in response to the fossil's physical and epistemic statuses. For example, because it was tiny and in multiple pieces, he carved matrix handholds and applied cyanoacrylate with a paintbrush hair. The rarity of Cretaceous mammal fossils makes this jaw scientifically significant, so Jay planned ahead, relied on the broken edges to guide his decisions, and took his time. These approaches drew from his embodied knowledge of handling fragile microfossils and his understanding of scientists' interest in the specimen. Crucially, Jay assessed his own state of mind as a factor in how well he could prepare the fossil. Because he felt rushed by his busy day and worried about the difficult final task, he postponed it. He therefore acknowledged his own role in the system of tools, techniques, priorities, and objects, and altered his preparation work accordingly. His in-the-moment assessments and reactions to the situation resemble the "reflection in action" (Schön 1983) that craft workers and other experts practice. These judgment calls, based on expertise, experience, goals, and values, shaped how Jay conducted the common tasks of defining and reconstructing fossils, and thus how that mammal jaw and its teeth look. Furthermore, teeth are scientists' primary diagnostic feature for mammals. By saving the tooth frags (and not the

tooth dust) and by reconstructing the gross morphology of the teeth and jaw, Jay turned barely-visible chunks of preserved bone into a researchable specimen of a long-dead mammal that lived alongside dinosaurs.

Later that day, Jay repaired another fossil, but not one fresh from the field: a holotype specimen of a small proto-horse species that had been first prepared in the 1950s. (A holotype or "type" specimen is the individual that scientists designate as the permanent defining example of its species.) A visiting scientist had found the narrow, palm-length skull lying in pieces in its storage box, so he brought it to Jay. Glue from many previous repairs coated the pieces' broken edges, hiding their shape. Jay told me, "I don't see any obvious joins. But that doesn't mean there aren't any." Preparators' power over a specimen's appearance includes their ability to *not* apply techniques, such as by not identifying or attaching broken pieces. When I suggested that one frag belonged to the skull's eye socket, Jay disagreed, saying wryly, "Put it there if you want it to be a *new* type," meaning a new—and invented—species. Then he suggested gluing an unattached canine tooth on the end of the skull's nose like a horn. These jokes highlight preparators' power to decide how a specimen looks, such as by their judgments of if and how broken bones fit together (chapter 4).

After many failed attempts to match the loose pieces with the skull's broken edges, Jay decided to consult the specimen's published description and photographs from the 1950s. I have seen preparators check scientific papers only a few times; this unusual step reflects how stumped Jay felt about how to reassemble this skull. Based on the paper's text and images, Jay identified and adhered several pieces. He also found traces of glue on a canine tooth fragment and a matching glue-lined edge on the skull, indicating a former join. So he adhered the tooth there, even though it was absent in the published photos. There is a kind of circularity in this story in that a preparator prepared this specimen, then a researcher described it in a publication, and then a later preparator (Jay) repaired the specimen to match the publication. Preparation thus seems to strive for continuity to preserve how a specimen looks over time. Jay, however, added an unpublished feature, the canine tooth, based on another preparator's undocumented repair work. He consulted the specimen's published description

as a reconstruction guide, but when he disagreed with it about the canine tooth, he acted on his own assessment. It is a power play of sorts between a publication (which in this case is particularly significant because it defines a species based on this type specimen) and Jay's visual judgment of potential joins as well as trust in the unknown preparator who had glued that tooth.

To protect the skull and his reconstruction work, Jay decided to build a custom storage container for it. This seemingly simple decision illustrates the priorities and constraints that influence how preparators choose techniques. Jay suspected that the skull's damage had resulted from rolling around inside its box, so he considered several ways to immobilize the skull. First he planned to make a "cradle," a plaster platform molded to fit one side of the skull. Then preparator Kevin suggested making a "housing," a box lined with foam cut to fit a fossil's shape. Jay and Kevin had recently learned how to make housings at a conference workshop led by another preparator. But Jay worried that there was no safe place to put "finger holds" in the foam lining to show people where to safely pick up the skull without grabbing its many fragile areas. As a result, Jay rejected building a housing and realized that a cradle would also lack a safe way to pick up the skull. Jay then decided not to be "lazy" and instead make a "clamshell jacket," in which two cradles fully encase a specimen. He half buried the skull upside down in a sandbox, where it was fully supported and protected while he laid plastic wrap and then wet plaster-soaked strips of cloth over it. Overnight, the plaster dried into a rigid, perfectly matched mold of the bottom of the skull. Then Jay laid more plaster-soaked strips across the half jacket's unmolded side and set it on a table to dry, thereby creating a flat bottom surface. Finally, Jay lined the top of the half jacket with a thin layer of archival foam, which cushions the fossil and resists chemical degradation.

When Jay set the skull in its finished half jacket, he realized that adding a top half would make the specimen too tall to fit in its storage drawer. Jay wanted to keep the skull in that drawer because its skeleton was in there too and he didn't want them to become disassociated. It was also important to him (like all museum staff) to minimize the space each specimen takes in the museum's overcrowded collection. So Jay declared the half jacket

to be a finished cradle. The skull "is already more protected now than it was," he said with a shrug. Jay's lengthy experience as a preparator as well as consultation with a coworker informed his evaluation of which design would best achieve his goals for this fragile and important specimen. The constraints and many possible forms of storage support alone point to the many embedded values and contingencies for a specimen. The cradle, after all, becomes part of the fossil's history and future.

No one had told Jay what to repair about the skull or to change the specimen's storage. He followed best practices he'd learned from experience, not from published instructions. He decided to reattach as many frags to the fossil as possible, including ones not pictured in its published description. Jay chose to invest time in making a cradle in hopes of preventing damage and reducing future preparators' time spent repairing this specimen. This example shows preparators' independence in choosing their methods and sometimes their tasks as well as how their priorities of preparing researchable specimens extend to protecting specimens from potential harm. Alongside these values-based decisions, the embodied expertise of finding, matching, and gluing fossil pieces into a stable, trustworthy representation of an extinct animal is a physical and epistemic triumph.

Making Fossils Mobile

In addition to being prepared and repaired, specimens must be transported. Scientifically valuable objects often circulate in the form of high-quality replicas. These replicas can be studied or put on display as replaceable but ostensibly exact copies of the original. Making representations of nature that are mobile and reliable (Latour 1986) requires trust in representation methods and makers, such as illustrators, photographers, and modelers. Preparators are responsible for molding and casting fossils to make researchable replicas. This process is long established and well trusted, even though preparators use a variety of materials and techniques.

When a scientist at another museum asked to borrow the skull of the type specimen of a fossil squirrel species, researcher Henry wanted to avoid mailing the important specimen. So he asked Jay if he could mold and cast the finger-length skull. This was not an order or even a request but rather

a sincere question. Henry knew the small skull with its fragile eye sockets would be complicated to mold and an especially perilous endeavor because type specimens are irreplaceable. Molding is always risky because removing the mold puts pressure and torque on the fossil. Preparators often recount stories about bad technique or "luck" that resulted in specimens breaking disastrously during molding. Still, Henry hoped that molding would be safer than mailing. According to Jay, Henry asked about molding "with a tone of 'tell me what I want to hear!'" Jay examined the skull, noting the paper-thin bone of the eye sockets, and said that he could mold it. Henry happily left the skull with Jay, relieved to loan a copy and spare the specimen a dangerous journey.

Jay's problems, on the other hand, were just beginning. He was not sure that he could deliver a research-worthy cast as well as an undamaged specimen. First, he was concerned that the liquid silicone molding material might penetrate the thin cracks lacing the fossil and then widen them or even pull the skull apart when Jay peeled off the dried silicone. So he painted thin water-soluble wax over the cracks, temporarily sealing them. The wax didn't dry smoothly, so Jay scraped off the excess with a delicate metal scraper that sculptors use to carve minute details into clay. Jay was trying "to get rid of the lumps" so they wouldn't be recorded in the mold and then appear as lumps on the cast. A researcher might interpret those lumps as natural bone features, as there would be no documentation of these unintended artifacts of molding. Jay knew he had the power to alter the cast's appearance and therefore the knowledge claims it might inspire. He was responsible for the skull's safety too. He balanced these roles by trying to maximize the cast's accuracy even as he minimized harm to the skull.

Molding is generally a dynamic compromise between protecting the specimen, making an accurate copy, and not wasting the expensive materials. These judgments rely on a practitioner's ongoing reflection in action to identify problems and adapt ways to respond (Schön 1983). For one side of the skull, Jay decided to use the "block mold" technique, which creates a thick, firm mold to provide support for the specimen. For the other side, which had a well-preserved and fragile eye socket, he planned an

unusually thin—and hence flexible—mold that could be peeled off the eye socket with more control than the inflexible block mold. "It may still break anyway but maybe I can minimize the damage" with this combination design, Jay said, planning for contingencies. To make the block mold, he first embedded one side of the skull in clay so that half the specimen rose above the clay's surface. Then he built a "wall" of clay a few centimeters away from the skull as a container for the liquid silicone that would form the mold. On the "floor" of the clay container, between the walls and specimen, he used the circular end of a dental tool to push shallow, round depressions into the clay, which would make "registration keys" in the mold to allow the mold's two halves to lock together. Then he prepared the liquid silicone, which involved careful measuring, mixing, and time in a vacuum chamber followed by slow pouring into the clay container around the fossil. These steps aimed to extract air bubbles, which leave holes in the mold and misleading lumps on the cast.

After several days, Jay hoped that the silicone had "cured" enough to make the second, flexible half of the mold. He gently removed the clay floor from the block mold, revealing the side of the skull that had been embedded in the clay. He built clay walls around the newly revealed skull side, with the floor now the skull surrounded by the block mold's surface with the registration keys. He made the silicone as before, but without bothering to put it in the vacuum chamber because he would "paint it on" instead of pouring it. Jay gave the painted-on silicone an hour or so to cure and thicken, then he brushed more on to create layers to improve the mold's flexibility. He repeated this procedure four times in one day, then pronounced the thin, layered mold finished and ready to fully cure. Jay made these decisions based on his ongoing assessments of the fossil and molding material.

Jay managed to delicately peel the cured, thin half of the mold off the eye socket with no damage. Relieved, he held the block mold as stretched open as he could and told me to remove the skull. I gently worked the skull back and forth until it pulled free. Jay was satisfied: the "specimen didn't break" and the "seam line looks good" between the two mold halves, meaning that they would close together tightly when making casts. Finally,

Jay dissolved the wax from the skull by applying water with a paintbrush and then put the specimen safely back in its storage box. The mold was finished and a success, according to Jay. The next step was to produce two research-quality casts, one to lend and one to keep.

Making an accurate cast relies on removing air bubbles from the liquid casting material (plaster in this case), among many other factors. If allowed to remain, bubbles would form holes and therefore inaccuracies in the cast. Jay planned to carve off any bumps on the cast caused by bubble holes in the mold, but there is no way to fix bubble holes in the *cast*. After mixing plaster powder with water, he poured it slowly into the block mold, pausing to tap the mold on the table, push and pull its sides, and run a metal scraper along the bottom, all to chase out air bubbles. He did the same with the thin mold half, then quickly flipped it on top of the block mold so that the registration keys would seal before the plaster leaked out. Filling the mold felt less tense than making the mold because the safety of the fossil was not at stake, but it nonetheless required Jay's full attention for several minutes.

After the plaster dried, Jay peeled off the mold to reveal the cast inside, which he described to Kevin as "99 percent good except for the bubbles on the teeth. They're not important." This was a joke because, as they both knew, teeth are the most important part of a mammal skull for researchers, as diagnostic indicators of species. Holes on the cast's teeth, made by air bubbles in the plaster, made it useless for research. Jay pointed out the importance of preparators knowing how artifacts of casting might affect research: "That's why it's good to go to [research] talks to see what they're looking at," meaning which anatomical features researchers consider significant. The rest of the cast, besides the bubble-obscured teeth, was "good," Jay said, because of the "faint seam line" around the skull where the two mold halves met. He used a metal scraper to carve off the raised seam, saying, "Have to be careful not to remove the sagittal crest," a raised bone suture on top of mammal skulls that lies just beneath this cast's seam. I wondered how he knew how much of the delicate ridge represented bone and how much was created by the mold. I asked if a researcher could distinguish between a seam and an anatomical feature, and Jay said, "Probably."

Researchers can easily distinguish casts from bones based on their weight and color, but deciding what about the cast to trust as evidence about an animal is more obvious if researchers understand the processes of molding and casting. Yet these processes, like other forms of preparing evidence, are rarely described in publications.

To prevent air bubbles in his second attempt at a cast, Jay planned and then followed a different procedure: mix plaster that is thicker in consistency (i.e., less likely to form bubbles), paint it into the mold instead of pouring it, then "top it off and vibrate it" to remove bubbles before fitting the two mold halves together. The next day, Jay removed the second cast from the mold and decided that it had fewer bubbles but looked different. I found small plaster pieces stuck in the mold, where they had broken off the cast's eye sockets. Disappointed, Jay decided he'd "pulled it [out of the mold] too early," when "the plaster was set but not hardened," as indicated by the eye socket edges that "shouldn't have broken." In the interactive triangle of technician, technique, and tools, Jay deemed the tools/materials to be appropriate and didn't fire himself as the task's technician. Rather, he saw a problem in the technique.

For the third cast, Jay copied his second procedure but with a longer cure time. When he pulled out the cast, Jay dubbed it "a keeper": the teeth were visible, and the eye sockets were intact. Jay assigned me to make a fourth cast by following his third procedure. I imitated his steps carefully, but the fourth cast had bubble holes on its teeth. Jay was dissatisfied yet friendly about my failure, setting a new plan for the next cast by saying to me, "Want to do the side without the teeth?" He judged my mold-filling skill as inadequate for the most important and trickiest area of the mold. In this case, the technician (i.e., me) was the weak link, not the techniques or tools. To improve on the technician variable, Jay decided to paint plaster into the fifth cast's teeth himself. But then a coworker started talking to him. Jay did not appreciate the interruption as he was filling the mold, saying quietly to me, "I forgot where I was" and "I have no idea what's going on with this." When his coworker left, Jay kept brushing plaster into the mold's tiny teeth-shaped crevices and tapping the mold to shake bubbles loose, trying to repair the effects of his lost concentration. I asked

him if he ever felt frustrated with his work. He said yes. I asked what he did to calm down, and he said, "Swear." I said that in my experience, he didn't swear, and Jay said that things don't usually bother him. His job includes many potential sources of stress that he can do little about, such as failed techniques, difficult tasks, unpredictable fossils, and rude people. So when the fifth cast's eye sockets broke inside the mold, Jay was frustrated but resigned. He settled for the one successful cast.

To achieve his task of making a reliable, useful cast, Jay set requirements such as visible teeth, intact eye sockets, and a minimal seam line. His adaptations of his methods relied on trial and error to identify a set of techniques that produced results from this particular fossil that matched his requirements. Different variations of technique, skill (his versus mine), and luck, however, produced bubble-obscured teeth and broken eye sockets. Thus these methods were difficult to replicate, even on the same mold. As craft workers respond to unexpected variations in ways that preserve their overall priorities and technicians tinker to preserve or restore the functionality of machines and techniques, evidence preparers evaluate materials' reactions to their work and then adapt their work in response. Specimens, then, are prepared based on ongoing, expert assessments of the materials of the physical world and the priorities of the social one.

CONTROVERSIAL TECHNIQUES: "PALEONTOLOGY DEPENDS ON ADHESIVES"

Instantaneity versus Reversibility

Preparators' methodological flexibility is widespread and well established, but occasionally it inspires fierce debates about which techniques are best and, therefore, the meaning of good fossil evidence. These debates shed light on the community's priorities for what specimens should be like. For example, the "cyanoacrylate controversy" (as one preparator called it) of the early 2000s blew up around preparators' divergent beliefs about whether cyanoacrylate is an effective and ethical adhesive to use on fossils. According to preparators, the conflict centers on whether specimens should be prepared primarily for immediate research or unknown future research.

But the underlying issue, I argue, is preparators' defense of their power to choose and invent techniques versus their desire for everyone to use certain "good" techniques and shun "bad" ones. Crucially, preparators disagree about whether certain techniques are always good or bad, or whether that judgment must depend on context.

The cyanoacrylate controversy reveals a plurality of priorities among preparators. Many preparators appreciate cyanoacrylate as a strong, instant adhesive, while other preparators as well as conservators and most collection managers oppose cyanoacrylate for its permanence and risk of degrading over the centuries-long shelf life of prepared fossils. Cyanoacrylate is a reaction adhesive, meaning that it undergoes an instantaneous chemical reaction to adhere to surrounding material. In fossils, it wicks into cracks and creates a strong network of bonds below the bone surface, which means it is impossible to fully remove. In comparison, solution adhesives create bonds when the solvent in them evaporates. These bonds can be dissolved by applying more solvent, such as acetone, which is why solution adhesives are considered "reversible." Common reversible adhesives in fossil preparation are a confusing list of synonyms and brand names that preparators use interchangeably and not always accurately. These include Vinac (aka McGean B-15 or polyvinyl acetate), Paraloid B-72 (aka Acryloid), and Butvar B-76 and B-98 (aka polyvinyl butyral) (Elder et al. 1997; Davidson and Alderson 2009). These adhesives are also archival materials, meaning they are relatively chemically stable and thus resistant to deterioration over time.

Reversible techniques and archival materials are key components of conservation, which is a field of research and methods to preserve objects in as close to their original state as possible, including artwork, paper, textiles, and specimens. Conservators assess the state of objects over time, and regulate storage environments to prevent destructive temperature changes, humidity, and pests (e.g., mice and insects). They perform chemical treatments, such as adding adhesives, as rarely as possible because they fear that any materials, even apparently archival ones, might damage the object over time. Conservators' work sometimes overlaps with that of preparators,

such as Jay's storage cradle for the horse skull. Conservators, though, have a master's degree in conservation, thereby defining their field through shared training and techniques. Their promotion of reversible adhesives and other archival materials, like the foam Jay used to line the cradle, has been gaining support among preparators. Traditionally, preparators have tended to prioritize researchers' rush to publish about specimens over the specimens' long-term well-being. But preparators often work with historic specimens that have been damaged by crude rock removal tools (e.g., hammers and chisels) and adhesives that degrade (e.g., crumbled plaster, rusty nails, and pest-nibbled glues made from flour or animal fat). As a result, many preparators want to avoid future damage by preparing today's fossils in more conservation-minded ways. Conflict between these seemingly irreconcilable priorities of the present and future underlies the cyanoacrylate controversy.

Preparators explain the properties of adhesives with reference to specimens' characteristics, suggesting that they organize their knowledge of materials by potential applications. Max, for example, prefers cyanoacrylate to Acryloid (a reversible adhesive) for his work with microfossils:

> Putting together a fossil that's in three pieces and altogether may be a millimeter wide, I want a glue with certain properties. And one of the beauties of cyanoacrylate is its ability to wick into cracks and practically disappear. . . . How are you going to get a drop of Acryloid in there? Acryloid does its work by the evaporation of the solvent . . . and that takes a certain amount of time and a certain amount of volume. What I need is something that I can apply what I call a microdot.

Max's justification demonstrates his knowledge of how the two kinds of adhesives work and how they align—or don't—with his goals for a fossil. His reasoning matches Jay's while assembling the mammal jaw. Bill, like many preparators, justified the use of cyanoacrylate based on confidence in his own skill and judgment: "If I get a joint cleaned and prepared so well that when it goes back together I would never want to take it apart again . . . or anyone else would ever want to take it apart, I don't see why I can't use a Krazy Glue on it." For Bill, the permanence of cyanoacrylate is

appropriate for the timeless quality of his work. Furthermore, he explained, "Whether people in the future, a hundred years, two hundred years from now, will have problems with it, I don't know, but I feel my job right now is to prepare the fossil the best I can to get as much information out of it now as I can. What's going to happen in the future is anybody's guess." The question of current versus future utility is a foundation of preparators' decision making and this debate.

Conceptions of time for specimens are contentious (Wylie 2019b). Conservators and conservation-minded preparators argue that investing time in conservation techniques now ensures longer-lived specimens, and hence more future research for scientists. For example, preparator Charles justifies using reversible adhesives to enable flexible research methods:

> If in the future there's some kind of technology coming along that you want to study some aspect of the specimen and the glue gets in your way of doing that, if you use a glue that's reversible . . . you'll be able to get that glue out of there and undertake that study.

All adhesives change the results of geochemical analyses, such as carbon dating for more recent bones; they therefore inherently limit research possibilities. Charles, like many conservation-minded preparators, dismissed cyanoacrylate as "just a quick fix" and not an ethical or justifiable practice. Most scientists agree, because conserving fossils maximizes future research opportunities. But the pressures of career advancement and time-limited funding can push scientists to need researchable fossils *now*. In the cyanoacrylate controversy, preparators debated whether and how to compromise between these temporal priorities for specimens.

Universality versus Preparators' Right to Choose

For preparators, their choices of materials and methods are indicators of their expertise and control over their work. The passionate, surprisingly confrontational cyanoacrylate controversy challenged this value. Several preparators told me that the worst of the conflict revolved around Walter, the inventor of a cyanoacrylate product that I call Geo Glue. Walter told me that he is a longtime fossil collector and preparator, as a hobbyist and

museum volunteer. While working in the adhesive industry, he patented several cyanoacrylate formulas, tested them on fossils at home, and founded a company to produce and sell them as Geo Glue.

When Walter started advertising Geo Glue at conferences in the 1980s, such as the Society for Vertebrate Paleontology (SVP), he did not sense a warm reception: "It upset several people within the paleontology prep business because their professors had said, 'We use polyvinyl acetate, we use polyvinyl butyral, we use plaster of paris, we use'—oh god, there was so many different chemistries used." Interestingly, not all preparators attend college, and they learn to prepare from preparators, not professors. These inaccuracies suggest Walter's lack of familiarity with preparators' training and values. His point was to portray the opponents of his product as resistant to change and thus obstructors of progress. For example, he wrote in an email to me, "The politics in the 'SVP' NIH [not invented here] mentality cripple our beautiful quest to find answers within our passion to know." Walter's dramatic phrasing captures his indignation at his product's rejection by some preparators. But he identifies a problem that many preparators agree with: the plurality of adhesives, which can complicate research and repair work because their use is not documented.

Preparators told me their skepticism about Geo Glue was a response to Walter's assertion of its universal utility. Jay mimicked Walter as saying Geo Glue was "all you need" in a prep lab so you should "throw away all your other stuff." Max explained Walter's single-option presentation as that of a businessperson, not a preparator: "[Walter] can be a very abrasive person and very opinionated. And he's a vendor, you know, he's selling a product." Max implied that Walter had a different motivation than preparators: making a profit, not necessarily preparing the best fossils. Another preparator told me that preparators suspect any mention of tools' or materials' brand names in presentations to be product placements, which they find offensive. This disapproval of marketing perhaps stems from preparators' suspicion of Walter's motivations for promoting Geo Glue as a capitalist rather than as an evidence-based advocate. Furthermore, most preparators are eager to exchange tips about materials. Profit seeking could pose a serious barrier to preparators' culture of information sharing.

Walter did not seem aware of preparators' disapproval of his advertising in the guise of information sharing. Instead, he understood his opponents' main criticism of Geo Glue, besides its novelty, to be its permanence—a concern he dismissed to me as irrelevant: "How many times, when you glue something together, are you going to take it apart? If you happen to know you're going to analyze something technically [i.e., geochemically], don't use this stuff. . . . But for day-to-day, everyday assembly, you're not going to analyze all that stuff." Walter argued for his product's universality not by denying its limitations on research methods but rather through appeals to efficiency. Many cyanoacrylate users share this view about the rarity of geochemical analyses relative to the overall number of prepared fossils.

Cyanoacrylate use may seem like a primarily technical debate, but the controversy is also inspired by social interactions. Preparator Anne explained why she is an ardent opponent of cyanoacrylate:

> It was talking with conservators and . . . there's a lot of back and forth with [Walter], who's marketing [Geo Glue] very aggressively with the Society [of Vertebrate Paleontology]. I know from personal experience that cyanoacrylates are not appropriate. They just simply don't work on certain things, and it's detrimental to our profession to promote this one adhesive that can actually be harmful to specimens.

In addition to conservators' and her own doubts about cyanoacrylate's functionality, Anne blamed Walter's forceful sales pitch for spurring her from mere disagreement to outspoken opposition. She fears for "our profession" as a potential victim of promoting cyanoacrylate, highlighting the importance of practices—and choosing them—to preparators' identity and reputation. "I always say, paleontology depends on adhesives. . . . And we're the ones making those decisions," Anne told me, emphasizing the scientific implications of preparators' judgment of tools and techniques. For Anne, using reversible adhesives helps preparators prepare good specimens, which is crucial for enabling good research and respect for the community of preparators.

Preparators blame individual personalities for escalating disagreements about cyanoacrylate. Jay described Walter and Anne as "like oil and water.

Or more like oil and fire." Their zealous opinions made them clash explosively, in Jay's terms. Max used the same metaphor to explain the conflict: "[Walter] mixed like oil and water with some of the folks here [in SVP], and they got just as crazy as he did. [*laughs*] So bring on the mediators!" Max was referring to an official attempt to calmly discuss the debate at the 2002 SVP meeting: "We actually had a special afternoon symposium regarding cyanoacrylates, and . . . they hired a professional mediator to oversee this meeting, trying to make sure everybody behaved themselves [*laughs*] and stayed in order and didn't get too crazy." Walter echoed Max's view of the symposium as a potentially unrestrained fight: "You have a monitor who keeps peace between divergent opinions. . . . Unfortunately [Anne]—you'd say the word 'cyanoacrylate' and it was like throwing a bomb. [*laughs*] She was just totally out of hand, I mean, just completely went crazy." Walter blamed his opponents for behaving badly, telling me that "it was an emotional diatribe . . . on their part." In contrast, Max said that "everybody behaved very well" at the symposium and the mediator was not needed. Regardless of how the symposium actually went, the controversy is widely perceived as a vicious dispute, and one that remains unresolved.

There are many debates on preparation techniques, but this one inflames more discord and leaves more scars than any other I heard about from preparators. As a result, Max distances himself from the debate: "I never cease to be amazed by how passionate preparators can be about materials they use, particularly the cyanoacrylate controversy. . . . They totally get crazy about this and, well, it's just glue, man! And these are fossils! Nothing to get that upset about." Due to this passion, Paul keeps quiet about his preference for cyanoacrylate. He told me, "I like cyanoacrylate as a glue. Some of these people would hate me for it! [*laughs*]," meaning other preparators at the 2010 SVP meeting. I witnessed why Paul kept quiet when a group of preparators and I were at a bar later that day. One preparator suggested that I ask the group about adhesives and thus start a discussion. Marc said dismissively, "We're all on the same page," meaning that it wouldn't be interesting to talk about because he assumed that the group, all friends, were staunch opponents of cyanoacrylate use. But that was not true; Paul was there. He looked at me and said quietly to the group

that he used cyanoacrylate, as if it were a confession. The others teased him in a friendly way, showing their awareness of the issue's potential hostility by making fun of the tension. Paul did not smile, though, and looked uncomfortable. Independently, Bill described techniques as the basis of sharp social divisions among preparators: "If you use Krazy Glue, you can't be in their clique." Jay suspects that all preparators use cyanoacrylate in certain situations, as he does, but that this choice has become stigmatized and is now something that "nobody wants to admit." Perhaps another bullied victim of the controversy is Walter himself. Max explained that Walter "got beat up so bad for so many years by some of the preparators in various discussions that he just decided he wasn't going to come [to SVP] anymore." Despite the opposition, Walter's company continues to profitably sell Geo Glue.

Tempers cooled after the 2002 SVP symposium, and both sides added nuance to their arguments. Most preparators have settled in a use-if-it's-the-best-option stretch of a spectrum of cyanoacrylate approval. Of seventy-three respondents to my 2010 survey, only 14 percent used cyanoacrylate most often, while 56 percent used reversible adhesives most often, and 30 percent used both equally often. In response to the statement "Cyanoacrylate should never be used on fossils," only 15 percent of the respondents agreed or strongly agreed, while 52 percent disagreed or strongly disagreed (and 33 percent neither agreed nor disagreed). Thus only a small number of the respondents opposed all cyanoacrylate use, while half considered it useful in at least some cases. Surprisingly, a third of the respondents did not have strong feelings either way. This group was perhaps shocked by the battle lines drawn between the two extremes and avoided joining in the fray.

These diverse responses suggest that preparators value choosing among many possible techniques, preferring to use "what works" for each particular fossil rather than a universal protocol. Many claim to be open to any technique, if there are good reasons for it. This is a kind of relativism in that preparators don't believe there can be a gold standard technique that works for all fossils. However, they do believe that techniques are not all equally good. "If for some reason you wanted to use Elmer's glue to

glue something together, you have to be able to justify that reason," Alan explained. Preserving justifiable flexibility, even to include a material Alan considers inappropriate for fossils (Elmer's glue), allows the consideration of multiple factors before choosing (or refusing) a technique. Marc agreed, saying, "If you have logically thought about the reason you make a choice between two different glues, cyanoacrylates or otherwise, that's awesome. That's what I really want in my lab." Max framed his decision making as context dependent: "I probably have a reputation among some of the folks here as being sort of a cyanoacrylate advocate. Which I am to a certain extent. Sometimes it's the best tool for the job." Sociologists Adele Clarke and Joan Fujimura's (1992) influential edited volume shows how research workers construct the rightness of tools by defining the tasks along with the values and goals for achieving those tasks. Preparators value their power to judge "the best tool for the job," thereby constructing their own tasks and priorities as well as assessing a tool's properties. This expertise to evaluate situations and decide how to respond to them is shared by craft workers (Sennett 2008) and professionals (Abbott 1988). I suggest that the cyanoacrylate controversy inspired hostility in part because preparators felt they had to defend that autonomy and identity. A few "oil and fire" personalities created conflict that somewhat obscured this main issue of preparators' power to choose from a plurality of potentially good techniques.

Like other controversies in science, this case illustrates groups' usually implicit ways of defining their conceptions of good practices, social order, and knowledge claims. For example, preparators discuss adhesives formally and informally, such as in conference talks, at social events, in the lab, and on the PrepList email list host. Surprisingly, these conversations employ a relatively consistent discourse style. I did not witness preparators speaking in the separate styles that sociologists G. Nigel Gilbert and Michael Mulkay (1984, chap. 3) documented among scientists: an "empiricist repertoire" that presents evidence as objective and a "contingent repertoire" for informal discussions about the realities of lab work. Preparators' speech register is relatively uniform, regardless of audience and context, and resembles the contingent repertoire by taking the form of stories of personal experience.

This speech style—particularly the lack of an empiricist repertoire—may serve to distinguish preparators from scientists.

Also, the cyanoacrylate controversy itself was enacted almost entirely through discussion, not through publications like most scientific controversies (e.g., Latour and Woolgar 1986). Latour (1987, 43) describes the transition of controversies from discussion to text as typical: "We go from conversation between a few people to texts that soon fortify themselves, fending off opposition by enrolling many other allies" such as through citations. But the cyanoacrylate controversy did not move into print. The oral-based nature of this controversy and thus this community reflects historian Derek de Solla Price's (1965) conclusion that the principal difference between scientists and "technologists" is that the former values writing publications while the latter values making objects. Furthermore, unlike many controversies, this one has not produced a "fact" or widely accepted conclusion. Instead, the détente between the two sides seems to have been achieved by continuing to allow preparators to choose their own materials and methods, without establishing community-wide protocols or bans. This preservation of local decision making thus reflects and shapes preparators' practices and identity, and, consequently, the specimens they prepare.

SPECIMEN PREPARATION AS CREATIVE PROBLEM SOLVING

Beyond Standards

Preparators pride themselves on their skill at assessing each fossil's features and adapting their work accordingly to produce visible, stable, researchable fossils. Likewise, when faced with a unique object, craft workers approach it with goals in mind, such as carving a straight table leg from a twisted tree branch. They evaluate the object and devise ways to make it achieve their goals. Preparators refer to this process as creative problem solving (Wylie 2015). Viewing research work as creative, adaptive, context-dependent problem solving highlights its dependence on situated judgment as well as the autonomy to act on one's judgment. Philosopher Thomas Kuhn (1996, 38) defines "puzzle-solving" as a crucial component

of science, such that a scientist's main motivation is "the conviction that, if he is skillful enough, he will succeed in solving a puzzle that no one before has solved or solved so well." Problem solving in ways acceptable to a field and its paradigm indicates a practitioner's socialization in that field.

But rarely do scientists attribute creativity to technicians. In physics, scientists and technicians are perceived as, respectively, "creative puzzle-solvers on the one hand, and those who are passive, uncreative, and unskilled on the other" (Law 1994, 123). As a result, scientists often "delete the work of subordinates: to assume that technical or low-status work gets done 'automatically,' as if people were programmable devices" (Law 1994, 131). Labeling technicians as "passive, uncreative, and unskilled" justifies "deleting" their work, as scientists delete fossil preparators' work in publications (Wylie 2016). Solving problems seems to serve as a high-status ability reserved for scientists. Preparator Alan defines technicians as those who fail to participate in knowledge making, observing that some preparators

> have no curiosity about what the animal is and they don't contribute any information to the research team when that specimen is being studied, except what they reveal physically. If you're just going to work on that level, kind of an automaton, then yeah, I guess you're just a technician, not part of the research process.

Alan disapproves of automaton-like preparators because they contribute to the perception of preparators as "just a technician," while other preparators—like Alan himself—actively participate in scientists' interpretations of prepared fossils. Claiming creativity helps preparators distinguish themselves from low-status technicians and liken themselves to high-status scientists (Wylie 2015).

On the other hand, technicians outside science, such as those who repair refrigerators or copy machines, are often considered problem solvers (Henning 1998; Orr 1996). Many kinds of technicians report that the best training for their work is experience solving problems: "Since, almost by definition, problems involved unanticipated troubles, technicians found they had to piece together most of the information necessary for resolution from the situation itself" (Barley 1996, 425). Likewise, preparator Gary

described the priorities that shape his problem-solving work: "What's the best way to solve this without compromising the integrity of the fossil or shortcutting conservation principles?" Understanding the many goals and constraints that shape a task, and acting accordingly, are key to expertise. To illustrate the importance of justifying problems and solutions, preparator Marc told a story to a group of preparators about a volunteer whose fossil was too large to fit under a microscope. To solve that problem, the volunteer picked up a hammer to break the fossil into smaller pieces. When Marc asked what he was doing, the volunteer was shocked at his own destructive plan. "We all get lost in our heads sometimes," Marc rationalized with a smile. Preparing specimens clearly requires solving problems, but not necessarily what scientists perceive as research problems.

Investigating the concept of "problem" reveals the situated work of defining and solving problems. "Puzzle-solving," according to anthropologist Tim Ingold (2000, 292–293), is not a standardized process but instead "is carried out within the context of involvement in a real world of persons, objects and relations." Fujimura (1996) likewise argues that scientists' success relies on their ability to construct "doable" problems and solutions, which are achievable as well as fit existing techniques, questions, and funding opportunities. This construction relies not just on knowledge or skill but also "articulation work: how to build and run laboratories, how to cultivate sponsors, how to manage and work with students and technicians, and how to negotiate with administrators" (Fujimura 1996, 185). Articulation work, also referred to as "housekeeping" (Garforth and Kerr 2010, 8) and "caretaking" (Knorr Cetina 1999, 38), is critical to the success of research communities. Yet it is considered low status and therefore made "invisible" (Fujimura 1996; Star and Strauss 1999). Despite its complexity and necessity, articulation work is not explicitly discussed, studied, or taught to science students (Star and Strauss 1999). If we recognize that "rational problem solving" is not objective or universal but instead specific to situation and culture (e.g., Lave 1988, 169), then problem solvers are expert judges of acceptable goals and practices. Presenting themselves as problem solvers as opposed to instruction followers can arguably promote preparators' expertise and elevate their status. It also allows

them to adapt techniques, based on their skill and ingenuity, to prepare good specimens.

Intervention through Invention

Preparators take pride in their improvisational ability, a resourcefulness forced by unique objects and restrictive budgets. Walter criticized opponents of his Geo Glue for their narrow-mindedness, which he considered a serious insult: "I used to go crazy when I would have someone say, 'Well, we've never done it that way, consequently we're not going to do it.'" I imagine most preparators would dismiss such an accusation as untrue. As evidence of preparators' ongoing and open-minded search for good techniques, fossil labs often look like workshops, full of potentially useful objects (e.g., various containers or scraps of wood and metal) and purpose-built tools (chapter 3). Other repurposed materials include welders' magnifying goggles (which a few preparators wear) and sandblasters' garnet sand in specimen-holding sandboxes (because it is less dusty than common silica sand). The identification of factors as problems, such as inadequate vision and dusty sand, is just as variable and expertise dependent as the solutions.

Researchers tend to appreciate preparators' specimen-specific innovations. Researcher Frank described a beautifully preserved raptor skeleton that preparators in his lab completely dismantled bone by bone. They removed matrix from both the top and bottom of the thin rock slab containing the specimen, which lay curled on its side and flattened. Along the way, the preparators molded each side of the slab several times to create replicas that preserved data about the bones' location and articulation. "No other lab would have taken it so far," Frank said proudly, adding, "Taking it to the eleventh degree is what we like to do." Frank does not want preparators in his lab to do "boring," "routine" work; instead he thinks they should understand each specimen's scientific importance and create ways to tell "the most convincing scientific story," such as by accessing as much data as possible. As a researcher, Frank encourages preparators to develop techniques in order to gather more information than his competitor researchers. Bill, a preparator in Frank's lab, appreciates Frank's support for

preparators' autonomy to generate new ideas: "[Frank] provides the money and the fossil and the equipment and the place to do it, and lets us figure out how to do it." As a result of this freedom, Bill has developed many techniques that he thinks might be novel, such as mailing a delicate fossil buried inside a box of sand to protect it.

Preparators consider most innovations to be welcome and uncontroversial. While preparing small, fragile fossils, Constance Van Beek (2011, 8) began to sharpen tool tips into specialized shapes to best remove matrix in particular situations, such as a "serrated blade," "hook," "cat claw," or "barb." The tips are thin needle-like cylinders of steel or tungsten carbide, and they fit into a pen-sized handle to create a ubiquitous preparation tool called a pin vise. Van Beek teaches other preparators to make these task-specific tool tips, and she published a rare paper to further disseminate the technique. Similarly, after volunteer Ken improved the design of plaster storage jackets, the Southern Museum hired him part time. Ken presented his technique at a conference and impressed Marc, who had previously made jackets at the Southern Museum: "He's done so many innovations. . . . His use of foam blocks for feet—you know, we were just taking gobs of fiberglass and balling them up [to become jacket feet], and it was all sort of slapdash and haphazard. . . . My jackets are not as pretty as the new guy's, for sure. His are just awesome." Marc praised Ken's jackets for being pretty, meaning carefully made. When comparing his own jacket design with Ken's, Marc sounded admiring rather than jealous or competitive. Preparators expect each other's practices to vary, and they're always on the lookout for good ideas. John explained, "There's no real, one right way to do anything in preparation, I don't think. And so that leaves a lot of room for people to come up creatively with their own solutions." Flexible practices allow—and perhaps require—innovation.

Outsiders to the preparator community seem unaware of the diversity of techniques and preparators' freedom to choose among them. For example, preparator Jay taught volunteer Derek how to make casts. One day when Jay was not at work, Derek asked staff preparator Kevin for help with a cast. Kevin said that he would have made the cast differently from the method that Jay had taught Derek, and Derek was surprised that

two preparators would disagree. The next day, Derek told Jay that he had new ideas to try on the cast, thereby adopting Kevin's method. Jay and Kevin laughed at him dismissively, not because Derek had appropriated Kevin's technique, but because staff believe volunteers shouldn't propose techniques (chapter 2).

Preparators know that overlap is likely in a geographically distributed community of workers who are all designing techniques. Steve even thinks that there are no new inventions: "Everything comes around. Everything's been invented before." For instance, he occasionally uses the centuries-old method of hammer and chisel because in some cases he finds it more effective than modern tools, such as for removing extremely dense rock. Likewise, after Gary gave a conference talk describing how to repair bone surfaces by gluing thin veil cloth over them as an external support, Gary told me that ideas, like this technique, are rarely new:

> **Gary:** It's not a new technique. I didn't invent it, but I guarantee that 90 percent of people in that room had never even heard of it.
> **Caitlin:** Where did you hear about it?
> **Gary:** I invented it. But I wasn't the first to invent it.

To invent for Gary means creative problem solving, not necessarily novelty. But he finds creative problem solving inefficient: "We have enough creativity generally to invent things again, and again, and again. . . . But it's kind of a waste of time." Preparator Alan is also frustrated by reinvention: "So many people spend so much time reinventing the same wheel over and over again." He considers communication the solution to repetitive invention: "There were eight of us at [one museum] . . . so you'd problem solve and troubleshoot and just chat among one another. . . . We were able to do a lot of really neat innovating that way." Innovation can come from people working together, though rarely do many preparators work in one lab. The average number of people preparing fossils in sixty-nine survey respondents' labs was five (the median was three, the mode was one), which includes volunteers, who are not encouraged to innovate (chapter 2). So preparators' innovation typically comes from individuals' creative problem solving more often than from collaboration.

Perhaps because of their low numbers in most labs, preparators value collective brainstorming and methods sharing at conferences and on the PrepList. Tim, for example, supports communication among preparators and so does his researcher boss: "Over the years we've tried quite a few different things, and experimented and modified our techniques. And I've tried to share those at SVP meetings and the Preparators' Symposium.[1] So that's been nice. I think [Frank] really appreciates that too, that we're showing what we're doing here and getting the word out about interesting spins on ideas." Preparators tend to frame methods sharing as a service to each other and specimens rather than as a service to scientists. Most PrepList emails and conference talks are told as stories, narrating the speakers' personal encounters with problematic fossils and how they responded. Usually the approaches are widely applicable, such as Gary's "bone bandage" of glue and veil cloth. Preparators in peril email the PrepList, which "is devoted to the exchange [of] information, questions, opinions, etc. about preparation of vertebrate fossils. . . . Debate is encouraged for honing our knowledge and thinking skills, for truth-seeking, and for clarifying our perspectives" (Preparators' Resources 2020). On this informal forum, preparators describe their problems and then advice comes pouring in from other subscribers. The advice too comes in the form of storytelling about similar experiences and how the writers approached them. These stories almost always end well, with occasional mentions of failed techniques recounted as warnings to others. This generosity seems striking compared with scientists' tight-lipped world, where unpublished methods and results are typically closely guarded. Perhaps knowledge can be more freely shared in a community for which indicators of expertise do not involve publications or citation counts.

Only one preparator, as a unique exception, mentioned competition and proprietary methods:

> I would like to be known in the world of paleontology as one of the best preparators that has ever been. . . . [If] a preparator wants to come and visit, I would gladly show them how to do other things. But mainly I don't really spread out too much of my little secrets. I mean, there are many, many things

that we all know, [that] all the preparators know. But there's one or two things that *you* know.

Clearly preparators value the ability to design effective methods for the benefit of specimens and the preparator community as well as demonstrate individuals' skills. But they rarely guard these ideas as "little secrets."

The concept of innovation carries particularly positive connotations in the United States. For example, "framing agendas under the rubric of innovation and change is inevitably a strategic move, appropriating the positive value of the term for whatever the agenda to be pursued in its name might comprise" (Suchman and Bishop 2000, 331). The celebration of innovation has even inspired a countermovement among STS scholars to reframe technological work in terms of maintenance and care so as to emphasize the value of keeping technologies functioning over inventing new technologies (e.g., Puig de la Bellacasa 2011; Russell and Vinsel 2018, 2019). Innovation is valued as intellectual property and for keeping companies attuned to changing consumer demands, which are not concerns for preparators. Why then might innovation appeal to them? Sociologist Andrew Abbott (1988, 30) argues that professional groups' ability to assert control over certain tasks relies on "the power of the professions' knowledge systems, their abstracting ability to define old problems in new ways." Promoting their ability to adapt methods lends credence to preparators' control over their work. Furthermore, a professional group legitimizes the scope of its power in the workplace and society by claiming and enacting control, or "jurisdiction" (Abbott's term), over specific tasks. Preparators may describe their work as innovative and creative to highlight their expert decision making along with their jurisdiction over preparation work, thereby defining themselves as a professional and expert community.

The Limitations of Creativity

When preparators say that they admire creativity and that it is crucial to preparation work, they mean only certain kinds of creativity. In some cases, they consider creativity risky and therefore ill-advised. After all, if a new technique fails to solve a problem, the consequences can include damaged fossils, wasted time and materials, and lost credibility. At the 2010 SVP

Preparators' Committee meeting, attendees discussed their concern that sharing techniques through a proposed series of training workshops would threaten individuals' creativity. One preparator said he did not intend for workshops to "kill creativity" by standardizing methods but rather to point out pitfalls and help people avoid problematic techniques. Likewise, another noted that preparators sometimes "reinvent old bad things," which he suggested workshops could prevent. The concern expressed by many attendees was, as one put it, "creativity without rationale": inventing or choosing methods without justifying them. The proposed workshops have still not been established. Perhaps preparators' fears of limiting creativity by promoting training outweigh their desire to prevent "bad" practices.

But innovation is inherently risky. For instance, a scientist asked preparator Erica to mold and cast a delicate ceratopsian skull—a task she was not sure was possible without destroying the scientifically important specimen. She laboriously designed a network of small separate molds that would fit together to form a complete mold of the skull. As she applied this complex method, she was worried but optimistic: "Every day I was working with that thing, I was like, 'Please work.' Because you really don't know if it's ever going to." Not knowing the results of a time-consuming and potentially destructive task like molding, which also requires costly materials, means that Erica risked time and money as well as the fossil's safety in hopes of producing a mold and, from it, a cast. After four months of work, she succeeded, and was proud of her techniques and the resulting mold and cast. She later gave a conference talk about the project, complete with photos of her experimental mold and nerve-racking descriptions of carefully extracting the fossil from each of the mold's many parts. After listening to Erica's talk, volunteer Tom decided not to learn molding and casting. He exclaimed to me, "There were seventeen pieces to that mold!" Tom was impressed by Erica's skill and method—molds are typically two pieces and almost never as many as seventeen—but he was also so intimidated by the risks that he avoided molding altogether.

Most preparation tasks have less daunting uncertainty than Erica's mold. However, no preparators told me about ideas they tried that failed. Perhaps preparators forget such attempts because they don't document their

methods, or perhaps they do not want to damage their pride or reputation by admitting to failed techniques. But for every successful innovation, there are surely many more that preparators reject. Preparing evidence, then, is a process of preparing practitioners' skills, priorities, and techniques as well as pieces of nature.

CONCLUSION: INVISIBILITY ALLOWS CREATIVITY

Fossils, as traces of past life, are rare and impressive objects. As specimens, fossils serve as enlightening evidence of the mechanisms of biology and geology. Learning about past life relies on the transformation of mysterious, incomplete, rock-encrusted objects in the field into specimens that can be seen, held, compared to other specimens, and trusted as a data source. To "clean" a specimen is to define it, because the boundary between a highly valued object and its inconvenient surroundings is not obvious and depends on its social and epistemic context. As anthropologist Mary Douglas (1966) argued, notions of clean and unclean, sacred and profane, or prepared and unprepared differ in different situations and communities. Preparing specimens involves defining those boundaries both epistemically and physically. These processes are requisite components of interpreting that object and its role in our knowledge about nature.

Everyday fossil preparation work reveals strikingly varied products—from cradles and casts to prepared fossils—which result from a diverse set of practices, such as searching, gluing, building, scraping, assessing, and discussing. Preparators' claims of creative problem solving further reflect the many ways in which they prepare nature into evidence. This case reinforces the view of evidence—and thus knowledge—as contingent and contextualized. It also sheds light on how workers' seemingly purely technical decisions about methods structure social roles as well as specimens that represent the physical world.

Preparators' autonomy over their practices may not be typical of science technicians, many of whom are expected to follow written protocols and document their work. Of course, craftwork is embedded in protocols too, such as knowing how to carry out incompletely described actions

and applying skillful personal strategies that cause one technician's completion of a protocol to produce more desirable data than another's. But most technicians can't alter their techniques too much without threatening the reliability of the data they produce, which is supposed to be replicable by other people. In comparison, vertebrate fossils are usually rare, and are stored and restudied over centuries; they are not considered replicable. This view perhaps permits preparators the leeway to select and modify methods to match these diverse specimens, rather than try to standardize the methods or objects.

Also, crucially, preparators leave few written records. Lab notebooks and other written sources can be audited for fraud (e.g., historian Gerald Holton's [1978] reassessment of Robert Millikan's incompletely reported data in his famous 1909 oil-drop experiments to quantify the charge of an electron); the dearth of documentation about fossil preparation arguably prevents such accountability. Furthermore, because preparation methods are not part of researchers' papers, researchers don't get involved in it (despite the obvious influence of those methods on the physical appearance of the fossils described in the papers). This lack of record keeping and supervision grants preparators de facto power over their techniques. From this perspective, preparators' defense of their preferred glue becomes an indication of expertise and personal pride in their work as well as an assertion of their right to control how they prepare evidence. This invisibility thus enables preparators' autonomy in that scientists prioritize good specimens over standard or documented practices and practitioners. Preparators then use this autonomy as a defining characteristic of their community.

2 PREPARING COMMUNITIES

One volunteer's interaction with a staff preparator about a particular fossil demonstrates the combination of technical and social knowledge transmitted between research workers on a daily basis. Ted, a volunteer at the Northern Museum, was preparing a dinosaur vertebra that unexpectedly had another fossil, an ossified tendon, preserved against it. He postponed removing the tendon because he feared the process would damage the vertebra. He consulted Amanda, a staff preparator, several times about this specimen, including how to support the crumbling bone (her answer: with water-soluble wax and B-72, a conservation-grade adhesive) and how much matrix to leave on the fossil. Their conversations define proper techniques as well as the hierarchy of staff preparators as decision makers and volunteers as instruction followers.

Sometimes Amanda checked on Ted, and sometimes he sought her out for help. For example, once as Amanda walked past Ted hunched over the vertebra in the lab, she asked, "How's your specimen?" "Coming along," Ted answered, without looking up. His response and body language suggested he didn't want to be interrupted. Amanda ignored these cues, subtly asserting her power as a staff member over a volunteer, and examined the vertebra over his shoulder. "Oh yeah, that is very nicely coming along," she said encouragingly. Positive feedback is just as important as criticism in any training process so as to allow novices to learn the characteristics of "good" work as well as "bad." After one discussion with Amanda, Ted said to me, "I learned a new word: centrum," the scientific name for a vertebra's

doughnut-shaped part. Alongside instruction in techniques and language, Ted was learning the lab's division of labor and social hierarchy. When I asked him whether the tendon or the "vert" was the more important specimen, he shrugged, "Don't ask me, ask [Amanda]." As a volunteer, Ted is not expected to judge the scientific value of fossils; that is a task for staff. Likewise, when I asked Ted who decides which volunteers work in which of the museum's two labs, he said, "the boss," meaning Amanda. When Ted explained preparation work to me, he detailed the goals of removing matrix and repairing breaks, but was at a loss regarding what happens when those tasks—his tasks—are finished: "Then [Amanda] does whatever she does," somehow transforming the specimen into part of the museum's collection. The responsibilities and hierarchy of staff and volunteers are constructed and communicated through everyday interactions. As a result, learning how to work and act like a preparator or volunteer is a long-term process of socialization and hands-on experience. Individual practitioners' ongoing learning is a key component of how experts prepare their community— that is, how they define a shared, collective identity based on often-tacit norms of social and technical behavior.

We know a lot about how scientists develop their sense of identity (e.g., Traweek 1988, chap. 3; Delamont, Atkinson, and Parry 2000). That well-defined path of graduate degrees and field-specific positions and experiences is common for a subset of scientists, technicians, and other research workers. But fossil preparators lack formal training and credentials in fossil preparation and sometimes in science altogether. As a result, their apprenticeship-like learning demonstrates how people acquire hands-on skills and experience-based social norms. Scientists, after all, learn this way too, as do other kinds of craft workers. Without standardized training or shared credentials, preparators offer insights into how people learn to do good work and identify with a group of practitioners. Together, these two processes constitute the preparation of a community.

One way to understand preparators' training is as the process of joining an epistemic community (Meyer and Molyneux-Hodgson 2010) or epistemic culture (Knorr Cetina 1999). These are groups that are primarily

defined by members' shared knowledge and shared ways of producing knowledge. In these conceptions, all the rest of an epistemic group's work, such as training novices, tinkering with techniques, and shaping pieces of the world, is subsidiary to knowledge. From the broader perspective of preparing knowledge, however, a community's tasks of preparing evidence, future practitioners, techniques, and its own sense of collective identity are all interdependent as well as equally important. Knowledge is one component of this system rather than the ultimate one.

A better heuristic for capturing what unites research workers is the idea of a community of practice (Lave and Wenger 1991). A community of practice centers around learning as a description of everyday interaction and a mode of shaping future practitioners. Learners are immersed in a group of workers and given real though marginal tasks. Anthropologist Jean Lave and education scholar Etienne Wenger (1991) call this process situated learning, which happens through "legitimate peripheral participation" in a community of practice. Lave and Wenger focus on how novices learn, but really doing skilled work involves ongoing learning by all practitioners, from each other and from working with materials. As a community that *only* has situated learning—without coursework or written instructions—preparators powerfully illustrate learning from each other and by interacting with the world. Furthermore, how preparators learn to work with specimens demonstrates how defining good work is inseparable from defining the community that does that work. It is the iterative process of developing skills, techniques, and identities that unites workers as a community, beyond knowledge alone.

This chapter investigates how technicians prepare a community, which is made most visible in how they prepare people to join that community. Teaching potential new members is inseparable from the work of defining a community's norms and values, and therefore serves as an important indicator of how a community perceives, defends, and occasionally adapts its identity. Other forms of community preparation include negotiations of social order, task responsibility, and group governance (e.g., at meetings of the Preparators' Committee at annual SVP conferences), but these processes tend to be subtle and happen infrequently. Hence I focus on

preparators' training and socialization as illustrations of how skilled workers prepare their community.

How preparators select and teach novices (both staff and volunteers) in the absence of training programs highlights this community's conceptions of whether skills are innate or learnable. Crucially, most staff preparators work alongside volunteers. The presence of volunteers in research spaces is not common, especially in facilities that require extensive training and safety clearance (e.g., spaces with dangerous chemicals or machinery). Yet volunteers' participation in research has historically persisted in some fields, such as paleontology and astronomy, and has returned to other fields, such as ecology and archaeology, through citizen science programs in which scientists invite the public to collect and/or analyze data (Strasser and Hacklay 2018; Strasser et al. 2019). Like staff preparators, volunteer preparators apply embodied skills to make specimens researchable, but unlike staff, volunteers do not apply expert judgment to assess *how* to alter a fossil. That craftwork—the creative problem solving, as discussed in chapter 1—belongs to staff. This distinction may help protect preparators from being replaced by an unpaid workforce. It also, I argue, helpfully delineates preparators' community of practice by placing volunteers at its periphery rather than its core. Teaching and learning are thus a dynamic process of defining a community of practice, its techniques and skills, and its sense of collective identity.

WHAT IS A COMMUNITY?

Learning how to communicate and behave is the first step in joining a community of practice. Sociologist Harry Collins (2011) contends that novices first must learn a community's work language in order to participate in and therefore learn from the community. Lynch (1985, 16) agrees that social interaction enables learning: "Adequate access to the social order of the lab is inseparable from a competence [in] the technical practices." Moreover, according to Lave and Wenger (1991, 92), social acceptance decides novices' future in the community: "The issue of conferring legitimacy is more important than the issue of providing teaching." Rick, who

was hired as a preparator without preparation experience, described the value of preparators' social connections: "There's a path to becoming a part of their world. . . . This [lab] is a good place to start because there are a lot of connections with other people and SVP."

How then do people learn a community's appropriate social and technical behavior? Unwritten methods, as well as the unwritten nuances underlying written methods, rely on tacit knowledge, which must be learned from experience and person-to-person instruction. Collins (2010, 11) names three types of tacit knowledge: "relational" (usually not explained, but it can be), "somatic" (muscle memory, such that explaining a task is insufficient to teach it), and "collective" (only learnable through immersion in a society). Preparation work relies on all three as both a cause and effect of preparators' nonstandard, hands-on, unwritten, "situated" training. The tacit nature of much of technicians' knowledge may also explain why, as studies show, technicians feel loyal to and self-identify with their community of practice more than with the institution they work for (e.g., Barley and Bechky 1994; Zabusky and Barley 1996). Understanding how technicians learn to do their work as well as identify with their community is a crucial, little-understood issue in the construction of scientific practice and social order. From the perspective of knowledge preparation, how research workers learn skills and identities helps define their community, and influences how they understand the world.

Preparators' variety of tasks as well as lack of standard procedures and shared training could indicate an absence of community. For example, respondents to my 2010 survey listed job titles including "museum specialist," "museum technician," "academic technician," and "field and lab technician," in addition to the more specific "fossil preparator," "conservator," and "collection manager." What makes people with these various job titles identify as preparators? Despite their apparent heterogeneity, preparators manage to prepare a community that they identify with. Preparators, for instance, tend to subscribe to the PrepList email list host, attend talks in the Preparators' Session at SVP, and, importantly for my research, respond to an email request to fill out "Fossil Preparation: A Survey." To match the diversity of roles that fit under "preparator," the SVP website describes

its Preparators' Resources (2020) page as "a resource for those concerned with the collection, preparation and conservation of vertebrate fossils and the care and management of collections." These wide-ranging tasks are presented as connected and specific to preparators.

It's possible that the creativity and adaptability that enable successful work with diverse fossils, tools, social structures, and priorities also function as unifying values. Sociologists Stephen Barley, Beth Bechky, and Bonalyn Nelsen (2016, 137) observed this appreciation for flexible methods in several communities of medical and science technicians:

> Because much of technicians' work was a response to the vagaries of physical, mechanical, and biological systems, none of which could be counted on to function predictably, their understandings of these phenomena remained open to continual modification. The upshot was that the technicians' knowledge remained resistant to codification and, on occasion, articulation.

Standardization would inhibit preparators' ability to respond to irregular specimens and situations (chapter 1). This reliance on dynamic specimen-tailored methods and mindsets may help preparators unite as a community across job titles and institutions.

One way to understand preparators' shared identity is to find the common frame that encompasses their various activities. In Abbott's (1988, 59) model, as noted in chapter 1, a professional group claims jurisdiction over certain problems and tasks and thereby creates a group identity. For example, preparators claim jurisdiction over removing matrix and repairing fossils, even though they lack the shared training and codified problem-solving techniques of most professions. As a weak endorsement of preparators' jurisdiction, the "SVP Bylaws" (2009) state that fossils "should be prepared by, or under the supervision of, trained personnel." This bylaw is vague (what constitutes trained personnel?) and unenforced, serving as a recommendation rather than a rule. Preparing preparators' collective identity, then, relies on more subtle mechanisms than professions whose jurisdiction is defined by law and credentials, such as doctors and lawyers.

The types of questions that a community chooses to ask—and not ask—also indicate the beliefs and tasks that unite the group. Historian

Nicholas Jardine (1991) argues that the questions that scientific communities ask reflect their epistemologies and social composition. The kinds of questions that preparators ask about their work make sense to all preparators, suggesting that they share a "scene of inquiry" in Jardine's term (1991). Preparator Charles said of preparation:

> It's always decisions. . . . How much dirt can you remove from the specimen before you're endangering the specimen? . . . You got to remember that it's going to be handled, it's going to be shipped. . . . You have to do these things in anticipation of other things that are going to happen to that specimen.

The basic question of "how can we see and study this fossil?" relates to "how can we remove this matrix?" and "how can we protect this fossil?" which are bounded by "what are we willing to risk or sacrifice to see this fossil?" Removing matrix, for instance, removes information, including strata composition data, microscopic fossils (e.g., pollen), and trace fossils (e.g., skin impressions). Deciding how much information to destroy in order to see a fossil has no standard answer; the question itself, however, is intrinsic to every matrix removal task. Sharing these questions makes preparators a unified group, regardless of how they later answer these questions. By having shared tasks and questions about these tasks, they prepare a community for themselves.

One indicator of how preparators view their community is how they portray themselves and their work to outsiders. Objects and events help solidify group identity for both members and nonmembers, such as community-specific symbols (e.g., the DNA double helix as a symbol of biologists [Nelkin and Lindee 1995; de Chadarevian and Kamminga 2002]) and historic commemorations (e.g., the 1959 centennial celebration of Charles Darwin's *Origin of Species* that helped unite scientists around the new synthesis of evolutionary theory and genetics [Smocovitis 1999]). Every year, preparators contribute photographs that one preparator selects and compiles into a calendar, which serves as a visual representation of the community of preparators and their work. The calendar's more explicit function is as a fundraiser for an annual grant awarded "to further the field of Vertebrate Paleontology through the advancement of preparation,"

such as by funding training workshops ("Marvin and Beth Hix Preparators' Grant" 2020). The calendar's twelve photos imply that preparation relies on individual skill, scientific knowledge, and hard work. In the 2010–2017 calendars, half of the ninety-six images (52 percent) show people carrying out preparation work, such as removing matrix, gluing, casting, mounting, and fieldwork. Twenty-five percent of the photos imitate the style of research publications by depicting fossils alone against a neutral background, often including species names and scale bars. Most of the remaining photos (22 percent) showcase specimens less formally, such as next to a smiling preparator, on exhibit, and in before-and-after-preparation shots. Ironically, although preparators and their work are missing in publications, they are visible in the calendar prominently displayed in most fossil labs. By creating an artifact to represent their community, preparators further define that community.

PREPARING PREPARATORS

Preparators' Paths

As diversely trained technicians, preparators' experiences illuminate a variety of possible paths to working in science, even without a PhD. To capture a snapshot of this community's demographics, backgrounds, and opinions, I conducted a survey.[1] I don't know whether the survey garnered responses from a representative sample of preparators, of whom there exist no centralized tallies or lists.[2] I do not attempt a full prosopography of preparators, but these survey responses convey at least an idea of the preparator community.[3]

Many preparators' work lives include academic degrees in science. Ninety percent of the survey respondents have bachelor's degrees, and 37 percent also have graduate degrees (27 percent have master's degrees, and 10 percent have PhDs). Many of their degree fields reflect the diversity of sciences that study fossils, such as geology, biology, paleontology, paleoanthropology, paleobotany, and zoology. The survey respondents also listed degrees in seemingly unrelated fields, including linguistics, history, marketing, art, and literature. Seventy percent of the respondents have at

least one degree in a science subject. This is not as high as for many laboratory technicians, such as those in the disciplines that expect technicians to hold PhDs in specific scientific fields. There seems to be more room for diversity in preparators' education than in researchers' and other kinds of technicians' schooling.

Volunteering is important in preparators' backgrounds and job responsibilities. Half of the respondents (thirty-two) were or had been volunteer preparators. Fifty of the fifty-seven respondents (88 percent) who were full-time staff members trained volunteers, indicating the high numbers of fossil labs that host volunteers. Of the thirty-one staff preparators I interviewed, thirteen (45 percent) learned to prepare as volunteers. Nine (29 percent) were hired without experience and then learned on the job. Four (13 percent) taught themselves to prepare. Four others (13 percent) learned to prepare as science students and chose jobs in preparation instead of research. Thus most staff preparators I met had experience before they were hired (twenty-one, or 70 percent), most often as volunteers but also as amateurs or students. Carter, a fossil conservator, said of his coworkers, "We all started as volunteers. And we're quickly becoming put in charge of departments. It's a nice way in." Volunteering is considered a good way to learn how to work with specimens and, implicitly, participate in the community.

There also seem to be personality traits that correlate with being a preparator. My impression is that many preparators are introverts who are drawn to details, committed to their work and hobbies, and susceptible to perfectionism. They happily spend hours focused on one specimen while making small, precise movements. Unlike technicians who work in teams, preparators' primary tasks—matrix removal and fossil repair—require intense concentration and frequently involve a microscope, which excludes collaborators. Preparators tend to be tinkerers, like many technicians. Sociologist Park Doing (2004, 2009), for example, observed that synchrotron operators judge each other's lab skill based on how well they maintain their own cars and motorcycles. Preparators reported hands-on hobbies that seem more diverse and less mechanical than those of Doing's technicians, including playing in rock bands, tending rare orchids, painting and

sculpting, and collecting fossils in the field. Many foster countercultural interests, such as *Star Trek*, the *Rocky Horror Picture Show*, techno music, and role-playing games. They prefer to be informal. For example, everyone in fossil labs is on a first-name basis, and old jeans and T-shirts are the unofficial lab uniform (worn beneath white lab coats in the United Kingdom, though not in the United States). Many preparators participate in institutional social gatherings such as happy hour, communal lunches, staff parties, and show-up-to-play sports teams. They regularly crack jokes and tell stories, perhaps to compensate for their long solitary stretches of working on fossils. But these personality traits are not prerequisites for or indicators of preparation skill, of course. Without shared training or credentials, how can preparators assess whether someone is—or could become—a good preparator?

The Prep Test: Are Preparators Born or Made?

Experience preparing fossils is one sign of a preparator's ability, but most applicants for volunteer positions and some applicants for staff positions have never prepared fossils. As a result, many staff preparators assess applicants' *potential* skill by evaluating their untrained performance at preparing a fossil (Bergwall 2009; Brown 2009, 52–57; Brown et al. 2010, 181–182). The goal is to identify novices who are likely to prepare fossils well, thereby maximizing the return on staff's time in training them and minimizing the damage inflicted on fossils. In a paper about a volunteer training program they led, preparator Matthew Brown and colleagues (2010, 183) claimed, "In most cases a future preparator's potential can be judged within moments of a candidate's first attempt to prepare a specimen." As an example of how most preparators judge applicants' first attempt, Paul described his lab's approach: "I usually start [volunteers] on something simple that'll test their patience, usually scrappy fossil fish. We give them a pin vise and a little poofer—an air blower—and tell them how to clean the fish. . . . It tests them, to see if, A, they have the patience, B, if they can do it, [and] C, if they want to keep doing it." Preparators judge applicants' manual ability, patience, and interest through a "prep test" that matches preparators' training by taking place on the job, in the lab, by actually preparing fossils.

The design of this prep test varies by institution, but it is always given before applicants are trained so as to judge their preexisting capabilities. It is prognostic in that it is intended to predict an individual's future performance. But the prep test has no universal assessment criteria (except, perhaps, not destroying the fossil). Preparators judge tests differently depending on their labs' needs and their own values, such as preferring faster versus more precise work, or gregarious applicants for exhibit labs versus quiet applicants for behind-the-scenes ones. Labs that have "easy" fossils to prepare are more likely to accept less skilled applicants than labs with "difficult" fossils, which admit only the highest-performing applicants. Thus this test is not looking for universal aptitude but rather for how well an applicant fits a specific workplace. If preparators judge that a volunteer applicant "fails" a prep test, then they encourage the applicant toward positions outside the lab, such as in collection management or public outreach. A staff applicant who fails a prep test is not hired.

Using a prognostic test implies that a job relies on innate abilities like the "black art" of computer programming (Ensmenger 2010, chap. 2) and indefinable "right stuff" needed to be a good astronaut (Santy 1994). Mysterious, unlearnable skill can seem exclusive and high status, as opposed to well-defined skills that anyone might learn. By designing and judging a test, preparators assert control over their community of practice by selecting their coworkers and defining the characteristics of a good preparator.

As their prognostic test suggests, many preparators believe that the relevant manual skill cannot be learned. In 1982, preparator Bill Simpson designed a prep test for his lab at Chicago's Field Museum (Bergwall 2009). Preparators often credit Simpson with inventing the prep test, or at least being the first to use one consistently. The design of his test reflects preparators' common view of manual ability, which is that "you can either do it or you can't," as Simpson explained to me. Furthermore, Simpson continued, this test "was measuring just basic hand-eye coordination. . . . Preparation involves knowledge of the anatomy and being really good with your hands. You can learn the anatomy. I don't think you can learn to be good with your hands." The unusual aspect of Simpson's test is that he asks

Figure 2.1
Photographs of several applicants' prep tests on *Priscacara* tails, showing various skill levels. A (top left) is a well-prepared "model test," while F (bottom right) is a poorly prepared "failed test" (Bergwall 2009, 39, reproduced with permission).

all applicants to prepare the same thing: the fossil tailbones of a *Priscacara* fish, of which his museum has many specimens. Simpson decided to use a consistent kind of fossil to facilitate comparison between applicants' results. He also believes that *Priscacara*'s anatomy differentiates applicants, telling me, "Most people that are good with their hands will have a fairly easy time doing preparation at the base of the fin, but you have this wonderfully gradual gradation to thinner and thinner bone as it goes out to the tip of the fin. Somewhere along there everyone's going to start having problems" (figure 2.1). Thus where along the fin applicants damage the bone indicates how good with their hands they are. Most labs use any available unimportant specimens instead of one particular species.

The applicant test that I witnessed at the closest proximity was my own, as a high school student, in the Dinosaur Lab at the University of

Chicago. Volunteers worked there every Sunday under the supervision of an undergraduate, Betty, who had been preparing fossils for two years. When I arrived, rock dust was floating through the air and the volunteers' pneumatic air scribes buzzed like dentists' drills. Betty handed me a pin vise and a little piece of dinosaur in a cardboard box. While I wondered why we weren't wearing gloves or encasing this priceless relic in glass, Betty pointed out the clumps of sandstone stuck to the fossil. She explained that I should chip them off in small pieces, without scratching the bone beneath them. Then she walked away.

I stared after her in astonishment and then turned anxiously to this balancing act of removing all the rock, but *only* the rock. The fossil was probably a chunk of rib or vertebra—bones considered sufficiently robust, common, and scientifically uninteresting to serve as tests and learning tools for novices. I scratched with the pin vise at millimeters of sandstone, surprised at how unsteady my hand was at that scale. One clump flaked off in one piece, popping cleanly off the bone surface. I was startled, but also strangely pleased at how smooth and shiny that newly revealed section of fossil was. I was learning how to notice, such as the visual details of the rock and bone, and the feel of the rock's resistance against my tool. Turning this multisensory awareness into decisions about how to work with an object relies on "synesthetic reason" (Paxson 2012, chap. 5). In this view, "an artisan habitus is less a matter of ability than of sensibility. It combines a synesthetic grasp of the materials with an ethic of doing a job well for its own sake" (Paxson 2012, 148).

"Good job," Betty said at my shoulder after a while, making me jump. I had not yet learned preparators' unspoken rule that if someone stands quietly in your peripheral vision, they want to talk to you. They wait for you to look up before they speak so as to prevent you from jabbing the fossil in surprise. I had missed the cue, forcing Betty to talk to get my attention. I had been thoroughly engrossed in the microworld of that fossil's bumps and striations and adversarial rock clumps, as preparators expect other preparators to be. Betty kept checking on me, and after a while she invited me to come back the next Sunday. I don't know what her criteria

were for passing the test, but I didn't damage the fossil. Despite my slow, unsure pace, Betty saw potential in me.

More recently, three volunteers who had passed a prep test described it to me as an indicator of hand-eye coordination, willingness to follow directions, dedication, love of fossils, and ability to perform repetitive work. Volunteers generally pride themselves on their ability to identify (and uncharitably laugh at) bad prep tests, such as fossils gouged by applicants. Recognizing and ridiculing bad prep tests asserts the volunteers' superior skill over the novices. The three volunteers credited the prep test as "a make or breaker" for applicants' admission to the lab. This all-or-nothing result reflects staff preparators' trust in the prep test as a reliable measure of applicants' potential ability. These volunteers' list of required skills matches staff preparators' except regarding love of fossils, which staff members don't consider a useful measure of a good preparator. That volunteers *do* may reflect their choice to work in the lab, which is usually motivated by their specific interest in paleontology

Preparators even interpret enjoyment as a sign of manual skill. Preparator Lisa Bergwall (2009, 37–38) published a list of "test criteria" to assess prep tests, including "did the candidate get bored?" Being bored would weaken an applicant's willingness to volunteer, but some preparators also see it as a sign of poor skill. Simpson said, "I would also ask people, 'Do you do things with your hands for fun? Do you paint, do you sew, do you build models like I did?' And if it was clear that they never did anything with their hands, well, people do what they're good at. They enjoy doing things they're good at." By assuming a link between skill and enjoyment, preparators use hobbies as an indicator of people's skills. Several preparators told me that people with preparation-like hobbies become more satisfied, motivated employees and volunteers. The volunteers I spoke with mentioned hobbies such as doing jigsaw puzzles (one volunteer makes his own), painting, drawing, making jewelry, and carpentry, all of which draw on manual precision and attention to detail. But I wonder if these hobbies are an effect of manual skill, as preparators imply, or rather a cause of it. Clearly, preparators' conception of manual skill as unlearnable shapes their chosen new recruits and thus their community.

Patience and Judgment as Skills

In addition to manual dexterity, preparators consider one personality trait to be necessary and unlearnable: patience. Marilyn, a volunteer at the Southern Museum, demonstrated preparators' characteristic patience when she told me that the fossil whale skull she was preparing was in hard, dense matrix that took a lot of work to remove. But she was not in a hurry, saying of the skull, "It's been around [for] sixty million years. It can wait a few more." Likewise, Kelly, a volunteer who searches matrix for microfossils (a task called microsorting) at the Northern Museum, said of her work, "It takes a lot of patience, and not everyone has patience." She considers it "a waste of time" to go too fast while microsorting: "The whole point is slow, careful, find everything. This isn't a race. It's not quantity, it's quality." Preparator Steve thinks patience is innate: "You can't teach patience to someone, because it's not in their psyche. . . . They're always going to be a restless soul. They're always going to be trying to rush it. [*parodying an impatient person*] 'I've got to see what the—ah, I've just chipped the edge off it.'" Being impatient is seen as a direct cause of poor work, such as overlooking microfossils or damaging specimens. The prep test is a chance for volunteers to decide whether they actually want to prepare fossils by trying it. Preparator Paul explained, "It all sounds exciting on paper to work on old dead things, but once you try it, it can suck. If you don't have patience, it can be a terrible thing to do [*laughs*]." Impatient volunteers can damage fossils and are likely to quit from boredom, thereby wasting employees' time to train them.

Preparators also name vision and visual practices as important skills; they consider the former innate and the latter learnable. One volunteer told me, "I flunked the prep test" due to poor vision in one eye. The staff agreed, blaming his damage to the test fossil on his lack of depth perception. (He was allowed to microsort instead, which doesn't require depth perception.) On the other hand, Bill described visual practices in terms of compliance rather than physiology:

> Sometimes I've seen students or people here using a [binocular] microscope and only using one eye. . . . So I'll tell them . . . if [researcher Frank] wants me to give that person a good fossil to work on, I'm going to advise [Frank]

that I've seen this person only using one eye through the microscope. I don't think they're trustworthy enough to work on something good. And that gives them a little kick-start into learning how to use the tools and the microscope in the proper fashion.

For Bill and many preparators, proper visual technique means using tools correctly. It also indicates a willingness to follow directions. Note that Bill invokes the *scientist's* dissatisfaction to motivate the learner; Bill's dissatisfaction, as a mere preparator, is somehow insufficient.

The ability to visually differentiate matrix and fossil bone—which preparators and volunteers refer to as having "the eye"—is a critical, difficult, and learnable skill, separate from three-dimensional vision and trustworthy visual practices (figure 2.2). When Northern Museum volunteer Keith was not sure if lumps on his specimen were matrix or bone, he asked preparator Amanda, who identified them at a glance as matrix. Then

Figure 2.2
A preparator points a pin vise tip at a small, triangle-shaped fossil reptile's jaw subtly protruding from a lump of rock. Only someone with "the eye" can spot this specimen.

76 *Chapter 2*

Keith said to me admiringly, "See, she's got the eye." He wasn't referring to Amanda's eyesight but rather her judgment. Ingold (2000, 354) argues that training functions not by teaching "formulae" or protocols but instead "by introducing novices into contexts which afford selected opportunities for perception and action, and by providing the scaffolding that enables them to make use of these affordances." Working with specimens, with guidance from experienced preparators, allows novices to learn to recognize the visual characteristics of fossil and matrix. Similarly, education researcher Philip Henning (1998, 116) found that refrigerator technicians diagnose mechanical problems based on "touchy-feely" sensory assessments of machines' temperature and sounds, which the technicians learn through experience and the advice of "old-timers" and other more experienced technicians (also see Orr 1996). Technicians' practiced sensory connection with objects, from refrigerators to fossils, matches Ingold's (2000, 354) claim that "practitioners' engagement with the material with which they work is an attentive environment, rather than a mere mechanical coupling." This sensorial engagement enables craft workers to use synesthetic reason and craft skill to embrace objects' variations and atypicality by altering their techniques to make the material comply with the workers' goals (Paxson 2012, chap. 5).

Besides manual skill and vision, preparators mention no requisite physical abilities. Most preparators sit at a counter or table to prepare, without moving much. This work suits the many volunteers who are past retirement age. Volunteers with bad backs often become microsorters to avoid lifting heavy specimens. But interestingly, I never heard preparators mention strength as a virtue, even though they regularly carry heavy specimens and tools. Despite the importance of manual skill, attributes of people's hands were not mentioned, unlike their eyes. Physical coordination is implicitly valued to prevent mishandling specimens, but many preparators I met are rather clumsy. They seem to step on others' feet, walk into furniture, and knock things over more frequently than the average person. One preparator was gently bending a plastic spoon during lunch, then accidentally snapped it and looked shocked. The ability to handle fragile fossils while being uncoordinated does not go unnoticed

by preparators themselves. One preparator described herself as clumsy and distractible. She thought that these traits made her a *better* preparator because she had to be aware that the clumsiness might "come out at any moment." This risk made her consciously vigilant when handling specimens. She considered this heightened awareness safer than being naturally coordinated.

Preparators prioritize manual dexterity, patience, and visual judgment over strength and coordination. Describing mainly cerebral versus physical abilities portrays preparation as skillful craft rather than brute strength. Preparation work can appear simple to nonpreparators, such as novices, researchers, institutional administrators, and the public. As a result, it is in preparators' interest to highlight the value of their skill and thus of themselves to their workplace through their criteria for their coworkers.

This lack of emphasis on physical traits may help explain the relatively minor difference in the numbers of men and women who are preparators. Fifty respondents to my survey were men (63 percent) and twenty-nine were women (37 percent). Of the thirty-one staff preparators I interviewed, nineteen were men and twelve were women. These numbers are not equal, but the lack of an even larger gender discrepancy in a scientific and technical field is unusual. For example, in 2010 only 20 percent of earth sciences faculty at the best 106 US graduate institutions were women (Currano, Marsh, and Vance 2014; Glass 2015; Pimiento 2016). In the nineteenth and twentieth centuries, women's contributions to science were largely dismissed as unimportant or illegitimate (e.g., Rossiter 1982; Oreskes 1996; Hartley and Tansey 2014). Preparators' more balanced gender ratio, however, suggests that gender discrimination is not a primary cause of their invisibility in scientists' publications. Fossil preparation aligns with traditionally "masculine" work in that it is dirty, manual, and involves tools and science. Yet it also relies on "feminine" attributes, such as fine-motor skills, patience, and appreciation for aesthetics (e.g., Traweek 1988; Faulkner 2007), which may encourage more women to try it. It's possible these stereotyped preferences cancel each other out numerically, resulting in more equal gender representation among preparators than in many kinds of scientific work.

LEARNING SKILLS AND SOCIAL ROLES

Skills for Staff

Hiring a preparator involves committing more time and money than accepting a volunteer, and also bestows the new employee with more power over the community. Yet the selection priorities are largely the same. The primary difference is that preparators highly value experience for staff positions and compliance for volunteer positions. Of the thirty-four preparator job openings advertised on the PrepList from 2010 to 2016, thirty (88 percent) required experience in tasks such as matrix removal, molding and casting, collection management, fieldwork, and fossil conservation. Four postings specified experience as "preferred" but not required. (Experience is generally assessed based on the amount of time the applicant has worked with fossils as an employee, volunteer, or amateur.) Despite this trend, preparator Mary lamented that experience is not always a factor in hiring: "There's still jobs that . . . want somebody to . . . be a preparator, but they want them to have a degree in geology or biology, and they don't really ask for experience in preparation." Mary, like many preparators, considers it a mistake to value an academic degree over preparation experience.

Some preparators are frustrated by the lack of consensus around what preparators should be able to do and thus who can be a preparator. Other groups' skills and membership are informed by guidelines set by professional societies. Preparators participate in scientists' main conference, SVP (which includes a Preparators' Committee and a Preparators' Session of talks; see Preparators' Resources 2020), and in 2014 created their own professional society, the Association for Materials and Methods in Paleontology ("About Us" 2014). But neither group credentials preparators or standardizes techniques. To address this gap, in 2012 a group of preparators led by Brown wrote a list of "essential competencies" for their community, which they posted on the SVP website (Brown et al. 2012). They modeled their list after the American Institute for Conservation's report about conservators' "essential competencies" (Perkinson et al. 2003), which was an approach Brown (2009) had long advocated for. The conservators' list includes specific academic degrees and technical protocols, while the preparators' list

is more open, focusing on general characteristics that preparators should have, such as "critical thinking" along with an "understanding" of fossils, tools, materials, conservation, and fieldwork. It also includes aspirational practices that the authors would like to become more widespread, such as "the preparator keeps records of all tools, techniques, and materials used to prepare or house the specimen" (Brown et al. 2012). This is not the current reality, but it mirrors conservators' dedicated documentation procedures that the list's authors admire. This document doesn't seem to have had much official impact (e.g., no job ads refer to it as guidance for applicants' skills), but it articulates the vision that one group of preparators have for themselves and their community.

In my early interviews, preparators mentioned seven general factors as relevant for job applicants. I then asked survey respondents to rank those seven factors (table 2.1). Sixty-seven respondents ranked skill, experience, and potential to learn as high-priority criteria, while formal training, interest in fossils, and meeting deadlines were lower priority.

Skill was ranked most important, and is arguably a combination of the next two most valued traits: experience and learning potential. The close rankings of experience and learning potential suggest that preparators value novices who can learn well in the lab as much as they value applicants who have prepared fossils before. One preparator, who was hired without experience, told me that hiring novices is preferable because the staff gets to control their training. Ironically, this preparator's boss told me separately

Table 2.1

	Technical skill	Preparation experience	Potential for learning or improving skills	Personality and how they get along with coworkers	Formal training in preparation	Interest in fossils	Ability to meet deadlines	Other
Average	1.7	3.0	3.1	4.5	5.4	5.4	6.0	6.8
Median	1.0	3.0	3.0	4.0	6.0	6.0	6.0	8.0
Mode	1.0	2.0	3.0	4.0	7.0	7.0	7.0	8.0

Note: Responses to survey question, "If you were hiring a preparator, what qualities would you consider most important in a candidate? Please rank the following options [top row of table 2.1], with 1 meaning 'most important.'"

that this inexperienced employee was "not working out" and would soon be fired, indicating that hiring inexperienced people is also risky. The crucial factor for preparators seems to be skill, or at least potential skill, with less concern for how it is acquired.

Volunteers are expected to have the same basic abilities as staff preparators, plus attentive instruction following. Archaeologists protect against volunteers' inexperience through highly standardized fieldwork practices: "Although there were a variety of different people with a range of skills and perspectives, their actions were made to be in certain respects the same. By erasing certain differences between people, these site conventions made it possible to elicit objectivity in the various finds" (Yarrow 2006, 24). Volunteer preparators don't follow standard "actions" because there are none. Instead, to ensure the reliability—or "objectivity"—of specimens prepared by volunteers, preparators direct and supervise volunteers closely.

As a result, preparators train volunteers to ask for help rather than make decisions. Leah, a volunteer at the Northern Museum, said, "You learn when to stop and ask questions" of the staff, such as "which tools, which adhesives, what to do next, what to look for." Preparator Marc emphasized the significance of teaching novices to ask for help: "One of the best things that you can do is know when to stop. See when you're getting into trouble and stop . . . [and] come to us for advice, because we'd way rather see you have a successful experience, an enjoyable experience preparing a fossil, rather than a frustrating one because something stops working. Because that will drive you crazy." Teaching volunteers to rely on employees is intended to keep them calm and happy, while also protecting specimens from inexperienced, potentially destructive preparation. Interestingly, Barley and colleagues' (2016, 141) study of multiple kinds of technicians found an opposite trend: "Although all technicians agreed that neophytes were expected to display a modest amount of hesitation or self-doubt, technicians expected an air of determination gradually to replace tentative behavior as newcomers perfected their skills and knowledge." Performing confidence in their work is important to technicians' identities, according to Barley and colleagues. Perhaps this is why staff preparators expect volunteers never to lose their tentative approach, which could be

a threat to the employees' status. Instead, employees expect volunteers to always act like novices by asking for help instead of trying to creatively problem solve (chapter 1). By training volunteers to prepare evidence but not techniques, preparators defend their own power domain.

Staff preparators view self-assessment, such as recognizing when to ask for guidance, as a crucial component of volunteers' skills and trustworthiness. Paul said his volunteers know when a specimen is too difficult: "If they get something too delicate they say, '[Paul], this one's for you.'" Similarly, Barry, a volunteer at the Northern Museum, wondered if he should realign the pieces of a geologically crushed vertebra by breaking them apart and then gluing them where they would have been in life. He said that when he finishes removing matrix from the vertebra, "that's when I'll ask the powers that be what they want me to do" about reconstructing it. In Barry's case, he was not unsure of his skills or abilities but instead unsure of what the staff—the powers that be—wanted the specimen to look like (i.e., crushed or reconstructed). Thus an important component of training novices is teaching them the boundaries of their power and the hierarchy of decision makers in their community.

Preparators also expect volunteers to commit to working in the lab so that the investment in training will pay off in volunteer-prepared fossils. Max said working with volunteers is "one of the joys of [my job], actually. Particularly when you get somebody who's really committed and stays on." Gary also appreciates volunteers who put in the time to improve: "We have a small corps of volunteers who have been with us for several years, and they're very valuable to us because they're skilled enough now that they can be assigned a job and left alone, pretty much." Even though volunteers are taught to *not* make decisions, they are arguably most useful to employees and institutions when they have gained enough skill and trustworthiness to work with less supervision. Preparators' different expectations for employees and volunteers help to prepare the community's social order.

Training in Action

Like staff preparators, volunteers must be trained and socialized as active participants in the lab's community of practice. Unlike employees who

learn on the job, volunteers are occasionally trained en masse. Training varies in structure from brief instructions followed by independent work with periodic check-ins to a few rare multiday courses. Though unusual, training programs' design and content show how preparators prepare their community by enculturating new members. Strikingly, volunteers are taught to prepare evidence through constitutive cleaning and specifically *not* to prepare techniques.

Training novices includes demonstration, explanation, and learning by doing. Vanessa, a preparator and conservator, trains volunteers to build storage containers for fossil fish: "I give them a crash course in how you handle a specimen, how you handle notes . . . how the finished product should look. . . . I show them and work with them on how to do everything. . . . But every tray, every specimen, is a little bit different, so you're constantly adjusting as you go." Adapting practices to variations in objects is a crucial component of preparing evidence. By working alongside volunteers, Vanessa guides their work so that they learn her techniques and acceptable alterations to them. Working with them also allows Vanessa to supervise their work closely, and keep them from straying into unapproved techniques or innovations. She builds relationships with them as well, such as by labeling the "strange fish drawer" and "sparkly fish" specimens to "make the volunteers laugh" and "keep them interested" in the project. At the Northern Museum, volunteers and employees also work side by side. Amanda recognizes the advantages and disadvantages of this system in that it is difficult to schedule enough employees to work alongside volunteers in the museum's two labs, but it is valuable that volunteers can easily ask the staff questions. Implicitly, it also makes it easier for the staff to supervise volunteers. Preparator Amanda prefers this arrangement over the Southern Museum's, which she had recently visited and where staff preparators work in a separate wing and volunteers have to telephone them to ask questions. Most preparators share her concern about leaving volunteers without supervision or easy access to help.

Preparators typically train novices by guiding them through the work on a particular specimen from start to finish. This approach encourages novices' commitment to that fossil, allows continuity of preparation, and

enables novices to learn all the steps of preparation, from opening field jackets to painting specimen numbers on finished fossils. It also means novices' ongoing learning requires employees' supervision and advice. For example, preparator Carla gave volunteer Maddie specific feedback on the fossil fish she was preparing: "I like right here where you've kept the scales on." When Tim was learning to prepare on the job as a staff preparator at a university lab, he remembers receiving detailed feedback on his first specimens: "[Another preparator] said, 'You've gotta do a little bit better job,' because I was going over [the fossils] so fast I wasn't really getting all of the sand. . . . I had to go back over quite a few of them to get them to the state where we could actually properly mold them and cast them and have them be nice clean fossils." Feedback helps novices learn to identify good versus bad work. These values are not obvious or codified, so understanding them is a crucial part of belonging to the community of practice. Furthermore, explaining these values to novices helps experienced practitioners recognize and reflect on their community's usually tacit beliefs and priorities.

Many of these values and techniques were articulated in a training program for twenty-nine volunteer preparators run by the Smithsonian National Museum of Natural History's Paleobiology Department in 2008. Preparator Steve Jabo and volunteer Abby Telfer organized the program and hired four other preparators as instructors. They later wrote at least one conference talk and two publications about the program in hopes that it could serve as a model for other labs (Jabo 2009; Brown et al. 2010; Jabo et al. 2010). The program's goal was "stocking the fishbowl"—that is, recruiting and training volunteers to prepare fossils in FossiLab, the museum's newly reopened glass-walled exhibit lab (Jabo 2009). The program was a six-day course on preparation along with a five-day course on molding and casting. This program demonstrates how preparators prepare their community by preparing future practitioners.

The instructors' priorities for selecting trainees were broader than the skill-focused prep test: "To gauge people's realistic commitment to the job, whether or not they had reasonable personalities, and whether or not

they were going to be physically capable of doing the work" (Jabo et al. 2010, 173). The first step was an online application, of which one section asked the applicants to self-assess on a list of abilities and personality traits, from good vision and ability to sit or stand for a long time, to "patient, careful, observant" and "willing to take direction" (Jabo et al. 2010, 171, appendix 1). The applicants were also asked about their hobbies, mirroring Simpson's approach, because "volunteers who enjoy preparing fossils tend, also, to engage in leisure activities requiring patience and planning, such as bridge or chess, or requiring close attention to visual cues, such as solving jigsaw puzzles . . . or involving intense and sustained appreciation of nature, such as hiking, bird watching, or collecting natural history specimens" (Jabo et al. 2010, 171, appendix 1). The instructors drew these indicators from their own and their coworkers' characteristics. Science and education featured in the application too, in questions about academic degrees and "please describe briefly how you learn about science and nature, and what topics interest you the most" (Jabo et al. 2010, appendix 1). The applicants were then interviewed, primarily as an opportunity for them to visit the lab and meet the staff. The staff rejected 30 percent of the applicants.

The 29 selected trainees were taught to be useful for that specific community by learning tasks suited to local researchers' projects and the museum's collection, such as preparing fossilized plants as well as animals, sorting microfossils, molding and casting, and building storage jackets (Brown et al. 2010, 181). Each topic included a lecture, demonstration, and "hands-on" practice (table 2.2).

The volunteers practiced each technique with explicit directions. For example, "instructors drew instructions on the matrix with a marker directing students to work within a certain area, with arrows indicating in which direction preparation will be most effective, and estimates of approximately how much time they should spend in a given area based on their skill level" (Brown et al. 2010, 181). Trainers thus left little for volunteers to decide or figure out through trial and error, encouraging them instead to concentrate on handling tools, removing matrix, and not

Table 2.2

Day 1	Lecture: Who are we? What is paleontology? What is preparation?
	Lecture: Lab safety and lab orientation, lab ethics/manners
	Lecture: Specimen handling
	Lecture: Documentation
	Lecture: Problem solving in the lab
	Demonstration/Hands-on: Opening field jackets
Day 2	Tour: Collections and basement with emphasis on preparation/conservation
	Demonstration: Intro to preparation with airscribe
Day 3	Lecture: Adhesive and consolidant basics, how to mix, how to apply
	Demonstration/Hands-on: Practice with airscribes, use of pin-vice and picks
Day 4	Hands-on: More practice with airscribes
	Hands-on: Use of pin-vice and picks
	Demonstration: Temporary jackets and stabilizers
	Demonstration/hands-on: Sediment washing and microfossil sorting
	Hands-on: Practice with pin-vice and picks
Day 5	Demonstration: Creating padded plaster jackets
	Hands-on: Specimen prep
Day 6	Tour/lecture: Basic vertebrate anatomy, why do you need to know it?
	Conclusion: Practicum/evaluation

Note: The curriculum for a training program for volunteer preparators includes explanation, demonstration, and "hands-on" practice. *Source*: Brown et al. 2010, 180.

damaging fossils. Marking matrix also taught volunteers to follow directions, as it was immediately clear to the staff if volunteers did not remove the matrix as directed. I have seen preparators in other labs use this technique with novices too. The program mirrored the typical ways of selecting and training novices, just scaled up and formalized to serve many learners at once.

The instructors valued explaining the rationale behind the techniques as well as how to conduct them. They thought it was important, for instance, that "students see that the lab is using Butvar B-76 as an adhesive not because there is a 50-year supply in the basement, but because it fits within a universal standard in the field" (Brown et al. 2010, 184). They presented the glue as the best option and not just the convenient one because they consider it important to justify all techniques (chapter 1). Also, this adhesive is not actually "universal" or a "standard." Instead, these

preparators believe that it *should* be a universal standard in fossil preparation because it is better for specimen conservation. Hence the instructors taught the learners according to how they want the field to become, not necessarily the status quo. Teaching to a desired future exemplifies how training prepares a community.

For instructors, the intended "core messages" of the training program were: "preparators take their work seriously; the techniques, materials, and methods used have a basis in scientific methodology; preparators respect the specimens and the conservation ethic" (Brown et al. 2010, 184). Promoting these messages to volunteers "demonstrates the institution's commitment to high quality fossil preparation" (Brown et al. 2010, 184), while simultaneously constructing a concept of what high-quality preparation means and producing volunteers who follow that ideal. Communicating practical skills and techniques as well as ideal visions of the work and the workers is a crucial component of preparing communities.

The program succeeded in the goal of providing volunteers—stocking the fishbowl—for glass-walled FossiLab: "Twenty months after the training, 62% of the trained volunteers are still working in FossiLab. . . . Anecdotally, this is a better retention rate than has been previously encountered by the VP [Vertebrate Paleontology] Lab" (Jabo et al. 2010, 175). Thanks to the program, more fossils were being prepared by trained preparators without pay in an exhibit for the public. To continue this success, instructors encouraged community building: "Productive volunteers must feel that they are doing 'real' work, that they are part of the larger mission of the institution, and that the institution cares about them. Face-to-face time with the permanent staff is the best way to convey this" (Jabo et al. 2010, 175). Studies find a clear correlation between volunteer-staff relations and volunteer commitment and retention (e.g., Bussell and Forbes 2002, 250–251). This training program's focus on skill development, justified techniques, and social inclusion reflects preparators' typical situated learning. It strives to convey the skills, knowledge, and behavior valued by the community of preparators, while also training workers to embrace ideals that the instructors want to promote more widely.

THE ROLE OF VOLUNTEERS IN A COMMUNITY OF PRACTICE

Why Host Volunteers?

Why do institutions bother to recruit, test, train, and supervise volunteer preparators when so many skills are required? Staff members answer this question both financially, in that volunteer labor saves salary costs, and in terms of institutional goals, by viewing volunteers as recipients of public outreach and education efforts. For my purposes, volunteers serve as a counterexample to technicians. Specifically, volunteers prepare evidence by constitutively cleaning fossils, but employees actively discourage them from innovating, tinkering, or applying craft judgment to choose or design techniques. Preparing techniques is the fiercely defended domain of staff preparators. In some contexts, volunteers do control their techniques, such as citizen scientists who pioneer new ways to collect or organize data (e.g., environmental monitoring methods [Ottinger 2013] and community-based clinical drug trials [Epstein 1998]). But generally, staff members enforce research volunteers' compliance and limit their creativity, perhaps because employees are responsible for volunteers' work. How employees enact this distinction is an example of how they prepare their community.

Most museum volunteers' work is relatively unskilled, such as staffing information desks, giving tours, or doing collection management work like data entry. In comparison, volunteer preparators undergo long-term, though informal, training. Many fossil labs have far more volunteers than staff members, such as the Denver Museum of Nature and Science's 125 volunteers and 3 staff preparators in September 2011 ("Earth Sciences Labs" 2020). Of the fourteen labs I visited, twelve hosted volunteers. (Another has since launched a volunteer program.) Preparator Carla explained that "it's a team effort" of volunteers working alongside the staff members. As a result, employees view volunteer preparators more like collaborators than they do other kinds of volunteers. Luckily, paleontology is popular and many potential volunteers request to work with fossils, providing a large pool for employees to select from.

Many fossil labs host volunteers for financial reasons. Conservator Carter said of volunteers, "What's now driving our research preparation

program is to actually bring people in and train people up. We will never have enough staff to do it ourselves." According to Luke, a researcher at the Northern Museum, volunteers make it possible for the museum to achieve much more than it can pay for: "We depend on the volunteers. I think we have about 1,100 of them [in the museum]. . . . We couldn't afford to replace all that. We would just be doing a lot less without them." To quantify volunteers' labor, let's consider the Southern Museum's paleontology department. As reported in a departmental staff meeting that I attended in October 2010, the department logged 10,366 volunteer hours in 2009. That equals 5.2 person-years, meaning the hours worked by about five full-time workers in a year.[4] This enormous number includes volunteers who give tours, talk to visitors in the galleries, conserve and organize fossils in the collection, update the collection database, contribute to various research projects, and more. But this number is actually incomplete; it omits the hours worked by volunteers in the museum's glass-walled preparation lab. According to the lab coordinator, those volunteers alone contributed 3,775 hours—almost 2 person-years—in 2009. The exhibit lab volunteers' hours were also increasing; they had already logged 3,373 hours in just the first ten months of 2010. The department chair explained that 2011 budget predictions were not good; as a result, he emphasized supporting and growing the volunteer workforce to compensate for the reduced funding.

Volunteers are not, of course, entirely free labor; they consume a considerable amount of staff time. Preparator Jay told me that volunteers are "nice people" and the department relies on their work, but that they are "a time sink" for him in that he spends a lot of his workday supervising them. For that reason, Max only allows a few volunteers in his lab: "I don't like having a lot of trainees under me because I like to prepare fossils myself. [*laughs*] And I don't really want to spend my whole day advising other people and looking over people's shoulders." As studies show, thinking of volunteering in terms of cost-benefit analysis for both volunteers and institutions reveals each group's needs and goals, such as enjoyable work, a supportive community for volunteers, and reliable, productive volunteers for institutions (e.g., Bussell and Forbes 2002, 246; Handy and Srinivasan

2004; Edwards and Graham 2006, 21; Handy and Brudney 2007). Deciding to volunteer and deciding to host volunteers are also complicated decisions that involve more factors than cost-benefit analysis can capture. Significant but difficult-to-measure factors include benefits to institutions from building a corps of local supporters, benefits to the health and happiness of volunteers, and altruism by volunteers as well as institutions.

For skilled work, volunteers' output rarely equals the cost of employees' time investment in training them. Seeking free labor therefore can't entirely explain why institutions host these volunteers. Another explanation is to perceive volunteers as participants in institutions' missions of education and public service. Preparator Gary explained, "We really consider volunteers more of a public outreach aspect, of developing museum friends. . . . We certainly respect their work and appreciate it, but it's not something that adds to our productivity." Volunteer programs are thus one way for institutions to fulfill their "social responsibility" to provide education, community, and skill development for the public (Edwards 2007b). In this view, the output of fossil labs broadens beyond prepared specimens to include community members who appreciate science and museums.

Volunteer preparators' roles also depend on the institutional context. According to Linda, a former preparator at the Northern Museum, volunteers at first had contributed primarily to public displays by staffing the glass-walled exhibit lab. She explained, "The specimens [that the volunteers] are given to work on, they're not critical specimens. So their role seems to be to do the work that isn't otherwise going to get done" while providing a tableau for visitors to watch, "so it looks like there's a lot of work going on" in the glass-walled lab. Preparing less scientifically significant fossils to give the public something to see is more of an educational and display-oriented role than the research role that staff preparators have. But after the museum reduced the number of staff preparators from five to two, Linda noticed that volunteers began preparing more scientifically valuable specimens. She said, "The volunteers themselves seem more important now because there are so few paid preparators." The complex and dynamic nature of this institution's context is evident in the roles of volunteers as demonstrators for the public and/or as preparators for researchers.

Why Volunteer?

Volunteers, as the majority of preparation learners and an important source of future staff preparators, illustrate how practitioners' motivations and identities help prepare their community. So what is it like to be a volunteer preparator? Despite their unusually skilled work, volunteer preparators' motivations largely align with those of other kinds of volunteers, such as by justifying their volunteering as educational, fun, social, and supportive of a worthy cause (Wilson 2000; Bussell and Forbes 2002; Boraas 2003; Mutchler, Burr, and Caro 2003; Edwards and Graham 2006; Grazian 2015, 108–114).[5]

Studies show that many volunteers pursue volunteering to develop career skills or job opportunities (Bussell and Forbes 2002, 249). Motivations of learning and career goals are also evident in Deborah Edwards's (2005, 5) survey study of 641 volunteers in a history museum, an art gallery, and a science museum in Australia. Of Edwards' respondents, 74 percent wanted to gain new skills by volunteering and 23 percent specifically wanted to gain work skills. Preparator Claire noticed that the number of volunteers rises when the national economy worsens as people try to add to their work experience when jobs are scarce. Yet a review of studies of volunteers found that "reliable social science evidence to support the idea that volunteering actually helps people find jobs, or improves the quality of those jobs, is scarce" (Wilson 2000, 232). It's possible that doing the relatively unskilled work that is typical of volunteering doesn't develop or demonstrate valued professional skills. This finding might also reflect that while volunteering can lead to a career in some fields, so few jobs exist in these fields that few volunteers are actually hired even though many of the staff were once volunteers. For example, zookeepers are expected to spend significant time in unpaid internships before they are hired, creating a career-oriented focus for some zoo volunteers (Grazian 2015, 87–88). Like preparators, there are far more zoo volunteers than zookeeper jobs. So only a small percentage of volunteers are realistically striving for a career in these fields, even though most current practitioners began as volunteers.

Many volunteer preparators talk about their work as meaningful because it serves the museum and science in general, but they don't

consider their work or themselves to be part of research. Some volunteers want to lessen the strain on staff preparators by producing fossils for them, some enjoy educating the public about preparation by working in glass-walled labs, and many value contributing well-prepared fossils to the museum's collection. The next logical step of why fossils and collections are important is that they enable research, but volunteers rarely extrapolate from their work to scientists' work. They seem to see the two as only indirectly connected. Keith, for instance, thinks the department is full of "good people who are actively doing stuff that's going to further the world of knowledge, and I'm along for the ride." He does not consider himself an active participant in knowledge production. Larry explained that while "science at the surface level interests me," such as identifying fossil species, he is not interested in doing fossil research, and noted, "That's why I'm not a paleontologist!" Volunteers tend to be more interested in their own learning than in producing knowledge through research.

Some volunteers are driven by an interest in fossils, sometimes obsessively. Like many volunteers (and other research workers), Barry's fascination with fossils began as a child. As for volunteering in the lab, "I love it. It's the highlight of my week." Milton echoed a widespread response when he told me in a serious tone, "Why do I volunteer? Because they won't pay me." Two of his fellow volunteers, Jack and Vince, agreed, saying respectively, "I answered a call for dinosaurs" and "A fossil lab? [*raises hand*]" They made it sound like an obvious answer. Many volunteers' reactions implied, "why wouldn't I volunteer?" as though it is too good to be true that they get to prepare fossils. Similarly, an ethnographic study of computer technicians found that they, like many volunteer and staff preparators, often describe their "love" of their work and "amazement that people would pay them to pursue something they loved" (Zabusky and Barley 1996, 197–198).

Love, though, does not necessarily make people good volunteers or preparators. Staff preparator Marc found that some volunteers can be "very, very enthusiastic, but they don't really have a good skill set and they're very slow to develop, and so you keep them on the ribs and whatever, and sometimes even that's kind of scary [*laughs*]." If Marc does not trust volunteers' skills, despite their enthusiasm, he has them work only on ribs,

as sturdy, predictably shaped bones that are relatively uninformative for researchers. Carla once rejected a potential volunteer because he failed the prep test—he "annihilated" the fish fossil, she said, aghast—and because he was "a fossil geek" who just wanted to be around fossils on a fanatic level, "because they have magical powers," Carla scoffed. "I don't want people like that around" the lab, she said, meaning those who volunteer for what she considers the wrong reasons. Preparators deride such passionate volunteers as "fossil geeks," even though "fossil geek" can also be used affectionately. Some employees even self-identify as fossil geeks. Zookeepers scorn "bunny huggers" for the same reasons, as eager potential volunteers who focus on their own interest in animals more than on the animals' well-being (Grazian 2015, 231–235). Zookeepers consider bunny huggers to be overly emotional and uninformed about animal care, and they often refuse volunteer applications on these grounds.

The social aspects of volunteering can be as important to volunteers as the actual tasks. Many value spending time with people who share their interests. While chatting with other volunteers about geology and fossils, Ted said to me, "This is why we're volunteers, so we can talk about rocks." Kelly finds her microsorting work "fun . . . when you're working with other people and trying to figure out what you're finding," thus combining socializing and learning. Volunteers frequently take breaks together. Staff also recognize the significance of community for volunteers. Carla said that she and coworker Amanda try to make the lab "inviting, educational, interesting, [and] convivial" for the volunteers to "make them feel like part of the team" along with the staff. Ways to do that include, she said, "giving them important specimens to prepare, giving good feedback," and encouraging them to ask questions.

But community is rarely volunteer preparators' primary motivation. Rather, they tend to enjoy preparation as a solitary, all-consuming task. For example, lab manager Amber suspects that Alison, a mother of three, likes to volunteer because the lab is quiet and has no distractions, unlike Alison's home. Sometimes when I spoke to volunteers in the lab, they wouldn't look up from their fossils or would turn on a noisy tool that prevented conversation. These gentle dismissals demonstrate their commitment to their

work (while also usefully suggesting that my presence did not significantly alter their behavior). Volunteers are usually keen to discuss their work with an interested listener (e.g., each other, the staff, or me), but they do not allow these conversations to interfere with their main reason for being in the lab: preparing fossils. Thus volunteers adopt and reinforce the social norms of the preparator community by valuing learning, careful work, and like-minded fellow practitioners, even though volunteers are permanently relegated to the periphery of that community. How preparators achieve that relegation is a mechanism of preparing their community.

PREPARING SOCIAL ORDER

How Staff Prepare Specimens

How do staff avoid being replaced by the skilled, unpaid workers they train? In other areas of volunteering, such as hospital work, there is a clear division of labor between staff and volunteers that is largely based on which tasks require credentials (Handy and Srinivasan 2004, 50–51). Without credentials, volunteer and staff preparators have to construct this division of labor locally and repeatedly. They employ concepts of "simple," "easy," "difficult," and "complicated" to differentiate between the appropriate fossils, tasks, and tools for volunteers versus for the staff, thereby distinguishing two levels of skill and status. The crucial difference lies in the autonomy to choose and design methods, which staff preparators claim for themselves and forbid for volunteers (Wylie 2015, 49–51).

Preparators perceive their work as divisible into two levels of skill. Anne believes that the simpler parts of preparation should be learned by anyone who handles fossils, including volunteers and researchers, "to at least know . . . how to piece together a specimen themselves with an archival adhesive, basic techniques, and basic understanding of good preparation and conservation principles." Of course, even this supposedly baseline work requires skill and alters specimens by preparing them to be evidence. The instructors of the National Museum of Natural History's volunteer training program were trying to teach that level: "Creating

Master Preparators was well beyond the scope of this programme, rather, providing a consistent knowledge base among the volunteer pool and teaching them when and how to ask questions was the goal" (Brown et al. 2010, 180). They don't specify what master preparators know or do, but it is somehow different from what they were teaching volunteers. Preparator Olivia describes preparation as "basically just being patient" and "not a difficult thing to learn"; however, "it's extremely difficult to excel in prep," such as "to get very creative in prep." She differentiates between "simple" tasks and those that require a "creative" or "artistic" approach, such as specially tailored techniques and tools (chapters 1 and 3).

These conceptions of "basic" and "complex" preparation influence and are influenced by who does the work—volunteers or the staff. Preston, a researcher at the Northern Museum, told volunteer Keith about a dinosaur skeleton he had recently collected that might represent a new species and had been preserved in hard, dense matrix. Keith responded sarcastically, "Glad to hear that the rock's really hard!" meaning that it would be difficult to prepare. Preston smiled and said, "That's why I'm saving it for [Amanda]," a staff preparator. Preston had already decided that a staff preparator—not a volunteer—would prepare this challenging and scientifically significant dinosaur, reflecting the widespread assumption that volunteers are less skilled than employees. The crucial difference in their skills, I argue, is whether they are permitted to prepare techniques by tailoring their approach to each specimen. Henry, a researcher at the Southern Museum, also distinguishes between volunteer and staff preparators' skills when assigning his unprepared fossils: "Most of my stuff is smaller so it requires really specialized skills, and I wouldn't entrust it to just anyone. If we get big things, then some of the preliminary work somebody [a volunteer] can do under the supervision of one of our regular technicians." This distinction in skill and supervisory power preserves staff preparators' higher status and arguably protects them from being replaced with a volunteer workforce—a problem faced by other kinds of workers. In some cases, workers' fear of job loss has led to union contracts protecting paid positions from volunteer replacement (Pimm and Wilson 1996; Macduff 1997; Zahnd 1997; Handy and Brudney 2007). Preparators

don't express this concern, perhaps because researchers expect the staff, not volunteers, to prepare their most important fossils.

How Volunteers Prepare Specimens

Workers use specimens to articulate their social order, particularly the distinction between staff and volunteer preparators. Some specimens—especially small, difficult, and important ones—are reserved for staff preparators, while others—for example, "simple" fossils, Henry's big things and preliminary work, and microsorting—are set aside for volunteers. Researcher Maurice considers sorting his microfossils to be a volunteer-appropriate task: "Almost anybody can do it if you're careful." Amanda said that often she prepares a specimen until it's "easy enough for a volunteer to do . . . because it's a waste of *my* time" to prepare more straightforward areas, such as smooth bone surfaces. For instance, to economize her paid time and greater skill, Amanda delegated part of one skeleton to a volunteer: "I really shouldn't be working on the tail; it's a really simple shape." The specimens in preparator Gary's lab require only one skill level: advanced. He explained, "We don't have a lot of semiskilled prep work, you know, not a lot of concentrate picking [microsorting]." As a result, the lab hosts only a few volunteers. Gary expressed this distinction between staff- and volunteer-appropriate work in terms of the lab's overall productivity:

> Most of the stuff that we have, within ten minutes of beginning the preparation on the thing you're at a point where there are decisions you have to make . . . that can really impact the research value of that specimen. Very critical, critical preparation. And as soon as a volunteer comes up with something like that, you're over there working with them and you're not getting your work done.

Decisions, then, are the boundary of volunteers' work. Even with appropriate skills to remove matrix and repair breaks, volunteers are not trusted to make choices about altering a specimen's appearance. Whether they might be capable of this judgment is irrelevant; preparators don't permit volunteers to stray beyond their instructions. Though volunteers and staff frequently work side by side on seemingly similar tasks,

researchers and staff identify a clear distinction in their skills and right to make decisions.

Staff preparators and researchers typically decide whether a specimen is volunteer friendly. For instance, preparator Kevin suggested to preparator George that they give "the little rhino skeleton" to a volunteer to prepare. George agreed because "it's easy, it's in soft matrix" that will come off the bone without much specialized work. At the Northern Museum, preparators Amanda and Carla looked through a list of unprepared specimens to find an appropriate one for a newly arrived volunteer:

> **Carla**: Maybe we should start her on that [*pointing to a bone labeled "indeterminate"*].
> **Amanda**: Yeah? Easier shape, you think?
> **Carla**: Yeah.
> **Amanda**: Maybe [it's] a neural spine. Yeah, that'd be fine.

An easier shape, usually meaning simple and straight, is less liable to surprise or confuse a volunteer and provoke damage. Most preparators also take volunteers' preferences into account to "make people happy" with their projects, as Amanda put it, as well as capable of doing them well. For that reason, preparator Brad and his coworkers find it difficult to fire poorly performing volunteers because "we're too nice." He reasoned that if these volunteers are preparing "a big enough bone with soft enough rock, they're not really going to hurt it." Assigning appropriate fossils can compensate for volunteers' (lack of) skill, to some extent. Likewise, Mary limits volunteers' tools to protect specimens: "I only let a couple of them use the Chicago pneumatic [air scribe] . . . because it's a little too brutal, and if you don't really know what you're doing, then you might totally destroy things." This perception of volunteers as somewhat risky and unpredictable is common. It may further justify preparators' refusal to let even skilled volunteers make decisions beyond constitutive cleaning.

When deciding which fossils to assign to which volunteer, staff preparators prioritize volunteers' skill over their longevity in the lab. Favoring "expertise rather than experience or seniority," as preparator Brad put it, is common among technicians (Zabusky and Barley 1996, 201). One

volunteer, for example, started learning how to prepare small fossils under a microscope and "got it" as if he'd been doing it forever. Brad said, "He just had the touch, the touch of an artist." As a result, he "gets the primo fossils" to prepare, despite his recent arrival in the lab. Note that even this talented volunteer remained under Brad's supervision and direction; skill is not sufficient to prepare techniques, which requires staff status. This distinction between the staff and volunteers delineates tasks that only staff preparators can do—specifically, prepare challenging and important fossils, assign fossils to others, supervise volunteers, and choose and design techniques—and thus cements their role as an irreplaceable part of the lab, institution, and research.

CONCLUSION: LEARNING TO BE A COMMUNITY

By working together to develop skills, define social order, and initiate future practitioners, individuals unite themselves into a community of practice. Technicians can prepare their communities in a variety of ways, from requiring formal science training to welcoming diverse backgrounds. In general, though, all skilled communities, including scientific ones, encourage learning as a way to unify a group. By learning from each other and their materials, and sharing their knowledge with each other, technicians establish hierarchy as well as shared values and practices. This focus on ongoing learning, no matter one's level of experience or skill, can help a community stay dynamic, flexible, and creative.

How preparators train each other demonstrates the core skills and values that underlie their work and identity. Specifically, preparators want new members of their community to have manual skill and patience, which they assume cannot be learned but can be improved with practice. They believe a good volunteer preparator should follow directions, and a good staff preparator should train novices, select and adapt techniques, and prepare difficult fossils. Volunteer and staff preparators, like scientists and craft workers, learn skills, techniques, and social norms by working with supervision in a community of practice. Many staff members first learned to prepare as volunteers. Why then do staff preparators denote themselves

as decision makers and volunteers as decision followers, regardless of individuals' skill or experience? This distinction points to the primary mechanisms of preparing a community: continuous learning through interactions with people and objects, and ongoing negotiations of identity and social order. Therefore the highest power in a community of practice is training others to apply your techniques and follow your social norms, as staff preparators do.

One explanation for the strenuous boundary work that preparators do to separate themselves from volunteers could be preparators' lack of formal training. On paper, their primary qualification is years of preparation experience, which can be similar for the staff and volunteers. Sociologists Peter Whalley and Stephen Barley (1997, 40) argue that "conscious attempts to construct skilled identities should be most common among technicians involved in occupationalizing amateur work" to ward off perceptions of their jobs as unworthy of paid status. To mark their professional claim to preparation over volunteers, preparators refer to two levels of tasks and associated skills, which are defined by the specimens and tools that they consider suitable for volunteers versus the staff. Although staff preparators bear responsibility for specimens and are (usually) more skilled and experienced than volunteers, the key distinction is that only staff preparators may select and adapt techniques. This approach is apparently succeeding because preparators do not express any fear of their jobs being replaced by volunteers' unpaid labor. For example, Max is impressed by and proud of his volunteers' skill, not jealous or worried about it: "Some of them are better preparators than some of the professionals that I know [*laughs*]." The next chapter investigates staff preparators' distinctive power and skill of preparing technologies.

3 PREPARING TECHNOLOGIES

Fossil preparators see all objects as potential tools. They are proud tinkerers, bricoleurs, recyclers, and sometimes dumpster divers. Most of the labs I visited happily accept donated tools, such as dentists' cast-off drills and scrapers. Preparators scour their institution's storage closets for unloved hardware. They surf the internet for deals on air scribes and drill bits as well as supplies for specimen storage and fieldwork. They also value the tools they have by taking meticulous care of them and avoiding throwing things away. For example, during my visit to the Southern Museum, someone invited the preparators to adopt supplies from the office of a recently deceased colleague. Despite this macabre context, Jay and Kevin were thrilled to find a well-stocked tool chest that included telescoping screwdrivers, piles of pin vises, and antique engraving tools. Lab manager Amber did not share their enthusiasm and teased them for saving junk. As they combed through the office, Amber opened a dusty cigar box to reveal a single razor blade. She asked where the sharps disposal was, and Kevin replied, deadpan, "What's wrong with it? Give it here." Amber rolled her eyes at the idea of keeping a rusty, broken razor. Poking fun at Kevin's hoarding tendency, she asked wryly, "Is it OK if I throw out this twist tie I found?" Jay chimed in with fake eagerness. "Has it been twisted?" Kevin followed up with, "Does it have any twist left?"

These preparators' self-deprecating embrace of their reputation as "obsessive-compulsive pack rats," in Jay's words, reflects the object-centered mission of museums as well as preparators' need for a variety of tools. As

a result, many fossil labs look like cluttered workshops, with assorted surprising objects including power tools, delicate artists' brushes, former yogurt containers filled with freshly mixed plaster or liquid adhesive, unidentifiable metal pieces carefully bent into precise but mysterious shapes, and fossils cradled on sandbags hand-sewn from old jeans. These collections are partly inspired by small supply budgets, though the pleasure that preparators take from creating, using, and adapting tools extends beyond thrift. Rather, their ability to imagine and use a tool to achieve each of the myriad tasks and priorities of preparing specimens encapsulates their skill. As discussed in chapter 2, the crucial autonomy to exercise this skill of preparing technologies belongs to staff preparators, not volunteers. It is this autonomy over techniques and tools, as opposed to the particular techniques and tools themselves, that shapes preparators' identity and the specimens they prepare.

We've seen that preparing evidence (chapter 1) and communities (chapter 2) are crucial components of preparing knowledge; how then do community members work with evidence? This chapter shows how practitioners prepare technologies—that is, how they create, adopt, adapt, maintain, and/or reject techniques and tools. By choosing how to work with fossils, preparators make momentous, though rarely documented, decisions about the physical and epistemic characteristics of the evidence they prepare.

Social studies of technology provide valuable insights into how and why people create and use techniques and tools. These studies typically investigate a sociotechnical system made up of components including designers, users, social values, environments, institutions, and objects (see classic studies in the social construction of technology, such as those collected in Bijker, Hughes, and Pinch 2012). This approach has inspired important analyses of the typically invisible infrastructure of science, such as material culture, representation techniques, and built environments. Yet somehow technicians tend to be lost or undervalued in these analyses. Hardware and its operation seem to attract STS scholars' interest more than the difficult-to-categorize humans who work with both.

This chapter demonstrates the fundamental role of technicians in sociotechnical systems by arguing that the history of fossil preparation technologies is better understood as a history of preparators. I trace the history of technologies used to remove rock from fossils from the centuries-old appropriation of stonemasons' hammers and chisels to the decades-old appropriation of doctors' computed tomography (CT) scanners.[1] These two technologies are enormously different in technical function and social meaning, however rock removal technologies have changed remarkably little in the time between these benchmarks. Instead of inventing or repurposing radically new technologies, preparators have invested in developing their own skill of modifying long-established ones for each particular specimen. The relative stability of rock removal technologies, in spite of significant changes in how fossils have been studied and displayed, indicates that preparing fossils relies on preparators' decisions and judgment more than on the tools. The importance of this expertise helps explain why fossil researchers and preparators are somewhat skeptical of CT scanning. They prefer physical fossils prepared by familiar people over digital fossils prepared by unfamiliar people and machines. Their skepticism of the newer technology is not Luddite, I argue, but rather a strategy for preserving their long-practiced skills and long-established trust in each other. Furthermore, by focusing on preparing technologies as a responsibility claimed by technicians, we can observe how skill, autonomy, and (lack of) technological change interact.

FROM HAMMER AND CHISEL TO PALEOTOOLS MICRO JACK #1

Nineteenth- and Twentieth-Century Preparation Practices

Examining the history of *who* prepared fossils alongside the history of *how* they did it reveals the rising status of preparators over the twentieth century, beginning with the widespread acceptance of pneumatic tools in the early 1900s. Paul Brinkman (2010, 71), a historian and former preparator, explains these new tools as well as a growing division of labor between researchers and preparators as inspired by "the race to obtain exhibit-quality

Jurassic dinosaurs." Museums such as the American Museum of Natural History in New York, the Field Columbian Museum (now called the Field Museum) in Chicago, and the Carnegie Museum in Pittsburgh wanted a giant mounted dinosaur to attract crowds and funders, and they each wanted to be the first to achieve such a display. But mounting a dinosaur required preparing a sauropod-size volume of fossils quickly and carefully (Brinkman 2010, 18–20). In contrast, Peter Whybrow (1985, 5), another preparator turned historian, argues that early twentieth-century inventions in preparation techniques were driven by research demand: "Techniques have evolved in parallel with and in response to requests for information about vertebrate fossils." Scientists today tend to agree with Whybrow. For example, researcher Randy described to me a "coevolution of preparators of some sort and paleontologists," thereby correlating researchers' interests and demands for fossil data with changes in preparators' techniques and skills. But this kind of instrumentalist explanation—that people selected better tools to produce better data—is always too simple to capture the reality of technological change.

Display and research are equally plausible causes for the development of more efficient preparation techniques at the turn of the twentieth century, and they are not mutually exclusive. But why has there been a relative lack of new mechanical tools ever since? The rest of the twentieth century saw only minor adaptations to the early twentieth-century pneumatic hammer and sandblast, despite major changes in fossil display styles and research interests.[2] I argue that the motivation for changing tools lies with preparators more than with museums or researchers. Overlooking technicians is a common practice in science and history, after all. In this case, the relatively static nature of preparation tools can be explained in part by preparators' development of skill in using and, crucially, modifying these tools in ways that they considered appropriate for each specimen.

In nineteenth-century Britain, the few geology handbooks and scientific articles that mention preparation describe it as a straightforward process of chipping off rock. Fossilists (i.e., naturalists who were interested in fossils) prepared specimens themselves or hired stonemasons for their rock-cutting skill. In 1842, George Fleming Richardson (1842, 493–494),

an assistant in the department of minerals at the British Museum, wrote in a geology manual that fossil preparation was flexible and easy to learn, perhaps to encourage his readers to try it: "No particular rules can be given for the operation of breaking, trimming, and fashioning rock-specimens; but the skilful management of the hammer, though some patience and practice be required, is by no means of difficult acquisition." His advice shows the preeminence of the hammer and chisel, traditionally stonemasons' tools, and hints at the lack of "rules" for preparing specimens—an assertion that preparators still proclaim today. British naturalist Gideon Mantell agreed that preparation was simple enough to be done by any fossil collector. When he bought an unprepared iguanodon specimen in 1834, he wrote with excitement in his journal, "Now for three months' hard work at night with my chisel, then a lecture!" (quoted in Dean 1999, 136). Mantell included instructions for matrix removal in his 1844 geology manual as well as a beautiful illustration of a fossil before, during, and after preparation (figure 3.1). He (1844, 57–58) also warned readers about the potential delicacy of preparation: "The bones of the large reptiles which occur in the Wealden and Oolite [geologic strata] . . . will often fly to pieces on the slightest blow of the hammer or chisel." The hammer and chisel were the universal tools for removing matrix. Naturalists did not doubt that fossil preparation was skillful and hard work; nonetheless, they assumed that anyone could learn to do it.

These authors may have presented preparation as learnable as an invitation to amateurs to try it. In nineteenth-century Britain, amateurs regularly contributed to research in natural history, such as by collecting and disseminating specimens, forming naturalist clubs, and corresponding with "gentlemen of science" to share their findings (Secord 1994; Kohler 2006; Gibson 2017). Identifying and mapping geologic features, and collecting and displaying fossils, were popular hobbies across social classes. Paleontological knowledge at the time relied on specimens provided by amateur collectors and prepared by working-class stonemasons, who rarely received scientific recognition and whose names typically went unrecorded. Their tools and techniques, though, were not forgotten.

Figure 3.1
A rare nineteenth-century image of fossil preparation work, showing (bottom) "two corresponding surfaces of a block of Chalk split asunder," (middle) the halves "cemented together" to match up the ovals of broken bone and "the chalk has been chiseled away . . . [and] a fish has been thus brought to light," and (top) "the specimen completely developed" (Mantell 1844, vol. 2, frontispiece).

By the early twentieth century, the conception of easily learnable hammer-and-chisel preparation was shaken by two inventions that would become preparators' tools of choice for at least a century: a sandblast and a pneumatic hammer. In 1894, invertebrate paleontologist H. M. Bernard (1894, 553) complained, "Picking at the fossil with a steel point taught me, what every worker soon finds out for himself, that the [trilobite] limbs . . . could not be differentiated from the matrix by any

such method." Bernard wondered whether washing the specimens in grit-filled water might help. Thus inspired, he visited the "London Sandblast Works," four miles from his job at Imperial College, where "the proprietor was kind enough to express interest in the idea, and showed me blocks of granite which had been treated with the sand-blast, and in which the harder elements stood out in good relief" (Bernard 1894, 554). Continuing fossilists' tradition of adopting tools built by tradespeople with rock-cutting expertise, Bernard designed an air-pressure-driven apparatus that blew sand down a rubber hose and against a specimen, eroding away the matrix. He found that the "sand-blast" only worked if the matrix was of less dense mineral content than the specimen; otherwise the sand ground away the fossil too. Yet "when the matrix is soft as compared with the fossil . . . the sand-blast cleans the objects very beautifully" (Bernard 1894, 557).

The quick adoption of Bernard's idea in the United States and Britain suggests that museums' workers were watching each other closely due to their intense competition for spectacular fossils. By 1904, the sandblast had crossed the Atlantic and been adopted at the American Museum of Natural History. Henry Fairfield Osborn (1904, 256), a curator of vertebrate paleontology, reported in a conference abstract that he had "recently been experimenting with a sand-blast, driven by a compressed air engine, with admirable results . . . both in cleaning surfaces and in removing the matrix in the cavities of small skulls."[3] By 1908, however, the sandblast was still not widely available in Britain. Francis Bather (1908, 81), an assistant keeper (i.e., assistant curator) of geology at the British Museum, wrote regretfully, "While every museum probably has access to a supply of electricity, it is not likely to be able to obtain compressed air. I will therefore merely recall the fact that attempts have been made to utilise the differentiating action of the sand-blast for the development of fossils." Adam Hermann (1909, 292–293), a preparator at the American Museum of Natural History, praised the sandblast in 1909 despite the scarcity of air compressors: "Wherever compressed air is installed, the sand blast may be of great help in freeing the bones from their matrix." This problem was alleviated with the rise in the availability of electric air compressors. The

sandblast, now called an air abrasive machine or air abrader, still retains the fundamentals of Bernard's design.

Like Bernard, Elmer Riggs (1903, 747), a paleontologist and preparator at the Field Museum in Chicago, was frustrated with hand tools: "The tedious work of removing fossils from their matrix by means of the hammer, chisel and awl has led to various experimentation with machine tools in the hope of devising some more rapid method." First he tried electric dental tools, which he deemed weak and therefore useful for "light work" only. Next Riggs (1903, 747–748) tried the handheld compressed-air-driven jackhammer used for masonry and metal engraving:

> The hammer in use consists of a cylindrical chamber in which a five-eighth-inch steel plunger having a five-eighth-inch stroke is caused to play upon the head of the chisel at the rate of 3,000 to 3,500 strokes per minute. This rapid succession of light blows sets up a vibration in the chisel, which, with even a slight pressure against the work, gives it a remarkable cutting capacity.

This tool is not so different from, and clearly inspired by, the hammer and chisel, as it replaces a few powerful human blows of the hammer with many gentle mechanical hammer blows. The pneumatic hammer was so effective at cutting rock that Riggs (1903, 748) feared it was a danger to fossils. As a result, he weakened the tool's power by attaching a small, light chisel to the smallest, lightest pneumatic hammer available, lamenting that "a still smaller size would often be convenient." Riggs (1903, 747–748) recommended that preparators alter the tool as appropriate for each specimen: "By adapting the size of the chisel to the work at hand and gauging the amount of air admitted to the tool by means of a push-button throttle valve, the stroke can be reduced so that [even] a scale may be removed from the most delicate surface." Clearly, even as preparators built mechanized tools, they assumed that other preparators would continue to adapt the tools for each specimen.

Preparators and researchers lauded the efficiency of Riggs's modified pneumatic hammer, reflecting the competition for fossil exhibits at the time. Osborn (1904, 256), as a thrifty museum administrator, noted the financial advantages of the two inventions: "Combined with the compressed

air chisel [the sandblast] will probably reduce the cost of preparing fossils to one third of that involved by the use of hand tools." As an adaptable tool that removed rock quickly and delicately, the pneumatic hammer—known today as an air scribe—was widely adopted by preparators.

Today PaleoTools, an influential preparation tool manufacturer, sells five varieties of air scribe ranging from the Micro Jack to the Mighty Jack, which vary in power by size and air pressure. The Micro Jacks are intended for more precise work and have six types, each costing about $450 (PaleoTools 2020). The newest and smallest Micro Jack, the #1, has achieved celebrity status among preparators. When Bill Murray, the owner of PaleoTools and inventor of its air scribe varieties, first sold the #1 at the 2010 SVP meeting, the Northern Museum preparators tried it and were so impressed that they bought Murray's entire conference supply of #1s, including the demonstration set. Murray explained the tool's appeal to me as a lack of lateral movement from the "fixed" pin, and that the #1's small size and lower air pressure makes matrix "chip off" rather than "turns it to dust" as other air scribes do. His website also offers to tailor the #1 for buyers by adding an on/off switch or lengthening the handle or pin (PaleoTools 2020). Murray told me that his business began when he found a fossil and brought it to a local university for identification. He offered to donate it to the university if the preparators would teach him how to prepare. They agreed, and he has been a volunteer preparator ever since. But he was soon frustrated with the destructiveness and limited control of the air scribes that the lab was using. Murray drew on his training as an engineer to modify the tool, and other lab members quickly bought the versions he built. He started PaleoTools in 1998. Air scribes, such as Paleo-Tools' Micro Jacks #1–6, exemplify preparators' preference for making minor adaptations to a design instead of inventing a new one.

Preparation as Skillful

Concurrent with the adoption of pneumatic tools, technical articles and manuals began to mention that preparation required skill, in contrast to the earlier view of preparation as a straightforward process that anyone could learn. Bather (1908, 90) wrote that "each case presents its own

difficulties and there is plenty of room for the exercise of ingenuity on the part of a practical palaeontologist." Similarly, Hermann (1909, 290) recommended, "The selection of tools, as to strength of the blow, etc., must be left to the judgment of the preparator." The variety of tools available by the early twentieth century, including electric, pneumatic, and hand tools, required specialized "judgment" or even "ingenuity" to select the best tools for each specimen. Also, because pneumatic tools could destroy rock—and fossil—faster than the hammer and chisel could, institutions discouraged their use by unskilled preparators. But preparators remained uncredentialed, unlike other emerging professions in science at the time (Bowler and Morus 2005, chap. 14).

Nonetheless, preparators' specialization and skill development are evident in two dicynodont skulls in one museum's collection. These mammal-like reptiles, who lived alongside the dinosaurs, belong to the same species yet look very different (figure 3.2). Researcher Kyle explained that they were prepared about fifty years apart:

> Not very much of this specimen's details are exposed, and you can see the damage the bone surface suffered from that issue where sediment and bone don't separate very well. . . . So that's an example of 1920s', 1930s' preparation techniques. Here is another specimen of [this species] that was collected at the same time in basically the same place that's been prepared with more modern preparation techniques [in the 1980s], and you can see you can get much better results, including much better separation of the matrix and the bone.

Kyle pointed out bone sutures visible on the 1980s' skull, but not on the 1930s' one, suggesting the sutures were destroyed during preparation. Similarly, there are ridges and grooves on the 1980s' prepared snout, but these are not discernible on the 1930s' snout. Kyle credits improved techniques for the better quality of the 1980s' skull, although the *techniques* probably differed little. Instead, I surmise that the most significant difference in these specimens' preparation was the preparators' skill. In the 1930s, preparators could be "people off the street" with no experience with fossils, as one preparator told me. But by the 1980s, preparators were expected to

Figure 3.2
These dicynodont skulls were prepared in the 1980s (left) and 1930s (right).

have specific skills and knowledge gained from experience preparing fossils (though they still lacked formal preparation training or credentials).

Experienced preparators have long been considered valuable employees.[4] Brinkman (2009, 25–26) describes the "luring" of preparators from one museum to another in the early twentieth century as sometimes "hostile." This was because "a staff of skilled and experienced technicians was the most vital ingredient for operating an efficient fossil preparation lab" (Brinkman 2009, 25–26). Current preparators report that their predecessors had all sorts of backgrounds, and rarely scientific ones. Most came from jobs that required manual skill and attention to detail. Drawing on institutional memory, one museum's staff members told me that a preparator hired in the 1950s had previously worked as an undertaker, while two hired as late as the 1970s were a shoemaker and pipe fitter, respectively. The rarity of experienced preparators at the time meant that museums sought out people whose previous jobs required skills applicable to preparation. By the early twenty-first century, preparators were hired primarily for their experience specifically in fossil preparation, as shown by its requirement in most of today's preparator job listings (chapter 2).

In the early twenty-first century, preparation is no longer considered a straightforward task that anyone can do, as it was perceived in the nineteenth century. New tools are no longer thought to be the answer to efficiently producing quality fossils, as early twentieth-century researchers and preparators believed. Instead, the vertebrate paleontology community values preparators with specific knowledge and skills, acquired through and evidenced by preparation experience. A century of relatively stable technology has been both a cause and effect of the development of preparators' expertise in choosing, adapting, and applying techniques. For example, preparator Brown (2013) published an article tracing the continuity of preparation tools between 1900 and 2013, including a striking image of Hermann's (1909) hand tools alongside matching tools that Brown found in his own laboratory at the University of Texas at Austin. The expertise of preparing these technologies, including not replacing them with significantly different approaches, came to define preparators as a community over the twentieth century.

PREPARING DIGITAL FOSSILS

How to See through Rock in Old and New Ways

It may seem obvious that using rather basic tools like sandblasts, hammers, and chisels—even those driven by compressed air—requires skill to successfully remove matrix from fragile fossils. Investing in the slow, painstaking development of that skill can explain why preparators would be disinclined to invent new tools that don't require that particular skill. But what about digital, mechanized technologies? One might think that they would operate more or less on their own, regardless of the operator's skill. This is, of course, a misconception, as shown by studies of the skill involved in successfully using such high-tech machines as electron microscopes (Rasmussen 1997), synchrotrons (Doing 2009), and DNA sequencers (Stevens 2013). Likewise, a recent challenge to preparators' technological stability offers insights into how scientists view technicians as a foundation for trustworthy evidence. Technologies alone, even impressively complex ones, are not sufficient to prepare good evidence. As historian Nicolas

Rasmussen (1997, 254) argued based on the electron microscope's adoption in twentieth-century biology, "New techniques must be assimilable to both paradigm and habitus, or both cognitively and culturally," such that they align with existing components of a discipline's identity, including its epistemology, social norms, and aesthetics. The same context dependence is true for technologies that are *not* adopted or adapted over time, and we can learn much about a community based on the techniques it chooses to use and not use. Like the long stability of rock removal tools, the skepticism surrounding a new and entirely different rock removal technology demonstrates that technicians are more important than technologies to the process of preparing knowledge from fossils.

At the end of the twentieth century, the medical imaging technology of CT scanning offered an intriguing potential: seeing *through rock* to the fossil bone encased in it (Chapman 1997; Kevles 1997, 159; Wylie 2018b). This still-developing approach can negate the need to remove that rock, which would seem to make preparators—and their time-consuming, potentially destructive work—obsolete. While scientists praise the "magic" of CT scans for their pristine views of unprepared fossils, they also express skepticism about this unfamiliar, suspiciously magical technique. They worry that it reduces their interactions with specimens and preparators, which they consider unwelcome changes to their well-established research practices. I argue that these seemingly contradictory assessments coexist because the crucial factor of any technological system is the people doing the work. Thus scientists' and preparators' responses to this revolutionary way of viewing fossils shed light on how they understand their own symbiosis as complementary communities as well as how they define good evidence and good technologies.

In basic terms, a CT scanner sends X-rays through an object and then recaptures them, thereby producing a cross section—a "slice"—of density readings. It rotates around an object to capture slices of its external and internal structure in three dimensions. Because of this mechanism, CT doesn't work on all fossils. Specifically, X-rays cannot penetrate some types of rock, and CT data only distinguish between matrix and fossil if the two have different densities. Also, some vertebrate fossils are larger than typical

CT scanners. The strength of the X-rays and sensitivity of the sensors vary with the kind and size of CT scanner and with the parameters set before each scan by the machine's operator, who is typically an imaging technologist, physicist, or materials scientist. One of these imaging experts or a fossil researcher then uses software to compute the quantitative density measurements into images, including views of each slice and a compilation of the slices into a three-dimensional, on-screen model of the specimen (figure 3.3). The images are then processed to depict areas of different densities in different colors or levels of opaqueness, depending on what the fossil researchers want to see. For example, certain densities can be removed from the on-screen model altogether, such as by making matrix transparent so as to display only fossil. The bones can also be manipulated to allow on-screen comparisons and measurements. Researchers access CT scanners at their own institution, or pay for scanner time at other universities, museums, or medical or industrial imaging centers. Scanner time is tough to access because museums' scanners are in high demand, and using

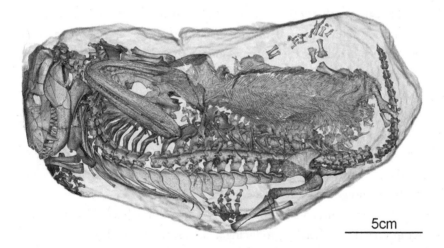

Figure 3.3
This image was made from data collected by synchrotron imaging (i.e., a high-resolution form of CT). It shows two fossil skeletons encased in an intact, three-dimensional burrow. The animals' bones are displayed as distinct from the surrounding matrix based on their different densities, with the edges of the burrow visible around them (Fernandez et al. 2013, 2). Reproduced with a Creative Commons license.

other institutions' scanners is expensive and/or logistically challenging (e.g., transporting the fossil).

A fossil appearing on a computer screen may seem futuristic, yet scientists and their fossilist predecessors have long practiced methods of representing fossils and what they may have looked like in life, such as drawing and model making (e.g., Rudwick 2000; Davidson 2008; Sommer 2010). Patty, a scientific illustrator at the Southern Museum, explained that she never draws specimens as they are, as was done in the nineteenth century, because photographs capture that information in more detail than she can (see Daston and Galison 2007). Instead, Patty draws reconstructions of damaged or incomplete specimens to produce views of how they may have looked without the effects of fossilization. For a fossil seal preserved in its natural death pose, for example, researchers decided to prepare it only from one side and leave it in its rock slab "because it had more information" that way, Patty said, such as about taphonomy (i.e., how it became fossilized). As an alternative to disassembling the skeleton, researchers asked Patty to draw it in a neutral pose, as if in life. She labeled every bone and its typical position in the skeleton with guidance from the researchers, and then drew each bone in its place. Her drawing served as a reconstruction of the skeleton without damaging its rare in situ preservation. It was based primarily on plausible guesses about body and bone position, as is typical for reconstructions of extinct organisms (e.g., Davidson 2008; Hochadel 2013). Researcher Sam believes artists' informed-speculation reconstruction work is irreplaceable because CT can't reconstruct crushed specimens, for instance, or imagine the missing pieces of a specimen.

Paleoartists also contribute to research by building 3D physical reconstructions of fossils and even flesh models of extinct organisms based on the available anatomical data. While most of paleoartists' work is for display (Hochadel 2013, chap. 7), their models are also used for experiments on physiology and locomotion as well as to inform researchers which bones might fit where. Digital models made from CT data are becoming increasingly common for such experiments. For example, one study asks whether a velociraptor's enormous claws could support its body weight and thus enable the animal to climb (Manning et al. 2009). Testing the mechanical

strength of a physical velociraptor claw would risk breaking a fossil, but on-screen bones can't be damaged. Digital models are difficult to build and require potentially questionable assumptions and parameters. As a result, many researchers prefer physical models, including cast replicas or sculpted reconstructions, which they consider easier to control than digital ones. Also, they believe that human model makers, unlike CT, can reconstruct any fossil, regardless of rock composition and density distinctions, even if the specimen is distorted, crushed, or incomplete. The preference for human skill and informed imagination over a machine's measurements and computations is not typical of today's science, and highlights the value of an individual's skill of preparing evidence over the value of technologies alone.

To inform drawings, models, and research, fossilists have historically relied on slicing through fossils (and rock) to view them in physical, fragile, crumbly cross-section. For example, paleontologist Jenny Clack's (1994, 7) descriptions of the skull of the tetrapod *Acanthostega gunnari* were based on anatomical data from specimens that had been "sectioned into approximately 1.5 mm slices using a Well diamond-wire saw." One preparator described such sawn slices to me as "an early form of CT, in a way." Physical slices show internal bone structures that are critical to anatomical description like Clack's, and otherwise invisible inside a skull and/or rock. As a result, though, these sectioned skulls now exist only as slices. Other methods of revealing internal structures such as serial grinding leave no specimen behind at all. Researcher Wayne described these methods as commonplace in the recent past: "For many years . . . they just took a specimen, embedded it in some kind of a plaster or plastic, and then just ground it away, maybe a millimeter at a time. Take photographs, and then they transferred the photographs to celluloid sheets, just drew it out like that, and then they just stacked the sheets up." By grinding away thin layers of a fossil and recording each layer as a photograph, researchers could "see" inside the fossil. Transferring the photos to sheets of plastic or wax and stacking the sheets—a technique also used to preserve organs and other anatomical specimens (e.g., Hopwood 2002)—created a 3D model made of cross-section views, which can serve similar purposes as a CT model.

Yet those images and model replaced the specimen, which was destroyed to create them. The noninvasiveness of CT scanning is more appealing to research workers than these destructive forms of analysis. In Wayne's opinion, thin sectioning and serial grinding are mercifully outdated: "Nobody does that sort of thing anymore. They don't need to. They can do it with [CT]." Some fossils no longer have to be ground away to reveal their insides. As one researcher told me, "Before modern times with CT scanning and things like that, you couldn't do anything with a vertebrate fossil until it's out of the rock." This observation highlights the fundamental importance of fossil preparation to vertebrate paleontology before CT as well as the significant potential of CT to upend that connection.

CT in Research: Visualizing the Invisible

How research workers talk about CT differentiates them by field, namely researchers, preparators, and conservators, but there are two shared themes: amazement at CT's images and skepticism about its widespread utility for fossil research. Everyone talks about CT scanning in fossil research in tones of awe and excitement, much like doctors' and patients' views of the "magic" of CT and MRI (Joyce 2008, 149–150; Saunders 2008, 175). Researcher Wayne's explanation of CT demonstrates this sense of wonder at the technique's capabilities: "Now we've got this tomography business that allows us to reconstruct a skeleton without ever taking it out of the rock. . . . They can turn it in any direction. They can make a model of any of the elements out of plastic. They can enlarge it, they can reduce it to any size you want. They can duplicate one side to the other, and it's just incredible." Wayne, whose career in paleontology spanned over sixty years when he spoke with me in 2010, was an expert preparator and mount maker in addition to researcher. His admiring description of CT reflects its ability to do what researchers dream of: accessing the maximum possible data from specimens by exposing, manipulating, and reconstructing them. CT can achieve these actions without fossil preparation, and also performs actions that can't be done to specimens such as changes in size. This concept of a magical and incredible technology captures CT's unique and rich data as well as the mystery of "this tomography business" to its users, in both paleontology and medicine. Radiologists, patients, fossil researchers,

and preparators rarely know the details of how CT works. They assume that the information is the realm of physicists, materials scientists, and imaging technologists—people whom Wayne refers to above only as an unnamed "they"—and as a result, they are generally uninterested beyond getting useful images.

The typical cause of practitioners' wonder at CT is its portrayal of views that are otherwise impossible, such as the interiors of fossil eggshells and skulls (e.g., Conroy, Vannier, and Tobias 1990; Balanoff et al. 2008, 2013). Then the image *is* the specimen. There is no physically visible object with which a researcher can compare the image. Historian Martin Rudwick (2000) describes Georges Cuvier's solution to the problem of rare and geographically dispersed fossils in the eighteenth and nineteenth centuries as the accumulation of a "paper museum" of "paper fossils"—specimen drawings—to complement Cuvier's collection of physical fossils at the Muséum d'Histoire Naturelle in Paris. By treating images as equally informative as specimens, Cuvier was able to improve his data access and therefore his research career. Cuvier's situation of inaccessible specimens is comparable to that of particle physicists, astronomers, molecular biologists, and many other researchers who rely on imaging technologies to provide the only visual access to their subatomic, telescopic, or microscopic research objects. Here I explore how CT images function as "digital fossils" that serve as specimen proxies and on-screen versions of Cuvier's paper fossils, and then I discuss scientists' preference for physical fossils.

In cases of invisible, unpreparable fossils, researchers trust CT images as digital fossils. Preparator and model maker Tim described how CT scans showed parts of an extinct crocodile's skull that preparation could not reach:

> You couldn't see any teeth on the lower jaw . . . because of how the skull was overhanging it. . . . I looked at the slices of CT data . . . and I could see that there were little teeth along the back of the jaw. . . . We never saw those. We still don't really know what they look like, but at least from the data we have this concept that they're there and that they're sharp, they're small, they're evenly spaced. So that was really neat.

Tim emphasizes the absence of direct views of the lower teeth, which is clearly striking to him in comparison with his vision-centric work of preparation and model making. He included the teeth in his sculpted reconstruction model, even though evidence for them exists only in CT images that create "this concept that they're there." His amazement is evident in his words, as he distinguishes ideas of vision based on teeth "I could see" on a scan from what "we never saw" in reality. For Tim, the CT data are *data*, meaning information about the skull's characteristics, but those data are also somehow different from data about teeth that are visible to his own eyes.

If the densities of matrix and bone are different enough, then software programs can differentiate ("segmentate") these substances based on CT data. Crucially, then the software can remove or reveal each density level from an image, such as "digitally preparing" a specimen by showing it without matrix. Wayne, for example, referred to the CT scanner as "the truth machine . . . because you can see everything. It's like looking at something in a glass box." He meant that looking at scans is like looking at a prepared fossil, with the only difference being that the fossil is inside a glass box—a computer screen. He thus suggests that a digital image can be treated like a specimen. Likewise, evolutionary biologist Vincent Fernandez and colleagues (2013) used only synchrotron scans (a technique similar to CT) to describe an amphibian and a mammal-like reptile that were fossilized together inside a burrow in the early Triassic. The burrow is a solid, three-dimensional rock nodule roughly the size of a bread loaf, with the eroded tip of one animal's skull peeking through the rock as the only indicator that anything is inside. Soon after the burrow was found in 1975, researchers broke it open to find out whether it contained more bone. The broken halves showed a cross section of two articulated skeletons, which inspired Fernandez and coauthors' recent analysis. Today the skeletons remain inside the rock, though their bones, positions, and even injuries are visible to researchers via image reconstructions from the scan data (figure 3.3). Thus the scans *are* the specimen; they are the only access to the fossils. If a preparator were to remove the rock around the fossils, they would have to dismantle the skeletons. This approach would destroy the unique

information preserved in the animals' remarkable 3D preservation, such as about posture, taphonomy, and why on earth a mammal-like reptile might have shared its burrow with an amphibian.[5]

Research workers consider CT most useful for accessing information that would otherwise require destroying the specimen, as in the case of the burrow. Preparator Mary explained that one role of CT is to do what preparators cannot: "The things you see in the scan are the things you can't really get to with preparation. I mean, you're limited to where the needle can get to and it's a straight line. You can't really do ninety degree bends back in space." Preparation tools, such as a "needle" of steel or tungsten carbide clamped in a handheld pin vise or air scribe, cannot reach certain spaces. Wayne's fossil-in-a-glass-box specimen thus seems ideal for studying these unreachable spaces. After all, a digital fossil is easily maneuvered and offers complete views of all its pieces, while a physical fossil is most likely fragile, heavy, not fully visible, and potentially damaged by preparation.

Another valued purpose for digital fossils, especially according to collection managers and conservators, is protecting physical fossils from transport and handling. Bob, a collection manager at the Southern Museum, finds the dangers of making specimens accessible to researchers particularly acute for unwieldy and scientifically important fossils:

> The type specimen of [an extinct species] is a whale skull six feet long. Maybe two of us could get it flipped [to study the underside]. . . . Every time I do that, [there's] a terror that "please please God, I hope I didn't bust it this time." . . . Gee, wouldn't it be easier on the specimen if we took that sucker and did an external scan, probably with lasers? And we could probably do a CT scan, though it's pretty big, if you wanted internal structure. Have it out there someplace on the web. You wouldn't throw away the original specimen, I'm not suggesting that. But I wonder how many people could save the trip in the airplane coming here [to study this skull], save my poor aching back and my nerves from flipping the thing, and the potential damage from handling this specimen.

Studying digital views of a fossil instead of the fossil itself would reduce stress on both the specimen and its caretaker. A fossil's digital scans can also

act as an archive or backup of the specimen's data. Oliver, a collection manager, extolled the benefits of digital specimen documentation: "By having a CT scan data set, you have a permanent visual record of the object. 3D, the whole thing. So that if it disappears for any reason, if it's in a cloud of dust, if it's gone, if it gets hit by a meteorite or something, you still have a record of it that you can go to and measure and compare with other things." No one suggested "throw[ing] away the original specimen," as Bob put it, but many scientists, collection managers, and conservators believe that digital data can and should substitute for specimens for some research purposes. As an extra bonus, digital specimens can make at least some information about specimens disaster proof.

Preparators appreciate CT as a way to protect fossils too, though from *preparation* damage rather than damage from handling or disaster. Like doctors who order CT scans to inform diagnosis and treatment, preparators see CT as a potential aid to choosing and applying preparation techniques. For example, preparator Marc explained, "Opening [field] jackets is always a terrifying experience" because preparators have to cut through a jacket's rigid plaster-and-burlap shell with a power saw and without knowing where the fossils are inside the jacket. It is easy to inadvertently grind through both the plaster and the fossil beneath it. As a solution, Marc said wistfully, it "would be great to CT-scan jackets before they're opened" to provide the saw-wielding preparator with a bone map of the jacket. His institution doesn't have access to a CT scanner, but he wishes they did. Several labs CT-scan or x-ray unopened field jackets. Researcher Luke at the Northern Museum noted, "We'll often x-ray rocks that we know have fossils in them to see, is this a high-priority prep job or a low-priority one?" These exploratory images of unprepared fossils rarely have research-quality resolutions, but they can inform preparation decisions. A few times I saw preparators consult CT images of specimens as they prepared them to see where bones were. CT scanning is too expensive and unreliable to use primarily as a preparation guide, especially because preparators have other ways of avoiding hidden bones (such as adding layers of dirt or packaging material around fossils before jacketing them in the field, labeling new jackets with maps to show the fossils' location, removing only small

amounts of matrix at a time once the jacket is open, "following the fossil" once they have found it, etc.). But if a specimen has already been scanned for research purposes, then those scans can serve double duty by helping the fossil's preparator see through—and selectively remove—rock.

CT as "Not a Panacea"

Despite enthusiasm about digital fossils as specimen proxies, research workers almost universally dismiss CT as not sufficiently detailed, reliable, or "real" to fully replace prepared specimens. This skepticism makes sense for a relatively new technology, and especially for one that was designed to image living humans and has been co-opted to visualize rock-embedded fossils. In researcher Preston's words, CT "is not a panacea for what we do. . . . It gives you a lot of power to do things, but it's not a complete answer." Workers give practical reasons (e.g., technical limitations) and epistemic reasons (e.g., trust in their own sensory interaction with a fossil) for their reservations about CT (Wylie 2018b). One common complaint is the size of micro-CT scanners, which offer the best scanning resolution but only for small specimens.

Crucially, whether a specimen can be successfully scanned is unpredictable. Northern Museum researcher Kyle described this frustration in his "two unsuccessful forays into CT scanning," caused by the geologic composition of the fossils and matrix. One attempt was several skulls of mammal-like reptiles found in the same locality: "The specimens had been altered by a mineral, presumably a fairly dense, metal-bearing mineral that caused a lot of artifacts in the scan, so it was very difficult to get a good clear image." Certain minerals deflect X-rays and thus create measurement "artifacts" that obscure the fossil. For Kyle's other CT attempt, an unprepared skull, "the problem is that the specimen and the sediment had very similar compositions . . . so when you're looking at the image of CT slices, it's very hard to say, all right, this is where the bone ends and this is where the sediment begins." Because CT works by sending X-rays through a specimen, it can only distinguish between areas of different densities. Kyle points out that he could manually draw this boundary onto CT images with software programs, but he rejects that option as too imprecise.

This issue of defining specimen versus not specimen appears in arguably all data processing methods and is one way in which practitioners skillfully prepare evidence. Galison writes of this definition task as a crucial application of workers' "laboratory judgment" in particle physics. He argues that editing out unwanted information is inseparable from denoting the desired information: "The task of removing the background is not ancillary to identifying the foreground—*the two tasks are one and the same*" (Galison 1987, 256, original emphasis). Deciding how to differentiate the foreground from the background can be controversial, especially when accessing nature indirectly via technology.

As in Kyle's experience, processing CT data into images is complicated. For example, a student in Wayne's department used CT images to reconstruct a digital fossil but "didn't do a very good job of Photoshopping. These [images of individual bones] are kind of ragged around the edges," Wayne complained. Using software like Photoshop is a difficult skill that has implications for the reliability of evidence. Image making as expertise is similarly discussed among astronomers (Lynch and Edgerton 1988) and cell biologists (Rasmussen 1997; Cambrosio and Keating 2000). Likewise, anthropologist Natasha Myers (2015, 144) found that protein crystallographers distrust and reject software that claims to automate the process of building models of protein structures. Instead, crystallographers consider models to be crafted, bespoke products of skillful human work and expertise. These scientific communities use images to judge the quality of *workers* as well as evidence and knowledge claims, much like fossil lab communities use prepared specimens as indicators of preparators' skills.

Subjective Images, Objective Specimens

Researchers in many fields worry about their own control over what images look like as a potential threat to the objectivity of their claims. Astronomers told sociologist Michael Lynch and art historian Samuel Edgerton (1988, 192–196, 202) that they process their digital telescope readouts into "pretty pictures" only for public viewers, not for researchers. However, Lynch and Edgerton witnessed such processing for both public and research images. In the mid-twentieth century, particle physicists advised against physics

training for the supposedly unskilled "scanners" who searched cloud chamber images for tracks of subatomic particles. They feared that the scanners would then "see" imaginary evidence that they thought would please the physicists (Galison 1997, 199–200; Traweek 1988, 28–29). These scanners were mostly women with little education but significant control over physicists' data. Likewise, leaders of the Manhattan Project found to their surprise that women with high school diplomas (or less) were more effective workers in uranium enrichment factories than PhD-holding scientists (Kiernan 2013, 109–110). They believed that the women, who were not told what the factory was producing or why, followed instructions better than the scientists, who knew the end goals and deviated from instructions to try to improve the process. Outsourcing evidence preparation to nonscientists can thus be a way of preventing scientists' assumptions from affecting the data. Another approach is to standardize protocols. For nanotechnology, which relies on indirect images, sociologist Martin Ruivenkamp and philosopher Arie Rip note that published descriptions of ways of processing the images produced by scanning tunneling microscopy became rarer as the methods became more standardized. They worry that as this trend continues, "the distinction between artist's impression and pictures linked to data may become invisible, and the image of nanotechnology becomes like a work of art" (Ruivenkamp and Rip 2010, 30). If research workers don't document how they make scientific images, then other workers may struggle to understand or interpret those images accurately because they can't know which aspects of the images were based on data.

This fear of inadvertently creating the phenomena they want to study drives practitioners either to set standards and attempt to police them, or to reject digital images altogether, as Kyle did. Scientific communities and journals try to impose standards for image making for publications, although they struggle to define or enforce characteristics of acceptable images (Frow 2012). In response to this fear, fossil researchers emphasize visible, tangible fossils as reliable evidence for scientific knowledge. Researcher Nathan believes CT images will never replace specimens because "specimens are the truth, in the end." Regardless of whether data processing is digital or physical, researchers hold physical fossils as the bearers of "truth."

Researchers often list examples of information that CT cannot provide, thereby criticizing the technique and implicitly promoting direct observation of fossils. Even if a fossil is scannable in size, mineral composition, and density differentiation, critical questions remain. For instance, the CT images published by Fernandez and coauthors (2013) of the fossilized burrow are "sensational," researcher Tobias (who was not involved in the study) said with admiration. Tobias "thought [the CT image] was a line drawing" because it was so clear and detailed. Despite these high-quality images that impress colleagues, the paper's authors admit that these digital fossils don't explain everything, such as the cause of two holes on the amphibian's skull. The holes' size does not match the mammal-like reptile's teeth, so it is not a sign of predation. They are in a thin-boned part of the skull, suggesting they may have been caused by disease or chemical changes during fossilization. "Unfortunately, the resolution of the scan does not allow further investigation," conclude Fernandez and colleagues (2013, 5). Researchers express frustration that CT cannot always yield the information they want to study, from Kyle's completely failed attempts to missing details like the origins of the amphibian's skull holes.

Today's CT data and images also cannot show bone surface details, histology, or cellular structures. Kirk, who studies the ear anatomy of fossil mammals, finds CT evidence unsatisfactory: "I can spend hours staring down a microscope at the thing, trying to figure out if . . . this shallow depression on the surface of the bone that I'm seeing is actually where a nerve or a blood vessel used to run. . . . I can only do that because I've done it before lots of times and because I am looking at the real thing in extraordinary detail." Perhaps CT cannot record the subtle anatomical details that Kirk studies; it is also possible that because Kirk has long done research by looking at real specimens, he is accustomed to that method and considers it the basis for his professional expertise. This is a version of "trained judgment," which historians Lorraine Daston and Peter Galison (2007, 355) define as the way twentieth-century scientists represented the natural world through "pictorial representation by (and for) the trained eye." Trained judgment relies on "skilled vision," which belongs to—and defines—a community of practitioners, such as cattle breeders and judges

who must interpret what makes a cow "beautiful" (Grasseni 2004, 2005). Both trained judgment and skilled vision are in some ways tacit, and therefore must be learned through direct experience as well as instructions and feedback. Studying CT data or images doesn't draw on fossil researchers' long-practiced skills of observing real specimens; perhaps as a result, they find CT alone inadequate for research. I suggest then that even if the resolution of future CT images could reveal the data that researchers seek, they would still be skeptical of how those data were prepared as evidence, such as accessed, processed, and analyzed. This skepticism, I argue, derives more from satisfaction with the social status quo than dissatisfaction with CT as a technology.

Complementary Technologies

As a solution for insufficient detail, scientists argue for digital fossils as a complement to physical fossils rather than a replacement. Preston explained, "When you work with CT scans, it's quite important to actually have the 3D object too, to be able to relate some of the structures." In this view, the specimen should serve as a check on the images. In a rare mention of preparators in a publication, researcher Christopher Brochu (2003, 36) hailed them as the solution to CT's technical limitations:

> Upon receipt of the CT data [of a T. rex skull], this author assumed the stapes was not preserved on either side; he was proved wrong when the preparators asked him to identify a slender rod of bone projecting from the braincase. He then returned to the [CT] data set and was able to pinpoint the stapes—an example of reciprocal illumination in comparative anatomy. The stapes is approximately as thick as the original slice thickness and nearly in the same plane; it was very easy to miss. This demonstrates that however powerful modern CT technology may be, it still cannot replace a well-trained preparator.

The unlucky coincidence of a scientifically valuable bone (a T. rex's stapes, which is an inner-ear bone) being roughly the same thickness and orientation as the CT scanner's "slice" parameters meant that Brochu would have overlooked the bone's existence if he had studied only the CT data or if the preparators had missed the tiny unexpected bone. Brochu concludes in a well-cited paper that CT "cannot replace a well-trained preparator."

The need to balance the limitations of digital and physical techniques as well as the variety of specimen conditions emphasizes the importance of adaptability and skill in preparing fossils as evidence.

When I asked preparator Mary whether CT could replace preparation, she laughed at the very idea. Then she answered dismissively, "No, because there's always things you can't see in the scan, or it's not clear in the scan, or some things don't scan well, so I end up preparing them anyway." Preparators are researchers' answer when CT is not good enough, just as researchers believe that their own trained judgment equips them to analyze bones better than CT can. I interpret researchers' complaints about CT's data detail and clarity as a perhaps unconscious way to promote their own and preparators' sensory judgment.

Researchers sometimes state directly that it's good to "evaluate with your own eyes," in Frank's words. They mention the scientific importance of fossil elements that are missing in CT scans, such as texture, color, or subtle impressions of skin or feathers. For researcher Maurice, CT is a poor substitute for his own experience with a specimen: "I have never seen a CT scan that didn't make me feel like I wanted to see it prepared. . . . It's just not the same as seeing the thing for real." In contrast to substituting for prepared specimens, CT images *heighten* Maurice's interest in seeing them directly. Researchers struggle to articulate the power of seeing the thing for real and why digital images cannot match that experience. By not explaining this mysterious quality of direct experience, researchers make it even more mysterious and thus in some ways preserve it as tacit knowledge. Collins (2010) categorizes different types of tacit knowledge based on whether or not they can be articulated, however he does not explore reasons *why* certain knowledge might be preserved as tacit instead of made explicit. Perhaps fossil researchers are not consciously aware of what they do with a fossil that cannot be done with a digital image, and therefore they cannot put words to it. Or this knowledge could be a kind of trade secret, whose secrecy defines a community while also claiming a domain of control for that community. Historian Myles Jackson (2003) contrasts eighteenth-century scientific instrument makers' closely guarded trade secrets—which are tacit in the sense of unarticulated by the knowers'

choice—with the purported openness and transparency claimed by the scientific community. By not defining how they study objects as compared to images, fossil researchers promote their own mastery of this process and thus their control over it. They stand to benefit from *not* explaining why fossils are better sources of evidence than images.

The Symbiosis of Researchers and Preparators

Researchers do not reject CT outright; most interviewees told me that CT should be used alongside specimens in a mixed-methods approach. According to Sam, the most "fruitful" research method is a combination of "CT and the human eye, an expert eye," on a physical fossil. By highlighting the limitations of CT, researchers show their preference for the flexibility and reliability of "expert" eyes.

So whose eyes are expert? Research workers recognize and appreciate each other's trained judgment, not just researchers'. For example, like Brochu, Maurice doubts that CT can replace the information a preparator learns about specimens while preparing them: "I know lots of examples of preparators discovering things in fossils, just by virtue of the fact that they're so intimately involved with the specimen. And they might say, 'Do you want this cleaned out?' And it's like, 'What is that? I never saw that before' [*laughs*]. And that kind of thing happens a lot, so it's hard to imagine not having that anymore." Maurice's appreciation for preparators' input reflects the symbiosis of the many kinds of fossil work and workers. Researchers depend on preparators' work, which depends on researchers' funding, all of which rely on the care and organization of specimens by conservators and collection managers (Wylie 2019b).

Perhaps because of this interdependence, preparator Bill framed his answer to whether CT can replace preparation in terms of people: "You do need to see the fossil and have a CT scan at the same time. I don't think we'll ever really be able to get rid of preparators. Might be able to cut back on the number you need, but I think there always will be a need for them as long as there's paleontology—paleontologists." Based on his own interests—preserving his job—as well as researchers' need to see the fossil, Bill justifies why preparators and researchers are inseparable. When

he changed his response from paleontology to paleontologists, Bill indicated an underlying connection specifically between these kinds of workers rather than between preparators and fossil *research*. Workers define their work and roles relative to each other, as opposed to relative to a process of research or specimen care. If CT were to replace preparation and thus preparators, this network of social roles and divided labor in labs would collapse. As merely an additional tool, however, CT does not threaten the status quo.

By rejecting CT as a panacea for fossil research, research workers reinforce the technology's perceived role as exterior to the fossil lab community. They worry about adding another field to the work of preparing and studying fossils, perhaps in the interest of preserving their current community. CT, after all, requires different skills, training, and tools than a prep lab can provide. Preparator Steve views this as a significant disadvantage of CT: "You've got to have someone to understand all the information you're getting out. You don't just get a lovely three-dimensional image, you have to take all that information and then merge it all together and decide on the resolution, how much you're going to have a contrast between the bone and the rock." Steve portrays CT as complex and reliant on parameters that few preparators or researchers know how to manage. He implies that having a preparator determine the physical boundary between fossil and rock is preferable to hiring someone to understand CT data and make decisions about how to turn it into images. Steve seemed wary of this someone, such as a CT operator or physicist, because they are not part of the lab or even necessarily the broader fossil community.

Likewise, many preparators consider CT irrelevant to their work. Max explained with a shrug, "Some of the things I've worked on have been scanned later by researchers. I had nothing to do with that process, though.... You pay somebody else to do that." Research workers' disinterest in the process of CT may implicitly serve to bar it from changing their skill sets or the social structure of their community. Researchers already trust preparators for their skill and judgment, and preparators' absence from publications protects them somewhat from researchers' scrutiny of their methods (chapter 1). In comparison, if researchers don't know CT

operators or understand their work, they may perceive them as suspiciously subjective or untrustworthy.

Even when fossil researchers process CT data into images themselves, sometimes with CT experts' assistance, they portray the scanning process as black boxed and somewhat uninteresting, as preparators do. Paleontologists consider CT's mechanism and operation to belong to the domain of imaging experts. When I asked researcher Tobias how the different kinds of digital scanning techniques work, he told me that he doesn't know: "I'm not a physicist," implying that it's not his responsibility to know. Sara, a CT facility manager and biophysicist, does not expect researchers to understand her work or CT: "Most paleontologists have no idea about the physics of a CT scanner." In her experience, because "they just want a picture," researchers typically aren't interested in how the picture is made. As a result, they need their "hands held" in the form of help from CT specialists to process and interpret scan images. Researchers often acknowledge this contribution by making Sara an author on papers about her scans. Tobias also lists the physicists and materials scientists who do his CT scans as coauthors because "they didn't do only the technical stuff but also the [image] construction, so it's justified." These imaging experts operate the scanner, which for Tobias is the technical stuff, and also discuss with him how to process the data into the views he wants. This latter contribution deserves authorship, according to Tobias.

This designation of CT experts as coauthors indicates the separateness of the primary author's disciplinary identity from imaging technology, and also recognizes imaging technology as a research field in itself, perhaps because many CT experts have PhDs. In comparison, preparators are rarely authors on fossil-based publications. Barley and colleagues (2016, 153–154) interpret this difference in contribution acknowledgment as based on status:

> When occupations are marked by well-understood differences in formal knowledge, respect for expertise is not usually a problem. For example, radiologists are unlikely to assume that they know what pathologists or orthopedic surgeons know. However, when collaboration involves occupations whose knowledge is contextual, practical, and situated and when those occupations

are also embedded in a hierarchy of authority, then it is apparently more difficult for higher status occupations to acknowledge the expertise of lower status occupations.

CT researchers with PhDs and fossil researchers with PhDs see each other as status equals with different areas of expertise. In comparison, researchers do not recognize technicians—or other workers with "situated" knowledge and lower status—as coauthors, even if they are skillful experts.

Another result of this separateness is that CT experts are relatively uninterested in the objects they scan. For instance, some CT manufacturers donate scanners to museums, in part for public relations reasons (e.g., Kremer 2011) and in part because the designers want to know what the scanner is capable of. Museums' nonhuman objects (e.g., fossils, taxidermied animals, paintings, and Stradivarius violins) serve as experiments about the kinds of materials the scanner can detect. Sara, for example, is interested in the "technical stuff" of optimizing the scanner's parameters for different kinds of objects and developing new ways to analyze scan data, such as combining it with chemical composition data. Despite job offers from several CT companies, Sara chose to work in a museum's CT lab because of the variety of objects to scan, including a Martian meteorite, glass sculptures, and wet specimens. "I see everything!" she said proudly, unlike the limited test objects that CT researchers normally work with. Sara usually knows little about the specimens she scans; instead, she appreciates this diversity of materials as a test of the machine's capabilities and her own techniques for using the machine.

Although many CT facilities are run by imaging experts like Sara, some are run by researchers in other fields. Julian, an anthropologist, operates the CT scanner at the Southern Museum, which he learned to do by "trials and errors." Many of the specimens he scans are not human and thus are outside his research expertise, and he enjoys testing the machine's abilities like Sara and other CT experts do. He likes "to see what can be done," such as by scanning an extant animal specimen and then dissecting it to compare with the CT data. "It's all experimental," he said. Julian gets particular satisfaction from using scans of museum specimens

to disprove the manufacturer's statements of what a scanner can do, such as successfully scanning metal-containing rocks. He then shares the results with the manufacturer to impress them and encourage them to donate scanners to museums. Preparator Jay describes this interaction between the museum and the CT company as "a symbiotic relationship" in that both sides benefit. Clearly most CT experts have different priorities from fossil researchers and preparators. Preparator Alan credits his institution's high-quality CT scanning work to its operators' expertise about CT *and* fossils. For example, Alan admired the software the operators built to filter "noise" from CT data of fossils based on their unusual interdisciplinary knowledge. He explained that CT requires skill, experience, and critical thinking to do well, "like preparation." Digital fossils are therefore not merely the automatic output of a machine.

Researchers believe that CT is a "great tool" (Sam) and "will become a standard method in paleontology" (Tobias), even if they believe CT is "not going to replace the preparator" (Sam). They are not Luddites; they are excited and optimistic about the use of CT on fossils, generally because they think it can provide otherwise impossible data access and a backup version of specimens. They just don't consider CT a panacea for all fossil research; it is a tool among many rather than a methodological revolution. This case illustrates the coexistence of technologies that take different approaches to the same goal: making fossils researchable. This complementarity matches the wide range of accepted methods for fossil preparation, such as preparators' fight to preserve their control over materials in the case of the cyanoacrylate controversy (chapter 1). Paleontologists share that flexibility in the form of an open-mindedness about research techniques that philosopher Adrian Currie (2015, 2018) calls "methodological omnivory." CT's technical disadvantages are not the only reasons research workers doubt that CT can fully replace prepared fossils or preparators. They value their own and each other's skills of seeing and interpreting fossil specimens, and resist the obsolescence of those skills by technology. Moreover, the underlying social and epistemic structures of scientific communities rely on divisions of labor between workers, which scientists do not want to lose by removing fossil preparators.

Preparing technologies, then, reveals research workers' priorities about their evidence and their communities.

CONCLUSION: TECHNICIANS AS TECHNOLOGY

Technologies—that is, techniques and tools—are a crucial part of science. In particular, they connect the preparation of communities with the preparation of evidence. By observing how communities prepare technologies in order to prepare evidence, and in turn how that evidence influences the design of technologies and how those technologies define communities' identities, we can see the intersections between preparation processes. Together, these processes prepare knowledge.

Preparing technologies can include developing and adapting tools and techniques as well as preserving and/or rejecting them. For example, rock removal tools have changed little in the history of fossil preparation. Even the primary tools today are only slightly modified from stonemasons' hammer and chisel (i.e., the air scribe) and sandblast (i.e., the air abrader). My explanation for this stability is that preparators have invested in their own skill development rather than in building radically new kinds of tools. This narrative aligns with the change in beliefs about whether fossil preparation was easy to learn, or dependent on extensive skill and experience. Thus in the sociotechnical system of tools, techniques, and technicians, preparators have developed the technician as the most valuable factor.

CT scanning offers a potential shake-up of fossil preparation technology by putting the need to remove rock into question. By converting a fossil into digital images, CT can help fossil researchers see through rock in some cases. Despite this apparent magic, researchers prefer to work with fossils over images. After all, they are accustomed to and skilled at interpreting objects; they consider images made by mysterious machines and unfamiliar operators questionable in comparison.

When fossil researchers talk about CT scanning, especially about its limitations, they articulate how preparators matter to epistemic work, specifically in terms of preparing evidence and implicitly in terms of preparing the community of people who work with fossils. This rare explanation for

why skillful people are more important than machines emphasizes the role of trust in research work. Relationships matter in that scientists seem more comfortable working with preparators to prepare evidence than working with CT experts. Because researchers and preparators have worked side by side for over a century, their roles and interdependence are established as well as embedded in their practices and communities. The desire to preserve this apparently functional social status quo could be the deciding factor in scientists' skepticism toward CT.

As a way to reap the benefits of a new technology without it radically shifting their social order, scientists talk about CT and fossil preparation as serving different epistemic purposes. For instance, CT can access features that preparation can't without damaging the fossil, such as the insides of skulls, eggs, and burrows. The coexistence of digital and physical fossils is scientists' preferred reality, CT's technical limitations and cost notwithstanding. As a result, scientists happily CT-scan a fossil and then send it to the prep lab, or vice versa, without cognitive dissonance. Accordingly, preparators do not feel threatened by obsolescence. They regard CT with optimistic expectations for informing preparation work and creating backup versions of specimen data, or they dismiss CT as irrelevant. The fossil community is placing CT alongside long-standing technologies as a potential complementary option. Knowledge is a product of the ongoing processes of how people prepare technologies and communities of trust. This view suggests that workers' situated skill and experience plays such an integral role in science that scientists actively work to preserve it—and likely will continue to do so. This interdependence among research workers stems from a shared sense of science as their collective mission.

4 PREPARING SCIENCE

A fossil emergency, so to speak, offers a revealing example of how research workers prepare their sense of what science is through their everyday work. This episode illustrates how workers differentiate themselves into professional groups that they believe are united by a common purpose: science. (Chapter 5 follows how research workers prepare a conception of science for the public through museum exhibits, as opposed to within the fossil community.) One afternoon, a collection management assistant at the Southern Museum telephoned the prep lab and asked preparator Jay to come immediately to the long rows of metal shelves that house the museum's fossils. Jay stopped what he was doing and hurried, with me in pursuit, to a small room surrounded by specimen cabinets and with a tense, funereal atmosphere. Grave-faced scientists and collection management workers were crowded around a three-foot-long fossil skull. The skull belonged to a phytosaur, an extinct semiaquatic reptile that resembled crocodiles. Jay and I had moved it from its shelf to that room a few days earlier so that a visiting researcher could study it. Preparator Kevin followed us in and asked Jay, "How bad is it?" Jay answered, staring at the skull, "Pretty bad. Three breaks and crumbs." The skull was disastrously split about halfway down its length, where it narrowed into a long snout (figure 4.1). The "crumbs" of fragile bone meant that the fossil was disintegrating along the breaks and thus the skull's pieces would not fit together cleanly when repaired. This severe damage was surprising because the skull was in a custom-made plaster clamshell jacket, which has two sides to allow the

Figure 4.1
The broken phytosaur skull lies in its plaster jacket with a long crack through its snout.

specimen to be turned over while supported inside the jacket. The workers did not have to say that the jacket should have prevented this damage; they all knew it. Only Jay touched the broken skull, while the others asked him subdued questions about how it may have broken and how to fix it. A collection manager, for instance, offered an idea as a question to Jay: "Flip it out [of the jacket] into the sandbox? Would that work?" Jay said shortly, "Uh-uh," meaning "no," and the collection manager did not question Jay's rejection. Mostly the staff members stared at the fossil, with long moments of shocked silence.

When the visiting researcher came in, the silence turned accusatory. With remorse, she explained that the skull must have broken when she and the collection assistant had turned it over, which, she swore, they had done with the clamshell jacket. Researcher Henry suggested that perhaps the jacket did not fit well and so had not protected the skull during turning. Jay checked the jacket and rejected that possibility: "There's contact on both sides. . . . There's not a lot of movement in here." Again no one argued. Jay's judgment was the end of the conversation. Jay told the assembled mourners that he would line the empty half of the jacket with plastic wrap,

turn the skull over into that half, and then lift out the bone crumbs to reattach them as best as possible. No one questioned his plan or approved it, or said anything at all. They understood that the skull would never be quite the same. Jay left the room to report the broken specimen to researcher Maurice, telling him that he suspected that the visiting researcher had tried to lift the fragile skull out of the jacket to study it. Maurice asked, "Well, there isn't any other way to break it, right?" He had faith in the jacket, which a preparator had made, and assumed that such destruction could only result from mishandling.

The scientists and collection staff did not know how to fix the fossil; they knew only to call a preparator. Then Jay was in control. The only conversation was in the form of questions to him, and his judgments were the deciding ones. Maurice's trust in the clamshell jacket further reflects scientists' confidence in preparators' expertise in specimen protection. This crisis made the distinctiveness of preparators' and researchers' skills as well as jurisdiction (Abbott 1988) strikingly clear. Which group has power in which situations reflects how these groups perceive their differences and, crucially, their shared purpose and raison d'être: science.

This chapter investigates the social roles and power structure between the two groups of research workers whose tasks are the most interdependent: scientists and preparators. Preparators' jobs rely on scientists' requests, and scientists' ability to study specimens relies on preparators' work. (This coreliance is not as significant for conservators or collection managers, who are concerned with specimen collections regardless of whether the objects are prepared or studied.) Sociologist Pierre Bourdieu characterizes people who do similar work and share entry criteria as a "field," which is a helpful framework for categorizing groups of research workers. These groups of workers have various combinations of "capital" (i.e., experiences and skills), "habitus" (i.e., work practices), and "doxa" (i.e., beliefs), thereby designating them as separate fields (Bourdieu and Wacquant 1992, sec. II; Bourdieu 1993, chap. 9). Sociologist Aaron Panofsky (2011) has shown how field theory can illuminate how interdisciplinary communities exchange different kinds of capital; here, I apply it to multidisciplinary communities

to analyze how separate fields work in parallel and coordination, yet with autonomy and distinct identities.

My aim is not to study demarcations between so-called scientific and technical work, which oversimplifies the divisions between research workers. Instead, I describe the fields that scientists and preparators enact for themselves and each other. This approach offers insights into how members of different fields collaborate in research communities, and how that collaboration reveals and helps define how these groups understand what it means to do science. Members of multidisciplinary research communities are united by their pursuit of a common vision of science, which they work to achieve while also advocating for their field's values. Specifically, scientists and preparators all want a researchable fossil. Preparators focus on making the fossil stable, protected, and undamaged, while scientists concentrate on gleaning the most and highest-quality data from it. Together, these priorities inform preparators' work in ways that satisfy both groups. This chapter studies how practitioners from separate fields prepare that common vision by enacting their divided labor, protesting when one group violates another's jurisdiction, and discussing their interrelated work to align it with each other's values.

Power in Context

Workers in vertebrate paleontology labs perceive science as a conglomeration of separate fields. This view has potential epistemic benefits, such as reducing theory-laden observation by distancing scientists from the preparation of evidence (chapter 3; Wylie 2019a, 2019b). It also justifies scientists' omission of fossil preparation work from publications because that work belongs to a different field. As a result, scientists don't pay much attention to how preparators make fossils researchable and thus preparators have de facto autonomy over their work. Scientific recognition—and the lack thereof—is a crucial mechanism of defining group identities and preparing a local conception of science as the goal that a research community works toward together. Like the preparation of evidence, communities, and technologies, the preparation of science is iterative, ongoing, and context dependent.

Less obvious, perhaps, are the social benefits for technicians of creating distinct spaces, responsibilities, and kinds of expertise for a research community's workers. By granting technicians (as well as scientists) autonomy over their work, this separation empowers all practitioners to develop their skills, train novices, choose and design techniques, and decide their own conceptions of good work and workers (i.e., to prepare their community, technologies, and evidence). This "craft control" (Keefe and Potosky 1997) encourages technicians' commitment to their field and institution, unlike demoralized workers who feel unappreciated. For example, one scientist told Barley and coauthors (2016, 143), "I have seen lab directors ruin their lab by giving orders to a technician. . . . A month later, the tech is looking for a new job and the director is left holding the bag." Control over techniques is a sign of expertise and respect, and receiving instructions from people in other fields can be interpreted as an insult.

Defining skill and identity relative to other groups is common in research communities. Doing (2009) describes a separation between physicists and "operators" based on their definitions of expertise. The physicists portray their expertise as abstract and theoretical, and operators perceive their expertise as manual and experience based, demonstrated by making lab machinery run effectively (Doing 2009, 58–59). Doing argues that these disparate beliefs allow each group to claim power over their own work, despite the formal status differential and the groups' de facto interdependence. While preparators' view of their expertise—as skillful and creative—matches abilities traditionally ascribed to high-status artists and scientists (chapter 1; Wylie 2015), Doing's operators present an opposite conception of expertise from that of their researcher-bosses. Both groups are trying to define themselves, but with different reference groups: for preparators, against the stereotype of protocol-following, low-status technicians, and for operators, against the high-status, theory-focused scientists who are—according to the operators—incompetent at using lab machines. Thus technicians may be less interested in authorship or useful objects than they are in the power to direct their own work.

Low or high status in research publications and institutional hierarchies has a major influence on research work, but as a shifting, local,

context-dependent practice rather than a predetermined status quo. A more accurate indicator of groups' relative power is context-based (in)visibility, which can confer control in unexpected ways. For example, museums' so-called scientific staff (i.e., scientists) and support staff (i.e., everyone else) have different expertises, but institutions tend to value research expertise over all other kinds. A similar distinction exists between factory managers and "unskilled" workers, because managers consider "unskilled" work inferior and yet don't actually know how to do that work (Kusterer 1978, 14). As a result, the supposedly unskilled workers control their work by choosing how to complete tasks and train novices (Kusterer 1978, 42–44), as preparators do. Preserving this knowledge separation "added to the workers' autonomy and decreased their alienation," thereby improving their job satisfaction despite their low institutional status (Kusterer 1978, 14). Barley (1996, 429) similarly observed that "our data are inconsistent with the view that a technician's knowledge is a proper subset of what another occupation knows. . . . A more accurate image would be that of intersecting sets." All fossil researchers and preparators, for instance, can distinguish fossil from rock, but in general only researchers know the unique characteristics of different species, and only preparators know how to remove matrix safely and effectively. Both groups need each other's expertise in order to prepare fossils to serve as evidence.

Likewise, biology research workers consider their expertises separate but equally important: "The technicians possessed most of the contextual knowledge of empirical matters whereas scientists were masters of formal representations. Because scientific productivity required both forms of knowing, scientists and technicians considered themselves to be *mutually interdependent*" (Barley and Bechky 1994, 119, original emphasis). Contextual knowledge means knowing how to use experiments and equipment to achieve desirable results. The embodied, adaptive craft of preparing evidence is a form of contextual knowledge. These biologists and technicians recognize their need for each other's knowledge, yet the technicians nonetheless have low institutional status. This situation "reflected a disjuncture between institutional and everyday evaluations of the importance of contextual and formal knowledge" (Barley and Bechky 1994, 116).

This disjuncture appears in preparation labs too, and may be common in research communities.

Differences in research workers' power can also be explained by differences in their goals. Technicians report that they work because they "love" and enjoy their jobs (Zabusky and Barley 1996, 197)—sentiments that preparators express frequently and paleontologists articulate less often, perhaps for fear of sounding too emotional and not purely rational. Sociologist John Law (1994, 123) found that synchrotron technicians named pay as their motivator, but acted as though pride was their aim by valuing autonomy and good work. In comparison, physicists told Law that success in their field was their goal, and acted accordingly by valuing respected experiments and publications. As a result of these disparate stated goals, physicists assumed that technicians were "passive, uncreative, and unskilled" and treated them that way, such as by giving them instructions rather than allowing independent work (Law 1994, 123). De Solla Price (1965) similarly argues that scientists write as many papers as possible for personal glory and to add to the "eternal archive" of knowledge, but they rarely read papers. In comparison, "technologists" rarely write papers but often read them, preferring to update their knowledge over sharing it and to measure their expertise by the production of objects or processes, not papers (de Solla Price 1965). Communities distinguish among fields in many ways, suggesting that workers' skills, motivations, and tasks are important indicators of social order as well as the more formal measures of job title, credentials, and pay.

HOW SCIENTISTS AND PREPARATORS DEFINE SCIENCE BY DEFINING THEMSELVES

There are social and epistemic benefits to dividing research communities into fields, despite these fields' interdependent expertises. Conflicts arise, however, when these fields do not have equal institutional status and thus their power dynamics depend on context. For example, as in the case of the phytosaur skull, preparators are in charge in situations of broken fossils. In comparison, scientists choose which specimens to be prepared. Other

contexts, such as setting deadlines for preparation work, require negotiation and shared contributions. In addition to different responsibilities, scientists and preparators enact different social norms (a form of habitus), such as their language and sense of humor. Understanding how these groups differ and how they work together sheds light on how they perceive their work, and thus what they understand science to be.

Prioritizing Specimens

Researchers request the preparation of what they deem the most scientifically significant specimens. That judgment is not inherent to particular fossils or researchers; rather, it changes based on what preparators reveal and what other projects might arise. Like many researchers, Preston monitors preparators' progress to inform the kinds of data he prioritizes: "As things are being prepared, you make decisions on what you particularly want to see." These ongoing decisions are crucial because of the long time frame of preparation work. Preston explained that he had asked a preparator to leave one fossil half embedded in matrix because "I could get all the information I pretty much needed from that level of prep, so taking it out further would simply have just cost a lot more prep time without necessarily too much research benefit." Maximizing research output involves minimizing preparation time, such as by prioritizing the most interesting aspects of the most scientifically valuable fossils based on dynamic assessments of the ongoing preparation work. Preston portrays preparators in a way reminiscent of Taylorism, in the sense of optimizing workflow as though the lab were a factory. But he doesn't suggest streamlining preparators' work. Instead, he adapts his requests to them in order to maximize his research benefit. Preston, as a researcher, seems to perceive how preparators manage their time and assignments as black boxed or irrelevant.

Because preparation reveals new information that can change researchers' priorities, workflows require communication. Preparator Bill's work depends on researcher Frank's priorities: "We always need to keep in touch with [Frank], as to asking him questions. 'Is this where you want us to work? Is this on the front burner now or is *this* on the front burner?' Things are always changing in our projects." Moving specimens to the front burner

Figure 4.2
Specimens in progress are carefully arranged as a physical to-do list on a table in a preparation lab. They are stored in various boxes, specimen drawers, field jackets, and plastic cups, and surrounded by written notes, specimen labels, sandbags, and foam pads.

means Frank wants to study them soon and so they need immediate preparation attention. Likewise, for preparator and conservator Laura, researchers set her projects, but she plans her work: "We get given a list of things for the year, and we talk to the curators and see which are urgent. We'll have ongoing projects as well, so they're the ones that will get put on the back burner." This recurring burner metaphor captures the flexibility of paleontology work environments in that researchers promote and demote specimens' priority levels depending on changing information (figure 4.2).

Preparators accept this system of dynamic assignments, mostly without complaint. Preparator Max, for example, works on fossils according to researchers' changing requests:

> I've had some pretty amazing projects put on hold for years because something cooler comes up. One year you'll start digging up some really neat sauropod and you'll get part way through preparing that, and you go out in the

field and you dig up a really neat theropod or you find a mammal skull, and all of a sudden that takes priority. I don't have a whole lot of choice over that, and sometimes that sucks, but most of the time . . . we're on the same page, "Yeah, this is exciting stuff, let's do it."

Researchers' changing priorities can be frustrating for preparators, but being on the same page suggests that preparators understand the reasons for researchers' sometimes erratic to-do lists. In comparison, preparator Steve pointed out that *not* having researcher-determined work assignments would be inefficient: "If I was allowed to go select what I was going to prepare, I'd have a fantastic [lab] bench full of oddities. But it possibly might coincide with none of the researchers' studies. . . . You can't have these prepared fossils just sitting waiting for the next twenty-five years, because somebody's paid me to do that." While Steve would love to work on fossils of his choice, he justifies researchers' power over his assignments as more economical for the museum. Note that he does not explain this system as preparators following the orders of a higher-status boss. Instead, like most research workers, he portrays the processes of preparation and research as separate, implying a division of labor between experts of equal status in different fields.

Setting Deadlines

Deadlines can be contentious for researchers and preparators due to different priorities along with disparate expectations of preparation time. One preparator's workplace plight was infamous among preparators for being an extreme example of researchers forcing faster work: "We were so pushed by our boss to get a particular project done that it led to huge tensions. In fact, we went over his head to his supervisor and said, 'Look, this is unhealthy, it's bad for us, it's bad for the fossils.'" The boss viewed preparation as a roadblock to research and therefore a task to finish quickly, while the preparators saw it as a process requiring skill, time, and patience. This difference in values led to conflict, which was intensified by the groups' unequal institutional statuses. The preparators' appeal for the well-being of the specimens ("It's bad for the fossils") reflects their own concern as well as perhaps an assumption that the boss and supervisor

might be more likely to slow the work pace for the *fossils'* sake than for the preparators'.

These firsthand stories are rare, however. Most preparators told me stories about other preparators' forced deadlines because they personally hadn't had this problem. Stories like these make Marc grateful for his sympathetic bosses, because "some people have pretty scary bosses who want shit done fast." Luckily, negotiating deadlines typically involves both groups' empathy for each other's goals. Steve, like most preparators, fears that obeying researchers' demand for speed entails destroying data:

> If I'm preparing something and I find a little tooth next to a bone, there's some interesting taphonomy there. Has that tooth washed in, or is that where something bit that bone and the tooth fell out? It's not for me to decide, but I need to leave that tooth there, whereas someone else might say, "Oh, bloody tooth in the way, take that off. Now there's a nice clean bone so I can see all the faces."

Researchers' need for quick preparation of the specific parts they want to study, which enables quick publication, can be at odds with preparators' goals of careful work and the long-term conservation of specimens. Steve's distinction between explaining an unexpected find and preserving that find captures the division between researchers' and preparators' perceived responsibilities, respectively. Balancing these responsibilities arguably helps produce a more complete fossil that can inspire more interesting interpretations.

When I emailed the PrepList to ask its members about using cyanoacrylate versus reversible adhesives, their answers were much broader in scope than just choosing glues. Specifically, they made rousing statements about preparators' role in counteracting researchers' potentially destructive impatience. For instance, preparator Bill responded to the list, "One of the most controversial issues we face is the continuing tension between the aim of preparators . . . to do the least harm to a specimen and preserve it as well as possible into the future, and the frequent need/desire/preference of researchers to have specimens prepared quickly, reassembled,

and cast" (Wylie 2009, 10). This perception of preparators as protectors of specimens becomes problematic when preparators, as support staff, are asked to prepare specimens quickly. Another respondent, Pete, used militaristic language to emphasize preparators' duty: "Preparators have the responsibility to speak for the long-view conservation of specimens to their administrative superiors. We are the first line of defense" (Wylie 2009, 11). Balancing preparators' and researchers' priorities is a major source of discussion and sometimes discord.

Preparators tend to portray researchers as impatient or pushy. Researchers define this characteristic more positively as, in Preston's words, "result oriented." Researchers' focus on papers and technicians' stress on objects has been long noted (de Solla Price 1965), and in paleontology labs, workers recognize these differences and try to compromise. For example, Marc finds deadlines in his lab to be negotiable: "Sometimes we prep to a deadline, but . . . my bosses have also appreciated the importance of slowing down. If I go to them and say, 'You're not going to get this on this date because of reasons X, Y, and Z, like, something's cropped up, this area's really smashed, we can't clean it up really rapidly,' they listen. In general."

Discussion between preparators and researchers allows both groups to share their goals and values, such as quick access to a prepared fossil versus allowing time for careful preparation and dealing with unexpected complications. After all, neither researchers nor preparators want damaged or badly prepared fossils. Allowing preparators to set their own pace prevents poor work and thus protects fossils. This system also benefits social relations: giving preparators input into their schedules makes them feel empowered, responsible, and respected, as opposed to low-status workers who are pushed to produce such as on factory assembly lines. Thus even though scientists set the deadlines, technicians can challenge those deadlines based on issues that they identify, such as surprise discoveries or the need for conservation. Furthermore, scientists rely on preparators' expert assessment to produce the best-possible specimens, making the power to revise deadlines more like a collaboration than a low-status worker begging a boss for more time.

Choosing Techniques

In some research communities, technicians have similar training and tasks as scientists; in others, scientists value technicians for their mastery of skills that scientists themselves lack. Scientists and engineers who analyze structures for earthquake resilience, for example, are grateful for the lab technicians' expertise in construction, which is crucial for building test structures that yield reliable research results (Sims 1999). Scientists and graduate students even learn their basic knowledge about constructing test structures from the technicians. Likewise, preparators are the experts on how to remove matrix, repair breaks, and mold and cast fossils as well as, crucially, how to prepare technologies for these tasks. Preparators and scientists agree that most scientists don't know how to design, select, or even apply preparation techniques. For instance, Carla said that researcher Luke does not tell her which techniques or tools to use on a specimen "because he wouldn't know." Carla surmised that if she asked for his guidance, Luke would say something like, "You're hired to do this. You're the expert. I leave it to you." According to Carla, her expertise—and job—centers on choosing methods, so of course a researcher would not tell her how to prepare fossils.

Preparators relish the power derived from having knowledge that the scientists need. As Steve said,

> One of the joys of being a preparator is the fact that nobody can tell you how to do it. . . . The researcher or the people on [the] exhibition [team] will just say what they want the thing to look like, or what they want to see on that specimen. How I actually go about giving them that information is entirely up to me, so I can use air pens, I can use grinders, I can dissolve the rock away using acid.

Deciding what they want the thing to look like is the domain of the end users, namely researchers or exhibit designers, while choosing ways of accessing that information is preparators' domain. Preparator Erica was shocked and a little insulted by the idea that researchers would choose preparation methods:

> **Caitlin:** So would [researcher Frank] tell you to do things in a certain way?

Erica: No, no, no, no. No. We're all sophisticated here enough and good at what we do enough to know what we have to do. . . . Unless it's otherwise not feasible to get it done, then we'll tell him, "That's not possible."

Preparators' commitment to selecting and adapting their methods, as discussed in chapters 1 and 3, is evident in Erica's adamant "no" response. She, like many preparators, claims responsibility for judging the feasibility of researchers' requests and, if necessary, rejecting them. Kevin finds himself in that position often: "Our experience is to overrule the curators" when choosing techniques. Researchers are not expected to know about preparation methods; hence preparators can "overrule" researchers' requests thanks to their expertise, despite researchers' higher status. Researchers agree that preparators should select methods. As Maurice humbly put it, "I have a lot of respect for what [preparators] have to do with the materials and for the fact that I know I can't do it."

Moreover, Preston thinks that fossils benefit from the separation between researchers and preparation work: "In the case of most scientists, it's probably not a good idea to have them do prep. . . . We focus more on what the scientific results might be, and less on the concern for doing it right and getting the specimen stable." This researcher agrees that separating researchers' and preparators' fields could protect fossils from rushed researchers. Distancing scientists from evidence production could also promote objectivity by preventing scientists' assumptions from influencing the evidence, as discussed in chapter 3 with regard to CT images. Yet paleontologists do not articulate this reason of epistemic defense; rather, they subtly dismiss preparation as merely manual work. Preston continued, "I trust [preparators'] judgment. They have the better knowledge of the particular adhesives. . . . That level of decision on it is not normally something I take part in." As his tone of voice implied, that "level of decision" means a lower-status level that is not important enough to merit his high-status paleontological expertise. Ironically, scientists' disinterest in preparation decisions empowers preparators to choose their techniques and to identify as experts and, in some cases, defenders of the specimens against

the scientists. But, of course, scientists and preparators both claim that their priority is to serve science by preparing good evidence.

Talking as Scientific Practice

To align their respective goals, researchers and preparators regularly discuss and negotiate. Maurice said that he frequently goes to the prep lab with an unprepared fossil and "specific questions. 'So if I want to see this, this, and this, is it possible?'" Checking in with preparators is important to Maurice because "if we're not conversing about it, then what [the preparators] might want to do may impact something I want to do later with the specimen." Discussing both groups' priorities and limitations is necessary in part because there are so many options for preparation techniques. Laura considers meeting researchers' needs as a way to protect specimens, not just a case of following instructions from a boss: "We always try and consult the curator to see how often [a fossil] is used and what it's going to be used for. I mean for simple things, like which side up should the crocodile jaw be stored, because are you interested in the eye sockets or the mandible? . . . To reduce the amount that it's going to be handled and shifted and turned over." Tailoring specimen storage to researchers' needs minimizes fossil handling and thus damage, which reduces future repair work for preparators. Communication is considered so key that it sometimes delays preparation work, which frustrates Steve: "If I need the researcher to come down to look at something before I can continue forward because they need to say, 'Yes, you can remove that bone' or 'No, I need that left there,' if they don't come down for a week or two, then that's a week or two that I've lost, and I can't undo it." Despite his aversion to losing time—an interest keenly shared by researchers—Steve values knowing researchers' priorities enough to wait. It is not always preparation, then, that slows down research; researchers and preparators also consider information exchange worth waiting for. A communication failure can cause wasted time, overdue specimens, and prepared fossils that don't reveal the features that the scientists want to study.

Despite their frequent conversations, preparators and researchers use language differently. This is a powerful indicator of separate Bourdieusian

fields. After all, knowing a group's "practice language" indicates membership and belonging in that group (Collins 2011). Because researchers' and preparators' tasks are interdependent, we might assume that they share a practice language. However, examples of preparator-specific terms and, revealingly, humor suggest that these groups have distinct practice languages. This difference could be problematic because knowledge cannot simply be "transferred" among occupational groups by shared words; it must be "transformed" to match each group's ways of thinking and working (Bechky 2003). Bechky (2003) observed that technicians act as transformers of knowledge between engineers and assemblers in a factory: the technicians participate in engineers' abstract communication style with reference to design drawings as well as in assemblers' concrete communication style with reference to the objects they build. To communicate, then, researchers and preparators must either use a "pidgin" language to allow simplified interfield conversations (Galison 1997, 832) or understand enough about each other's field to be able to discuss it, which means achieving interactional expertise (Collins 2011, 282–283). Interactional expertise resembles these workers' discussions about fossils because both groups typically understand each other's perspectives. Yet these discussions also involve transforming knowledge so that it makes sense for the other group. Sometimes preparators don't bother to transform their knowledge for scientists, and vice versa. Reserving one's knowledge for one's field can be a way to assert power.

Not all preparators know all techniques and materials, but they are much less likely to confuse or mispronounce preparation-relevant words than researchers are. For example, after I interviewed Kirk, a researcher and collection manager, I mentioned that I had worked as a preparator. He replied that if he had known that, "I would have used the long words instead of the short words, like 'Butvar' and 'resin.'" He meant that he would have spoken preparator language with me, such as by using adhesive names. Kirk actually revealed himself as a *non*preparator, however, by mispronouncing Butvar (a brand name for the adhesive polyvinyl butyral).[1]

Workers use discourse style as an indicator of who belongs to their field and a way to exclude nonmembers. For instance, preparators use scientific

terms such as species names when talking with scientists. Technicians generally are proficient in the practice language of their bosses, though that proficiency is not always reciprocal (Barley et al. 2016, 136). Preparators rarely use scientific terms among themselves, such as by nicknaming specimens instead of using species names. Several preparators call *Priscacara* fish fossils "Priskies," for example, and the Southern Museum preparators refer to specific specimens of stegosaur, camptosaur, and fossil frog as "Steggy," "Campty," and "Froggy," respectively. These diminutive names suggest fondness and informality, perhaps reflecting preparators' affection for specimens from spending many hours preparing them—a long-term familiarity that scientists may lack. These nicknames are not intended to serve as a secret language since they are not difficult to decode. Rather, this subtle avoidance of scientific terms may serve to assert preparators' identity as proudly separate from that of scientists.[2]

Separate Humor

A joke highlights a linguistic and cultural divide between preparators and researchers, while also pointing out preparators' power over scientific evidence and knowledge. I first heard it from preparator Mary, who told me that she and a coworker joke about the pressure to provide what researchers want to see in a specimen. For instance, if a researcher expects to find a foramen—a naturally occurring hole in a bone that blood vessels and nerves pass through (plural: foramina)—in a certain bone, then, Mary joked, she might reply, "You want a foramina [sic] there? OK." The implication that Mary would purposefully bore a hole through a fossil to create a feature that a researcher expects is unthinkable—and therefore laughable—to preparators. It violates their primary priority of revealing data while conserving fossils. This joke thereby makes this priority explicit. Also, using "foramina" instead of the grammatically correct "foramen" shows that Mary knows scientific terms but imperfectly, suggesting that she is a preparator rather than a researcher.

Preparators use the same joke to describe accidentally making holes. Marc worries about unconsciously making a fossil look as he expects it to, which illustrates that technicians' observations are, of course, also theory

laden. Thus his goal is to "follow the fossil, and not try to put too much of my ideas about what it should look like into it, because I think that's where mistakes come from, in a lot of cases. You know, you want a fenestra to be someplace and so you put it there [*laughs*]." A fenestra is a natural opening in a bone that muscles pass through, similar to a foramen. Presenting a mistake—such as a preparator-made hole—as a natural feature is a joke so often told among preparators that it is rather formulaic. Preparators' low institutional status somewhat restricts them from pointing out their necessity to scientific endeavors; instead, they use humor to subtly remind scientists that the coveted fossil evidence is literally in preparators' hands.

This joke depends on the use of scientific terms too, such as foramen and fenestra, to emphasize the jarring misalignment of scientific rhetoric and human work. Mulkay and Gilbert (1982, 592; see also Gilbert and Mulkay 1984, chap. 8) claim that humor is a result of scientists' mixing of ways of describing science: "Participants regularly create the incongruity essential to humour by bringing together two distinct interpretative repertoires . . . which are normally kept separate." Calling a hole made by a preparator a foramen or fenestra is funny both because it is not a natural hole, and foramina and fenestrae cannot be "made," and because the formal scientific terms do not fit the stressful, messy situation of a preparation mistake (or fraud). Normally, such a mistake would belong to the less formal "contingent" repertoire used for everyday lab conversation as opposed to the dry, publication-style "empiricist" repertoire that includes scientific terms (Gilbert and Mulkay 1984, chap. 3). Preparators' infrequent use of empiricist language accentuates the misalignment and therefore the humor.

Humor is important for building relationships among members of a community. Zookeepers, for example, use humor to create social bonds as well as provide distraction from boring, unpleasant work, such as by telling each other poop jokes while they clean animals' habitats (Grazian 2015, 100–101). Humor also denotes members—and outsiders—of a field. Strikingly, only preparators laugh at the foramina joke. This became clear when I witnessed the joke told to an audience of researchers. Henry, a researcher at the Southern Museum, had done more preparation—and

thus spent more time with preparators—in graduate school than most researchers do. His immersion in preparator culture may explain why he was in on the joke, which he told to me in an interview: "We always joke about, you know, making foramina! [*laughs*]. . . . I'm currently studying a specimen that was first exposed by a volunteer at another museum, fortunately not ours, and when the volunteer uncovered the specimen, he made a couple of really nice big holes in it [*laughs*]." A few weeks later, Henry presented this specimen as a new dinosaur species at a conference. Preparation is rarely mentioned in research talks and is not mentioned in Henry's published abstract, but he explained in the talk, with a laugh, that a volunteer preparator "added some foramina" to the specimen's snout. The stakes of this damage were high because as a new species, no one knew whether the animal had foramina there.[3] In his talk, Henry likened the holes to extant animals' "foramen of Winchester"—the bullet hole in zoological specimens' skulls from collectors' Winchester guns. Bullet holes are obviously not a natural feature of animals' skulls and so it is ironic to call them—and the holes made by the volunteer preparator—foramina. But hardly anyone in the large auditorium laughed at Henry's comment about the human-made foramina. It was not clear whether the audience of researchers understood that a preparator had damaged the skull.[4] This lack of reaction suggests that the joke belongs to the community of preparators.

The foramina joke is self-deprecatory when preparators tell it, but it can sound reproachful coming from an outsider. Henry could have been understood to be criticizing the volunteer for clumsy work. Yet he had a lighthearted tone while talking about the false foramina, and at the end he thanked a staff preparator for her "excellent" work on the specimen—an uncommon practice in research talks that shows Henry's respect for preparators. Thus he told the foramina joke as a preparator would—as a humorous way to point out the difficult and important work that preparators do. When I told a group of preparators what Henry had said in his talk, they all laughed. They had apparently already heard and probably told jokes about making foramina. Perhaps preparators poke fun at the potential epistemic significance of their mistakes to lighten the mood around stressful preparation work as well as to assert their power over scientific evidence.

TASK TERRITORIALITY

Preparators Doing Research

The separation and resulting autonomy of researchers' and preparators' fields creates space for them to respect each other's work and skill. This respect's dependence on separateness is made clear when a practitioner conducts another field's habitus, provoking an assault of indignant sanctions from that field's members. This problem is particularly acute when scientists pull rank over technicians, as Barley and coauthors (2016, 152) documented among medical and science technicians: "It was only when superiors wielded the power of their positional authority without concern for the technician's substantive expertise that the web of collegial relations—and the 'trust' they inspired—unraveled." Such conflicts reveal technicians' preference for valuing expertise over institutional hierarchy. Of course, technicians and scientists both act as gatekeepers to defend their respective areas of work (Merton 1973), but their methods differ because scientists are typically preparators' bosses.

The ire that some preparators have faced when conducting paleontological research indicates some researchers' strong opposition to nonresearchers studying fossils. For example, one preparator told me that his researcher-boss "was getting upset that I was doing research on fossils. So I stopped, and I started doing a lot of research into plastics [i.e., adhesives] . . . [as] things that were directly related to preparation." This researcher considered testing materials to be acceptable work for a preparator, unlike publishing fossil research. In another case, a researcher judged it inappropriate for preparators to do any research, including on materials. A preparator therefore faced "a really hard environment" when he and another preparator began testing materials: "We started doing experimentation on adhesives. . . . That was too scientific, too much like research for our boss and he put the kibosh on it. In fact, he stole our glues! . . . Anything that was not simply removing rock from bones and sticking things back together and putting them on a shelf was frowned on by our boss." This strict enforcement of the researcher's perceived division of labor between researchers and preparators apparently defines all experimentation as researchers' domain and only a narrow list of tasks as suitable for preparators. This preparator felt

oppressed by the order to stop doing research, which he perceived as a way for the researcher to unfairly assert power over him.

Researchers' negative reactions to preparators doing research reveal the social significance of fields' claims to certain kinds of work. The addition of unequal formal power complicates this territoriality because researchers can punish technicians in ways that technicians cannot punish them. Gary sympathizes with preparators who do not feel valued by researchers: "I've always had the respect of my boss . . . but there are bosses . . . [who] don't have a lot of respect for the professionalism that we all have, the dedication we have to do them no harm while we're preparing fossils." I understood Gary to mean "do *fossils* no harm," but his words could also be interpreted as "do *researchers* no harm." This seems like an obvious statement, but it implies that researchers can feel threatened by preparations' incursion into research and/or their reduced focus on the specific tasks that researchers rely on them to do. Overall, the fact that only a few preparators have personal experience feeling disrespected by researchers—although all preparators know stories about others feeling that way—suggests that researchers and preparators generally collaborate effectively and peacefully. Their conflicts reflect the closeness of their work and the resulting precarity of their fields' separateness, which they have to continually reassert through territorial disputes about responsibilities.

Researchers Doing Preparation

Researchers can likewise incur preparators' wrath by preparing fossils. Preparators, however, must express their disapproval more subtly than simply forbidding researchers from removing matrix. I happened to interview researcher Tom on a day when he had crossed the boundary between researchers' and preparators' domains of power: "I went down there [to the prep lab] today after a frustrating meeting. . . . Every time before I've saved [preparator Jane] weeks' worth of work by chopping a slab down. . . . This time I did it and I broke the fossil [*laughs*]. So I apologized and kind of crawled out of there" (figure 4.3; Wylie 2016). This explanation demonstrates researchers' characteristic interest in time efficiency. Also, Tom thought he had offended the preparator, which he indicated by apologizing and leaving in shame. (This reaction may also reflect Tom's

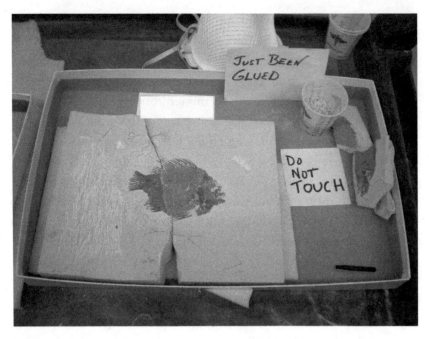

Figure 4.3
A scientist smashed this fish fossil with a preparation technique that its preparator disapproved of. After the preparator made initial repairs to reunite the fish's pieces, she lined the specimen box with notes to warn away the scientist while the specimen's glue dried.

regret at damaging the fossil that he so eagerly wanted to study.) His feeling of guilt suggests that he views the lab and the unprepared fossil as preparators' domain of power, which he knowingly invaded. Tom told me, "I try not to do much preparation, although every now and then I need some mindless thing to do, after a meeting or something, [so] I'll wander down and pick on a fossil. But preparators don't appreciate that." Preparation is a mindless escape from his own tasks such as attending meetings. He knows that preparators don't approve of him preparing fossils, and he often jokes about it. I overheard Jane tell Tom, for instance, that she had pointed him out as a famous paleontologist to a tour group visiting the lab, to which Tom joked that Jane must have actually said, "Here's that darn [Tom] in here screwing up the preparation." This lighthearted view of his visits to the lab is probably an attempt to downplay preparators' frustration

with him. Nevertheless, the preparators quietly complained about his interference in their work and, as further insult, his refusal to use their preferred techniques.

After I interviewed Tom, I sought out Jane. She said that Tom wanted to thin the rock slab containing a specimen of a new fossil fish species using a hammer and a butter knife as a chisel. Jane rejects this method as hard to control and thus an unnecessary risk. She told me in a disgusted tone, "You don't need a butter knife. Take a little time to do it right." Jane said that she warned Tom that the matrix grains are "tight" and would not split as he expected. Tom insisted, and hammered the knife tip against the slab a few times. The fossil fractured into three pieces. Jane reported that Tom had said, "I'm sorry" and "You can call me an idiot," but that she had responded, "No, but I will say I told you so!" She appreciated his apology and felt she had won a battle: "Score one for me in a way. Fish lost, but I won" because she had warned Tom that the fossil would break. Jane hoped that her "win" over Tom in terms of judging techniques would keep him away from the lab. "I don't think he'll be sniffing around here tomorrow," she told a coworker. Despite this victory, Jane was rather shaken. The episode "took the wind out of my sails," and she left work early. Her dismay encompassed the damaged fish, her insulted sense of expertise, and the disrespect Tom's destruction showed for the hours of meticulous work she had already invested in the fossil.

As usual, hierarchy complicated the interactions between this researcher and preparator by making the discussion rely on differences of institutional power rather than expertise. Jane remarked to me that Tom is a researcher and her boss, "and he's [Tom]. He's going to do it anyway" despite Jane's warnings. "What can you do?" she said, smiling sadly, perhaps because she felt powerless to protect fossils from her boss. Another preparator said, "[Tom] used to drive me nuts" by preparing fossils—often poorly—in the lab when no one was around. "You'd be afraid to go to lunch" in case Tom came in. To protect fossils from Tom's preparation, this preparator had installed locks on the lab's specimen drawers. Preparators and other workers took advantage of the broken fish episode to enact some power over Tom by teasing him to his face as well as criticizing him behind his

back. Denigrating researchers' incompetence at preparation celebrates preparators' skill in comparison.

The power dynamic also shaped Jane's assessment of the broken fossil when she and I were alone in the lab. She said that the fish had broken apart cleanly, meaning with edges that fit together closely, because she had already applied a weak adhesive over the entire fossil to strengthen it. By taking credit for the fossil's clean breaks, Jane asserted her expertise and claimed that she had done the "right" technique, just as she had advocated against Tom's "wrong" one. Jane was also confident that she would be able to reassemble the fish because of its clean breaks and scientific importance. Furthermore, "I think it'll be easier" to prepare the fossil now than before it was broken. Jane immediately realized what she had admitted, turned to me, and said adamantly, "Don't you dare tell [Tom] that! Caitlin, I will get you with my pin vise!" The threat, though of course not intended, communicates her fierce desire to not let Tom win by admitting that his preparation had perhaps had the effect he intended: to reduce the time Jane would spend preparing the fossil. The broken fish reveals a researcher's power to carry out a preparation technique despite a preparator's opposition. By complaining about the researcher's preparation work to coworkers, the preparator reinforced the idea that researchers and preparators have different expertises and should therefore stay out of each other's areas of power. This approach is not always effective, as shown by Tom's years of preparing fossils in the face of preparators' resentment. But clearly members of both fields know the agreed-on demarcations of their fields' jurisdictions, even if they don't always follow them.

FROM PREPARATION TO FACT

A Fish's Tale

To illustrate how scientists' and preparators' work interlocks and reflects their shared notions of what science is, I analyze one fossil's journey from being freed from rock to being described in a publication. This process was surprisingly difficult for me to observe because the timeline for fossil-based knowledge preparation tends to be long and unpredictable, and because

institutions' collection databases don't typically include information about specimens' preparation or publication. The methodological difficulty of accessing these apparently discontinuous processes may imply that preparation and research occur in separate times, spaces, and/or fields from each other, making them tough to correlate. But I don't think that's the case, even if record-keeping practices present them as unconnected. After all, researchers and preparators regularly peer over fossils together to discuss future plans. Rather, it seems to me that they have little interest in each other's work beyond what they need to achieve their own goals. When I asked a few preparators years later for publications about the specimens they'd prepared during my visits, they didn't know whether those specimens had been studied, didn't know how to find out, and didn't much care. I didn't think to record the accession numbers of the fossils I was watching under preparators' tools. This unfortunate oversight means that I can't search for papers that mention that accession number or ask scientists whether they have published about a particular fossil. Luckily for me, one preparator published a paper (Van Beek and Brown 2010) detailing how she prepared a particular fossil that a scientist later designated as a new species in a journal article (Grande and Hilton 2006). As a case study of how a research community prepares its beliefs about what science is, I draw from these publications and interviews with the fossil's primary preparator and researcher to shed light on how preparators and researchers understand their collective work.

Sometime in the late Cretaceous, in a bountiful, salty sea overlying the middle of what would become the United States, a 2.5-foot-long fish was sheltering in and perhaps snacking on the bloated carcass of a hadrosaur, a duck-billed herbivore dinosaur. Suddenly, "both animals were quickly and completely covered by sand, trapping and burying the fish" (Ancell, Harmon, and Horner 1998) and fossilizing it, ironically, inside its potential prey. Seventy-eight million years or so later, in the 1990s in central Montana, legendary paleontologist Jack Horner and the field crew of the Museum of the Rockies found what they called a "gar in a duck-bill" (Ancell, Harmon, and Horner 1998; Grande and Hilton 2006, 8). The crew "rough-prepared" the fish, identified it as a gar, and presented it in a

poster at the 1998 SVP conference (Ancell, Harmon, and Horner 1998). A few years later, Lance Grande, a fish expert and curator at the Field Museum in Chicago, asked to borrow the specimen, which he identified from a photograph as a sturgeon, not a gar (Grande and Hilton 2006). In 2003, Horner mailed the fish to Grande. "After many months of additional fine preparation of the specimen, it revealed amazingly detailed information on the skeletal anatomy of this Cretaceous species" (Grande and Hilton 2006, 1). Based on that information, Grande and Eric Hilton (2006), a postdoctoral researcher, named the sturgeon the type specimen of a new genus and species.

The sturgeon's story is relatively clear, but how its fossil moved from a hadrosaur's belly to the pages of the *Journal of Paleontology* is not. To help fill this gap, Van Beek, the fish's preparator at the Field Museum, published a rare paper about preparation methods to explain her work on this unusually well-preserved fossil (Van Beek and Brown 2010). The paper drew from presentations that Van Beek gave at the 2005 SVP conference and the 2008 Fossil Preparation and Collections Symposium. Preparator Matthew Brown had brainstormed ways to prepare the sturgeon with Van Beek, and he encouraged her to publish about it. According to Brown, Van Beek emailed him her presentation slides and notes, and Brown wrote the manuscript. They both thought the story of her work to prepare the sturgeon served as a powerful example of "how great preparation helps the science," as Van Beek told me. How she imagined and achieved this great preparation shows how she conceptualizes the science that it contributes to. In an email to me, Brown explained his motivation: "I really wanted the story of the specimen told . . . to plant a flag contradicting the Grande and Hilton [2006] assertion that 'we [the authors] spent several months fine-preparing the specimen.'" Brown believed a paper would properly award the credit for the preparation to Van Beek instead of the scientists, while also documenting the complex preparation more accurately than the basic description that Grande and Hilton (2006) published.

The sentence that goaded Brown to publish appears in a section titled "Preparation Methods," a rare occurrence in paleontology publications. It consists of one paragraph explaining that "we" prepared, documented, and

disassembled the fish's bones (Grande and Hilton 2006, 3). For example, the scientists wrote, "The matrix was a soft, loosely consolidated sandstone that we removed with sharpened needle pin vises under a microscope" (Grande and Hilton 2006, 3). But it was Van Beek, who is not an author on the paper and did not contribute to this paragraph about her methods, who removed the matrix with pin vise tips that she had designed specifically for this challenging task. The "we" seems at least inaccurate and at most, as Brown interpreted it, insulting.

I surmise that the scientists wrote a methods section in part to defend their unusual decision to disassemble (or "disarticulate") the bones of the fish's skull. Disassembling fossil skeletons is controversial because it destroys the bones' original positions relative to each other and risks damaging the bones while separating them. But it grants three-dimensional views of each individual bone, which enables scientists to describe them in detail and compare them more easily with other specimens' bones. The scientists justify this decision in the methods paragraph: "Because the specimen was unique, well articulated, and unusually complete, we dissected it in stages, and were careful to photograph and draw each stage of disassembly for documentation in this paper" (Grande and Hilton 2006, 3). (Like Van Beek, the individuals who photographed and drew multiple beautiful depictions of these bones are obscured by the authors' use of "we" and named only in a brief acknowledgments paragraph.) This serial image making is an attempt to reduce the information loss inherent to disassembly. Nonetheless, Grande told me that Horner, whose employer, the Museum of the Rockies, owned the sturgeon, did not hesitate to agree to the fossil's preparation and disarticulation. According to Grande, the Museum of the Rockies "got a good deal" because the fish "was a lump of nothing when they sent it to us . . . and now it's a holotype." He meant that the museum benefits from the prestige of the specimen's new scientific importance, made possible by Van Beek's preparation and Grande's analysis, which were free for the Museum of the Rockies. This portrayal of a win-win situation, though, omits the destruction of the skull bones' contextual information, and the risk of damage during the fish's preparation and transport.

Interestingly, the scientists did not intend to mislead or claim undue credit by using the word "we" to describe the fish's preparation and documentation. When I asked Grande if he had helped prepare the sturgeon, he said, "Yes, I work with the preparators." He explained that he tells preparators what to expect about a specimen, such as where certain bones are likely to be, their shape, their fragility, and so on. He continued, "They're not morphologists. They're artists in the sense they take such skill and care to extract bones out of the matrix. But [Eric and I] are people who know how sturgeons are built." Grande considers his morphological advice part of preparation, and he's right that preparators take this information into account while preparing. Preparators, on the other hand, do not consider morphological road maps to be preparation; for them, preparation is the hands-on work of making that morphology researchable.

This disagreement reflects the two fields' assumptions about what research and preparation are, and therefore what science is. Preparators value the specimens' stability, completeness, and beauty, in part because of scientists' interests in specimens and in part because they consider specimens to be inherently important objects. Preparators see current and future research as reasons to change pieces of nature to be accessible and preserved. This perspective explains their commitment to conservation-friendly techniques and materials as well as their willingness to compromise conservation in exchange for research access (e.g., disarticulating a unique skull to enable the detailed description of a new species). Researchers share preparators' assessment of specimens as a means to achieve new knowledge, but with arguably less appreciation for fossils' inherent value or potential future research. Their interest is more grounded in current research and intellectual contributions as activities that align with how their field measures success. The two groups' everyday interactions, then, are guided by these overlapping ideas about what it is they are doing together. Namely, for preparators, science is making fossils useful and then using them; for paleontologists, science is trying to understand a lineage, an ecosystem, the mechanisms of evolution, or other abstractions. These visions are essentially the same, just with different priorities that (ideally) complement each other to help achieve good science.

Preparing a Species

As a type specimen, the sturgeon is the defining example of its species (and genus, in this case). How this individual sturgeon looks is—and always will be—the gold standard for understanding how its species looked. Van Beek prepared the evidence from which the scientists prepared the knowledge claim that this sturgeon represents a previously unknown species (and genus). The scientists describe the preparation primarily as time intensive—"many months" (Grande and Hilton 2006, 1)—which is likely how they experienced it in their excitement to study this sturgeon. Van Beek, more precisely, reports that she worked on the sturgeon for about 750 hours (Van Beek and Brown 2010, 152), which, she told me, took about a year. How, then, did she transform the rock-encased skeleton into a fully visible, three-dimensional specimen with its individual skull bones separated?

Van Beek and Brown's paper details several tasks that the scientists don't mention. For example, before Van Beek started on Grande's request to remove matrix from the skeleton and dissect the skull, she decided to remove a thick layer of glue that a fieldworker or previous preparator had applied to the fossil, thereby obscuring the bones' surface details (figure 4.4). Van Beek told me that Grande "wanted to see every suture" (i.e., the thin ridges where skull bones meet). Grande, a biologist by training, integrates fossil fish into the evolutionary study of living fish; as a result, he said, "I need anatomical detail that is as close to an extant species as possible." That meant scraping away all the matrix—"every grain of sand," Van Beek emphasized—from the sturgeon. She interpreted this priority to also include removing the cloudy glue. She didn't ask Grande for permission nor about how to remove the glue. Instead, she got to work. Luckily, the glue was Vinac B-15, a reversible adhesive that can be dissolved by adding a solvent. So first Van Beek brushed on a solvent (acetone), but that only made the dense glue "gummy" (Van Beek and Brown 2010, 149). Next, she tried scraping the glue off with a pin vise, which, to her dismay, peeled away the bone surface along with the glue. As a result of this experimentation, she selected "continuous light brushing . . . with acetone" as the least destructive way to dissolve the glue, even though it left the exposed bones "extremely soft and fragile" (Van Beek and Brown 2010, 149). Van

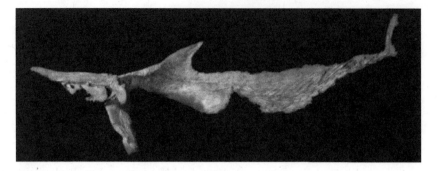

Figure 4.4
This photograph shows a side view of the beautifully preserved, three-dimensional sturgeon after delicate, innovative preparation work and before Van Beek took apart the skull bones (Grande and Hilten 2006, 6, reproduced with permission).

Beek's published description provides far more detail than the scientists' paper (and almost all scientists' papers), yet it still omits the frustration of counterproductive techniques and the patient labor of repeatedly brushing solvent over stubborn glue atop delicate bones. To address the newly glue-free but soft bones, Van Beek, counterintuitively, added more glue. But first she thinned the glue with solvent so that it would soak into the bones rather than solidifying on the surface (Van Beek and Brown 2010, 149). As a result of removing the original glue, "detailed features such as skull sutures, ornamentation and scale tubercles became visible," as Van Beek had hoped (Van Beek and Brown 2010, 150).

The experience of defining a goal, encountering challenges, and experimenting with possible solutions is repeated throughout Van Beek and Brown's paper. Van Beek employed particularly creative and diverse ways to reinforce the fragile bones, including at least three kinds of glue as well as external supports such as adding a coat of resin to serve as a transparent scaffold to hold up the fish's three-dimensional dorsal fin. Van Beek used a watchmaker's oiler (a miniature spatula) to apply the glue of her choice exactly where she wanted it on the fossil, much like how watchmakers lubricate miniscule components (Van Beek and Brown 2010, 150). This ingenious appropriation of another field's tool reflects her expert understanding of preparation problems and creativity to imagine potential

solutions. Similarly, Van Beek (2011) is known among preparators for carving needle-like pin vise tips into purpose-specific shapes, as mentioned in chapter 1. She ground a pin vise tip into a thin, almost-invisible scalpel-like edge to "cut between the very tightly packed cranial elements" to disarticulate the sturgeon's skull (Van Beek and Brown 2010, 152). Before touching tool to fossil, Van Beek thought carefully about her and the scientists' goals, and then selected and altered tasks and technologies accordingly.

Van Beek also changed her plans based on the ongoing influx of in-the-moment information from the fossil. As she meticulously scraped sand grains from the fish, for instance, she came across minuscule double-pointed spikes—a surprise to her as well as the scientists. One of the many figures in Grande and Hilton's (2006, 34) paper (e.g., photographs, line drawings, a scanning electron microscope micrograph, and even an X-ray) shows these "tiny (i.e., < 0.5 mm), sharply pointed denticles . . . [that] were found scattered and loose in the matrix . . . and were mostly removed during preparation." Of course, it was Van Beek who found and, in her words, "saved" them. As a hypothesis for what these denticles are, Grande and Hilton (2006) liken them to spines in the skin of other fish. No mention is made of Van Beek's keen attention and skill to notice as well as preserve these unexpected and easy-to-miss spikes, which created the opportunity for Grande and Hilton to compare them with other species' features to inspire an explanation.

Another way in which Van Beek anticipated the scientists' needs, and thereby shaped the present and future specimen, is by designing a storage box to hold the small, delicate skull bones that she disassembled one by one. First, Van Beek traced a predisassembly photo of the skull onto a transparent sheet, creating a bone map. She then lined the storage box with this schematic as an easy indicator of where each bone had been on the skull, "making their identity far more obvious if the box were ever to be overturned or the elements were otherwise misplaced" (Van Beek and Brown 2010, 152). Then she segmented the box with foam to create a labeled compartment for each bone, preventing collisions between bones and confusion about which bone is which. Van Beek is so experienced with the common problems of collection storage and research, such as lost,

unlabeled, or physically damaged specimens, that she actively engineers ways to prevent them.

Selective Recognition

This case demonstrates that the process of preparing evidence, communities, technologies, and conceptions of science is one and the same. How practitioners divvy up the responsibilities of separate fields reveals their values and social order as well as what they believe they are accomplishing together—that is, their conceptions of science. Their commitment to this underlying purpose guides their practices and interactions to pursue good science, such as communicating, compromising, and respecting each other's priorities for their mutual work.

The two papers' similarities and differences illustrate where researchers' and preparators' doxa align and diverge. For example, Grande and Hilton (2006) focus on the fish's morphology relative to other species, while Van Beek and Brown (2010) consider how to enable researchers to study that morphology now and in the future. Both sides encountered surprises and problems, a few of which they documented in their papers. Both papers include some of the same photographs of the fossil. Both papers defend disarticulation by offering alternative ways of preserving information from the original articulated skull; specifically, the scientists credit the many photographs and drawings, and the preparators credit Van Beek's storage box. Clearly both sets of authors expected some criticism from their colleagues about disassembling such a complete, three-dimensional, beautiful skull. They differ in how they rationalize the disarticulation: the scientists omit themselves from consideration by arguing that the specimen's remarkable preservation and "unique" anatomy justify its dissection, while the preparators invoke the scientists' practices in that their "thorough description of an exceptionally well-preserved fossil sturgeon required nearly complete disarticulation" (Van Beek and Brown 2010, 149). Both papers express the authors' pride in the achievement of disarticulating the delicate skull. Interestingly, the scientists wrote their paper with the pronoun "we," even for tasks that they did not do themselves, and the preparators wrote their paper entirely in a passive voice, a style typical of scientific rhetoric. Thus

the scientists implicitly took credit for all work leading to their knowledge claims about the fish, while the preparators eliminated themselves from their own description of their work. Even with the omission and self-effacement, both papers bestow more credit and documentation than preparators and preparation normally receive.

The preparators' paper documents the techniques with some misgivings as well as pride. They wrote with a regretful tone, "Reversibility was sacrificed in favor of greater strength several other times throughout the preparation of this specimen" (Van Beek and Brown 2010, 153). Van Beek, for example, mixed a familiar adhesive with loose matrix to create a filler for a small gap on one fin: "Elmer's Glue is also not recommended for use in fossil preparation, as it can become brittle, discolored, and insoluble over time" (Van Beek and Brown 2010, 153). The paper emphasizes the importance of conservation-friendly adhesives despite Van Beek's application of some nonreversible materials. This paper was published roughly six years after the preparation work, so Van Beek and Brown may be implying that beliefs about appropriate materials for fossils had changed in that time. Or they may have felt that they had no choice because, as they explain, "Justification was made based on research needs to sacrifice certain aspects of conservation principles in selection of non-reversible adhesives" (Van Beek and Brown 2010, 149).

But the preparators are not blaming the scientists for research needs that are best served with nonideal preparation techniques. They even express muted pride in the outcome of Van Beek's materials and methods: "The delicate specimen underwent frequent handling during photography, illustration, and study. However, it withstood such treatment admirably" (Van Beek and Brown 2010, 152). Van Beek's goal for the preparation, then, was to enable research in the safest way for the specimen's current stability. As a result, she risked the specimen's long-term stability by using some materials that degrade over time and cannot be removed (i.e., are not reversible). Rather than downplaying or apologizing for these decisions, she explains why she made them and how they achieved what she and the scientists wanted for the specimen. This justification can enrich future scientists' understanding of this fossil's appearance. It also serves as

a model for other preparators for how to think about balancing research access with specimen conservation. By pointing out the choices that she considers imperfect or even regrettable, Van Beek calls attention to ways in which future preparators can learn from and improve on her techniques. As a technician, Van Beek didn't have the power to oppose the scientists' goals but could control how she achieved them. Namely, she devised a combination of reversible and nonreversible support systems for the fossil (such as the storage box and the dorsal fin's resin scaffold, respectively), and partially offset the loss of information from the destructive preparation (e.g., disarticulation and complete matrix removal) through meticulous documentation (e.g., detailed notes, photographs, and a methods paper).

Van Beek considers this sturgeon her favorite project of her twenty-year career because of the challenging process of making this extremely complete, delicate specimen visible and beautiful. Grande also praised the prepared sturgeon to me, though in less powerful terms that perhaps reflect the significantly less time he spent working with the fish: "This one came out particularly nice." Grande and Hilton (2006) named the fish's genus *Psammorhynchus*, after the sandstone that preserved the fossil (*psammos* means sand in Greek) and the fish's snout (*rhynchos*), whose large size characterizes sturgeon.[5] It seems ironic for scientists to name a fossil after its matrix, which they typically perceive as an impediment to research and which preparators labor to remove. Yet these scientists credit that soft matrix, along with the fish's holotype status and three-dimensional preservation, as reasons why they decided to disarticulate the skull (Grande and Hilton 2006, 6). Grande remarked to me with a laugh, "We named it after the preparation, of sorts."[6] The work on this fossil illustrates how researchers and preparators take different approaches to serve their shared scientific mission of making sense of nature based on preserved, useful, beautiful specimens.

CONCLUSION: SCIENCE AS A CONNECTOR

Research communities enact their conceptions of science in everyday interactions, such as scientists designating specimens for preparation,

preparators selecting techniques, and both groups negotiating deadlines. These separate fields bring distinct priorities to science as their shared work and purpose. Aligning those priorities is a crucial mechanism of preparing a research community's social order as well as their vision of science. Preparing science also happens in more subtle ways, like when members of a field use language or make jokes in ways that assert power over other fields. Preparing science, then, is a foundational and often implicit component of how fields work together in a research community.

Perhaps their closely related work as well as their need for each other drives scientists and preparators to distinguish themselves by claiming separate expertises, responsibilities, and identities in the belief that good fences make good neighbors.[7] This social order exemplifies Bourdieusian fields, albeit closely interdependent ones, along with Bourdieu's (1993, chap. 9) idea that expertise, as a form of capital, is socially attributed. For instance, as Abbott (1988) points out, professional groups define themselves by fiercely defending the tasks for which they claim ownership from other professions' encroachment, thereby continuously defining each other's relative power in context. These processes of preparing notions of what a community does together are widespread and crucial for inspiring collaboration, communication, and compromise in service of a collective big-picture goal.

As evident in the case of the fossil sturgeon, fields may have different tacit conceptions of good practices and what they are striving to achieve. The scientist, for example, believed that he had contributed to the specimen's preparation, while the preparator laughed dismissively (to me) at the idea of the scientist helping her prepare the specimen. This disagreement arguably inspired the preparator to write a paper detailing her methods, however it did not affect the physical work or the specimen's finished appearance. In comparison, disarticulating the fish's skull forced the scientist and the preparator to articulate their priorities. The scientist was eager to study an entirely visible fish to glean the most comprehensive information and publish his interpretation of it as soon as possible. The preparator wanted the fish to be complete (e.g., by saving the surprise denticles), sturdy enough to be handled (e.g., by consolidating it with both internal chemicals and external supports), and accessible for future researchers (e.g., by storing it

in a custom-made protective box that also serves as a bone map). These goals overlap and are not necessarily contradictory, although a disassembled fossil is more fragile than an assembled one and a more complete fossil takes longer to prepare than a less complete one. Thus these two fields' goals complement each other by preventing rushed, present-centric work while also informing the preparation of specimens that will be useful and interesting to researchers, both now and in the future.

Collaboration and compromise between fields can therefore promote better science by balancing out the extremes of each field's doxa (Wylie 2019b). Strict divisions between fields can also impede their shared work, such as the problematic chasm between scientists and nonscientists. For example, after the 1986 nuclear disaster in Chernobyl spread radioactive particles over British pastures, British sheep farmers and scientists failed to negotiate a response policy that aligned with both groups' priorities. Sociologist Brian Wynne (1989) explains this failure as a result of scientists' refusal to take farmers' expertise seriously because the scientists had higher social status and considered themselves more reliable sources of knowledge than farmers. Hierarchy can certainly impede the communication and interfield empathy that the preparation of knowledge relies on, as we've seen in situations of conflict between scientists and preparators. Hence another interpretation is that the British farmers and scientists failed to prepare a shared perception of what they wanted to accomplish together, such as protecting public health as well as farmers' financial success. Without this unifying purpose, the two fields struggled to align their capital, habitus, and doxa enough to work together. When various fields in a research community incorporate each other's priorities to inform their own work, then the ongoing, dynamic process of preparing science is succeeding. This success is crucial for preparing evidence, communities, technologies, and knowledge that suit everyone involved, including—as the next chapter discusses—the public.

5　PREPARING PUBLIC SCIENCE

A woman with a child approached the windowed walls of a fossil preparation laboratory at the Southern Museum. She pointed at the man inside the walls who was spreading plaster-soaked burlap strips over a nearly finished specimen cradle and exclaimed with excitement to the child, "Look! People making fossils!" It did indeed look like Harry, a volunteer, was making fossils out of the materials around him, including wet plaster, piles of burlap, blocks of wood, a level, scissors, a razor blade, and rubber gloves. In a flipped reality of typical museum exhibits, there were no fossils in sight and there was a live human on display.

Showing visitors how workers prepare fossils portrays science as situated human action, adding nuance and complexity to the facts and objects usually on display. Unlike traditional exhibits, glass-walled labs portray science as ongoing rather than preexisting (Meyer 2011). As a result, this visitor actively constructed her own knowledge about what was happening, based on her interpretation of her own observations. Thus the display both showcased science as a process and encouraged a visitor to conduct it for herself. This approach could mislead visitors into the misconception that research workers are making *up* specimens and facts. Nonetheless, opportunities to apply scientific practices such as observing and drawing evidence-based conclusions (even wrong ones) are arguably what museums strive to provide for the public. Museum staff hope that displaying people at work can increase visitors' interest in the exhibits as well as enrich their understanding of how research is done. Crucially, it also

shows that museums house research in addition to displays. Glass-walled laboratories seem like a rare and intriguing glimpse "backstage" (Goffman 1956) and into the "black box" of scientific practice (Latour 1987; Wylie 2020). How museum staff portray science for the public differs from how communities of practice enact their beliefs about what science is through their everyday work (as discussed in chapter 4). This chapter examines how museums present scientific specimens, work, and workers to visitors, and how museums thereby prepare a conception of science for the public.

The process of preparing displays to communicate proposed conceptions of science is dynamic, iterative, and responsive to contextual factors, which for displays include institutional culture, funding, available collections, and local interest. This process also shapes and is shaped by other knowledge-preparation processes, such as selecting and explaining objects for a nonexpert audience (i.e., preparing evidence), trying to inspire future scientists through exhibits (i.e., preparing community), and designing how objects will be displayed (i.e., preparing techniques and tools). Furthermore, this process serves as a boundary object between groups within and beyond the usual divides of research communities, including scientists, technicians, volunteers, display designers, architects, educators, institutions, and museum visitors. This chapter investigates public science from the point of view of its preparers—namely, museum staff. How the public experiences this portrayal of science is beyond the scope of this chapter, but certainly deserves further research.[1] This chapter elucidates how practitioners use displays as a medium for preparing a conception of science for public consumption. It highlights the tensions between education and entertainment, research and display, and backstage work and public performance. Moreover, it's possible that watching relatable-looking people performing achievable-seeming research work can serve as powerful inspiration for visitors to interpret science as relevant, inclusive, and perhaps participatory.

What Museums Display

The typical and long-established narrative of museum displays presents science as facts, demonstrated by galleries full of beautiful but static

reconstructions of nature accompanied by authoritative text panels (Nyhart 2004; Kohlstedt 2005; Alberti 2008). In comparison, glass-walled exhibit labs portray science as dynamic work done by ordinary people (see figure 0.1 in the introduction). Yet, like traditional natural history dioramas (with their taxidermied animals, plastic plants, painted horizons, and/or mannequins in cultural garb), exhibit labs place glass between visitors and workers. This "fishbowl" design makes science visible though not necessarily comprehensible to visitors. For example, most display labs have brief text panels explaining their work, and a few have ways for visitors to talk to workers, but interpreting what they see is left largely to visitors' inductive thinking. Glass-walled labs thus serve to inspire questions more than deliver answers (Meyer 2011). Glass-walled fossil preparation labs tend to spark so many questions from visitors that lab workers can easily spend more time talking than preparing fossils. As a result, several institutions have purposefully removed communication methods between visitors and workers, such as a phone or a hole through the glass (Gavigan 2009, 16–17; Noble 2016, 256–257). The balance between labs as exhibits and workplaces can be a fraught one.

Noble (2016) argues that including a glass-walled lab in an exhibit lends legitimacy to the fossils and facts on display by illustrating how they were made. This interpretation aligns with museums' long-standing efforts to present reliable knowledge about nature. But a more important function of these labs, I argue, is that they invite visitors to reconsider their knowledge about *science*. A glass-walled lab portrays science as human work that visitors must interpret, thereby somewhat decentralizing museums' typical presentation of finished specimens and knowledge. This approach reverses the role of an exhibit as a source primarily of facts to a source primarily of data. Being invited to make sense of what they see may explain why glass-walled labs are popular with visitors as well as why the enthusiastic visitor quoted earlier might conclude—incorrectly yet inductively—that she was watching a worker build fossils out of burlap and plaster.

How displays portray scientific specimens, knowledge, and work sheds light on museum workers' priorities. For instance, aspects of research work that are commonly made invisible in fossil exhibits include specimen

collection and preparation, reconstruction practices (e.g., filling in gaps and sculpting replacements for missing bones), and how specimens are studied. Obscuring or omitting practices deemed the "background stuff" of fossil research (as researcher Kirk called it) may reflect the prioritization of finished, accepted knowledge. It's also possible that the perception of fossil preparation as a separate field from research has inspired exhibit designers and even the public to consider fossil skeletons and facts to be the most worthy topics of displays. Of course, some displays do explain fossil collection and preparation through objects and text. And some exhibits discuss controversies in scientific knowledge, such as whether dinosaurs were warm or cold blooded, thereby challenging the conception of science as unquestioned facts. Many exhibits label which objects or parts of skeletons are reconstructed (although few describe how these parts are made or how repairs change how a fossil looks). These are steps to present some of the messy, laborious process of preparing evidence and knowledge, though in rather subtle ways that are easy to miss among towering dinosaurs.

Glass-walled labs are more direct. They blatantly display many things that are usually kept out of public view, such as dirt, tools, unprepared and partly prepared fossils, specimen storage containers, people at work, and typical workplace paraphernalia that visitors may not associate with doing science, including lunch boxes, headphones, informal clothes, and dinosaur cartoons taped to lab walls. These aspects arguably make exhibit labs and therefore the science they represent look more familiar, relatable, social, and *human* than other forms of museum display do.

Experiencing Authenticity

Several museum volunteers and staff members told me that visitors often ask "is this real?" about the exhibit specimens, the fossils in the glass-walled lab, and the actual lab and its workers. After all, what visitors see may not align with their previous experience of science as facts, creating dissonance as they try to meld the certainty of exhibit panels' information and the solidity of mounted fossils with this dynamic, disorganized workspace of humans drilling away on unlabeled pieces of dinosaurs. Authenticity has long been a goal for museums (e.g., Haraway 1984; Macdonald 2002;

Lorimer 2003; Nyhart 2004; Alberti 2008; Rossi 2010; Rieppel 2012), but ironically, what authenticity means and how it is achieved is rarely explained to visitors. "Authentic" nature is displayed to the public through the invisible design processes of exhibits, which sociologist David Grazian (2015) calls the "stagecraft" of "nature-making." For example, zoos mimic nature in the design of animal enclosures while minimizing nature's unappealing aspects, such as poop, death, fighting, sex, and, for some visitors, mentions of evolution (Grazian 2015, chap. 1). What institutions choose to make visible and invisible about nature (extinct as well as extant) reflects their assumptions about visitors' expectations and values, including learning and being entertained but not being offended at a zoo or museum. In the early twentieth century, museums began to display animal specimens placed in naturalistic dioramas instead of isolated and decontextualized, reflecting an underlying belief that visitors learn more by (and prefer) viewing reconstructed environments and narrative scenes (e.g., Haraway 1984; Mitman 1993; Rader and Cain 2008). Museums rarely reveal to visitors how these displays are made, probably in an effort to let the displays stand alone as representations of nature. What then do they choose to make visible about *science*?

Display labs seem inherently authentic because they contain real people doing real work with real specimens. But they are nonetheless a performance space. What happens there is somewhat controlled, designed, and censored by lab workers, exhibit staff, and museum administrators. For instance, "risky" fossil preparation tasks that are dangerous for fossils or people are conducted behind the scenes to avoid public surveillance and/or possible harm, such as from loud tools or inhalable rock dust. Scientifically valuable specimens are sometimes prepared off exhibit for security because glass-walled labs tend to be unlocked or several people have a key.[2]

These labs are therefore not sociologist Erving Goffman's (1956, 69–82) "backstage" of research or museums; rather, they house a *performance* of backstage—a public version of the work that shapes fossils as data sources and exhibit objects (Wylie 2020). Similarly, exhibits of "visible storage" offer visitors views of objects arranged in crowded drawers and

shelves as if they were behind the scenes, yet which objects are on view and how they are presented are political, carefully curated decisions (Brusius and Singh 2018; Reeves 2018). Education scholar Joe Heimlich (2013, 132) points out that glass-walled labs have a "fourth wall" as stages do, but their wall is physical as opposed to imaginary (though it is transparent), and blocks contact and most sounds. These labs resemble anthropologists Sharon Macdonald and Paul Basu's (2007) "reflexive" or "meta" exhibits in that they display a process, though these labs show the work of research rather than the work of display as reflexive exhibits do. Also, unlike many reflexive exhibits, these labs are not "spaces of enactment" for the public (Macdonald and Basu 2007). Visitors can look into labs, but can only participate in the work happening there if they become volunteers for the museum, which is a substantial time commitment. Glass-walled labs are a fascinating indicator of what institutions and workers want the public to witness—and not witness—about scientific work.

My aim is not to critique or celebrate these goals, or the resulting displays, but rather to analyze them to understand research workers' conceptions of science, learning, and public access. The constructed authenticity of specimen displays to nature, for example, is not quite the same as that of display labs to truly backstage labs. Display labs are workplaces versus stages of simulated work, as dioramas simulate natural scenes. Work behind glass walls is not a purely public-facing demonstration (e.g., Collins and Pinch 2002, chap. 3), as are museums' performances of historic experiments (e.g., Sibum 2000). Instead, display labs house necessary and skillful research work, which is conducted in ways deemed appropriate for public view *but* not for public view alone. Tellingly, preparators in display labs continue working when no visitors are present. Also, these labs perform the important function of showing visitors that museums do research in addition to their better-known work of displaying and storing specimen collections. Emphasizing research may make museums seem more valuable and credible to the public. Furthermore, displaying research work offers a more active, human-driven narrative of science than does a mounted dinosaur or a text panel about that dinosaur's environment or diet. One problem, though, is that an exhibit lab's work and workers can be just as

mysterious to visitors as a dinosaur's hidden steel frame or the epistemic debates unmentioned in text panels.

In displays of people and fossils, museum workers carefully plan what visitors will see (and not see), and negotiate compromises between best practices for fossils, lab workers, and visitors (Wylie 2020). How does this shift in display style from science as facts to science as work reflect current trends surrounding citizen science, calls for research with "broader impact" for society, and open-access journals and other portals of previously exclusive knowledge? The work and workers of research are becoming more visible to the public at the same time that the public is being invited to participate more in knowledge preparation. Exhibit labs are thus a cause and effect of museums' increasingly comprehensive and inclusive portrayal of science. Perhaps this changing mindset will alter technicians' status from invisible research worker to valued link with the public as leaders of volunteer workforces in glass-walled labs. Even if technicians are omitted from scientists' view of science (i.e., in publications), exhibit labs can make them literally the public face of science.

PREPARING SCIENCE THROUGH DISPLAY

Research Workers' Assumptions about the Public

Museum staff feel a sense of responsibility to provide good displays for the public. Preparator Brad pointed out, "If people aren't coming to your museum, what are you?" Providing people with access to specimens and scientific knowledge as well as an enjoyable visit is a role of museums that research workers embrace, even if it's not specifically part of their job. Brad conveyed a sense of urgency, for example, when he told me about displaying a ceratopsian skull recently found nearby: "The public has to know about this!" Brad and other preparators are committed to educating and engaging visitors, especially about the local environment.

Research workers particularly value displaying information about paleontological practices alongside information about dinosaurs, such as the work of collecting, preparing, and studying fossils. For instance, researcher Emily wants people to understand how dinosaurs looked and moved, and

also "how we got there," meaning how researchers learned about dinosaurs from fossils. Researcher and collection manager Kirk agreed, and admired another museum's exhibit for its images of preparation: "You could actually watch a video of [a preparator] grinding away rock from around the specimen to show how you do it. And they had photographic sequences to say, 'This is what it looked like when we found it, and this is what it was like after a hundred hours [of preparation work], after two hundred hours, three hundred hours." Of course, research workers don't control exhibit design, which may explain why many exhibits don't mention paleontological practices. But, unlike research publications, at least some displays do include information about working with fossils.

Research workers appreciate exhibits as an important way to "extend the discipline" too, as researcher Frank put it. Many of the research workers I spoke with chose their careers because of powerful childhood experiences in museums like gazing up at a dinosaur with its teeth (and everything else) bared. Studies suggest that engaging in science activities outside of school, such as visiting museums, correlates with children's interest in science careers (e.g., Dabney et al. 2012). Designing exhibits to be engaging and educational can inspire the next generation of research workers as well as other people who are informed about and supportive of science. The belief that spectacle encourages learning is old, such as the full-size models of extinct animals at London's Crystal Palace in the 1850s (Secord 2004) and even P. T. Barnum's exhibits of shocking, allegedly natural animals and people (Kohlstedt 2005, 598). This enduring idea is evident in today's zoos' offerings of entertainment experiences such as IMAX films, trained animal performances, and amusement-park-like rides as well as visitors' expectations that animals "do something" to earn their attention (Grazian 2015, chap. 5).

Perhaps visitors' expectation of entertainment contributes to the growing popularity of glass-walled labs in museums for topics ranging from DNA research, astronomy, archaeology, art conservation, and fossil preparation (Gavigan 2009; Meyer 2011; Heimlich 2013; Carvajal 2016). The attraction may be the novelty of seeing people inside a display case, the portrayal of science as activity as well as objects and facts, or the mystery

of typically behind-the-scenes work. Peering into a space where you don't belong also imparts an intriguing sense of spying, like in restaurants with viewable kitchens or construction sites with peepholes in their safety fences. These situations usually involve one-sided surveillance. For example, workers can't see well from the bright lab into the dark exhibit space. They also try to ignore distracting outside activity to focus on their work. The one-sidedness can make the watching feel somehow more clandestine and attractive. For fossil preparation, the strong public appeal of dinosaurs (Mitchell 1998) adds to visitors' interest in exhibit labs. One contributing factor to this appeal is dinosaurs' reputation for large size and predatory scariness—a stereotype that leaves out the vast majority of dinosaur species but nonetheless persists (Noble 2016). Preparator Carla catered to these beliefs when she selected an artist's depiction of an extinct marine reptile to tape to the lab's window above an in-progress fossil of an ichthyosaur. The picture was "not what [this specimen] looked like [in life], but it was the biggest, scariest ichthyosaur I could find" on Google image search, she told me. She decided that visitors would prefer size and fear over accuracy to the specimen in view.

Glass-walled labs are dynamic to watch, but it is not clear how well visitors understand what they are watching. Researcher Emily prefers her museum's portrayal of preparation through detailed text descriptions supported by photos, tools, and fossils instead of a glass-walled lab. She considers glass-walled labs uninformative: "All you do is stare through the glass at somebody with a drill [*laughs*] working on a specimen, but it doesn't actually explain in detail how you go about doing it, what's involved. I'm glad we did that." It's possible that Emily is expressing the common belief among researchers that preparation is boring. But I think her primary point was that watching research work without understanding it is boring. Herein lies a trade-off between entertainment and information. Is visitors' engagement or learning more important to museums? Would museums prefer to have visitors watch workers interact with specimens or read text that describes that work? I watched volunteer William, for example, slide open a fast-food-style window in the wall of the Southern Museum's exhibit lab to talk to a group of schoolchildren clustered outside. Leaning through

the window, he asked them, "Have you been to the dentist?" He followed this unexpected question by holding up and talking about the dental drills and scrapers he uses to prepare fossils—tools that were vaguely familiar to his young audience. One child asked William, "Are you a paleontologist?" He answered, "No, but I work for a paleontologist." William refuted this common misconception that people in display labs are scientists, though without explaining what a preparator is or that he is a volunteer. The children were astonished and impressed, and perhaps they learned that cleaning fossils is like cleaning teeth. Thus this encounter could be understood as both entertaining and educational. More important, it contained the implicit message that people who aren't scientists can do interesting, comprehensible work for scientists, such as scraping rock from fossils with dentists' tools.

A Right to Be Informed

How research workers talk about displaying fossils reveals their implicit conceptions of museums' civic duty as well as of visitors' interests and cognitive abilities. For instance, as preparator Kevin and I walked past a bipedal dinosaur mounted in the Southern Museum's exhibit hall, he pointed at the dinosaur and said, "Somebody took his arms off." My jaw dropped and I stared at the skeleton, shocked by the desecration and implication of theft. There was no sign explaining that this dinosaur normally had arms. A visitor would assume, justifiably, that this species had no arms. (There are stranger features of extinct species, after all.) Then Kevin continued, with deadpan humor, "It was me." A researcher had asked to study the arms, so Kevin had removed them from the skeleton. Leaving the removal unannounced (e.g., no informative sign) and not replaced with replica arms suggests that the researcher's access to the bones took priority over visitors' access. Interestingly, researchers' view of a skeleton as discrete parts—for instance, research-worthy arms—doesn't match the more common view of a skeleton as an animal.

How research workers talk about specimen reconstruction reflects their assumptions about the public. Seemingly simple decisions of whether to fill in a gap between two fossil fragments, and, if so, how to indicate that fill to

visitors, raise complex questions of epistemology, authenticity, and responsibility. Researcher Kirk explained how ideas about visitors' comprehension of science have changed over time: "Back in the day, people used to go to great lengths to make [plaster additions] the same color as the bone. . . . Their reason was it'll confuse people if they can see that some of that's real and some of it isn't. . . . We don't think today that that's an ethical thing to do." Museum staff have long believed that reconstructed completeness, like adding plaster sculptures of missing bones to a mounted dinosaur skeleton, helps compensate for visitors' lack of "skilled vision" (Grasseni 2004) to interpret bones, which scientists and technicians acquire through years of experience. To make fossils accessible to nonexperts, museum staff try to make them look relatively familiar by centering exhibits around complete skeletons (of bone and plaster) rather than fragmentary fossils. But the problem that staff see with historical mounts, as Kirk points out, is that visitors don't know which parts of a skeleton were made by people.

By referring to this issue in terms of ethics, Kirk raises questions of visitors' autonomy and what they ought to be allowed to know. Kirk's view is that reconstruction is a choice and should be explained to the public. As he put it,

> That's something that preparators have to think about when they prepare these things, is they have to make it very clear [that] these are the bits that are real, that we know about, and these are the things that we don't know about, that we don't have, and we're not going to fill them in. Or if we are going to fill them in, then we're going to make it very clear that they're add-ons.

The mainstream approach among research workers regarding reconstruction for display is that add-ons and fills must be visually distinguishable from "real" bones. Methods for distinguishing them include painting them a different color from the bones' natural color or filling gaps to just below the bone surface, leaving a shallow but visible undercut. In my experience, however, the prevalence of specimens on display without distinct reconstructed parts is high. This suggests that other museum staff, such as in education or exhibit design, may prefer uniformity and the "big picture" of a specimen, rather than the details of which parts are real and which are

built. It's also likely that many of today's mounts are historic and do not reflect current beliefs about what information to share with visitors.

These goals of a whole specimen view and visually obvious reconstructions are not mutually exclusive. Laura, a conservator and preparator, described a common way to achieve both: "Everything we do we try and make visible, and we try not to falsify anything, even if it's for display. For exhibitions they have a six-foot, six-inch rule, that the repairs that you've made should be visible six inches away, but could be invisible about six feet away. . . . The overall effect, standing back, makes it look pristine." Pristine for Laura seems to mean complete and cohesive such that a skeleton looks like it is made only of bones. But she doesn't want to hide fills and other reconstructions, which to her implies falsifying the specimen. To resolve these seemingly conflicting goals, exhibit staff consider scale: repairs to bones should look natural from a visitor's view—six feet away—but should look reconstructed from a researcher's view—six inches away.

Interestingly, this solution relies on assumptions about access (i.e., how close a visitor or researcher can get to a specimen) and experienced, skillful vision. After all, researchers know how to identify reconstructions and other artifacts of preparation work such as tool marks even at a distance. Display design incorporates the assumption that the public does not know how to "see" the distinction between fossil and reconstruction, even when they're painted subtly different colors or set at different surface heights. Visitors don't know to look for those display conventions, or, if they do notice, how to interpret the differences to mean that one part is reconstructed (and which one? Or what if the entire skeleton is a plaster cast?). The most common way of addressing this problem is through text panels. For example, preparator Paul criticized another museum for inadequately labeling a mammoth skeleton on display: "The [tusks] that they faked, they painted [them] just a little bit different color so that the average person can't actually tell that there's two different color schemes there. The signage that's being put up this week hopefully will say 'tusks, cast.'" Thus the goal of making specimens look complete and natural to nonexperts is not purely historic. It persists in today's museums, though with more transparency about which parts are (not) fossils.

PRIORITIZING ACCESS FOR SCIENTISTS OR THE PUBLIC

Protect or Display the "Real Thing"?

Research workers explain the reason why the public should know which objects are real as epistemological as well as ethical. They consider specimens to be a physical defense of scientific knowledge; therefore specimens must be educational but also honest, such as with labeled reconstructions. Kirk linked this defensive role to US culture: "Museums always need to show the real thing, if only to show that they actually have it and they're not just making stuff up. . . . Sad to say, this is a country where people still think that they get lied to by scientists." Museums need specimens not just to help the public learn about nature but also to win their trust and challenge science deniers, like creationists and climate change skeptics. This view reflects a conception of science as an endeavor of persuasion and argument building (Shapin and Schaffer 1985), which occurs among scientists as well as between scientists and the public. In that sense, museums' specimen displays and collections are a bank of evidence in the service of persuasion. That evidence might be less persuasive if the specimens are partly reconstructed, especially if they are falsely presented as entirely real.

Displaying real specimens brings challenges, however. Preparator Brad portrayed his museum's display criterion as simple: "If we can do a real specimen without destroying it, we will." In addition to fragile specimens, they also keep most type specimens in storage because they are "too important" to subject to the risks of display (e.g., damage from mounting or visitors), and too frequently studied to justify taking them on and off display. Yet when Brad and coworkers decided to display a particular type specimen, they molded it to make a cast for the exhibit. Then the original bones could be stored for protection and study. The process of molding a fossil, though, can cause significant damage. By risking it, the staff prioritized the public's view of this unique specimen, even while protecting the bones from display.

Furthermore, all mounted fossil skeletons are a mix of bone and reconstruction. As Brad pointed out in a joking understatement, "It's hard to find a complete dinosaur." Researchers try to align the realities of

specimen condition and scientific value with museums' mission to educate the public through physical evidence of scientific knowledge. Researcher Emily similarly values balancing visitors' and scientists' access to fossils. She explained that at her museum, decisions about displaying specimens or casts are based on two main variables: "A, what we actually had that was originally in the collections, and B, how fragile things were." She added, "With original material that still has ongoing research on it, you then have the problem of making it accessible to perfectly legitimate visiting researchers' requests [*laughs*]." Prioritizing a museum's own less fragile specimens saves the trouble of borrowing other institutions' fossils, while also promoting institutional pride. Of course, mounting real fossils inconveniences the research workers who must take down the specimens on researchers' demand, but the staff decided to accept that extra work because they value showing visitors real fossils.

Another option that staff members consider—and consistently reject—is displaying digital models of fossils instead of physical specimens. Researcher Henry, for instance, told me, "There are some things you can completely do with CT scanning, but . . . [if] you want to put [a fossil] on display, then you have to clean it up nicely so that people can see it." Research workers prefer physical fossils for display and only approve of on-screen models made from CT scans when they are displayed alongside the specimens themselves. These views match their preferences for fossils over images for research too (chapter 3). They fear that only seeing a fossil "on a screen" (Tobias), or even "a really great interactive or something, like a touch screen that might have a rotating specimen" (Tim), isn't sufficient to convince people that fossils—and fossil-based knowledge—are real. Perhaps most museum visitors' everyday encounters with digital and 3D images via the internet and virtual reality means they know how easily these images can be faked. In comparison, few visitors have experience with fossils. Research workers thus assume that visitors might be more skeptical of overly impressive images than of dusty, slightly crumpled, partially reconstructed bones. This assumption matches research workers' own belief that seeing "real" fossils is emotionally and epistemically powerful.

Why Have a Glass-Walled Lab?

Visitors tend to crowd around glass-walled labs with excitement and curiosity, yet many workers are ambivalent about them as work spaces. The labs' primary stakeholders—visitors, exhibit designers, lab workers, and fossils—hold diverse priorities that they must strive to balance (Wylie 2019b, 2020). Macdonald (2002) documents the complex, dynamic design process that struggled to coordinate the diverse needs and values of museum administrators, curators, physical space, budget, visitors, and objects for a new exhibit at London's Science Museum. That exhibit did not contain scientifically valuable specimens, focusing instead on common artifacts and interactive machines. Adding fossils and researchers as actors further complicates the process. The very existence of exhibit labs suggests that the public's benefit is prioritized because preparing with observers does not benefit lab workers or fossils (though it might not harm them either). But preparing fossils is also a necessary task for research rather than a mere demonstration for visitors. How lab communities create compromise between these multiple perspectives reveals their priorities and beliefs about how they ought to portray science to the public.

Fossil exhibits are designed to communicate relatively direct messages about the history and evolution of life and environments, as shown by exhibit names such as *Prehistoric Journey* (Denver Museum of Nature and Science), *Deep Time* (Smithsonian Museum of Natural History), *Dinosaurs in Their Time* (Carnegie Museum of Natural History), and *Evolving Planet* (Field Museum). In comparison, it is less clear what glass-walled labs are meant to convey to visitors. For example, London's Science Museum displays James Watt's early nineteenth-century workshop behind glass for visitors to marvel at his engineering and chemical research equipment placed alongside art objects and everyday clutter. Historian Ben Russell (2014) argues that the workshop display can portray seemingly outdated engineering research as "making," a familiar and trendy activity for today's visitors. Are glass-walled labs intended to display science as messy and human, as is Watt's workshop? This idea would address historian Steven Shapin's (1992, 28) call for teaching the public that science is collective, trust dependent, and revisable. The typical public portrayals of a single

and infallible "scientific method," or scientists as "magic," all-knowing practitioners, risk both "public ignorance and public idealizations" of science, Shapin (1992, 29) warns. Glass-walled labs are one way to show what Shapin (1992, 28) calls the real, "warts-and-all" work of research. Likewise, collection manager and preparator Brent trusts glass-walled labs to correct visitors' misconceptions:

> People know about preparation, if they know about it at all, . . . from scenes in *Jurassic Park* where they're . . . just brushing away the sand and gravel from a fossil, and after two or three minutes it's perfectly prepared. I think people will have a greater appreciation for a mounted skeleton when they realize just how much work has gone into taking the rock off the bone. . . . The only way you're going to teach the public that is to show it to them. Seeing is believing.

For Brent, witnessing fossil preparation can convince visitors that their knowledge—such as from a science fiction movie—isn't accurate. If this realization can improve people's appreciation for fossil mounts, perhaps it will also strengthen their trust in fossil-based knowledge.

If the goal of display labs is to provide public access to "real" scientific work, it is not made explicit to visitors. The text panels around display labs typically describe tools and specimens, but do not explain what an observer should learn from watching the lab. The grand narrative is missing. Lab workers, for instance, complain that visitors rarely understand whom they are watching. At best, visitors assume that the workers are scientists, though they actually self-identify as preparators or volunteers. In the least informed but surprisingly common cases, visitors think that the workers are mannequins or robots. After all, visitors do not expect to see living humans inside a museum case (Noble 2016, 255–256). Also, individual preparators are not named on the text panels around glass-walled labs. Unlike researchers who are named in descriptions of their work in text panels and publications, preparators are anonymous in exhibits, even when visitors are looking right at them. And unlike docents, preparators do not wear name tags. This anonymity suggests that preparators themselves are not the primary focus of display labs; instead, I surmise that their work and perhaps generic scientific work is the primary topic presented to visitors.

For example, Noble (2016, 264) observed that visitors mainly ask preparators questions about fossils, not about being a preparator. Even though the workers and work are on display, visitors tend to ask about facts, perhaps reflecting their past experiences with fact-based exhibits along with their lack of familiarity with displays of people and processes.

A Spectrum of Labs from Demonstration Space to Research Workplace

Exhibit lab workers themselves interpret their purposes and priorities in different ways. Most communities consider their lab a research space that also happens to be on display. One exception is a fossil preparation lab located among the fossil displays at a university museum in the United States. This lab is a small space separated from the exhibit only by shoulder-high plastic walls around a workbench, thereby allowing visitors to talk to a preparator at work. It is only occasionally staffed, usually when school groups are visiting. The preparator is most often Livia, who works for the museum's education department and learned to prepare fossils as an undergraduate. This lab is distinct from the university's research preparation lab, which is across campus. The research prep lab provides the exhibit prep lab with specimens and tools as well as occasional training.

Livia's work is a balance between ideal preparation methods and the constraints of a public exhibit space. Typical air scribes, for example, are too loud and create too much dust. Instead, Livia uses a small, weak Micro Jack that buzzes quietly and is only effective for removing soft rock. Alan, the head preparator in the research lab, told me that he gives museum staff fossils that are easy to prepare and not scientifically important. These fossils therefore don't need to be prepared quickly or particularly carefully. Perhaps in accordance with the fossils' low research value, Livia uses cyanoacrylate (i.e., a permanent glue that degrades over time) to repair them. In comparison, Alan "threw out" all the cyanoacrylate in his lab and replaced it with conservation-friendly reversible adhesives (chapter 1). Thus the exhibit lab's tools, techniques, and specimens differ from the research lab's. The lab serves more as a demonstration space than a research workplace. These adapted practices allow for an open-air prep lab to operate inside an exhibit, such that visitors can see specimens and tools up close as well

as speak with a preparator. In this display lab, the museum prioritizes education and public access over best practices for fossils or research. For a similar lab inside an exhibit, Noble (2016, 336) contends that the fossils emerging from preparators' tool tips served as "instruments" to demonstrate preparation work more than they served as evidence behind the facts on display.

In contrast, the Northern Museum's preparators consider their exhibit lab a research lab that just happens to have glass walls. They have multiple lab spaces, like Livia's university does. But the Northern Museum uses all its labs exclusively to prepare research specimens. Volunteer Daniel told me that before the glass-walled lab was built, he would microsort fossils on open tables in the exhibits and talk to visitors as he worked: "People loved it." In comparison, he finds that work in the enclosed exhibit lab focuses more on specimens than on the public. "We get more work done, but I miss talking to [visitors]." Preparator Amanda agrees with Daniel regarding the lab's productivity, but dismisses talking to visitors: "I'm interested in fossils being prepared, not interacting with people, and the more you talk to people, the less fossils get prepped." She thinks that docents, trained by education staff, should talk to visitors. This view matches her identity as a preparator who works for researchers. On the other hand, she is happy for the public to watch "our setup," meaning the glass-walled exhibit lab, because "from outside people aren't going to disturb our work but they can still see what's going on." As long as being on display doesn't affect her or other preparators' work, she is open to it.

What a lab looks like reflects its workers' priority for research or display too. For example, Amanda noticed that the Southern Museum's lab, which she had recently visited, has many "display items" out for the public to see, such as finished fossils as well as photos and drawings of specimens. She thought those items cluttered up important preparation space. Likewise, I noticed that the Southern Museum preparators and volunteers leave their specimens and tools on the lab tables when they go home. While this may be a pragmatic solution to storage shortage and the large size of some specimens, it also provides something for the public to look at when no one is in the lab. Northern Museum workers, in comparison, put away

their fossils and tools when they finish, leaving the lab rather barren. On Sundays, when the Northern Museum lab is not staffed, only microscopes, tables, and chairs are visible. The exception is staff preparator Carla, who intentionally leaves out specimens in progress for visitors to see. Carla works in this lab five days a week, unlike the rotating roster of volunteers, so perhaps her status as staff and an everyday presence allows her to claim one tabletop as always hers, and hence to skip putting her work away. Carla sometimes tapes paper signs to the windows for visitors to read, as do a few volunteers. Some signs describe the specimens being prepared and others beg, "Please do not tap on the glass," as a poignant reminder of the challenges of doing delicate, precise work while on display.

Despite facilitating the public's view and knowledge of her work, Carla—like Amanda—considers her primary responsibility to be preparing fossils for research. Amanda even expressed some disdain for the Southern Museum's visitor-friendly display of specimens and tools: "We don't have that sort of thing, just a lab operation." Amanda's perspective may reflect our society's greater appreciation for research than for display. At a privately funded museum whose budget relies on ticket sales, it seems counterintuitive that the Northern Museum staff would focus on research over visitor satisfaction. Indeed, these research workers perceive their display lab as a valuable opportunity for the public to watch preparators work. But they believe that a display lab should be first and foremost a lab, not just another area to show objects and information or for staff to interact with visitors.

The Southern Museum's approach is a middle ground, with more research-focused preparation in the display lab than at Livia's university museum, but with a stronger effort to engage with the public than at the Northern Museum. Because it is publicly funded, the Southern Museum has less financial need to attract visitors. Lab workers' greater attention to visitors perhaps derives from the museum's mission of public service. The Southern Museum's lab, for instance, has a sliding window, mimicking a fast-food drive-in, to allow preparators and visitors to talk. The window locks from the inside, though; preparators choose whether to open it. The Northern Museum's lab has no such portal. Also, the Southern Museum's

lab has windows all around it, while the Northern Museum's lab has a small back room that visitors can't see. Workers use this room for storage and as a retreat during breaks. Amanda noticed with disbelief that the Southern Museum's lab gives preparators "no place to escape" the public. On the other hand, the Southern Museum's design offers the public more visual access. Another indicator of their different approaches are the signs about specimens. Unlike the Northern Museum's occasional informational signs alongside permanent warning signs, the Southern Museum has many homemade signs describing specimens and none asking the public to stay back (figure 5.1). These window decorations are a powerful indicator of the labs' different ideas of their purpose: to serve primarily science and scientists, or education and the public.

Display labs serve political purposes too by attracting and impressing visitors, and thus earning lab workers the museum's gratitude. Preparator

Figure 5.1
Some preparators in glass-walled labs set up signs to tell museum visitors about specimens, such as this whiteboard describing a skull and inviting questions from the public.

April said about her museum's glass-walled lab, "The public loves it, and Public Programs loves it. . . . So the biggest problem with it is staffing, . . . [access to compressed] air, and dust buildup." For the museum, the financial and educational importance of pleasing visitors outweighs the lab's not-ideal equipment and April's challenge of recruiting and training enough volunteers. Amanda explained that the Northern Museum's glass-walled lab enjoys the same admiration from visitors and the institution: "Education [Department] loves us, right, because of fossils, dinosaurs, lots of action in the lab." A disadvantage of the institution's appreciation for visitor-friendly attractions is that it causes a "flood" of demands on staff preparators' time, such as giving lab tours. Amanda considers it her responsibility to limit these requests, which she sees as detrimental to the staff's primary task of preparing fossils.

The Art of Omission

Museum staff sometimes make decisions that limit public access in order to protect research. For example, institutions typically conceal new specimens from external researchers until their own researchers have published scientific descriptions of the specimens and thereby claimed that intellectual property. So when preparators Amanda and Carla built a website to tell the public about current projects in the Northern Museum's display lab, the website's information could only be basic because most of the specimens that the lab prepares have not yet been studied. Amanda explained, "It's fine to tell [the public] that we are working on a theropod, but we can't give them too much detail." Revealing a specimen's general classification category (e.g., belonging to the suborder of Theropoda) does not threaten researchers' claims to first publication, but describing its specific features could give away important data. For the same reason, the website does not include high-quality photos of specimens. Ownership of unpublished specimens came up in my ethnographic fieldwork too, in that research workers were hesitant to allow me to photograph fossils for fear that other scientists would be able to study the specimens from the photos I publish. Displaying scientific works in progress in exhibit labs seems to conflict with the common practice of not sharing unpublished data.

The fact that researchers permit specimens to be prepared in public view—which I never heard them voice concerns about—may indicate a distinction they perceive between the public and researchers. It's fine for visitors to see an unpublished, new-to-science fossil, but not for competing researchers. This may reflect these groups' difference in skilled vision (Grasseni 2004) given that a fossil researcher is much more likely to notice a rare specimen in the lab than a nonexpert is. Likewise, nonresearcher visitors to Amanda and Carla's website may not notice the absence of the detailed information that researchers value, such as what is new about a particular fossil. But it does surprise me that research workers do not see the boundary between these groups as more porous. A researcher could potentially access an unpublished, partially prepared fossil by standing outside a glass-walled lab or finding a visitor's photo of a specimen posted publicly online. But no research worker mentioned this possibility to me. Perhaps this is not a concern because scientifically important specimens are more likely to be prepared by staff preparators, most of whom work behind the scenes (chapter 2). So blockbuster fossils might be kept out of public view coincidentally rather than to protect researchers' publication priority.

The concern—or lack thereof—about showing unpublished specimens is a reminder that a display lab is a performance space, with the actions and objects inside controlled and planned to project certain impressions to the public. This is easy to forget because the lab contains living people with real fossils, dust, snacks, and conversations. As a result, I got caught up in the exciting idea of everyone being able to watch the fossil labs that I find fascinating. Preparator Jay reminded me of the importance of controlling performance by laughing at my naivete. Early one morning at the Southern Museum, he and a collection manager, Bob, and I went to the display lab to turn over a fossil whale skull so that its underside could be prepared. It was large, heavy, and spiderwebbed by cracks that threatened to crumble it into pieces. I suggested that they wait to turn the skull until after the museum had opened so that visitors could watch their skillful handling of unwieldy fossils. Jay answered emphatically that he does this kind of work *before* the public arrives. With a jolt, I realized the implications that were obvious to Jay: damaging the skull would be terrible, but damaging it with

an audience would be worse. The image of professionalism that lab workers try to project would be as shattered as the skull. On the other hand, was the lab misleading viewers by hiding risky yet integral components of preparation work?

Lab manager Amber expressed similar concerns about preventing an embarrassing performance when the Southern Museum's Exhibits Department wanted to install a webcam to livestream the glass-walled lab's activities online. In response, Amber told me, she printed a screenshot from another museum's fossil lab webcam that showed an empty room. She brought it to the Exhibits Department staff, asking sarcastically, "Is that what you want?" No lab is staffed all the time, such as during lunch and outside museum opening hours. Volunteer-staffed labs in particular struggle to "stock the fishbowl" (Jabo 2009) with workers. Amber thought portraying that reality to the public did not reflect well on the lab or museum. It's possible that she feared an empty lab would suggest laziness or unprofessionalism, or perhaps portray the lab as just another unpeopled display space rather than a workplace. Controlling aspects of the portrayal of research work is one way in which museums prepare a vision of science for public consumption.

Exhibit labs, despite their transparent walls, are selective. Aspects of laboratory practice that are omitted can include risky tasks, loud tools, unpublished specimens, techniques requiring ventilation or compressed air systems that a lab may lack, and who the workers are (i.e., the unexplained distinctions between volunteers, staff preparators, and scientists). These omissions can make preparation appear simpler for workers and safer for fossils than it is. Of course, all displays offer selective versions of complex systems. No display can be comprehensive due to constraints of money, space, and visitors' attention spans. Rather, what displays include and don't include reveals the values and beliefs of the workers and institutions that build them. Specifically, museum workers assume that visitors should learn how science is done but not the unpleasant aspects of it, such as the perils of damaging specimens, inhaling rock dust, or gluing your fingers to a fossil. They also believe that visitors benefit from watching lab work, even a selective performance of it and even without necessarily understanding

what they see. In most museums, that benefit is subordinate to scientists' access to prepared fossils, such that scientifically significant fossils are not on display and preparators spend most of their time preparing rather than educating. In this view, glass-walled labs are spaces that house research work that, lightly edited, serves a secondary purpose as a learning opportunity for visitors to glimpse science as a process.

DISPLAYING OURSELVES

Displays as Sources of Pride

Museum workers perceive exhibits as the public version of their work, even if they are not specifically responsible for exhibits. They want the exhibits to reflect well on themselves, their museum, and science. As a result, they use exhibits as a way to influence how visitors perceive them—a process that Goffman (1956) calls impression management. For instance, preparator Kevin walked by a recently mounted cast stegosaur skeleton that was temporarily parked in the behind-the-scenes lab. He took a moment to fix a dried paint drip on its plaster vertebra. "What color is he?" Kevin wondered aloud as he mixed a few drops of gray and brown paints in a paper cup. He brushed one stroke of the paint over the drip and was satisfied with the improvement: "That's been keeping me awake nights." He was joking, but with a vein of truth. His interest in making the mount look its best reflects his commitment to doing good work and presenting his work well for the public.

The primary way that research workers voice their investment of identity in exhibits is about cleanliness. They are quick to spot a dusty dinosaur, and then express disapproval or even shame. Workers' concern can be explained by the fact that dust can damage fossil bone in the long term as well as their desire to have specimens appear well cared for to a public audience. One volunteer called dusty exhibits "embarrassing." Likewise, preparator Mary hates the gravel placed beneath her museum's mounted sauropod skeleton because it "attracts dust," is hard to clean, and therefore "always looks bad." At the opening of one museum's new fossil exhibit, several preparators from other institutions criticized the plastic

plants placed artistically around the dinosaurs. Their complaint was that the plants' complex surfaces would take a lot of work to clean.

Cleaning large exhibit specimens is a major event for research workers and institutions because it is risky for the specimens as well as logistically challenging. Dinosaur dusting attracts visitors' attention and even press coverage, perhaps because it is so incongruous to see a human perched precariously on a ladder waving a pink feather duster between a dinosaur's ribs. Only preparator and collection manager Bill Simpson is allowed to clean the Field Museum's famous T. rex Sue because of the expertise required (Johnson 2015). Removing dust and cobwebs from fragile bones, often with a duster or the tube of a vacuum cleaner, requires a delicate touch, long reach, and good balance. One preparator told me that he broke the tip of a rib off an important specimen just by touching it with a duster. Another found bird droppings on a vertebra of an extremely tall dinosaur and had to leave them there because he didn't know how to best remove them at such a height, and without damaging the bones with water or chemical cleaners. This inability to clean the fossil bothered the preparator, even though no one could actually see the top of the dinosaur. Valuing good exhibits reflects research workers' hope that the public will admire their work and institution.

Looking Good

Like fossil displays, exhibit labs are a source of pride for research workers. They consider the labs and specimens as the performative "front stage" of their work, even while visitors might assume that it is the backstage (Goffman 1956). As mentioned, some staff and volunteer preparators illustrate their work for the public, such as by placing images and information about extinct animals in public view, or writing daily descriptions of their work on small, propped-up whiteboards (figure 5.1). In addition, many volunteers create personal files of their work-in-progress photos, hand-drawn maps showing bones' locations in a block of rock, and notes on their techniques and experiences with each fossil. Staff preparators do not require or even suggest this documentation in most labs, and few record this kind of information themselves. Rather, the files are more like personal reflections and memory joggers to help volunteers keep track of their work.

This informal record keeping reflects volunteers' intention to do good work in the interest of the fossil, research, their own pride, and, in exhibit labs, visitors. Disorganized or misdirected preparation work could be visible to visitors, and record keeping can help volunteers feel more confident in their practices.

Presenting themselves as competent and professional to the public is important to lab workers. Their occasional self-consciousness about preparing in public evokes Goffman's (1956) idea of impression management in that they articulate their underlying hopes for how others perceive them. As discussed before, cleanliness is one factor they especially value for workspaces as well as fossils. For example, Southern Museum volunteer Carl complained to me that while custodians regularly clean the public side of the lab's windows, where "kids put their hands and noses," the windows stay dirty on the inside and therefore never look clean. Once, an offer of media attention triggered a flurry of activity from the Southern Museum staff and volunteers to make the exhibit lab look its best: a TV news program wanted to interview a museum administrator with the lab as backdrop. When staff preparator Jay heard this plan, less than twenty-four hours before the interview, his first reaction was, "We better clean up the place." Volunteers set to work tidying the lab's tools and specimens. Lab manager Amber asked the maintenance department to collect the lab's trash, even though it wasn't the normal pickup day. Her next planning move, interestingly, was to call a woman volunteer and ask her to work in the lab during the interview. Only men were scheduled to volunteer that day and "we can't have all men," Amber told me. She saw the televised spotlight as an opportunity to portray scientific work as women's work as well as men's. The larger audience of TV news, as compared to the lab's normal visitor numbers, revealed lab workers' beliefs about how they want to portray their work and themselves.

Another high-profile event, one museum's annual Fossil Day, attracts large crowds to the glass-walled prep lab, which gives lab workers minor performance anxiety. When volunteer Jack showed off an easy-to-prepare fossil (with "good color distinction" between the soft matrix and hard bone) to other volunteers, he joked that he'd like to "save it" to prepare on

Fossil Day "so people won't see me cursing and swearing" at a more difficult specimen. His comment captures volunteers' motivation to perform their roles well for the public. Another of Jack's stories that reflected volunteers' awareness of being watched and the humor of a fishbowl workplace was when he told a group of volunteers and me that his wife teases him that he, an octogenarian, would accidentally take his nap while working in the lab. Another volunteer replied, "Then people will say, 'There's the fossil!'" This was a good-natured and well-received joke about Jack's age, while also indicating how volunteers think about their exposed position as representatives of the museum and paleontology. They don't want visitors to perceive them as messy, unprofessional, frustrated, or sleepy, and this aversion shapes their behavior.

How Exhibit Labs Prepare Science for the Public

Exhibit labs are a powerful medium for presenting research workers' message about what science is to a public audience. There are aspects of that message that workers do not mention and may not be aware of, but that I see as crucial. Specifically, I argue that exhibit labs subtly present science as accessible and relevant to nonexperts. Labs are less narrated and labeled than fossil displays—an approach Emily criticized as less informative than her museum's text-and-object way of explaining fossil preparation. On the other hand, leaving the display lab rather unexplained encourages visitors to pose questions and observe closely to try to answer them, such as "What are they doing?" "What is that tool for?" and "Are those people or robots?" Of course, visitors also wonder about text panels and labeled specimens, but text-directed observation may be a less engaged, less inductive learning experience than curiosity-driven observation. For example, students are more likely to remember information they learn through constructivist activities than from reading or listening to lectures (Hein 1998); this is likely true for museum visitors too. Perhaps this outcome occurs because learners are practicing skills of question formation, close observation, and theory construction. Their theories (e.g., that lab workers are "making fossils") may not agree with lab workers' own conceptions of their work, but encouraging visitors to practice evidence-based wondering is a powerful

contribution to visitors' understanding of how scientists do research as well as how to learn for themselves. Honing these skills is arguably more important than remembering the specific facts listed on a text panel.

Moreover, I wonder whether visitors might feel empowered by using their own logic and experiences to construct an explanation. As a result, they may be more likely to perceive science as interesting, relevant, and achievable. They could even feel encouraged to pursue science through formal or informal study, or perhaps by volunteering. How visitors perceive the conception of science that workers perform in glass-walled labs is a separate question that deserves more research. Nonetheless, these speculations would all be desirable outcomes for museums by increasing public satisfaction with museum visits as well as promoting science as accessible and important.

Technicians' active work with specimens, tools, and each other makes a better show than researchers' common low-action tasks of examining specimens, reading and writing papers, and staring at computer screens. Thus one plausible motivation for establishing glass-walled labs full of technicians and volunteers as opposed to scientists is that visible, physical research practices are more accessible to nonexperts than are the details of morphology and phylogeny that fill scientific publications. Furthermore, scratching rock off a fossil with a buzzing tool might look easy to an uninformed observer. This perception, though inaccurate, could encourage visitors to participate in research work, such as by volunteering for a museum or citizen science project. These ideas can help construct a new view of science, not as the black boxed, exclusive domain of lab-coated, PhD-holding scientists, but as enjoyable, significant, learnable work to which anyone can contribute.

The "like me" appearance of research workers on display, most of whom after all are volunteers, can further support the idea that research work is inclusive and relatable. Amber wanted a woman volunteer present for the lab's TV debut, perhaps as a role model for girls to recognize that people like them prepare fossils. Also, rather than uniforms or lab coats, lab workers tend to wear casual clothes, much like museum visitors. Staff and volunteer preparators wear old, comfortable clothes, sometimes stained by

matrix, adhesives, and plaster. They pair jeans or nylon hiking trousers with an overrepresentation of dinosaur T-shirts. Sneakers or hiking boots are standard. This performance of science, then, is costumed for the look of manual or outdoor work. One might expect an admonition from lab staff or museum administrators to "look nice" while working in public view, but I never heard anyone comment on preparators' clothes.

Preparators' informal, self-chosen clothes indicate their identity as creative experts. A group of volunteers in one US lab designed work aprons emblazoned with the lab's name, but wearing them was not required or common. Staff talked about the aprons as a rather cute display of volunteer community building, implying some disdain for a desire to wear matching clothes. Wearing a uniform, even a high-status one like a lab coat, could diminish preparators' identity as skilled craft workers by sacrificing control over their wardrobe. Similarly, workers in settings with white-collar dress codes can declare their group's identity and power through casual clothes. For example, "computer techs could get by wearing jeans and even t-shirts. . . . Their clothing signaled that their skills were so critical to users that they could disregard fitting in as long as they kept the machines and systems running" (Barley, Bechky, and Nelsen 2016, 139). The clothing distinction between preparators and researchers is less striking than between computer technicians and their white-collar clients, because fossil researchers (men and women) most often wear jeans or slacks along with a T-shirt or collared shirt, not suits. I wonder if lab workers' fashion choices might inadvertently help visitors imagine themselves doing scientific work as a result of watching people who look like them doing it.

Scientists and preparators alike primarily framed the labs' mission as demonstrating a little-known and interesting-to-watch component of paleontology. No practitioners told me that the labs are walled with glass to encourage visitors to consider participating in science. For instance, I have never seen a display lab with a sign inviting people to become museum volunteers, even though an audience of lab observers seems like a prime recruitment opportunity. So it's possible that the inclusive message that I perceive in the display of familiar, relatable people doing active, appealing work is unintentional, though certainly not misaligned with museums'

goals. Even if lab workers understand display labs as research spaces and/or educational viewing more than as advertisements for inclusive participation in science, I think these labs have the potential to achieve all three.

Including the public in research work relies on and defines science as a kind of work that benefits from diverse skills and perspectives. The locked, hidden, behind-the-scenes lab and the exclusive realm of legitimate knowledge preparation are tightly connected. Accordingly, opening research spaces could also involve welcoming nonexperts into the assiduously controlled world of scientific publications, conferences, and respected knowledge claims. If people collect, process, and analyze data, after all, they are preparing evidence and thereby contributing to the preparation of knowledge. Some researchers even recognize citizen scientists by designating them as coauthors of publications (e.g., Banfield et al. 2016; Bohannon 2016). Fossil preparators—staff and volunteer—are rarely granted authorship, but their skill, expert judgment of technologies, sense of identity in their community, pride in their work, and role as the de facto public face of fossil research are powerful achievements. In this frame, their invisibility in print seems less like an insult and more like a means to allow them to create their own visibility where they want it, namely as leaders in the lab, both backstage and on display.

CONCLUSION: PREPARING AN AUDIENCE FOR SCIENCE

Displays are a long-established and powerful mechanism of proposing a conception of science to the public. Traditional exhibits of inanimate objects and strongly stated facts tend to present science as passive, dehumanized, reliable, and finished. Displays of live laboratory work, in comparison, offer a view of science as active, human, ongoing, and perhaps relatable. How visitors interpret these messages merits further study, but it is likely that how practitioners prepare conceptions of science, along with how they prepare evidence, communities, and technologies, influences everyone's knowledge about nature.

How practitioners prepare a conception of science for public consumption is not always intentional. Embedded in decisions about whether to

display sculpted reconstructions, cast replicas, or "real" fossils, for example, are assumptions about what visitors can understand, will be interested in, and deserve, as well as priorities about whether specimen access is more important for the public or scientists. Research workers articulate a responsibility to share knowledge with the public about research work and nature. Traditional exhibit designs tend to omit information about how facts and finished fossils were produced and by whom; glass-walled labs have the potential to fill in that omission by offering literal—though managed—transparency, or what I elsewhere call a glass box instead of a black box around research work (Wylie 2020). What happens on display is always edited, sometimes misleading, and may not be comprehensible for visitors. Nevertheless, these labs can provide a powerful opportunity for visitors to wonder about what they're seeing, thus inspiring them to apply classic scientific skills of posing questions, collecting evidence by observing, and constructing interpretations of their evidence. This inductive experience of an exhibit offers more open-endedness than a beautifully finished diorama or dinosaur mount, thereby requiring more cognitive labor from visitors but also encouraging their engagement and curiosity.

Displaying science as tasks as done by people whose clothing and behavior are somewhat familiar to visitors portrays science as just another kind of work. This view challenges a common perception of science as exclusive and mysterious. Telling the public that these technicians don't have PhDs and that many are volunteers would further break down perceived barriers between nonscientists and scientists, and more strongly portray science as inclusive and accessible. Furthermore, glass-walled labs make visible the everyday actions of preparing knowledge—that is, the skillful, inseparable analysis of social and physical contexts to make informed decisions. What workers choose to perform and not perform in these fishbowl labs reflects their notions of good work, and how they behave under surveillance indicates their desires for how they want others to perceive them. I speculate and hope that inserting these windows into scientific work and communities encourages the public to learn more about science, and even participate in it as a career or hobby.

CONCLUSION

Every other Thursday morning during my five-week visit to the Northern Museum's fossil preparation lab, preparator Amanda would unearth a giant slow cooker from among the lab's tools, fossils, potted plants, and fish tank for Jack the guppy. She would add spices, chopped vegetables, and cans of beans and tomatoes to the vat, which would soon fill the lab with pungent smells. Word of mouth, a hallway chalkboard, and emails would circulate reminders for Chili Thursday around the department, as people popped into the lab all morning to confirm the event and taste-test the chili. By noon, at least thirty people would be jostling for a place in line, bowls in hand. The regular attendees of these much-anticipated meals included researchers, collection managers, preparators, conservators, and volunteers, all mingling freely over chili and preparator Carla's renowned cornbread. These diners all worked with fossils of vertebrates, invertebrates, or plants. They ranged from teenagers to retirees, and those with high school diplomas to doctorates. Twice a month they crowded into the lab to share museum gossip, catch up on the status of projects, and tell stories about fieldwork, travel, childhood, and—a major source of conversation that summer—an online livestream of a wild eagle's nest that everyone was watching in their offices. These representatives of several communities of practice were brought together not just by free lunch and deep interest in the natural world but also by shared reliance on the fossil preparators.

Like this scene, this book puts creative, nonstandard, nonscientist workers at the center of scientific communities and work. Unlike the

dinosaur-focused displays we encountered at the start of this book, in this scene people are the foreground and specimens are the background. Collaborators chatting over lunch in a bustling backstage lab is a crucial part of maintaining social bonds and learning from each other. Thinking about science as knowledge preparation highlights the interlocking relationship between evidence, communities, technologies, and conceptions of science, and thereby encompasses the entire research community, the variety of work those people do, and the ongoing feedback between research work and knowledge. Regardless of workers' credentials, institutional status, or recognition in print or exhibits, everyone contributes to how this community makes sense of nature. Their work does not finish with a new publication or theory; rather, the process continues and adapts to new specimens, workers, technologies, and beliefs. The concept of knowledge preparation yields rich insights into the social structure of research communities, and reframes who can and should contribute to research.

Like they artfully mixed ingredients to prepare chili and cornbread, Amanda and Carla regularly combine skills, technologies, conceptions of science, and knowledge to prepare fossils. They craft messy, difficult-to-define, and fragile pieces of nature into physically delineated, somewhat less fragile specimens that are trusted to represent particular species and environments. This transformation is more than mere cleaning or routine processing; deciding what to "clean" off requires experience-based judgment, and has irrevocable implications for specimens' physical and epistemic form. Furthermore, deciding how to remove unwanted material—and preserve the treasured material beneath—relies on expert assessments of tools and techniques, innovative ways to adapt and design them, skillful applications of them, and ongoing evaluations of their effects with regard to the priorities of various fields. Piecing those prepared fragments together into an animal—or perhaps just a single bone—is also equally complicated, significant, and not obvious or predetermined. Fossil preparators do not sculpt fossils from matrix like artists sculpt statues from marble, nor do they collect them from the ground as pristine, stable, complete skeletons. Instead, preparators draw on creativity, sensory judgment, and notions of beauty to craft evidence from nature. Other members of

their research community then interpret this evidence to craft knowledge about nature.

I derived these arguments from the particularities of fossil preparation, yet they ring familiar about many kinds of scientific research. In this conclusion, I draw on three ethnographic moments to crystallize the book's arguments about laboratory labor and scientific evidence, and propose how knowledge preparation defines important trajectories for studying scientific work and workers. I end with a reflection on the implications of knowledge preparation for the inclusivity of scientific communities. Specifically, this book shows the pivotal contributions of nonscientists to research as well as the many kinds of interesting work that research relies on. This approach has the potential to frame science as more relatable, comprehensible, and hopefully appealing to people who feel excluded by stereotypes about who can do research.

ETHNOGRAPHIC MOMENT #1: WHAT CHILI THURSDAY SHOWS US ABOUT SCIENCE

Labor as Relationships and Relationships as Labor

The Northern Museum preparators were committed to hosting Chili Thursday in part because these informal interactions were key to community building. Amanda and Carla dismissively labeled colleagues who didn't regularly attend as "antisocial," and described them only half jokingly as strangers, despite working with them for years. Attendance, then, was an important factor in earning the preparators' favor—a crucial commodity for anyone who needed prepared fossils, tools, or help repairing, identifying, or transporting fossils. Research workers nurture relationships with each other in order to facilitate mutually beneficial research work, such as specimens that suit each field's requirements (chapter 4). When I asked Amanda whether she worried about someone spilling chili on the fossils that occupied every surface in the lab, she shrugged: "They're rocks, right?" She said that the museum's safety officer opposed food in labs, but she and Carla valued the camaraderie of Chili Thursday—and their powerful role as hosts—enough to ignore the rules. As a result, they reigned over a regular

meeting of (almost) everyone they worked with, thereby exchanging information as well as building loyalty and friendship in ways that effectively made the preparators the center of the department's work and social life.

The irony of the Northern Museum fossil research community being centered around its preparators is that those technicians are not recognized in any other setting besides the lab itself. They are not authors on scientific papers, principal investigators on grants, media personalities, or highly paid. Yet they are the crossroads of their department's diverse work, from collection management and conservation to research and display, and everyone they work with knows that. After all, preparators prepare the specimens that unite their coworkers' fields. Their lab is one space that everyone regularly visits, thus allowing preparators' news about projects, coworkers, and the eagle cam to spread quickly and comprehensively through their community. In some institutions, preparators even serve as the public face of paleontology by populating glass-walled display labs. These are significant domains of power for uncredentialed, unpublished, low-status "support staff."

Preparators' context-based autonomy illustrates that institutional hierarchy alone does not determine the social structure of research communities. Preparators claim these areas of autonomy and jurisdiction through the everyday interactions of defining boundaries and group identities, such as locking fossils into drawers to exclude a meddling researcher, telling jokes that only preparators understand, reprimanding volunteers if they attempt to choose their techniques instead of following directions, and nicknaming fossils to express affection and a kind of ownership (chapters 2 and 4). Preparators work closely with other fields, such as to negotiate preparation deadlines and priorities with scientists, discuss appropriate adhesives and specimen safety with conservators, coordinate fossils' organization and documentation with collection managers, dust mounted skeletons, and create labs that are simultaneously displays and workplaces with exhibit designers. This collaboration thrives on mutual trust and goodwill, with rare exceptions of top-down orders from scientist-bosses whom preparators resent as a result. Despite—or perhaps thanks to—this tandem work with several fields, preparators define themselves as distinct from impatient

scientists, risk-averse conservators, paperwork-loving collection managers, and visitor-focused display designers. They first learn to enact this group identity while learning how to remove matrix, glue frags, open field jackets, microsort, and build storage cradles from more experienced preparators on the job (chapter 2). Selecting and teaching novices grants preparators enormous power over their field's skills, values, techniques, and shared sense of what it means to be a preparator.

The ongoing collaboration across fossil-focused fields means that everyone understands each other's motivations and priorities to some extent. Thanks to a shared conception of science—that is, a sense of what they're doing together—these fields are motivated to try to respect each other's needs and values, even when those priorities conflict. This respect inspires communication and compromise to prepare specimens such that they make each field's work possible. Preparators are the skillful, creative tinkerers who craft fossils into specimens that serve a variety of purposes for several fields. For example, scientists Grande and Hilton's desire to see the fossil sturgeon skull disassembled and entirely free of matrix challenged preparator Van Beek's desire to protect the skull from potential damage from both preparation and the long-term chemical degradation of adhesives (chapter 4). Of course, the scientists likewise didn't want to harm the specimen, and the preparator wanted to facilitate learning about the magnificently preserved fish too. By each taking responsibility for one of these perspectives, they managed to negotiate a middle ground approach in which Van Beek's expert matrix removal, adhesive selection, and storage box design achieved a specimen that enabled research access while preventing major damage and data loss. Yet the collaborators disagreed about who deserved credit for this success. The scientists claimed in their paper to have prepared the specimen, which so astonished Van Beek that she and a colleague published their own version of the event. Even when fields achieve a mutually satisfactory specimen, they can still disagree about how to recognize each other's contributions.

It is when we recognize science as the actions of distinct groups of actors, with varying values, goals, expertise, and forms of power, that we can fully understand knowledge as the hard-won outcome of compromise

and cooperation. Because of the unequal institutional status of interdependent fields in vertebrate paleontology, one might assume that nonscientist research workers are oppressed by their omission in scientists' main form of recognition: publications. Some preparators do feel underappreciated, although being excluded from scientists' publications yields some benefits—principally preparators' control over their techniques and training. Sociologists Susan Leigh Star and Anselm Strauss (1999, 20–21) found that a lack of recognition can protect practitioners' autonomous decision making, while by contrast, imposing documentation of previously unwritten work can cause the insulting "eradication of discretion from skilled workers." So if scientists begin to coauthor with preparators or record preparators' methods in print, it's likely that the scientists would pay more attention to preparators' training and methodological decisions, and try to align them with scientists' own relatively standardized backgrounds and techniques. This would limit or even deny preparators' cherished creative problem solving and control over their practices. Thus "the phenomenon [of invisibility in print] is one of tradeoffs and balances" (Star and Strauss 1999, 24). Identifying those trade-offs and balances reveals the priorities of the groups involved, and sheds light on the mechanisms of power in a community, including who is allowed to decide how they are represented (Suchman 1995). After all, "the politics of crediting" in science encompasses all the complexities of social interactions, including biases, competition, and personal relationships (Timmermans 2003).

Fossil preparators witness the everyday realities of laboratory life that don't include scientists, and that scientists and STS scholars therefore tend to overlook. Because preparators reject standardization and automation, don't value credentials, and embrace volunteers, their perspectives can help us imagine how research work in general can be done differently and recognized more inclusively. Specifically, preparators alone choose and design techniques tailored for each specimen, and select and train future preparators (chapters 1–2). They even teach their skills to volunteers with no fear of replacement by this free workforce. Many research communities rely on students in similar ways as fossil research communities rely on volunteers. Like volunteers, graduate and undergraduate student research

workers are unpaid or low paid, and require substantial training (often from technicians) to conduct useful work (Wylie 2018a; 2019c). Nonetheless, like technicians and volunteers, students can contribute influential ideas and methodologies as well as labor to research groups (Wylie 2021).

Technicians' experience of doing science is not universal, of course, but there are some common trends. Technicians share low institutional status. They perform manual and epistemic work to produce objects or data that achieve their and their bosses' goals thanks to their somewhat inexplicable ability to conduct techniques, adapt tools, and troubleshoot machines (e.g., Law 1994; Goodwin 1995; Sims 1999, 2005; Timmermans 2003; Doing 2004, 2009). These poorly understood, seemingly magical skills characterize many kinds of technicians (Barley, Bechky, and Nelsen 2016), including medical technicians (Joyce 2005; Alac 2008), repair technicians (Orr 1996; Henning 1998), field collectors (e.g., in natural history [Kohler 2006; Delbourgo 2017] and anthropology [Bangham 2014]), and even supposedly unskilled factory workers (Kusterer 1978). Scientists know that technicians' abilities are crucial for successful research, though they typically express this appreciation, if at all, outside publications. Paleontologists regularly told me how important preparation is for research, and occasionally I heard them say that to preparators. Similarly, engineering firms colocate research and design work because they want researchers' abstractions and designers' hands-on skills to inform each other (Carlson 2005; Carlson and Sammis 2009). Some scientists' job negotiations include demands for positions for their most valued technicians (e.g., Timmermans 2003, 204). Similarly, paleobotanist Hope Jahren's (2016) best-selling memoir *Lab Girl* can be read as a tribute to the wisdom, work ethic, expertise with instruments and samples, and loyalty of her longtime technician, Bill. How a research community works together is intricately linked to the relationships between workers.

Who Is Missing?

The metaphor of preparing knowledge embraces the plurality of research work and workers, regardless of their forms of recognition or power. It highlights that making sense of nature relies on skills, foibles, social

conventions, and relationships just as all human endeavors do. It focuses on the various ongoing kinds of research work more than on the intended outcomes. It thereby encompasses a broad arc of scientific labor by situating theory formation alongside how those theories influence work, workers, and ways of knowing, and vice versa, in an iterative, adaptive, dynamic cycle. This labor is done by many people, not all of whom are scientists. Yet research communities fail to recognize people's contributions for a variety of reasons that deserve further study. The marginalization of some research workers can be explained by many possible factors beyond scientists' long-standing efforts to hide the messy, subjective work of research, such as discrimination based on education, gender, and race and ethnicity. Knowledge preparation demands that we pay attention to all workers and ask why some may seem difficult to find. Understanding their exclusion offers insights into widespread social values and biases, and can help us conceptualize what research communities ought to look like.

One reason for exclusion is a lack of scientific credentials. For example, doctors and clinical researchers have long considered patients to be passive recipients of health care and experiments because they lack medical training. As a result, they typically ignore patients' experience-based expertise about illness. Clinical researchers also strip patients of their identities and individualities to make unique patients comparable in order to support generalizable epistemic claims about health (Campbell and Stark 2015), in addition to more recent reasons of privacy and ethics. Incorporating patients' knowledge into medical knowledge, however, can improve patients' treatments and doctors' understanding of the experience of disease (Pols 2014). For example, people with HIV/AIDS in the 1980s believed that established ways of knowing in medicine exploited patients such as in clinical drug trials that used placebos (Epstein 1998). In response, they developed alternative ways of testing drugs that the medical establishment eventually adopted, such as before-and-after-treatment comparisons of patients' own health records instead of placebo groups. Thus including diverse forms of knowledge and knowers can yield more valuable research and more satisfied participants.

Gender discrimination can also impede the categorization of women as contributors to knowledge. Women scientists in the nineteenth and

twentieth centuries experienced many kinds of institutionalized and casual discrimination (e.g., Rossiter 1982; Oreskes 1996). Women nonscientists have gone unacknowledged for their contributions to research too, such as the only recently told stories of nineteenth-century women data analysts in astronomy at Harvard University (Sobel 2016), women machine operators at Oak Ridge during the Manhattan Project (Kiernan 2013), women tech experts in mid-twentieth-century Britain (Hicks 2017), and African American women "computers" at NASA during the space race (Shetterly 2016). This discrimination continues today as both a cause and effect of women's underrepresentation in the science and engineering workforce.[1] Women are overrepresented in lower-status, lower-paid "pink-collar" jobs like teaching, nursing, cleaning, service, and low-level administration (Blum 1991). These care-centered jobs resemble evidence preparation in the sense that workers receive little recognition even though their work permits the achievement of crucial social functions, such as education, health care, and research.

Bias against certain racial and ethnic groups similarly results in the denial of their knowledge and research work. European explorers and colonists in the eighteenth and nineteenth centuries relied on Indigenous and enslaved people for their familiarity with local environments, as well as for their labor. Naturalists, such as Sir Hans Sloane and Charles Darwin (1913), used local people as guides and collectors of natural history specimens (and food), without recording their names or considering their interpretations of their environments to be legitimate knowledge (Delbourgo 2017). One example of more recent race-based marginalization is Vivien Thomas, an African American technician in the United States in the 1940s–1970s. He conducted decades of influential physiology experiments and designed a lifesaving surgical technique, yet received no mention in print from his scientist-boss (Timmermans 2003). This invisibility was a result of many factors, including Thomas's race, occupational status, and lack of formal education as well as his boss's fear that Thomas would gain acclaim and then take another job, stranding the scientist (Timmermans 2003). Racism thus benefits the powerful. Likewise, Indigenous knowledge continues to be ignored if it does not fit empowered groups' paradigms or goals, such as when Native American communities' notions of identity

conflict with—and are overridden by—the US government's definitions of tribal membership (TallBear 2013). The striking underrepresentation of most racial and ethnic groups in science degrees and careers today suggests that our society has regularly denied these groups access to the education, identity, and employment opportunities that have long been required for successful participation in science (National Science Foundation 2019).[2] Thinking about science as knowledge preparation calls attention to all research workers and why they may have been marginalized, and raises the question of who may still be missing in today's research communities, as I will discuss at the end of this conclusion. As the next section argues, how we think about the work of preparing nature into evidence through constitutive cleaning is an important way to broaden conceptions of research work and workers.

ETHNOGRAPHIC MOMENT #2: PREPARING EVIDENCE AS CRAFTING DATA

Volunteer Keith peered into a basketball-size plaster jacket, carefully scraping away rock with a pin vise from the just-visible edge of a dinosaur vertebra. Muted sunlight filtered through the lab's dusty windows at the Northern Museum, falling on a row of workers hunched over assorted fossils and tools at long tables. With his eyes on the fossil, Keith asked staff preparator Amanda which species this bone came from. She replied, with her own eyes pressed firmly against a binocular microscope mounted over a fossil, that one researcher had said that the specimen belonged to *Eolambia*, a genus of herbivorous dinosaurs. "Supposedly," researcher Todd chimed in from across the room. Keith and Amanda both looked up, surprised by his skepticism. Todd then explained the dearth of diagnostic evidence for the specimen's classification. Keith joked, "Oooh, I'm in a controversy! One little slip [of my pin vise] and it won't be *Eolambia*." Todd quipped, "It'll be neolambia!" Everyone laughed.

Preparators' ability to decide a specimen's appearance and therefore influence how a researcher interprets it is a secret that all research workers know, even though they only address it in the private, ephemeral medium

of lab jokes (chapter 4). The idea of a preparator making a mistake that creates a new species—like Keith's "one little slip," or preparators' joke about making foramina—is funny because it could happen. Even during error-free preparation, fossils' appearance and designation as specimens rely on preparators' skill and expert decision making (chapter 1). For example, Jay decided which tiny chunks of teeth to glue together to reconstruct the fossil mammal jaw and which chunks to discard as useless tooth dust. Likewise, he trusted his judgment (and wisely rejected mine) to decide whether and where to reattach broken pieces of the fossil horse skull, including a canine tooth that was missing in the skull's published description. Adding the tooth altered the definition of the species for which this particular fossil serves as the type specimen. Also, Jay's cast of the fossil squirrel skull could have shown an animal with unidentifiable teeth (because they were obscured by air bubbles in the casting material) and an enormous sagittal crest (created by the gap between the two halves of the mold). As a result, he threw away the bubbled-teeth cast and carved off the fake crest. Furthermore, whether preparators are innately patient and dexterous, as the prep test assesses (chapter 2), has physical and epistemic implications for specimens, as in the case of the unskilled volunteer who accidentally bored holes through a skull that became the type specimen of a new dinosaur species (chapter 4).

Fossils can look like an undefined, chaotic mess. While cleaning and sculpting them into specimens, preparators' decisions and actions physically shape those fossils and the evidence they can yield. This is the process of constitutive cleaning. Likewise, handwritten field observations; samples of blood, pollutants, and pollen; a machine's readout of experimental results; and any other kind of data can appear incomprehensible. These potential sources of evidence are useless until someone skillfully makes them visible and legible, such as by removing the surrounding distractions and thereby defining the object of interest. In addition, someone has to categorize, document, and store those data in ways that make them safe and findable. As Leonelli (2015) argues, data also become evidence only when someone uses them to support a knowledge claim. Before that, they are merely objects without meaning. All steps and supposed missteps are part of the work of preparing knowledge, in which the work itself has no

end but rather creates an ongoing series of possible paths that branch off and loop back together. I do not suggest that science is self-correcting, nor that knowledge preparation aims to uncover universal truth. Instead, the work of making sense of nature is shaped by practitioners' dynamic decisions, as is the knowledge that such work produces. Following all the components of that work can lead us to encounter all the relevant people, and learn how their backgrounds and expertise shape scientific practice, community, and knowledge.

Preparators are responsible for choosing techniques and tools to achieve appropriate outcomes for each fossil. They consult with members of different fields and try to prepare a specimen that satisfies each field's needs. Preparators revel in the power and challenge of this creative problem solving, in which they anticipate how different technologies might affect a fossil in terms of speed of preparation, risk of damage, and which aspects will be made visible, and then select the best approach, adapt it accordingly, or occasionally invent a new one (chapters 1 and 3). When Carla struggled to keep a beautiful fish's scales in place while removing the thin layer of rock on top of them (chapter 1), she switched tools from pin vise to air abrader, and then carefully tuned the air abrader's settings several times based on how each setting changed the specimen's scales and matrix. Her decisions and actions responded to the moment-to-moment behavior of the fossil, rock, and tool as well as her own hand. If her problem-solving judgment and movements had failed, the fish would have lost its scales. By succeeding, Carla provided scientists with visible scales positioned where they had been fossilized as a wonderfully complete and in situ source of data about the fish's anatomy and taphonomy.

Preparators so value their autonomy to choose and alter techniques and tools that they argue ardently about these decisions, and have no standardized protocols or universal methods. For example, consensus continues to elude them about how to balance the short- and long-term purposes of specimens, such as with regard to using cyanoacrylate or reversible adhesives on fossils (chapter 1). Because preparators have invested in learning how to adapt technologies to each fossil's particular situation, they have used essentially the same technologies for over a century, such as an air scribe as

merely a pneumatically powered version of the ancient hammer and chisel. Preparators' inability to tinker with CT scanners may be one reason why they—and the scientists who are accustomed to relying on preparators' expertise—are wary of them (chapter 3). Asserting their jurisdiction over preparation techniques and tools defines preparators' identity as well as prepared fossils' physical structure.

The social and epistemic issues involved in deciding the durability of fossils shed light on the fraught process of preserving other kinds of data while also making them flexible enough to address a variety of research questions.[3] The rise of public databases and the open science movement have made research data more accessible and alterable for people who did not collect them (e.g., Leonelli 2008, 2016; Levin and Leonelli 2017). Data sets can thus be reprepared to serve as evidence for research questions beyond the ones for which they were created. The crucial work of organizing, formatting, labeling, and analyzing data sets involves similar evidence-crafting expertise as preparing specimens and managing specimen collections. As this constitutive cleaning is increasingly distanced from data creation, the importance of data curators and their practices to scientific knowledge and communities will only grow. The "data journeys" that result from this transfer and repreparation influence how data are structured, analyzed, and interpreted (Leonelli and Tempini 2020). Sometimes preparing evidence and preparing knowledge happen in different times and places during this journey, such as when Jay reprepared the horse skull fifty years after its original preparation and published description (chapter 1). Nonetheless, these processes are inseparable and have important implications for the iterative, responsive, ongoing cycle of preparing knowledge as well as for the people who do that work.

ETHNOGRAPHIC MOMENT #3: PREPARING AS INCLUSIVE AND TRUSTWORTHY

How Research Workers See Their Publics

Collection manager Bob strolled into the glass-walled prep lab at the Southern Museum with a mischievous gleam in his eyes. He told two

volunteers and me that he had just examined an object whose owner had asked the museum to identify it. The owner, who had found the specimen, suggested that it was a "fossil male organ," Bob quoted with delight. Encouraged by his audience's cringing giggles and eye rolls, he described the specimen's cylindrical shape in lascivious detail and noted, with a straight face, that "the color was right on." Bob's assessment was that the specimen was "quartzite"—rock, not fossil—and was therefore no one's organ. "She was so disappointed," Bob sighed in mock sympathy for the specimen's owner. Then he launched into an enthusiastic impromptu lecture about the function and phylogeny of the baculum, which is a bone inside the penis of many extinct and extant mammal species.

Research workers often tell each other stories about objects that they've been asked to identify as a courtesy to the public. Most of these narratives, like Bob's, feature themes of how ignorant people are about fossils and how disappointed specimen bringers are by identifications that make their finds less interesting than they had hoped. Research workers don't mind these reactions as they consider it their responsibility to address people's lack of knowledge about fossils, even if that means making a kid cry by telling him that his cherished dinosaur tooth is merely an ammonite (as happened to Carla at the Northern Museum). According to a few stories, this disappointment has led specimen bringers to reject the workers' identification and insist that the object is indeed a T. rex claw, dinosaur feather, fossilized amber entombing *Jurassic Park*-inspired mosquitoes, or whatever other desirable designation they have already given it. This reaction offends research workers because these specimen owners deny the workers' expertise, refuse to be open to learning, and occasionally argue aggressively with the workers.

These stories show how interactions between research workers and visitors can challenge both groups' assumptions about specimens, nature, scientific practice, and scientific knowledge. For example, at the start of Bob's story, the volunteers and I were laughing at the specimen finder for making silly assumptions about any torpedo-shaped rock. But at the end, Bob justified the specimen finder's seemingly ridiculous classification by explaining that a "male organ" can in fact have a bone that can fossilize. The

volunteers and I dismissed Bob's explanation as a joke, so he indignantly marched us out of the lab and into the exhibit hall to point at a baculum mounted on a fossil seal skeleton on display. Duly chastened, we listened as Bob added that fossil bacula are prized specimens for museums because they are rarely preserved due to their small size and presence only in male individuals. The object he'd evaluated that day wasn't a baculum, but it was not crazy for its finder to wonder—and ask an expert—whether it might be. And if it had been a baculum, that expert probably would have tried to acquire it as a valuable research specimen for the museum's collection.

Despite commiserating over stories about people's dumb questions and insulting skepticism, research workers also readily say that they serve and learn from the public. Their thoughtful attention to how they portray themselves and their work on the stage of glass-walled labs reflects how important it is to them to make a good impression on museum visitors (chapter 5). How they agonize over exhibit designs, such as whether to display real fossil bones or casts, indicates how deeply they care about visitors' access to specimens and scientific knowledge (chapter 5). Research workers also recognize that people provide them with valuable information about their local environments. Bob explained to me, "Very often it's the amateurs I'll call up and say, 'Hey, what quarries are open right now? Have you got anyplace rich that's really working?' and very often they're the ones who help us decide where to go when we're [collecting fossils] in the field." Experience with local conditions is a priceless form of expertise for specimen collecting. Bob is grateful for these collectors' generosity with their information: "You owe them something in return, and of course diffusion is part of our goals as [the Southern Museum], so you're educating them" through the museum's exhibits as well as by offering educational resources and fossil identification at festivals and other public events ("It's like *Antiques Roadshow!*"). Bob continued, "There is that selfish aspect. We'd like them to give us some of their fossils too. . . . People's basements and living rooms are the best place to find fossils." He portrays the relationship between the museum's employees and hobbyists as mutually beneficial; people trade their fossils and local expertise for research workers' knowledge about species, environments, and ethical collection practices

that protect specimens along with their contextual data. Thus building relationships with the fossil-interested public can reap valuable donations of specimens and collection information for research workers as well as grow an important audience that enables them to share their knowledge and justify their work.

Beyond Scientists

The key role of fossil preparators in paleontology is an example of how all workers influence research communities' social structure and epistemic work. Knowledge preparation forces us to recognize unsung research workers, many of whom perform a range of critical tasks for little pay or glory. Technicians and other overlooked workers can thereby inspire models of more inclusive participation so that nonscientists can more easily influence how research is done. This is more than a pleasant experience for participants of Bob's top-down knowledge diffusion; it is a way to incorporate more voices, skills, and kinds of wisdom into what we know and how we know it.

Working as technicians is one way in which people can contribute to research without being scientists. Crucially, technicians' jobs do not always include the formal barriers and strict gatekeeping of scientists' jobs, such as a PhD, publications, grants, and experience working with respected mentors in a specific field. Some technicians have these credentials, while preparators and others learn on the job with little formal science education. Preparing evidence can be a paid career, temporary or part-time gig, or unpaid volunteering. Workers' motivations for joining a research community differ accordingly, such as career aspirations, support for a worthy institution (e.g., a museum or university), or personal interest in the topic (chapter 2). They all influence the preparation of knowledge by their work and social interactions. Furthermore, presenting science as work done by skillful, creative workers with control over their techniques and community can appeal to the currently widespread interest in craft (e.g., as artisanal food and services [Paxson 2012; Ocejo 2017], and social activism via "craftivism" [Roosth 2013; Greer 2014]). The abilities required for craftwork are arguably "shared in common by the large majority of human beings

and in roughly equal measure" (Sennett 2008, 277); by this logic, craft is an inherently inclusive activity. Thus advertising flexible requirements and interesting craft-based tasks without long-term investment in specific credentials could encourage more kinds of people to contribute to research. Rethinking science as work and craft can create a welcoming invitation to participation.

Like technicians, volunteers also contribute to research without traditional credentials. They include people Bob calls amateurs, who pursue natural history as a hobby and might share their knowledge and specimens with scientific institutions. Other volunteers are tied closely to institutions, such as the many kinds of museum volunteers who prepare evidence by constitutively cleaning, conserving, organizing, and documenting specimens. Another category is citizen scientists, who collect and/or analyze data for scientists or conduct their own research. Citizen science projects invite the public to observe local wildlife through backyard bird counts or to analyze data online, such as using the GalaxyZoo website to categorize scientific images and playing the online game FoldIt to test potential protein structures (Strasser and Hacklay 2018; Strasser et al. 2019). These kinds of programs attract lots of participants, thanks to public interest in science and the programs' nonexistent or minimal training and commitment requirements. Citizen science benefits researchers by providing free labor, and participants by offering opportunities for learning and personal enjoyment (Rotman et al. 2012). Nonscientists also lead citizen science projects, usually as a form of advocacy. For example, some communities monitor their local environments for industrial pollution or nuclear fallout in order to demand protective action from corporations or governments (Ottinger 2013; Jalbert and Kinchy 2016; Lindee 2016). Other groups conduct research in order to call for appropriate governance of biotechnology (Kinchy 2012; Benjamin 2013) or more ethical clinical trials (Epstein 1998).

There are of course potential limitations to these participatory forms of research, such as conflicts between scientists and nonscientists, difficulties in assessing the quality of nonscientists' work outside traditional research avenues like peer review, and misleading promises about participants' learning and empowerment (Riesch and Potter 2014; Strasser et al. 2019).

Nonetheless, inclusive research communities can harness more kinds of knowledge. Volunteers, for instance, can bring a valuable "wisdom of peripherality" (Wenger 1998, 216) to expert communities as well as the wisdom of their own perspectives and experiences (Wylie and Sismondo 2015). Likewise, undergraduate research assistants ask paradigm-challenging questions and propose ideas inspired by their broad education, thereby highlighting research communities' tacit assumptions and providing fresh perspectives (Wylie 2021). Students, volunteers, and citizen scientists are even sometimes recognized as authors on scientific publications. Hence, even with a variety of backgrounds and roles, these groups all shape the community they work with and, consequently, the knowledge they prepare together.

Institutions, however, currently dedicate relatively little funding for technicians, students, volunteers, and other nonscientist research workers, even though there is an enormous amount of work for them to do (e.g., building and maintaining databases, conserving natural history specimens, organizing collections and archives, maintaining research equipment, preparing samples, running experiments, and leading public outreach activities). Even so, volunteers tend to prove their value as "museum friends," donors, and eager learners as well as laborers. Creating more (and better-paid) salaried positions for technicians and more (and better-funded) volunteer programs would further support these important opportunities for inclusive participation in knowledge preparation.

This more accessible social structure for research matches recent calls for science to be more open, such as through open-access publications, publicly available data and methods, and more inclusive research communities (e.g., National Academies of Sciences, Engineering, and Medicine 2018; Mendez et al. 2020). Building glass-walled research workplaces is one powerful way of making scientific work (more) transparent and its workers more familiar, relatable, and perhaps welcoming to museum visitors (chapter 5). Instead of the strictly divided scientific disciplines and professions formed in the nineteenth century (Bowler and Morus 2005, chap. 14), and the rise of the specialization and division of scientific labor in the twentieth century (Bowler and Morus 2005, chap. 11), today's

science can—and should—be more integrated into mainstream society, such as by making its evidence and practices more open, research questions more socially beneficial, community more participatory, and knowledge more accessible and comprehensible.

The model of preparing knowledge thus proposes a public conception of science that is more relevant, inclusive, and hopefully appealing to more kinds of people. Welcoming nonscientists into research communities also welcomes new ideas, skills, and values to permeate the boundaries that have long demarcated science. Research workplaces can therefore function as a liminal space connecting scientists and nonscientists. In these communities, nonscientists can learn how science is done and potentially shape new ways to investigate based on their diverse skills and experiences, while scientists can learn what nonscientists want to know and can cultivate these collaborators as powerful supporters of scientific work, institutions, and knowledge. Inviting the public to view science as important and interesting work that they can contribute to would be a powerful way to address two critical problems: the underrepresentation in science of people with diverse identities and backgrounds, and growing public skepticism and outright denial of scientific knowledge.

What We Owe Technicians: Preparing Trust

To finish, let's return to these three ethnographic moments: the cheerful bustle of Chili Thursday, the joke about inventing neolambia, and the disappointed owner of a phallus-shaped rock. In each of these interactions, research workers nurtured trust. They invest time and effort (sometimes over lunch) to earn each other's trust, which serves as a foundation for all of their work. Trust underlies their collaborative compromises across fields, even during controversies. It gives credence to preparators' skillfully crafted specimens and creatively designed technologies. It leads museum visitors to respect and admire displays of scientific knowledge, specimens, and sometimes workers. It encourages amateur fossilists to swap expertise with research workers. Crucially, trust allows us all to see a rock not as a rock but instead as a fossilized relic of an unfamiliar animal in an alien environment, and therefore as one fragment of a grand narrative about life on Earth.

This book has shown the foundational contributions of nonscientists to the practices and people of research communities, conceptions of what science is, and the preparation of current and future scientific knowledge. These processes are best understood by following them in action within communities where a variety of workers transform unique pieces of nature into evidence for global knowledge claims. This approach yields insights into how science works as a critical starting point for evaluating how we want it to work in the future. Reframing research as an ongoing, iterative process of preparation enriches our understanding of how the everyday labor of familiarly multifaceted humans allows us to learn about nature. This framework offers a way to welcome more kinds of people to contribute to research. Broadening participation and improving inclusion can help achieve accessible, respected, socially significant science.

In our era of alternative facts and selective truths, more people are questioning whether science is a reliable way to understand the world. Making research work more transparent and inviting, and recognizing more kinds of people as contributors to knowledge, can inspire widespread trust in science. Throwing open the doors of the laboratory for public participation—and scrutiny—can help disprove denialism, and reassert that science is a credible and socially beneficial activity. It's possible this strategy could backfire if nonscientists are shocked by the "warts-and-all" view of science as human work (Shapin 1992, 28). But I think this fear discredits people's genuine curiosity to look behind the scenes of science as a seemingly secret society. Critique of science is bound to follow, but hopefully the resulting debates at least would be more informed and at best would offer insightful, actionable feedback for improving the process of preparing knowledge.

Notes

INTRODUCTION

1. Scientists have long relied on specimen collectors from diverse populations and without formal science training, including amateurs, enslaved people, and people from Indigenous groups (e.g., Darwin 1913; Secord 1994; Kohler 2006; Bangham 2014; Delbourgo 2017). These workers are rarely recognized in exhibits or scientific papers for their contributions.

2. On the history of paleontology, see Sepkoski and Ruse 2009; Brinkman 2010; Sepkoski 2012; Rieppel 2019. On the philosophy of paleontology, see Turner 2007, 2019; Currie 2018. On the history of geology, see Rudwick 1976, 1985, 2005, 2008. On historic and recent taxidermy, see Haraway 1984; Star and Griesemer 1989; Star 1992; Alberti 2008; Patchett and Foster 2008; Poliquin 2008. On the sociology and philosophy of archaeology, see Holtorf 2002; Wylie 2002; Edgeworth 2006; Chapman and Wylie 2016.

3. I collected most of this book's data in 2008–2012, with follow-up visits to labs and conferences in 2012–2017. These data represent a particular moment in the nebulous community of fossil research workers. The data are not universal or timeless, and of course experiences and opinions vary between individuals and can change over time. Nonetheless, these interviews and observations offer compelling insights into laboratory life.

4. Interviews followed a semistructured protocol of prepared questions with space for unexpected topics (Bryman 2008). Interviewees signed a consent form and had the opportunity to comment on their interview transcripts. I conducted sixty-four formal interviews and countless informal conversations. I coded the transcripts and my field notes following inductive analysis and grounded theory.

5. For example, I mixed plaster, repaired fossils, molded and cast a dinosaur footprint to create replicas, and cut open the plaster-and-burlap protective casing (called a jacket) around recently collected fossils.

CHAPTER 1

1. The Fossil Preparation and Collections Symposium has been held annually since 2008. In 2015, it became part of the newly founded Association for Materials and Methods in Paleontology.

CHAPTER 2

1. I distributed the survey in 2010 at conferences, lab visits, and online via the PrepList. I analyzed the seventy-nine responses with basic statistics.

2. As one indicator of the size of the preparator population, the PrepList had 231 subscribers in 2011 (and 415 in 2018). But not all preparators belong to the PrepList, and most of its subscribers live in North America. People from several countries responded to my survey, but I do not try to compare global cultures of fossil preparation.

3. On prosopography, see Shapin and Thackray 1974; Bourdieu 1988.

4. A person-year means 2,000 hours of work.

5. These studies investigate volunteers in zoos, "human services, arts and culture, religion, youth development, education and health," not in labs or science museums (Bussell and Forbes 2002, 247). As an exception, Deborah Edwards has done extensive research on museum volunteers (Edwards 2005, 2006, 2007a, 2007b; Edwards and Graham 2006; Holmes and Edwards 2008). But Edwards's participants were primarily docents, so her studies overlook volunteers who do research tasks. Likewise, David Grazian's (2015) study of zoo workers includes animal care volunteers and docents, but not research volunteers.

 Perhaps surprisingly, no volunteer mentioned to me the institutional perks as motivating factors, such as free museum entry, shop discounts, subsidized travel costs, or volunteer appreciation events. This suggests that these benefits serve to celebrate volunteers rather than compensate them. Recognition of their work—or more often, lack thereof—is a crucial factor for volunteers' level of commitment (Edwards 2007a). Few of the volunteers I spoke with, however, reported feeling unappreciated; in fact, the vast majority expressed gratitude for being allowed to volunteer. This difference indicates that volunteer preparators, and perhaps skilled volunteers in general, may value their internal, personal motivations more than external motivations such as recognition, as compared to other kinds of volunteers.

CHAPTER 3

1. Another rock removal technology is acid preparation, in which preparators soak specimens in acid to slowly dissolve away matrix. I don't address acid preparation here because it's not widely used on vertebrate fossils. Specifically, it only works on certain kinds of matrix, it can be destructive to fossils, and only some institutions have the facilities to do it (e.g., the space, safety equipment, and potentially hazardous materials to bathe fossils in acid for days at a time).

2. Museum displays became more interactive during the twentieth century, arguably lessening their focus on specimens. Also, the posture of fossil mounts has changed considerably with new beliefs about animals' weight distribution and functional morphology. Changes in fossil research include the emerging interest in the 1960s in whether dinosaurs were warm or cold blooded, leading to searches for fine fossilized details such as the impressions of feathers and blood vessels. On twentieth-century fossil research, see Sepkoski and Ruse 2009; Sepkoski 2012.

3. Brinkman (2009, 32) points out that it was most likely the museum's preparator, Adam Hermann, who was experimenting with the sandblast, not Osborn himself, who was a busy museum administrator as well as a researcher.

4. It's not clear how many people worked as preparators in the early twentieth century or today. Brinkman documents at least one well-known preparator at each major museum in the early twentieth century, plus a cadre of lesser-known workers who were preparing fossils. As one indicator of today's preparator population, the PrepList had 415 subscribers in 2018.

5. The authors propose that the mammal-like reptile may have been estivating (i.e., in a low metabolic state similar to hibernation) in the burrow and for unknown reasons "tolerated the amphibian's presence" (Fernandez et al. 2013, 1). The two were trapped inside the burrow by a fast flood, which probably killed them and then quickly fossilized their remains.

CHAPTER 4

1. He said "but-var" (/bʌtvar/), while preparators say "butte-var" (/bju:tvar/).

2. One famous case of a nicknamed fossil is "Sue," a T. rex. The skeleton's collectors named it after its discoverer, Sue Hendrickson. The press picked up the name when high-profile federal lawsuits arose to determine the fossil's ownership. Chicago's Field Museum later bought Sue at auction for a record-setting $8.4 million in 1997 (Fiffer 2000). Preserving the name probably had marketing benefits because it identifies the fossil as an individual and is more familiar than a Latin species name, even one as well-known as T. rex. I only met one scientist who nicknames fossils. Jenny Clack, a researcher at the University of Cambridge, named her various *Acanthostega* specimens Boris, Pop, Patch, Fido, Grace, and Rosie (Lewis 2012). Clack, however, told me that she had learned to prepare fossils; perhaps her penchant for specimen names was inspired by her time spent with preparators.

3. This uncertainty about whether the holes existed prior to preparation might seem unresolvable, but there are no matching holes on the snout's opposite side, which the volunteer had not prepared. Also, human-made holes tend to have jagged edges, unlike a natural hole's smooth edges.

4. In the later publication describing this specimen, Henry and his coauthors explained that a volunteer had damaged one side of the skull. This is a rare example of preparation appearing in a research paper. It matches Shapin's (1989, 1994) observation that technicians are made visible in situations of questionable research results, for which researchers label them the scapegoats, deservedly or not.

5. Interestingly, three years later the authors changed the fish's genus name because they discovered that *Psammorhynchus* had already been assigned to another genus (Grande and Hilton 2009). To avoid duplication, they replaced it with *Priscosturion*, for primitive (*priscus*) sturgeon (*sturio*). This name loses the references to the fossil's matrix and morphology. The fish's species name, which has not changed, is *longipinnis*, meaning "long sail" for its distinctively tall dorsal fin.

6. Scientists have named species after preparators, such as the remarkably preserved nodosaur *Borealopelta markmitchelli*, whose name "honors Mark Mitchell for his more than 7,000 hours of patient and skilled preparation of the holotype" (Brown et al. 2017, 2514). As far as I know, only one of the preparators I've met is the namesake of a species, suggesting that it is an unusual practice.

7. With apologies to Robert Frost (1914), whose poem "Mending Wall" suggests the opposite.

CHAPTER 5

1. For studies of visitors to glass-walled fossil preparation labs, see Gavigan 2007, 2009; Noble 2016, chap. 12. For examples of visitors' reactions to these labs, see Wylie 2020.

2. Preparators also work on important fossils while on display, including type and famous specimens, for convenience or publicity. For example, preparators prepared the Field Museum's Sue the T. rex almost entirely in a purpose-built and well-publicized glass-walled lab ("SUE the T. rex" 2018).

CONCLUSION

1. Only 28 percent of workers in science and engineering in the United States were women in 2015 (National Science Foundation 2017).

2. There aren't official demographics data for fossil preparators. As one measure, I have not met or heard about an African American preparator, and I know of only a few Hispanic, Latinx, or Asian preparators. Nearly everyone is White. Preparators in the United States resemble scientists in their racial and ethnic homogeneity.

3. See the 2017 special issue of *Osiris* titled "Historicizing Big Data," especially historian Mirjam Brusius (2017) on archaeological artifacts.

References

Abbott, Andrew. 1988. *The System of Professions: An Essay on the Division of Expert Labor*. Chicago: University of Chicago Press.

"About Us." 2014. Association for Materials and Methods in Paleontology. https://paleomethods.org/About-Us-2.

Alac, Morana. 2008. "Working with Brain Scans: Digital Images and Gestural Intersections in fMRI Laboratory." *Social Studies of Science* 38 (4): 483–508.

Alberti, Samuel J. M. M. 2008. "Constructing Nature behind Glass." *Museum and Society* 6 (2): 73–97.

Ancell, Carrie A., Robert Harmon, and John R. Horner. 1998. "Gar in a Duck-Bill: Preservation of a Scavenger and Its Prey." In *Abstracts of Papers, 58th Annual Meeting, Society of Vertebrate Paleontology* 18:24A.

Appadurai, Arjun, ed. 1986. *The Social Life of Things*. Cambridge: Cambridge University Press.

Balanoff, Amy M., Mark A. Norell, Gerald Grellet-Tinner, and Matthew R. Lewin. 2008. "Digital Preparation of a Probable Neoceratopsian Preserved within an Egg, with Comments on Microstructural Anatomy of Ornithischian Eggshells." *Naturwissenschaften* 95:493–500.

Balanoff, Amy M., Gabe S. Bever, Timothy B. Rowe, and Mark A. Norell. 2013. "Evolutionary Origins of the Avian Brain." *Nature* 501 (7465): 93–96.

Banfield, Julie K., Heinz Andernach, A. D. Kapińska, Lawrence Rudnick, Martin J. Hardcastle, Garret Cotter, S. Vaughan, et al. 2016. "Radio Galaxy Zoo: Discovery of a Poor Cluster through a Giant Wide-Angle Tail Radio Galaxy." *Monthly Notices of the Royal Astronomical Society* 460 (3): 2376–2384.

Bangham, Jenny. 2014. "Blood Groups and Human Groups: Collecting and Calibrating Genetic Data after World War Two." *Studies in History and Philosophy of Science Part C: Studies in History and Philosophy of Biological and Biomedical Sciences* 47:74–86.

Barley, Stephen R. 1996. "Technicians in the Workplace: Ethnographic Evidence for Bringing Work into Organizational Studies." *Administrative Science Quarterly* 41 (3): 404–441.

Barley, Stephen R., and Beth A. Bechky. 1994. "In the Backrooms of Science: The Work of Technicians in Science Labs." *Work and Occupations* 21 (1): 85–126.

Barley, Stephen R., Beth A. Bechky, and Bonalyn J. Nelsen. 2016. "What Do Technicians Mean When They Talk about Professionalism? An Ethnography of Speaking." *Research in the Sociology of Organizations* 47:125–160.

Bather, Frances A. 1908. "The Preparation and Preservation of Fossils." *Museum Journal* (September): 76–90.

Bechky, Beth A. 2003. "Sharing Meaning across Occupational Communities: The Transformation of Understanding on a Production Floor." *Organization Science* 14 (3): 312–330.

Benjamin, Ruha. 2013. *People's Science: Bodies and Rights on the Stem Cell Frontier*. Stanford, CA: Stanford University Press.

Bergwall, Lisa. 2009. "Fossil Preparation Test: An Indicator of Manual Skills." In *Methods in Fossil Preparation: Proceedings of the First Annual Fossil Preparation and Collections Symposium*, edited by Matthew A. Brown, John F. Kane, and William G. Parker, 35–40.

Bernard, H. M. 1894. "On the Application of the Sand-Blast for the Development of Trilobites." *Geological Magazine*, 553–557.

Bijker, Wiebe E., Thomas P. Hughes, and Trevor Pinch, eds. 2012. *The Social Construction of Technological Systems, Anniversary Edition*. Cambridge, MA: MIT Press.

Blum, Linda M. 1991. *Between Feminism and Labor: The Significance of the Comparable Worth Movement*. Berkeley: University of California Press.

Bohannon, John. 2016. "For RNA Paper Based on a Computer Game, Authorship Creates an Identity Crisis." *Science*, February 17. http://www.sciencemag.org/news/2016/02/rna-paper-based-computer-game-authorship-creates-identity-crisis.

Boraas, Stephanie. 2003. "Volunteerism in the United States." *Monthly Labor Review* 3:3–11.

Bourdieu, Pierre. 1988. *Homo Academicus*. Stanford, CA: Stanford University Press.

Bourdieu, Pierre. 1993. *Sociology in Question*. London: Sage Publications Ltd.

Bourdieu, Pierre, and Loic J. D. Wacquant. 1992. *An Invitation to Reflexive Sociology*. Chicago: University of Chicago Press.

Bowler, Peter J., and Iwan Rhys Morus. 2005. *Making Modern Science: A Historical Survey*. Chicago: University of Chicago Press.

Brinkman, Paul D. 2009. "Dinosaurs, Museums, and the Modernization of American Fossil Preparation at the Turn of the 20th Century." In *Methods in Fossil Preparation: Proceedings of the First Annual Fossil Preparation and Collections Symposium*, edited by Matthew A. Brown, John F. Kane, and William G. Parker, 21–34.

Brinkman, Paul D. 2010. *The Second Jurassic Dinosaur Rush: Museums and Paleontology in America at the Turn of the Twentieth Century*. Chicago: University of Chicago Press.

Brochu, Christopher A. 2003. "Osteology of Tyrannosaurus Rex: Insights from a Nearly Complete Skeleton and High-Resolution Computed Tomographic Analysis of the Skull." *Memoir (Society of Vertebrate Paleontology)* 7.

Brown, Caleb M., Donald M. Henderson, Jakob Vinther, Ian Fletcher, Ainara Sistiaga, Jorsua Herrera, and Roger E. Summons. 2017. "An Exceptionally Preserved Three-Dimensional Armored Dinosaur Reveals Insights into Coloration and Cretaceous Predator-Prey Dynamics." *Current Biology* 27 (16): 2514–2521.e3.

Brown, Matthew A. 2009. "Preliminary Report on Professional Development in Vertebrate Fossil Preparation." In *Proceedings of the 15th Annual Tate Conference and Second Annual Fossil Preparation and Collections Symposium*, Tate Museum, Casper College, Casper, Wyoming, June 5–7, 52–57.

Brown, Matthew A. 2013. "The Development of 'Modern' Palaeontological Laboratory Methods: A Century of Progress." *Earth and Environmental Science Transactions of the Royal Society of Edinburgh* 103: 205–216.

Brown, Matthew A., Amy Davidson, Marilyn Fox, Steve Jabo, and Matt Smith. 2012. "Defining the Professional Vertebrate Fossil Preparator: Essential Competencies." http://vertpaleo.org/For-Members/Preparators-Resources/Preparators-Resources-PDF-files/Preparator_Core_Competencies.aspx.

Brown, Matthew A., Matthew Smith, Steve Jabo, and Abby Telfer. 2010. "The Smithsonian Institution's Exhibit Fossil Preparation Lab Volunteer Training Programme, Part II: Training and Evaluating Student Preparators." *Geological Curator* 9:179–186.

Brusius, Mirjam. 2017. "The Field in the Museum: Puzzling out Babylon in Berlin." *Osiris* 32 (1): 264–85.

Brusius, Mirjam, and Kavita Singh. 2018. Introduction to *Museum Storage and Meaning: Tales from the Crypt*, edited by Mirjam Brusius and Kavita Singh, 1–33. New York: Routledge.

Bryman, Alan. 2008. *Social Research Methods*. 3rd ed. Oxford: Oxford University Press.

Bussell, Helen, and Deborah Forbes. 2002. "Understanding the Volunteer Market: The What, Where, Who and Why of Volunteering." *International Journal of Nonprofit and Voluntary Sector Marketing* 7 (3): 244–257.

Cambrosio, Alberto, and Peter Keating. 1988. "'Going Monoclonal': Art, Science, and Magic in the Day-to-Day Use of Hybridoma Technology." *Social Problems* 35 (3): 244–260.

Cambrosio, Alberto, and Peter Keating. 2000. "Of Lymphocytes and Pixels: The Techno-Visual Production of Cell Populations." *Studies in History and Philosophy of Biology and Biomedical Sciences* 31 (2): 233–270.

Campbell, Nancy D., and Laura Stark. 2015. "Making Up 'Vulnerable' People: Human Subjects and the Subjective Experience of Medical Experiment." *Social History of Medicine* 28 (4): 825–848.

Carlson, W. Bernard. 2005. "Invention, History, and Culture." In *Science, Technology, and Society: An Encyclopedia*, edited by Sal Restivo, 230–236. New York: Oxford University Press.

Carlson, W. Bernard, and Stuart K. Sammis. 2009. "Revolution or Evolution?: The Role of Knowledge and Organization in the Establishment and Growth of R&D at Corning." *Management and Organizational History* 4 (1): 37–65.

Carvajal, Doreen. 2016. "Showtime at the Musée d' Orsay: Watching Varnish Dry." *New York Times*, August 15. http://www.nytimes.com/2016/08/16/arts/design/showtime-at-the-musee-dorsay-watching-varnish-dry.html?_r=0.

Chapman, Ralph E. 1997. "Technology and the Study of Dinosaurs." In *The Complete Dinosaur*, edited by James O. Farlow and Michael K. Brett-Surman, 112–135. Bloomington: Indiana University Press.

Chapman, Robert, and Alison Wylie. 2016. *Evidential Reasoning in Archaeology*. London: Bloomsbury Academic.

Charlesworth, Max, Lyndsay Farrall, Terry Stokes, and David Turnbull. 1989. *Life among the Scientists: An Anthropological Study of an Australian Scientific Community*. Oxford: Oxford University Press.

Clack, Jenny A. 1994. "Acanthostega Gunnari, a Devonian Tetrapod from Greenland; the Snout, Palate and Ventral Parts of the Braincase, with a Discussion of Their Significance." *Meddelelser Om Gronland, Geoscience* 31:3–24.

Clarke, Adele, and Joan H. Fujimura, eds. 1992. *The Right Tools for the Job: At Work in the Twentieth-Century Life Sciences*. Princeton, NJ: Princeton University Press.

Collins, Harry M. 1975. "The Seven Sexes: A Study in the Sociology of a Phenomenon, or the Replication of Experiments in Physics." *Sociology* 9 (2): 205–224.

Collins, Harry M. 2004. *Gravity's Shadow: The Search for Gravitational Waves*. Chicago: University of Chicago Press.

Collins, Harry M. 2010. *Tacit and Explicit Knowledge*. Chicago: University of Chicago Press.

Collins, Harry M. 2011. "Language and Practice." *Social Studies of Science* 41 (2): 271–300.

Collins, Harry M., and Trevor Pinch. 2002. *The Golem at Large: What You Should Know about Technology*. Cambridge: Cambridge University Press.

Conroy, Glenn C., Michael W. Vannier, and Phillip V. Tobias. 1990. "Endocranial Features of Australopithecus Africanus Revealed by 2- and 3-D Computed Tomography." *Science* 247 (February 16): 838–841.

Creager, Angela N. H., Elizabeth Lunbeck, and M. Norton Wise, eds. 2007. *Science without Laws: Model Systems, Cases, Exemplary Narratives*. Durham, NC: Duke University Press.

Cruickshank, Arthur R. I. 1994. "A Victorian Fossil Wholemount Technique: A Cautionary Tale for Our Times." *Geological Curator* 6 (1): 17–22.

Currano, Ellen, Lexi Jamieson Marsh, and Kelsey Vance. 2014. "The Cold Hard Numbers." Bearded Lady Project. http://thebeardedladyproject.com/about/the-cold-hard-numbers.

Currie, Adrian. 2015. "Marsupial Lions and Methodological Omnivory: Function, Success and Reconstruction in Paleobiology." *Biology and Philosophy* 30 (2): 187–209.

Currie, Adrian. 2018. *Rock, Bone, and Ruin: An Optimist's Guide to the Historical Sciences*. Cambridge, MA: MIT Press.

Dabney, Katherine P., Robert H. Tai, John T. Almarode, Jaimie L. Miller-Friedmann, Gerhard Sonnert, Philip M. Sadler, and Zahra Hazari. 2012. "Out-of-School Time Science Activities and Their Association with Career Interest in STEM." *International Journal of Science Education, Part B* 2 (1): 63–79.

Darwin, Charles. 1913. *A Naturalist's Voyage Round the World: Journal of Researches into the Natural History and Geology of the Countries Visited during the Voyage Round the World of H.M.S. Beagle under the Command of Captain Fitz Roy, R.N.* London: John Murray.

Daston, Lorraine, ed. 2004. *Things That Talk: Object Lessons from Art and Science*. New York: Zone Books.

Daston, Lorraine, and Peter Galison. 2007. *Objectivity*. Brooklyn: Zone Books.

Davidson, Amy, and Samantha Alderson. 2009. "An Introduction to Solution and Reaction Adhesives for Fossil Preparation." *Methods in Fossil Preparation: Proceedings of the First Annual Fossil Preparation and Collections Symposium*, edited by Matthew A. Brown, John F. Kane, and William G. Parker, 53–62.

Davidson, Jane P. 2008. *A History of Paleontology Illustration*. Bloomington: Indiana University Press.

Dean, Dennis R. 1999. *Gideon Mantell and the Discovery of Dinosaurs*. Cambridge: Cambridge University Press.

de Chadarevian, Soraya, and Harmke Kamminga. 2002. *Representations of the Double Helix*. Cambridge, UK: Whipple Museum.

Delamont, Sara, Paul Atkinson, and Odette Parry. 2000. *The Doctoral Experience: Success and Failure in Graduate School*. New York: Falmer Press.

Delbourgo, James. 2017. *Collecting the World: Hans Sloane and the Origins of the British Museum*. Cambridge, MA: Harvard University Press.

de Solla Price, Derek J. 1965. "Is Technology Historically Independent of Science? A Study in Statistical Historiography." *Technology and Culture* 6 (4): 553–568.

Doing, Park. 2004. "'Lab Hands' and the 'Scarlet O': Epistemic Politics and (Scientific) Labor." *Social Studies of Science* 34 (3): 299–323.

Doing, Park. 2009. *Velvet Revolution at the Synchrotron*. Cambridge, MA: MIT Press.

Douglas, Mary. 1966. *Purity and Danger: An Analysis of Concepts of Pollution and Taboo*. London: Routledge.

"Earth Sciences Labs." 2020. Denver Museum of Nature and Science. https://www.dmns.org/science/earth-sciences/earth-sciences-labs.

Edgeworth, Matthew, ed. *Ethnographies of Archaeological Practice: Cultural Encounters, Material Transformations*. Lanham, MD: AltaMira Press.

Edwards, Deborah. 2005. "It's Mostly about Me: Reasons Why Volunteers Contribute Their Time to Museums and Art Museums." *Tourism Review International* 9 (2): 1–11.

Edwards, Deborah. 2006. "How Volunteers Are Organized: A Review of Three Museums." In *Cutting Edge Research in Tourism—New Directions, Challenges, and Applications*, School of Management, University of Surrey, 1–15.

Edwards, Deborah. 2007a. "Corporate Social Responsibility of Large Urban Museums: The Contribution of Volunteer Programs." *Tourism Review International* 11:1–8.

Edwards, Deborah. 2007b. "Leisure-Seeking Volunteers: Ethical Implications." *Voluntary Action* 8 (3): 19–39.

Edwards, Deborah, and Margaret Graham. 2006. "Museum Volunteers: A Discussion of Challenges Facing Managers in the Cultural and Heritage Sectors." *Australian Journal on Volunteering* 11:19–27.

Elder, Ann, Scott Madsen, Gregory Brown, Carrie Herbel, Chris Collins, Sarah Whelan, Cathy Wenz, Samantha Alderson, and Lisa Kronthal. 1997. "Adhesives and Consolidants in Geological and Paleontological Conservation: A Wall Chart." *SPNHC Leaflets* 1 (2): 1–4.

Ensmenger, Nathan. 2010. *The Computer Boys Take Over*. Cambridge, MA: MIT Press.

Epstein, Steven. 1998. *Impure Science: AIDS, Activism, and the Politics of Knowledge*. Berkeley: University of California Press.

Falzon, Mark-Anthony, ed. 2009. *Multi-Sited Ethnography: Theory, Practice and Locality in Contemporary Research*. Burlington, VT: Ashgate.

Faulkner, Wendy. 2007. "'Nuts and Bolts and People': Gender-Troubled Engineering Identities." *Social Studies of Science* 37 (3): 331–356.

Fernandez, Vincent, Fernando Abdala, Kristian J. Carlson, Della Collins Cook, Bruce S. Rubidge, Adam Yates, and Paul Tafforeau. 2013. "Synchrotron Reveals Early Triassic Odd Couple: Injured Amphibian and Aestivating Therapsid Share Burrow." *PloS One* 8 (6): e64978.

Fiffer, Steve. 2000. *Tyrannosaurus Sue: The Extraordinary Saga of the Largest, Most Fought over T. Rex Ever Found*. New York: W. H. Freeman.

Frost, Robert. 1914. *North of Boston*. New York: Henry Holt and Co.

Frow, Emma K. 2012. "Drawing a Line: Setting Guidelines for Digital Image Processing in Scientific Journal Articles." *Social Studies of Science* 42 (3): 369–392.

Fujimura, Joan H. 1996. *Crafting Science: A Sociohistory of the Quest for the Genetics of Cancer*. Cambridge, MA: Harvard University Press.

Galison, Peter. 1987. *How Experiments End*. Chicago: University of Chicago Press.

Galison, Peter. 1997. *Image and Logic: A Material Culture of Microphysics*. Chicago: University of Chicago Press.

Garforth, Lisa, and Anne Kerr. 2010. "Let's Get Organised: Practicing and Valuing Scientific Work Inside and Outside the Laboratory." *Sociological Research Online* 15 (2): 1–15.

Gavigan, Annette M. 2007. "Fossil Laboratory Exhibitions in Natural History Museums: Communicating the Human Dimension of Fossil Research with Visitors." Master's thesis, John F. Kennedy University.

Gavigan, Annette M. 2009. "Working Fossil Laboratories as Public Exhibitions." In *Methods in Preparation: Proceedings of the First Annual Fossil Preparation and Collections Symposium*, edited by Matthew A. Brown, John F. Kane, and William G. Parker, 13–20.

Gibson, Susannah. 2017. "The Careering Naturalists: Creating Career Paths in Natural History, 1790–1830." *Archives of Natural History* 44 (2): 1–21.

Gilbert, G. Nigel, and Michael Mulkay. 1984. *Opening Pandora's Box: A Sociological Analysis of Scientists' Discourse*. Cambridge: Cambridge University Press.

Glass, Jennifer B. 2015. "We Are the 20%: Updated Statistics on Female Faculty in Earth Sciences in the US." In *Women in the Geosciences: Practical, Positive Practices toward Parity*, edited by Mary Anne Holmes, Suzanne O'Connell, and Kuheli Dutt, 17–24. American Geophysical Union.

Goffman, Erving. 1956. *The Presentation of Self in Everyday Life*. Edinburgh: University of Edinburgh Social Sciences Research Centre.

Goodwin, Charles. 1995. "Seeing in Depth." *Social Studies of Science* 25 (2): 237–274.

Grande, Lance, and Eric J. Hilton. 2006. "An Exquisitely Preserved Skeleton Representing a Primitive Sturgeon from the Upper Cretaceous Judith River Formation of Montana (Acipenseriformes: Acipenseridae: N. Gen. and Sp.)." *Journal of Paleontology* 80 (4): 1–39.

Grande, Lance, and Eric J. Hilton. 2009. "A Replacement Name for Psammorhynchus Grande and Hilton, 2006 (Actinopterygii, Acipenseriformes, Acipenseridae)." *Journal of Paleontology* 83 (2): 317–318.

Grasseni, Cristina. 2004. "Skilled Vision: An Apprenticeship in Breeding Aesthetics." *Social Anthropology* 12 (1): 41–55.

Grasseni, Cristina. 2005. "Designer Cows: The Practice of Cattle Breeding between Skill and Standardization." *Society & Animals* 13 (1): 33–50.

Grazian, David. 2015. *American Zoo: A Sociological Safari*. Princeton, NJ: Princeton University Press.

Greer, Betsy, ed. 2014. *Craftivism: The Art of Craft and Activism*. Vancouver, BC: Arsenal Pulp Press.

Hacking, Ian. 1999. *The Social Construction of What?* Cambridge, MA: Harvard University Press.

Handy, Femida, and Jeffrey L. Brudney. 2007. "When to Use Volunteer Labor Resources? An Organizational Analysis for Nonprofit Management." *Vrijwillige Inzet Onderzocht (VIO, Netherlands)* 4:91–100.

Handy, Femida, and Narasimhan Srinivasan. 2004. "Valuing Volunteers: An Economic Evaluation of the Net Benefits of Hospital Volunteers." *Nonprofit and Voluntary Sector Quarterly* 33:28–54.

Haraway, Donna. 1984. "Teddy Bear Patriarchy: Taxidermy in the Garden of Eden, New York City, 1980–1936." *Social Text* 11:20–64.

Haraway, Donna. 2000. "A Cyborg Manifesto: Science, Technology, and Socialist-Feminism in the Late Twentieth Century." In *The Cybercultures Reader*, edited by David Bell and Barbara M. Kennedy, 291–324. New York: Routledge.

Haraway, Donna. 2016. *Staying with the Trouble: Making Kin in the Chthulucene*. Durham, NC: Duke University Press.

Hartley, J. M., and E. M. Tansey. 2014. "White Coats and No Trousers: Narrating the Experience of Women Technicians in Medical Laboratories, 1930–90." *Notes and Records of the Royal Society*.

Heimlich, Joe E. 2013. "The Nature Research Center at the North Carolina Museum of Natural Sciences." *Curator: The Museum Journal* 56 (1): 131–138.

Hein, George E. 1998. *Learning in the Museum*. New York: Routledge.

Henning, P. H. 1998. "Ways of Learning: An Ethnographic Study of the Work and Situated Learning of a Group of Refrigeration Service Technicians." *Journal of Contemporary Ethnography* 27 (1): 85–136.

Hermann, Adam. 1909. "Modern Laboratory Methods in Vertebrate Paleontology." *Bulletin of the American Museum of Natural Histor* 26:283–331.

Hicks, Mar. 2017. *Programmed Inequality: How Britain Discarded Women Technologists and Lost Its Edge in Computing*. Cambridge, MA: MIT Press.

Hochadel, Oliver. 2013. *El Mito de Atapuerca. Orígenes, Ciencia, Divulgación*. Barcelona: Edicions UAB.

Holtorf, Cornelius. 2002. "Notes on the Life History of a Pot Sherd." *Journal of Material Culture* 7 (1): 49–71.

Holmes, Kirsten, and Deborah Edwards. 2008. "Volunteers as Host and Guest in Museums." In *Journeys of Discovery in Volunteer Tourism: International Case Study Perspectives*, edited by Kevin D. Lyons and Stephen Wearing, 155–165. Cambridge, MA: CAB International.

Holton, Gerald. 1978. "Subelectrons, Presuppositions, and the Millikan-Ehrenhaft Dispute." *Historical Studies in the Physical Science* 9:161–224.

Hopwood, Nick. 2002. *Embryos in Wax: Models from the Ziegler Studio*. Cambridge, UK: Whipple Museum.

Ingold, Tim. 2000. *Perception of the Environment: Essays on Livelihood, Dwelling and Skill*. London: Routledge.

Jabo, Steven. 2009. "Stocking the Fishbowl: A Program to Teach New Exhibit Lab Volunteers the Basics in Fossil Preparation, Molding and Casting." Talk at the Society of Vertebrate Paleontology Annual Conference, Bristol, UK.

Jabo, Steven, Abby Telfer, Matthew A. Brown, Peter Reser, Matthew E. Smith, and Michael Holland. 2010. "The Smithsonian Institution's Exhibit Fossil Preparation Lab Volunteer Training Programme, Part I: Design and Recruitment." *Geological Curator* 9:169–178.

Jackson, Myles W. 2003. "Can Artisans Be Scientific Authors?" In *Scientific Authorship: Credit and Intellectual Property in Science*, edited by Mario Biagioli and Peter Galison, 113–132. New York: Routledge.

Jahren, Hope. 2016. *Lab Girl*. New York: Vintage Books.

Jalbert, Kirk, and Abby J. Kinchy. 2016. "Sense and Influence: Environmental Monitoring Tools and the Power of Citizen Science." *Journal of Environmental Policy and Planning* 18 (3): 379–397.

Jardine, Nicholas. 1991. *Scenes of Inquiry: On the Reality of Questions in the Sciences*. Oxford: Oxford University Press.

Johnson, Steve. 2015. "Cleaning Sue the T. Rex Takes Patience and Feathers." *Chicago Tribune*, June 11.

Jordan, Kathleen, and Michael Lynch. 1992. "The Sociology of a Genetic Engineering Technique: Ritual and Rationality in the Performance of the 'Plasmid Prep.'" In *The Right Tools for the Job: At Work in the Twentieth-Century Life Sciences*, edited by Adele Clarke and Joan H. Fujimura, 77–114. Princeton, NJ: Princeton University Press.

Jordan, Kathleen, and Michael Lynch. 1998. "The Dissemination, Standardization and Routinization of a Molecular Biological Technique." *Social Studies of Science* 28 (5–6): 773–800.

Joyce, Kelly A. 2005. "Appealing Images: Magnetic Resonance Imaging and the Production of Authoritative Knowledge." *Social Studies of Science* 35 (3): 437–462.

Joyce, Kelly A. 2008. *Magnetic Appeal: MRI and the Myth of Transparency*. Ithaca, NY: Cornell University Press.

Keefe, Jeffrey, and Denise Potosky. 1997. "Technical Dissonance: Conflicting Portraits of Technicians." In *Between Craft and Science: Technical Work in U.S. Settings*, edited by Stephen R. Barley and Julian E. Orr, 53–81. Ithaca, NY: Cornell University Press.

Kevles, Bettyann. 1997. *Naked to the Bone: Medical Imaging in the Twentieth Century*. New Brunswick, NJ: Rutgers University Press.

Kiernan, Denise. 2013. *The Girls of Atomic City*. New York: Simon and Schuster.

Kinchy, Abby J. 2012. *Seeds, Science, and Struggle: The Global Politics of Transgenic Crops*. Cambridge, MA: MIT Press.

Knorr Cetina, Karin. 1999. *Epistemic Cultures: How the Sciences Make Knowledge*. Cambridge, MA: Harvard University Press.

Kohler, Robert E. 1994. *Lords of the Fly: Drosophila Genetics and the Experimental Life*. Chicago: University of Chicago Press.

Kohler, Robert E. 2006. *All Creatures: Naturalists, Collectors, and Biodiversity, 1850–1950*. Princeton, NJ: Princeton University Press.

Kohlstedt, Sally Gregory. 2005. "'Thoughts in Things': Modernity, History, and North American Museums." *Isis* 96 (4): 586–601.

Kremer, Randall. 2011. "Smithsonian Uses Siemens CT Scanner to Unlock Secrets of the Past." Newsdesk: Newsroom of the Smithsonian. October 27, 2011. http://newsdesk.si.edu/releases/smithsonian-uses-siemens-ct-scanner-unlock-secrets-past.

Kuhn, Thomas S. 1996. *The Structure of Scientific Revolutions*. 3rd ed. Chicago: University of Chicago Press.

Kusterer, Kenneth. 1978. *Know-how on the Job: The Important Working Knowledge of 'Unskilled' Workers*. Boulder, CO: Westview Press.

Latour, Bruno. 1980. "The Three Little Dinosaurs or a Sociologist's Nightmare." *Fundamenta Scientiae* 1 (1): 79–85.

Latour, Bruno. 1986. "Visualisation and Cognition: Drawing Things Together." In *Knowledge and Society: Studies in the Sociology of Culture Past and Present*, edited by H. Kuklick, 1–40. London: Jai Press.

Latour, Bruno. 1987. *Science in Action: How to Follow Scientists and Engineers through Society*. Cambridge, MA: Harvard University Press.

Latour, Bruno. 1999. *Pandora's Hope: Essays on the Reality of Science*. Cambridge, MA: Harvard University Press.

Latour, Bruno, and Steve Woolgar. 1986. *Laboratory Life: The Construction of Scientific Facts*. 2nd ed. Princeton, NJ: Princeton University Press.

Lave, Jean. 1988. *Cognition in Practice: Mind, Mathematics and Culture in Everyday Life*. Cambridge: Cambridge University Press.

Lave, Jean, and Etienne Wenger. 1991. *Situated Learning: Legitimate Peripheral Participation*. Cambridge: Cambridge University Press.

Law, John. 1994. *Organizing Modernity: Social Ordering and Social Theory*. Cambridge, Mass: Blackwell.

Leonelli, Sabina. 2008. "Circulating Evidence across Research Contexts: The Locality of Data and Claims in Model Organism Research." Working Papers on the Nature of Evidence: How Well Do "Facts" Travel? No. 25/08. London.

Leonelli, Sabina. 2009. "Understanding in Biology: The Impure Nature of Biological Knowledge." In *Scientific Understanding: Philosophical Perspectives*, edited by Henk W. de Regt, Sabina Leonelli, and Kai Eigner, 189–209. Pittsburgh: University of Pittsburgh Press.

Leonelli, Sabina. 2015. "What Counts as Scientific Data? A Relational Framework." *Philosophy of Science* 82 (5): 810–821.

Leonelli, Sabina. 2016. *Data-Centric Biology: A Philosophical Study*. Chicago: University of Chicago Press.

Leonelli, Sabina, and Niccolo Tempini, eds. 2020. *Data Journeys in the Sciences*. Berlin: Springer.

Levin, Nadine, and Sabina Leonelli. 2017. "How Does One 'Open' Science? Questions of Value in Biological Research." *Science, Technology and Human Values* 42 (2): 280–305.

Lewis, Helen. 2012. "The Trouble with Fossils." *New Statesman*, May 2, 2012. http://www.newstatesman.com/sci-tech/sci-tech/2012/05/trouble-fossils.

Lindee, Susan. 2016. "Survivors and Scientists: Hiroshima, Fukushima, and the Radiation Effects Research Foundation, 1975–2014." *Social Studies of Science* 46 (2): 184–209.

Lorimer, Anne. 2003. "'Reality World': Constructing Reality through Chicago's Museum of Science and Industry." PhD diss., University of Chicago.

Lucas, Gavin. 2001. *Critical Approaches to Field Archaeology: Contemporary and Historical Archaeological Practice*. London: Routledge.

Lynch, Michael. 1985. *Art and Artifact in Laboratory Science: A Study of Shop Work and Shop Talk in a Research Laboratory*. London: Routledge and Kegan Paul.

Lynch, Michael. 2002. "Protocols, Practices, and the Reproduction of Technique in Molecular Biology." *British Journal of Sociology* 53 (2): 203–220.

Lynch, Michael, Simon A. Cole, Ruth McNally, and Kathleen Jordan. 2008. *Truth Machine: The Contentious History of DNA Fingerprinting*. Chicago: University of Chicago Press.

Lynch, Michael, and Samuel Y. Edgerton. 1988. "Aesthetics and Digital Image Processing: Representational Craft in Contemporary Astronomy." In *Picturing Power: Visual Depiction and Social Relations*, edited by Gordon Fyfe and John Law, 184–220. London: Routledge.

Macdonald, Sharon. 2002. *Behind the Scenes at the Science Museum*. Oxford: Berg.

Macdonald, Sharon, and Paul Basu. 2007. "Introduction: Experiments in Exhibitions, Ethnography, Art, and Science." In *Exhibition Experiments*, edited by Sharon Macdonald and Paul Basu, 2–24. Malden, MA: Blackwell Publishing Ltd.

Macduff, Nancy. 1997. "Solving the Hazards of Unions and Volunteer Relations in Government Organizations." *Journal of Volunteer Administration* 14:34–39.

Mackenzie, Donald. 1990. *Inventing Accuracy: A Historical Sociology of Nuclear Missile Guidance*. Cambridge, MA: MIT Press.

Manning, Phillip L., L. E. E. Margetts, Mark R. Johnson, Philip J. Withers, William I. Sellers, Peter L. Falkingham, Paul M. Mummery, Paul M. Barrett, and David R. Raymont. 2009. "Biomechanics of Dromaeosaurid Dinosaur Claws: Application of X-Ray Microtomography, Nanoindentation, and Finite Element Analysis." *Anatomical Record* 292:1397–1405.

Mantell, Gideon Algernon. 1844. *The Medals of Creation; or First Lessons in Geology, and in the Study of Organic Remains.* London: Henry G. Born.

"Marvin and Beth Hix Preparators' Grant." 2020. Society of Vertebrate Paleontology. http://vertpaleo.org/the-Society/Awards/hix-preparators-grant.aspx.

Mendez, Eva, Rebecca Lawrence, Catriona J. MacCallum, and Eva Moar. 2020. "Progress on Open Science: Towards a Shared Research Knowledge System." European Commission, Final Report of the Open Science Policy Platform. https://doi.org/10.2777/00139.

Merton, Robert K. 1973. *The Sociology of Science: Theoretical and Empirical Investigations.* Edited by Norman W. Storer. Chicago: University of Chicago Press.

Meyer, Morgan. 2011. "Researchers on Display: Moving the Laboratory into the Museum." *Museum Management and Curatorship* 26 (3): 261–272.

Meyer, Morgan, and Susan Molyneux-Hodgson. 2010. "Introduction: The Dynamics of Epistemic Communities." *Sociological Research Online* 15 (2): 1–7.

Mitchell, W. J. Thomas. 1998. *The Last Dinosaur Book: The Life and Times of a Cultural Icon.* Chicago: University of Chicago Press.

Mitman, Gregg. 1993. "Cinematic Nature: Hollywood Technology, Popular Culture, and the American Museum of Natural History." *Isis* 84 (4): 637–661.

Mukerji, Chandra. 1989. *A Fragile Power: Scientists and the State.* Princeton, NJ: Princeton University Press.

Mulkay, Michael, and G. Nigel Gilbert. 1982. "Joking Apart: Some Recommendations concerning the Analysis of Scientific Culture." *Social Studies of Science* 12:585–613.

Mutchler, Jan E., Jeffrey A. Burr, and Francis G. Caro. 2003. "From Paid Worker to Volunteer: Leaving the Paid Workforce and Volunteering in Later Life." *Social Forces* 81 (4): 1267–1293.

Myers, Natasha. 2015. *Rendering Life Molecular: Models, Modelers, and Excitable Matter.* Durham, NC: Duke University Press.

National Academies of Sciences, Engineering, and Medicine. 2018. *Open Science by Design: Realizing a Vision for 21st Century Research.* Washington, DC: National Academies Press. https://doi.org/10.17226/25116.

National Science Foundation. 2017. "Women, Minorities, and Persons with Disabilities in Science and Engineering: 2017." Arlington, VA. https://www.nsf.gov/statistics/2017/nsf17310.

National Science Foundation. 2019. "Women, Minorities, and Persons with Disabilities in Science and Engineering: 2019." Arlington, VA. https://www.nsf.gov/statistics/wmpd.

Nelkin, Dorothy, and M. Susan Lindee. 1995. *The DNA Mystique: The Gene as a Cultural Icon.* New York: W. H. Freeman.

Noble, Brian. 2016. *Articulating Dinosaurs: A Political Anthropology.* Toronto: University of Toronto Press.

Nyhart, Lynn K. 2004. "Science, Art, and Authenticity in Natural History Displays." In *Models: The Third Dimension of Science*, edited by Soraya de Chadarevian and Nick Hopwood, 307–335. Stanford, CA: Stanford University Press.

Ocejo, Richard E. 2017. *Masters of Craft: Old Jobs in the New Urban Economy*. Princeton, NJ: Princeton University Press.

O'Connor, Erin. 2006. "Glassblowing Tools: Extending the Body towards Practical Knowledge and Informing a Social World." *Qualitative Sociology* 29 (2): 177–93.

O'Malley, Maureen A. 2011. "Exploration, Iterativity and Kludging in Synthetic Biology." *Comptes Rendus Chimie* 14 (4): 406–412.

Oreskes, Naomi. 1996. "Objectivity or Heroism? On the Invisibility of Women in Science." *Osiris* 11:87–113.

Orr, Julian. 1996. *Talking about Machines: An Ethnography of a Modern Job*. Ithaca, NY: Cornell University Press.

Osborn, Henry Fairfield. 1904. "On the Use of the Sandblast in Cleaning Fossils." *Science* 19 (476): 256.

Ottinger, Gwen. 2013. *Refining Expertise: How Responsible Engineers Subvert Environmental Justice Challenges*. New York: New York University Press.

PaleoTools. 2020. https://www.paleotools.com.

Panofsky, Aaron L. 2011. "Field Analysis and Interdisciplinary Science: Scientific Capital Exchange in Behavior Genetics." *Minerva* 49 (3): 295–316.

Patchett, Merle, and Kate Foster. 2008. "Repair Work: Surfacing the Geographies of Dead Animals." *Museum and Society* 6 (2): 98–122.

Paxson, Heather. 2012. *The Life of Cheese: Crafting Food and Value in America*. Berkeley: University of California Press.

Perkinson, Roy, Judy Bischoff, Martin Burke, Kathleen Dardes, Frank Matero, Carolyn Rose, Joyce Hill Stoner, and Pam Young. 2003. "Defining the Conservator: Essential Competencies." http://www.conservation-us.org/docs/default-source/governance/defining-the-conservator-essential-competencies.pdf?sfvrsn=1.

Pimiento, Catalina. 2016. "Palaeontology Is Full of Dinosaurs—and Not in a Good Way for Women's Careers." *The Guardian*, October 11, 2016.

Pimm, Gina, and Aubrey Wilson. 1996. "The Tyranny of the Volunteer: The Care and Feeding of Voluntary Workforces." *Management Decision* 34 (4): 24–40.

Poliquin, Rachel. 2008. "The Matter and Meaning of Museum Taxidermy." *Museum and Society* 6 (2): 123–134.

Pols, Jeannette. 2014. "Knowing Patients: Turning Patient Knowledge into Science." *Science, Technology, and Human Values* 39 (1): 73–97.

"Preparators' Resources." 2020. Society of Vertebrate Paleontology. http://vertpaleo.org/For-Members/Preparators-Resources.aspx.

Puig de la Bellacasa, Maria. 2011. "Matters of Care in Technoscience: Assembling Neglected Things." *Social Studies of Science* 41 (1): 85–106.

Rabinow, Paul. 1996. *Making PCR: A Story of Biotechnology*. Chicago: University of Chicago Press.

Rader, Karen A., and Victoria E. M. Cain. 2008. "From Natural History to Science: Display and the Transformation of American Museums of Science and Nature." *Museum and Society* 6 (2): 152–171.

Rasmussen, Nicolas. 1997. *Picture Control: The Electron Microscope and the Transformation of Biology in America, 1940–1960*. Stanford, CA: Stanford University Press.

Reeves, Nicky. 2018. "Visible Storage, Visible Labour?" In *Museum Storage and Meaning: Tales from the Crypt*, edited by Mirjam Brusius and Kavita Singh, 55–63. New York: Routledge.

Rheinberger, Hans-Jörg. 2010. *An Epistemology of the Concrete: Twentieth-Century Histories of Life*. London: Duke University Press.

Richardson, George Fleming. 1842. *Directions for Collecting Specimens of Geology and Mineralogy, for the British Museum*. London: Hippolyte Bailliere. https://archive.org/details/geologyforbeginn00richuoft/page/484/mode/2up/search/konig.

Rieppel, Lukas. 2012. "Bringing Dinosaurs Back to Life: Exhibiting Prehistory at the American Museum of Natural History." *Isis* 103 (3): 460–490.

Rieppel, Lukas. 2019. *Assembling the Dinosaur: Fossil Hunters, Tycoons, and the Making of a Spectacle*. Cambridge, MA: Harvard University Press.

Riesch, Hauke, and Clive Potter. 2014. "Citizen Science as Seen by Scientists: Methodological, Epistemological and Ethical Dimensions." *Public Understanding of Science* 23 (1): 107–120.

Riggs, Elmer S. 1903. "The Use of Pneumatic Tools in the Preparation of Fossils." *Science* 17 (436): 747–749.

Roosth, Sophia. 2013. "Biobricks and Crocheted Coral: Dispatches from the Life Sciences in the Age of Fabrication." *Science in Context* 26 (1): 153–171.

Rossi, Michael. 2010. "Fabricating Authenticity: Modeling a Whale at the American Museum of Natural History, 1906–1974." *Isis* 101:338–361.

Rossiter, Margaret. 1982. *Women Scientists in America*. Baltimore: Johns Hopkins University Press.

Rotman, Dana, Jenny Preece, Jen Hammock, Kezee Procita, Derek Hansen, Cynthia Parr, Darcy Lewis, and David Jacobs. 2012. "Dynamic Changes in Motivation in Collaborative Citizen-Science Projects." *Proceedings of the ACM 2012 Conference on Computer Supported Cooperative Work—CSCW '12*, 217–226.

Rudwick, Martin J. S. 1976. *The Meaning of Fossils: Episodes in the History of Paleontology.* 2nd ed. Chicago: University of Chicago Press.

Rudwick, Martin J. S. 1985. *The Great Devonian Controversy: The Shaping of Scientific Knowledge among Gentlemanly Specialists.* Chicago: University of Chicago Press.

Rudwick, Martin J. S. 2000. "Georges Cuvier's Paper Museum of Fossil Bones." *Archives of Natural History* 27 (1): 51–68.

Rudwick, Martin J. S. 2005. *Bursting the Limits of Time: The Reconstruction of Geohistory in the Age of Revolution.* Chicago: University of Chicago Press.

Rudwick, Martin J. S. 2008. *Worlds before Adam: The Reconstruction of Geohistory in the Age of Reform.* Chicago: University of Chicago Press.

Ruivenkamp, Martin, and Arie Rip. 2010. "Visualizing the Invisible Nanoscale Study: Visualization Practices in Nanotechnology Community of Practice." *Science and Technology Studies* 23 (1): 3–36.

Russell, Andrew L., and Lee Vinsel. 2018. "After Innovation, Turn to Maintenance." *Technology and Culture* 59 (1): 1–25.

Russell, Andrew L., and Lee Vinsel. 2019. "Making Maintainers: Engineering Education and an Ethics of Care." In *Does America Need More Innovators?*, edited by Matthew Wisnioski, Eric Hintz, and Marie Stettler Kleine. Cambridge, MA: MIT Press.

Russell, Ben. 2014. "Watt's Workshop: Craft and Philosophy in the Science Museum." *Science Museum Group Journal* 1 (Spring).

Santy, Patricia A. 1994. *Choosing the Right Stuff: The Psychological Selection of Astronauts and Cosmonauts.* Westport, CT: Praeger Publishers.

Saunders, Barry F. 2008. *CT Suite: The Work of Diagnosis in the Age of Noninvasive Cutting.* Durham, NC: Duke University Press.

Schaffer, Simon. 1988. "Astronomers Mark Time: Discipline and the Personal Equation." *Science in Context* 2:115–145.

Schön, Donald A. 1983. *The Reflective Practitioner: How Professionals Think in Action.* New York: Basic Books, Inc.

Secord, Anne. 1994. "Science in the Pub: Artisan Botanists in Early Nineteenth-Century Lancashire." *History of Science* 32:269–315.

Secord, James A. 2004. "Monsters at the Crystal Palace." In *Models: The Third Dimension of Science*, edited by Soraya de Chadarevian and Nick Hopwood, 138–169. Stanford, CA: Stanford University Press.

Sennett, Richard. 2008. *The Craftsman.* New Haven, CT: Yale University Press.

Sepkoski, David. 2012. *Rereading the Fossil Record: The Growth of Paleobiology as an Evolutionary Discipline.* Chicago: University of Chicago Press.

Sepkoski, David, and Michael Ruse, eds. 2009. *The Paleobiological Revolution: Essays on the Growth of Modern Paleontology.* Chicago: University of Chicago Press.

Shapin, Steven. 1989. "The Invisible Technician." *American Scientist* 77 (6): 554–563.

Shapin, Steven. 1992. "Why the Public Ought to Understand Science-in-the-Making." *Public Understanding of Science* 1:27–30.

Shapin, Steven. 1994. *A Social History of Truth: Civility and Science in Seventeenth-Century England*. Chicago: University of Chicago Press.

Shapin, Steven, and Simon Schaffer. 1985. *Leviathan and the Air-Pump: Hobbes, Boyle, and the Experimental Life*. Princeton, NJ: Princeton University Press.

Shapin, Steven, and Arnold Thackray. 1974. "Prosopography as a Research Tool in History of Science: The British Scientific Community, 1700–1900." *History of Science* 12 (1): 1–28.

Shetterly, Margot Lee. 2016. *Hidden Figures: The American Dream and the Untold Story of the Black Women Mathematicians Who Helped Win the Space Race*. New York: William Morrow and Company, Inc.

Sibum, H. Otto. 2000. "Experimental History of Science." In *Museums of Modern Science*, edited by Svante Lindqvist, 77–86. Canton, MA: Science History Publications.

Sims, Benjamin. 1999. "Concrete Practices: Testing in an Earthquake-Engineering Laboratory." *Social Studies of Science* 29 (4): 483–518.

Sims, Benjamin. 2005. "Safe Science: Material and Social Order in Laboratory Work." *Social Studies of Science* 35 (3): 333–366.

Sismondo, Sergio. 1996. *Science without Myth: On Constructions, Reality, and Social Knowledge*. Albany: SUNY Press.

Smocovitis, Vassiliki Betty. 1999. "Commemorative Practices in Science: Historical Perspectives on the Politics of Collective Memory." *Osiris* 14:274–323.

Sobel, Dava. 2016. *The Glass Universe: How the Ladies of the Harvard Observatory Took the Measure of the Stars*. New York: Viking.

Sommer, Marianne. 2010. "Seriality in the Making: The Osborn-Knight Restorations of Evolutionary History." *History of Science* 48 (3–4): 461–482.

Star, Susan Leigh. 1992. "Craft vs. Commodity, Mess vs. Transcendence: How the Right Tool Became the Wrong One in the Case of Taxidermy and Natural History." In *The Right Tools for the Job: At Work in the Twentieth-Century Life Sciences*, edited by Adele Clarke and Joan H. Fujimura, 257–86. Princeton, N.J: Princeton University Press.

Star, Susan Leigh, and James R. Griesemer. 1989. "Institutional Ecology, 'Translations,' and Boundary Objects: Amateurs and Professionals in Berkeley's Museum of Vertebrate Zoology, 1907–39." *Social Studies of Science* 19 (3): 387–420.

Star, Susan Leigh, and Anselm Strauss. 1999. "Layers of Silence, Arenas of Voice: The Ecology of Visible and Invisible Work." *Computer-Supported Cooperative Work* 8 (1995): 8–30.

Stevens, Hallam. 2013. *Life Out of Sequence*. Chicago: University of Chicago Press.

Strasser, Bruno J., Jérôme Baudry, Dana Mahr, Gabriela Sanchez, and Elise Tancoigne. 2019. "Citizen Science? Rethinking Science and Public Participation." *Science and Technology Studies* 32 (2): 52–76.

Strasser, Bruno J., and Muki Hacklay. 2018. *Citizen Science: Expertise, Democracy, and Public Participation*. Report to the Swiss Science Council, Bern, Switzerland.

Suchman, Lucy. 1995. "Making Work Visible." *Communications of the Association for Computing Machinery (ACM)* 38 (9): 56–64.

Suchman, Lucy, and Libby Bishop. 2000. "Problematizing 'Innovation' as a Critical Project." *Technology Analysis and Strategic Management* 12 (3): 327–333.

"SUE the T. rex." 2018. Field Museum Blog. https://www.fieldmuseum.org/blog/sue-t-rex.

"SVP Bylaws." 2009. Society of Vertebrate Paleontology. http://vertpaleo.org/the-Society/Governance-Documents/Constitution-and-Bylaws/SVP-Bylaws.aspx.

TallBear, Kim. 2013. "Genomic Articulations of Indigeneity." *Social Studies of Science* 43 (4): 509–533.

Timmermans, Stefan. 2003. "A Black Technician and Blue Babies." *Social Studies of Science* 33 (2): 197–229.

Traweek, Sharon. 1988. *Beamtimes and Lifetimes: The World of High Energy Physicists*. Cambridge, MA: Harvard University Press.

Turner, Derek. 2007. *Making Prehistory: Historical Science and the Scientific Realism Debate*. Cambridge: Cambridge University Press.

Turner, Derek. 2019. *Paleoaesthetics and the Practice of Paleontology*. Cambridge: Cambridge University Press.

Van Beek, Constance. 2011. "Putting a Fine Point on It . . . Advanced Pin Vise Preparation Techniques: Materials and Methods." *Brigham Young University Geology Studies* 49B:7–10.

Van Beek, Constance, and Matthew A. Brown. 2010. "Three Dimensional Preparation of a Late Cretaceous Sturgeon from Montana: A Case Study." *Geological Curator* 9 (3): 149–153.

Wenger, Etienne. 1998. *Communities of Practice: Learning, Meaning, and Identity*. Cambridge: Cambridge University Press.

Whalley, Peter, and Stephen R. Barley. 1997. "Technical Work in the Division of Labor: Stalking the Wily Anomaly." In *Between Craft and Science: Technical Work in U.S. Settings*, edited by Stephen R. Barley and Julian E. Orr, 23–52. Ithaca, NY: Cornell University Press.

Whybrow, Peter J. 1985. "A History of Fossil Collecting and Preparation Techniques." *Curator* 28 (1): 5–26.

Wilson, John. 2000. "Volunteering." *Annual Review of Sociology* 26:215–240.

Wylie, Alison. 2002. *Thinking from Things: Essays from the Philosophy of Archeology*. Los Angeles: University of California Press.

Wylie, Alison, and Sergio Sismondo. 2015. "Standpoint Theory." In *International Encyclopedia of the Social and Behavioral Sciences*, edited by James D. Wright, 324–330. 2nd ed. Amsterdam: Elsevier.

Wylie, Caitlin Donahue. 2009. "Preparation in Action: Paleontological Skill and the Role of the Fossil Preparator." In *Methods in Fossil Preparation: Proceedings of the First Annual Fossil Preparation and Collections Symposium*, edited by Matthew A. Brown, John F. Kane, and William G. Parker, 3–12.

Wylie, Caitlin Donahue. 2015. "'The Artist's Piece Is Already in the Stone': Constructing Creativity in Paleontology Laboratories." *Social Studies of Science* 45 (1): 31–55.

Wylie, Caitlin Donahue. 2016. "Invisibility as a Mechanism of Social Ordering: Defining Groups among Laboratory Workers." In *Invisibility and Labour in the Human Sciences*, edited by Jenny Bangham and Judith Kaplan, 85–90. Berlin: Max Planck Institute for the History of Science.

Wylie, Caitlin Donahue. 2018a. "'I Just Love Research': Beliefs about What Makes Researchers Successful." *Social Epistemology* 32 (4): 262–271.

Wylie, Caitlin Donahue. 2018b. "Trust in Technicians in Paleontology Laboratories." *Science, Technology and Human Values* 43 (2): 324–348.

Wylie, Caitlin Donahue. 2019a. "Overcoming the Underdetermination of Specimens." *Biology and Philosophy* 34 (24).

Wylie, Caitlin Donahue. 2019b. "The Plurality of Assumptions about Fossils and Time." *History and Philosophy of the Life Sciences* 41 (21).

Wylie, Caitlin Donahue. 2019c. "Socialization through Stories of Disaster in Engineering Laboratories." *Social Studies of Science*.

Wylie, Caitlin Donahue. 2020. "Glass-Boxing Science: Laboratory Work on Display in Museums." *Science, Technology and Human Values* 45 (4): 618–635.

Wylie, Caitlin Donahue. 2021. "The Epistemic Importance of Novices: How Undergraduate Students Contribute to Engineering Laboratory Communities." *Sociology of the Sciences Yearbook*.

Wynne, Brian. 1989. "Sheepfarming after Chernobyl." *Environment* 31:10–39.

Yarrow, Thomas. 2003. "Artefactual Persons: The Relational Capacities of Persons and Things in the Practice of Excavation." *Norwegian Archaeological Review* 36 (1): 65–73.

Yarrow, Thomas. 2006. "Sites of Knowledge: Different Ways of Knowing an Archaeological Excavation." In *Ethnographies of Archaeological Practice: Cultural Encounters, Material Transformations*, edited by Matthew Edgeworth, 20–32. Lanham, MD: AltaMira Press.

Zabusky, Stacia E., and Stephen R. Barley. 1996. "Redefining Success: Ethnographic Observations on the Careers of Technicians." In *Broken Ladders: Managerial Careers in the New Economy*, edited by Paul Osterman, 185–214. Oxford: Oxford University Press.

Zahnd, Li. 1997. "Volunteer Staff Relationships in a Unionized Environment." *Journal of Volunteer Resources Management* 6:8–9.

Index

Abbott, Andrew, 56, 66, 169
Acanthostega gunnari, 116
Access, public
 protecting or displaying the "real thing" for, 183–184
 reasons for glass-walled labs and, 185–187
Acryloid, 42
Adaptation and iteration in preparation, 6
Air scribe, 25, 97, 109, 187
Alberti, Samuel, 14
American Institute for Conservation, 79
American Museum of Natural History, 104, 107
Articulation work, 51
Association for Materials and Methods in Paleontology, 79
Authenticity in public science, 174–177
Autonomy of preparators, 58–59

Barley, Stephen, 66, 81–82, 99, 130–131, 140, 154
Barnum, P. T., 178
Basu, Paul, 176
Bather, Francis, 107, 109–110
Bechky, Beth, 66, 150
Bergwall, Lisa, 74
Bernard, H. M., 106–108
Bourdieu, Pierre, 137, 169
Brinkman, Paul, 103, 111

British Museum, 105, 107
Brochu, Christopher, 126, 128
Brown, Matthew, 70, 79, 112, 160, 163–168

Capital, 137, 169
Career paths of preparators, 68–70
Carnegie Museum, 104
Casts and casting, 35–40, 53–54, 57, 182–184, 201, 213
Citizen science, 177
Clack, Jenny, 116
Clarke, Adele, 48
Collins, Harry, 64, 65, 127
Community, 61–64, 203–205. *See also* Identity; Volunteers
 defining, 64–68
 language of a, 14, 61–62, 64, 142, 149–153, 169
 learning skills and social roles for, 79–87
 power and hierarchies in, 138–141
 of practice, 63–65, 71, 82, 84, 88–94
 preparators learning to be, 98–99
 preparing preparators for, 68–78
 preparing social order for, 94–98
 situated learning in, 63
 training and, 62–64
Computed tomography (CT), 103, 133–134, 184. *See also* Technologies
 basic mechanism of, 113–114

Computed tomography (CT) (cont.)
 complementary technologies to, 126–128
 digital fossils and, 118–121
 digital models made from, 115–116
 emergence of, 113
 in mixed-methods approach, 128
 noninvasiveness of, 117
 not a panacea, 122–123
 specimens created by, 119–120
 specimens not destroyed by, 120–121
 subjective images, objective specimens and, 123–126
 symbiosis of researchers and preparators and, 128–133
 visualizing the invisible, 117–122
Conservators, 41–42, 45–46, 79. *See also* Ethics (of specimen conservation); Reversibility
Contingent repertoire, 48, 152
Craft control, 139
Craft work in preparing fossils, 14–17, 30–40. *See also* Technologies
 consulting scientific papers during, 33–34
 controversial techniques in, 40–49
 creative problem solving in, 49–58
 instantaneity versus reversibility in, 40–43
 making fossils mobile, 35–40
 preparing evidence as, 212–215
 reflection-in-action in, 30
 storage containers for, 34
 values-based decisions in, 35, 49
Creative problem solving, specimen preparation as, 49–58
Creativity
 invisibility allowing, 58–59
 limitations of, 56–58
Currie, Adrian, 132
Cuvier, Georges, 118
Cyanoacrylate controversy, 40–43, 45, 47, 49, 132

Darwin, Charles, 67, 211
Daston, Lorraine, 125

Data. *See* Evidence, preparing
 from CT, 113–127, 130–134
 journeys, 215
 loss of, 145, 207,
 preparing, 14–15, 22, 28, 212–215
 specimens as (*see* Specimens)
 technicians as producers of, 10, 12, 59, 142, 209
 technology and, 104
Deadlines, setting of, 144–146
Dental tools, 108
De Solla Price, Derek, 49, 141
Discussion and negotiation in science, 149–151
Display. *See* Public science
Documentation of evidence, 28, 59
Doing, Park, 69, 139
Douglas, Mary, 58
Doxa, 137, 166, 170
Drosophila fruit fly, 12

Edgerton, Samuel, 123
Edwards, Deborah, 91
Elmer's glue, 47–48, 167
Embodied skill and knowledge, 10, 15–16, 28, 32, 35, 64
Empiricist repertoire, 48–49, 152
Ethics
 of display, 180–183
 of specimen conservation, 40, 43, 181
Evidence, preparing, 25–29
 controversial techniques in, 40–49
 as crafting data, 212–215
 documentation in, 28, 59
 example of, 25–27
 invisibility allowing creativity in, 58–59
 as key process in preparing knowledge, 27–28
 specimen preparation as creative problem solving in, 49–58
 specimens in, 28–40
Exhibits. *See* Public science

Expertise
 as capital, 169
 and hierarchy, 43, 55, 130–132, 139–140, 148, 154, 157
 and identity, 59, 112, 216
 and image making, 123
 as interactional, 150
 in scientific practice, 16, 31–32, 51–52, 103, 125, 215, 217
 of technicians, 10, 48, 97, 107, 112, 134, 137, 139, 141, 147–148, 158, 209

Fernandez, Vincent, 119, 125
Field Museum, 104, 108, 160, 195
Field theory (Bourdieu), 137–138, 149–150, 169
Fossil Preparation and Collections Symposium, 160
Fossils. *See also* Specimens
 defining, 30–35
 made mobile, 35–40
Fujimura, Joan, 48, 51

Galison, Peter, 16, 125
Gender stereotypes and discrimination, 78, 210–211
Gilbert, G. Nigel, 48, 152
Glass-walled labs, 2–3, 173–174, 176–177, 179–180
 preparing science for the public, 197–200
 reasons for having, 185–187
 spectrum of workspaces in, 187–191
Goffman, Erving, 175, 194, 196
Grande, Lance, 160–168
Grazian, David, 175

Habitus, 73, 113, 137, 142, 154
Hacking, Ian, 7
Hammer-and-chisel preparation, 106–107, 108
Heimlich, Joe, 176
Hermann, Adam, 107, 110, 112

Hierarchy. *See* Power and hierarchies in science
Hilton, Eric, 160–168
Holton, Gerald, 59
Horner, Jack, 159, 160
Humor in science, 33, 38, 151–153, 156, 180, 196–197, 212–213, 217

Inclusion, 87, 198–201, 205, 215–222
Identity, 45, 62–67, 98–99, 113, 139, 151, 188, 194, 199
Ingold, Tim, 51
Innovations by preparators, 52–56
 limitations of creativity in, 56–58
Intervention through invention, 52–56

Jabo, Steve, 84
Jackson, Myles, 127
Jahren, Hope, 209
Jardine, Nicholas, 67
Jordan, Kathleen, 12
Journal of Paleontology, 160

Kludging, 30
Knowledge preparation, 5–9. *See also* Evidence, preparing
 choosing techniques and, 147–149
 labor as relationships and relationships as labor in, 205–209
 labor of scientists in, 9–13
 about scientific labor, 20–23
 who is missing in, 209–212
Kohler, Robert, 11–12
Kuhn, Thomas, 49–50

Latour, Bruno, 6, 7, 49
Lave, Jean, 63, 64
Law, John, 141
Leonelli, Sabina, 28, 213
Lynch, Michael, 12, 64, 123

Macdonald, Sharon, 176, 185
Manhattan Project, 211

Mantell, Gideon, 105
Manual dexterity, 77–78
Michelangelo, 16
Millikan, Robert, 59
Mobility, fossil, 35–40
Molding, 35–38. *See* Casts and casting
Moore-Fay, Scott, 18
Mukerji, Chandra, 8
Mulkay, Michael, 48, 152
Murray, Bill, 109
Museum displays. *See* Public science
Museum of the Rockies, 159

Nature
 constructing evidence in investigating, 17
 pieces of, 7–8
 politics of display and, 8
Nature-making, 175
Nelsen, Bonalyn, 66
Noble, Brian, 8, 173, 187, 188

Objective specimens and subjective images, 123–126
Origin of Species, 67
Osborn, Henry Fairfield, 107, 108–109

Paleoartists, 115–116
Paleontology, 12–13, 117. *See also* Science
 depending on adhesives, 40–49
PaleoTools, 109
Panofsky, Aaron, 137
Participant observation of "invisible" technicians, 17–20
Patience and judgment skills, 75–78
Paxson, Heather, 16
Photoshop, 123
Pneumatic tools, 103–104, 108–109
Power and hierarchies in science, 138–141
Preparation
 achieving physical and epistemic goals through, 8–9
 adaptation and iteration in, 6
 communities (*see* Community)
 evidence (*see* Evidence, preparing)
 as inclusive and trustworthy, 215–222
 knowledge, 5–9
 labor of scientists and others in, 9–13
 for public science (*see* Public science)
 science (*see* Science)
 specimens, 6–8
 technologies in (*see* Technologies)
 theory of social construction and, 5–6
 trust and, 221–222
Preparators/technicians, 3–5, 14–17, 25–27
 assumptions about the public, 177–180
 career paths of, 68–70
 choosing techniques, 147–149
 competition and proprietary methods among, 55–56
 creativity allowed by invisibility of, 58–59
 defining science by defining themselves, 141–153
 devaluing of work done by, 50–51
 discussion and negotiation by, 149–151
 doing research, 154–155
 evidence preparation by (*see* Evidence, preparing)
 gender stereotypes and, 78
 humor among, 151–153
 innovations by, 52–56
 intervention through invention by, 52–56
 labor as relationships and relationships as labor and, 205–209
 labor of, 9–13, 17
 learning skills and social roles, 79–87
 limitations of creativity for, 56–58
 observation of, 17–20
 observing "invisible," 17–20
 patience and judgment as skills for, 75–78
 power and hierarchies and, 138–141
 preparing knowledge about, 20–23
 PrepList email and, 48, 55, 65, 79, 145–146
 prep test for, 70–74

prioritizing specimens, 142–144
problem solving by, 49–52
setting deadlines, 144–146
social roles and power structure between scientists and, 137–138
specimen preparation by, 94–96
standards of, 49–52
technologies used by (*see* Technologies)
as technology, 133–134
training of, 62–63, 82–87
universality versus right to choose by, 43–49
views on community of, 66–67
volunteer, 61–62, 64, 69
working together with scientists, 158–168, 218–221
work performed by, 14–17
PrepList, 48, 55, 65, 79, 145–146
Prep test, preparators', 70–74
Prioritization of specimens, 142–144
Priscacara fish, 72–73, 151
Problem solving by preparators, 49–56
Public science, 171–172. *See also* Access, public
art of omission in, 191–194
cleaning and sculpting fossils for, 14–17
displaying ourselves, 194–200
displays as sources of pride in, 194–195
exhibit labs preparing science for the public and, 197–200
experiencing authenticity in, 174–177
fossil preparators for, 3–5
as front stage for research work, 195–197
glass-walled labs in, 2–3, 173–174, 176, 179–180, 185–191, 197–200
preparing audiences for science, 200–201
prioritizing access to, 183–194
protecting or displaying the "real thing" in, 183–184
public understanding of, 1–2
research workers' assumptions about the public and, 177–180

right to be informed and, 180–182
spectrum of labs from demonstration space to research workplace in, 187–191
visible storage in, 175–176
what museums display in, 172–174

Racial bias, 211–212
Rasmussen, Nicolas, 112–113
Reflection-in-action, 30
Reversibility (adhesives), 8, 40–43, 163, 167–168
Richardson, George Fleming, 104–105
Riggs, Elmer, 108
Right to be informed, 180–182
Rip, Arie, 124
Rock-cutting, 104–105
Rudwick, Martin, 118
Ruivenkamp, Martin, 124
Russell, Ben, 185

Sandblasting, 107–109
Science, 135–138
choosing techniques in, 147–149
as connector, 168–170
discussion and negotiation in, 149–151
gender stereotypes and discrimination in, 78, 210–211
how scientists and preparators define, by defining themselves, 141–153
humor in, 151–153
labor as relationships and relationships as labor in, 205–209
power in context of paleontological, 138–141
prioritizing specimens in, 142–144
racial bias in, 211–212
scientists and preparators working together from preparation to fact in, 158–168, 218–221
setting deadlines in, 144–146
task territoriality in, 154–158

Science and technology studies (STS), 6, 9, 17, 102
　craft knowledge and "moral economy" of research in, 11–12
Scientific illustration, 115
Scientists
　career paths of preparators and, 68–70
　choosing techniques, 147–149
　defining science by defining themselves, 141–153
　discussion and negotiation by, 149–151
　doing preparation, 155–158
　gender stereotypes of, 78
　humor among, 151–153
　labor as relationships and relationships as labor and, 205–209
　labor of, 9–13
　power and hierarchies and, 138–141
　prioritizing specimens, 142–144
　sense of identity in, 62
　setting deadlines, 144–146
　social roles and power structure between technicians and, 137–138
　working together with preparators, 158–168, 218–221
Sensory judgment, 16, 73, 75–77, 122, 127
Sereno, Paul, 17–18
Shapin, Steven, 185–186
Simpson, Bill, 71, 195
Sismondo, Sergio, 5
Sloane, Hans, 211
Smithsonian National Museum of Natural History, 84, 94–95
Social construction, theory of, 5–6
Society for Vertebrate Paleontology (SVP), 44, 46, 47, 64–66, 79, 160
Specimens. *See also* Fossils
　as cultural objects, 8
　defining fossils and, 30–35
　everyday work of preparing, 30–40
　as evidence, 28–29
　holotype, 33
　how staff prepares, 94–96
　how volunteers prepare, 96–98
　objective, 123–126
　omitted from display, 191–194
　as pieces of nature, 7
　preparation of, 6–7
　as creative problem solving, 49–58
　prioritizing of, 142–144
Standards, fossil preparation, 49–52
Star, Susan Leigh, 208
Stonemasonry, 104–105
Storage containers, 34–35, 53, 83, 149, 165, 175
Strauss, Anselm, 208
Subjective images, 123–126
Synesthetic reason, 16

Tacit knowledge, 65, 127
Talking as scientific practice, 149–151
Taphonomy, 115
Task territoriality, 154–158
Technicians. *See* Preparators/technicians
Technologies, 101–103. *See also* Computed tomography (CT)
　19th and 20th century, 103–109
　preparing digital fossils, 112–133
　skills in using, 109–112
　technicians as, 133–134
Telfer, Abby, 84
Thomas, Vivien, 211
Type (or holotype) specimens, 33–36, 160, 163, 183, 213

Universality versus preparators' right to choose, 43–49

Van Beek, Constance, 53, 160–168
Visible storage, 175–176
Visual skills, 75–77
Volunteers, 61–62, 64, 69
　preparation of specimens by, 96–98
　reasons for hosting, 88–90

reasons for volunteering, 91–94
role in community of practice, 88–94
skill levels of, 80–82
social aspects for, 93
training of, 82–87

Watt, James, 185
Wenger, Etienne, 63, 64
Whalley, Peter, 99
Whybrow, Peter, 104
Wynne, Brian, 170